SAM BOUGH RSA

SAM BOUGH RSA:

The Rivers in Bohemia

Gil and Pat Hitchon

Best wishes
from

Pat Hitchon

The Book Guild Ltd
Lewes, England

The Book Guild Ltd.
95 High Street,
Lewes, Sussex

First published 1998
© Gil and Pat Hitchon 1998

Set in Bembo

Typesetting by
Acorn Bookwork, Salisbury, Wiltshire

Printed in Great Britain by
Bookcraft (Bath) Ltd, Avon

A catalogue record for this book is
available from the British Library

ISBN 1 85776 230 4

For our parents
Terry and Frank

Alas! sir, there are privations upon either side; the banker has to sit all day in his bank, a serious privation; can you not conceive that the landscape painter, whom I take to be the meanest and most lost among contemporary men, truly and deliberately prefers the privations upon his side – to wear no gloves, to drink beer, to live on chops or even on potatoes, and lastly, not to be 'One of us' – truly and deliberately prefers his privations to those of the banker? I can. Yes, sir, I repeat the words; I can. Believe me, there are Rivers in Bohemia.

Robert Louis Stevenson
'On the Choice of a Profession'
Essays Literary and Critical

The true Bohemian, a creature lost to view under the imaginary Bohemians of literature, is exactly described by such a principle of life. The Bohemian of the novel, who drinks more than is good for him and prefers anything to work, and wears strange clothes, is for the most part a respectable Bohemian, respectable in disrespectability, living for the outside, and an adventurer. But the man I mean lives wholly to himself, does what he wishes, and not what is thought proper, buys what he wants for himself, and not what is thought proper, works at what he believes he can do well, and not what will bring him money or favour. You may be the most respectable of men, and yet a true Bohemian. And the test is this: a Bohemian, for as poor as he may be, is always open-handed to his friends; he knows what he can do with money and how he can do without it, a far rarer and most useful knowledge; he has had less, and continued to live in some contentment; and hence he cares not to keep more, and shares his sovereign or his shilling with a friend.

Robert Louis Stevenson
Lay Morals

CONTENTS

1

Starting Out

Return of a native

The small matter of an arduous stagecoach journey the length of England in 1805 was unlikely to trouble Dr Joseph Dacre Appleby Gilpin. Not after fighting yellow fever in Grenada and helping out in the British invasion of Martinique. But he was 70 – old by the standards of his day. The coaches were cramped and comfortless. Progress was slow, hazardous and depended on the uneven quality of roads maintained by myriad turnpike trusts. And it was expensive. So even he would not have travelled on a sudden impulse from Bath to Carlisle.

After 26 years' service as an army doctor in the West Indies, he had settled with his family in Bath towards the turn of the century. Although no longer the centre for the fashionable, what Bath had lost in gaiety it gained in respectability. Once the playground of the wealthy, it was now the last watering hole of the professional middle classes. Yet the legacy of the earlier era lingered – it was still the most civilized city in the country, with elegant architecture and fine amenities. After the deprivations of the colonies, living there must have been a constant source of joy for a man of such 'great urbanity'.

Carlisle was of another way of life. Bombarded by the Duke of Cumberland's cannons in the 1745 rebellion, it had never fully recovered. When Dorothy Wordsworth visited in 1803, the walls were still 'broken down in places and crumbling away, and most disgusting from filth'[1]. In plan, the city had changed little since medieval times but was now bursting at the seams, with a population of over 9,000. Improved roads and the burgeoning local textile industry simply served to attract ever more working people to the city. Neither the housing nor the sanitary arrangements could cope.

Faced with such contrasts, Dr Gilpin must have had a compelling reason to take his whole household north. In fact, it was intended as a final homecoming for one of Cumberland's most-travelled sons.

The family had been connected with the area since the thirteenth

century, and recent generations had made their home in Carlisle. Gilpin's links with the '45 rebellion could hardly have been more intimate, although he was hardly in a position to know that at the time.

His father, Captain Bernard Gilpin, was in charge of the garrison at Carlisle Castle, courtesy of the Lowthers, and lived at the Cathedral Deanery. Apart from his family – he had 16 children – painting was the Captain's great passion. He taught a number of Cumberland's better-known eighteenth-century artists, including Robert Smirke, Guy Head, John 'Warwick' Smith and Joseph Stephenson, and two of his older sons – the Reverend William (he of the 'picturesque') and Sawrey – attained artistic fame in their own rights.

When Bonnie Prince Charlie came over the Border, young Joseph was only eight months old, and his father had just been replaced at the garrison by one of the Duke of Cumberland's own men, Colonel Durand. It hardly mattered, for at the first whiff of bombardment, the two regiments of militia at the castle mutinied and surrendered to the Scots. Captain Gilpin and family – including his heavily pregnant wife – beat an uncomfortable but temporary retreat to Whitehaven in a cold December.

Back home again after so long, Dr Gilpin settled into a fine house in Castle Street and for the next 28 years played a leading part in civic affairs as magistrate, justice of the peace, alderman and – on four occasions – mayor. He also gave his clinical services to the local Dispensary for treating the poor. There might have been more local honours but for the fact that, between 1813 and 1814, he answered his nation's call once more, serving as Deputy Inspector of Hospitals in Gibraltar, where an outbreak of yellow fever was again the problem. He got a knighthood for that piece of work. In 1833, with failing health, the old man returned to Bath and died there on 30 September the following year.

Of love and legitimacy

Among those who made the journey north with Dr Gilpin in 1805 was an 11-year-old valet, James Bough. Said to be a native of Hereford, he had moved to Bath as a young boy when his father died. There in 1801 his mother Alice met and married William Carter, bachelor and landlord of The Rummer Tavern, New Market Row, Walcot Street. As soon as he was old enough, James went into service with the doctor. When he left Bath, Alice stayed behind, but in later years

followed her son to Carlisle, widowed once again.

Young Bough may have gone to Gibraltar with Dr Gilpin (for he took his family with him), but by the time the old man returned to Bath, James had long been running his own shoemaking business, a trade learned while in service.

More significantly, he had met and married a Carlisle woman, Lucy Walker. Born in 1785, she was the oldest daughter of James Walker and Dorothy Dixon, both families with strong Border connections. The Walkers came from Dumfries, while the Dixons were related, through the Graemes, to the Armstrongs. James Walker was a nailor, with a house and shop in Whippery Lane, Rickergate. He and Dolly had three children: Lucy, Sarah and Thomas, all of whom settled in Carlisle.

Lucy had entered service with Dr Gilpin to work in his kitchens. There she met James Bough and, on 18 January 1818, they were married in St Mary's Parish Church (then located in the cathedral nave). Her brother Thomas and one William James witnessed the ceremony.

Lucy was 33 and James 24, a significant age difference given the times and their circumstances. She was also pregnant, their first child was born in May. The little girl was called Alice after James' mother. Given the difference in their ages and the proximity of the marriage to the birth, it might have been a marriage of convenience. Everything in their subsequent life, however, points to an enduring love, even if the initial act was simply designed to legitimize their daughter.

The Boughs settled in a small house at the poorer end of Abbey Street, where James plied his trade. By August the next year, little Alice had a brother, Joseph James.

Samuel came along a few years later, born on 8 January 1822. He was baptised in St Mary's Church on Sunday, 10 February 1822, by the assistant curate, the Reverend Morgan Morgan. His father's trade was mistakenly given in the register as 'cord winder', whereas it should read 'cord wainer', i.e. shoemaker.

By 1826, there were two more hungry mouths to feed. Anne was born in August 1823, and James Walker arrived in January 1826. The Bough household was now complete.

Within eight years, James and Lucy had gone from being carefree lovers to parents of five young children. Any dreams of an easy life were shattered. The problem now was to put enough bread on the table. No easy task, but as a Wellington boot hand with good contacts among the gentry, James should have been able to earn a decent living. Yet it would always be a struggle.

Part of the difficulty was the number of competitors. By 1837, for

example, there were 60 boot and shoemakers working in a city of some 20,000 people – too many to ensure a profit for all. Carlisle was not alone in this – during the years following the Napoleonic wars, the whole country simply had too many bootmakers, and their average income dropped dramatically. Cut-price competition, new imports from France and the rise of the Northampton industry all played their part.

In James Bough's case, there was one other significant factor working against him: his own temperament. Mild and easy-going, he lacked the ambition and drive to be a successful businessman. Friends saw him as a gentle, thoughtful, and well-read man who remained 'untainted by vulgar oath or loose conversation'[2]. Viewed from another angle he was said to 'take the world easily and, if offered, to make concessions as the best means of avoiding friction'[3].

Lucy was the more outgoing, vivacious, brave and witty, with fine narrative skills and a good memory. She was noted for her kindness to neighbours in sickness and in hard times, but had little passion for housework. To keep her husband to task, she would read to him as he worked.

While the Bough household may not have been the most industrious of homes, nor the most comfortable, it offered a warm, human environment in which the children could develop.

Decay and change

In the first three decades of the nineteenth century, Carlisle was a strange mixture of old and new. The walls surrounding the medieval city were finally dismantled, along with the city gates. Some of the stones built the new courthouses – a sign of fresh beginnings, of a more ordered time to come.

But death sentences were still passed on horse thieves and house-breakers. Suicides were buried in the public highway. Bull-baiting and cock-fighting remained popular sports. And robbers and bodysnatchers prowled the streets and churchyards after dark.

For most people living conditions were primitive, with houses, pigsties and slaughterhouses built side by side, presenting a constant health hazard. Epidemics were commonplace and child mortality was high. An outbreak of smallpox in 1785 led to the founding of the Carlisle Dispensary, housed in the Cathedral gateway at the head of Abbey Street, but bouts of typhoid in 1822 and of cholera in 1832 still claimed many victims.

Freak weather also caused devastation. A severe drought in the summer of 1821 reduced the river Eden to a mere mill-stream. Then the storms of the following February broke its banks and led to the worst flooding ever known.

It was also an era of social upheaval, nationally and locally. With the French threat removed, the plight of the working classes deteriorated. Universal suffrage became the dream that would prove one more false dawn.

The Border city was a hotbed of restiveness, and in 1819 its weavers, along with other workers, petitioned the Prince Regent to send them all off to America, in the hope of a better life. The Carlisle weavers were a highly politicized group, mostly supporting the Whigs in default of anything better. They subscribed to the latest London papers delivered from the mail coaches, then read their contents avidly and debated the issues long into the night. At the elections of 1826 they rioted when the Tory candidate canvassed in their neighbourhood. The mayor was captured, the garrison called out, and three women and a small girl were left dying when the mob finally dispersed. When the Reform Bill was finally passed in 1832, Carlisle celebrated with a grand pageant and procession.

A new era of culture and commerce was emerging. The city got its first permanent theatre in 1813, and a gas light company was formed in 1819. In March 1823 the £90,000 canal linking Carlisle with the Solway was opened. The intention had been to extend it eastwards to Newcastle, giving a waterway link between the Irish Sea with the North Sea, but this idea was soon abandoned in favour of a railway. The first section of the Carlisle-Newcastle line was opened in 1835.

Other intimations of change were the city's first balloon ascent (1825); the completion of the new £40,000 gaol (1827); the founding of a police force (1829); the building of the Cumberland Infirmary (1830); and the formation of a host of local organisations, such as the Carlisle Society for the Encouragement of the Fine Arts in the North of England (1822), the Mechanics Institute (1824) and the Literary and Philosophical Institution (1835).

While much of this was moved by the middle classes, in Carlisle at least it was an era rich in independently-minded working people, artisans who had a sense of their own worth; people who would question the status quo and strive to improve their own hard lives, driven not by any sense of social standing, but simply as a statement of their right to occupy a space in the world they inhabited. Men who would not be told what to think by those who expected respect because of their economic standing or family history.

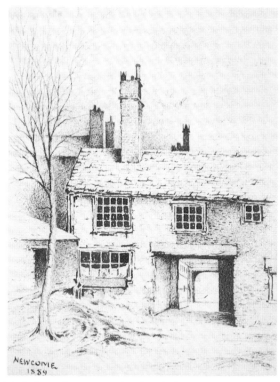

Sam Bough's birthplace from a sepia sketch by F.C. Newcome. Tullie House
Museum and Art Gallery.

Home in Abbey Street

Into this confusion of decay and change, Sam Bough was born. A
contemporary drawing by F.C. Newcome shows the original house.
Access was gained through an archway in Abbey Street that led to
Atkinson's Court, on the left of which was the Bough's: a low two-
storey brick building, the end house of a tenement. The front, and
only, door in the gable end opened onto the close, with one window
looking out into Abbey Street.

Sam was born in the upper room (with the small 20-paned window
in Newcome's picture), little more than nine feet wide. Downstairs,
the kitchen/workshop was of a similar size.

Abbey Street housed the whole of local society in microcosm. To
the south, across the head of the street, stood the old Abbey gateway
and, looking northwards from this point towards the Castle, the
changing character of the buildings spoke clearly of the prevailing
social structure.

Nearest to the gateway was the seventeenth-century Tullie House and some fine new Georgian houses. Those buildings were the substantial homes of the city's better-off inhabitants, while further down, and particularly on the western side, lived the poorer families (including the Boughs), housed in closes off the main street. Bough's journey through life would reflect the first steps he took down Abbey Street, from poverty to plenty.

Tullie House was the finest piece of domestic architecture in the city at that time, and 'a centre of social and intellectual life'[4] under its various owners. In Bough's childhood, these were the Dixons. They owned the city's major cotton factory, employing 8,000 workers in its heyday. Just opposite lived a relative and fellow businessman of the Dixons, Robert Ferguson, who was a Whig Radical politician, Mayor of Carlisle in 1836–37 and MP from 1852 to 1857. Others, such as Richard Cust and John Hodgson were described simply as 'gentleman'. Men like Major George Stevenson Mounsey needed no such postscripts. Of the women, 'the benevolence and charity of Mrs Lodge and Miss Bowes' were 'too well known to require eulogy'[5].

Further down the street (and the social scale) were the professional men, such as physicians Robert Harrington and George Tinniswood and the dentist and city councillor, Thomas Sheffield. 'They formed a background to the little shoemaker's shop – Sam's father and mother had served these people – and some patronised to Sam's intimate scorn – and others befriended.'[6]

All of these households, of course, had their domestic staff, who 'generally formed a little community of their own, where Mrs Bough and her family, their talents, eccentricities and romances played no unimportant part'[7]. Such people were 'full of life and fun, and had a very good share of independence and keen intelligence'[8].

The Directories of the day ignore the lower social orders, and only with the Census of 1841 does a detailed picture emerge. In addition to the wealthier families and their servants, a multitude of occupations was represented in Abbey Street: architect, watchmaker's apprentice, calico printer, designer, dressmaker, stationer, dry salter, builder, shoemaker, bricklayer, painter, clerk, factory reeler, agricultural labourer, weaver, musician, surgeon, teacher, plumber and glazier, cabinet maker, tanner's apprentice and 'pauper'.

During Sam's childhood, the Boughs moved to number 21, a house on the opposite side of the lane, fronting onto Abbey Street. Lucy's sister and her husband Richard Wright also moved into Abbey Street from Old Whippery Lane. He was a builder by trade who had married Sarah Walker in 1815, settling near his in-laws in Rickergate, but at

some time after 1829 they moved to Atkinson's Court. Their children – William, Jane, James and Thomas – grew up alongside Sam and his brothers and sisters, sharing in their games and adventures. Jane in particular would remain a great favourite with Sam throughout his life.

Among the Boughs' closest friends were their next-door neighbours, the Atkinsons. Mary Atkinson had been maid to Mrs Howard of Corby Castle and 'had travelled and mixed with refined, highly educated people. She had been a most devout Roman Catholic and had carried her husband with her – after adorning the Church of England, Presbyterian Church and Quaker meetings.'[9] Her husband, William, was an extremely able man in his own business of house-painting and decorating (inn signs being a speciality). Having worked for 'good people in Edinburgh – had excellent taste and produced first-rate work'[10], he now had a prestigious contract at Lowther Castle, decorating doors and panelling with landscapes and floral designs. In his spare time, he was a keen amateur artist.

Both William Atkinson and Richard Wright made a greater success of their trades than James Bough ever managed. By the 1840s the Wrights were employing their own female servant, suggesting an annual income exceeding £300. They were now part of the lower middle class.

Educating an eccentric

James and Lucy Bough's love of literature did little to enhance their material standing, but their children grew up in a household where book-reading was the norm. At that time any sort of formal education relied largely on the ability of the parents to pay, despite the city's proud claim in 1829 that 'such is the amplitude of the provision made here for the gratuitous education of the rising generation, that none are obliged to grow up without acquiring at least the rudiments of learning, be the poverty of their parents ever so abject'[11].

There was truth in the claim. Literacy levels in Cumberland and Westmorland were among the highest in the land and, in addition to its endowed Grammar School, Carlisle had four schools supported by annual contributions, 10 Sunday schools and 28 other 'academies'. In practice, economic pressures often limited the time spent in school.

William Farish, a contemporary of Sam, knew the problems. Born in 1818, the son of a handloom weaver, he grew up during one of the most depressed times in the trade. 'My short course of schooling began

in my sixth year, with an old crippled [Irishman], Billy Morgan, in a room in a lane off John Street. ... My next academy was the Free School down the Sallyport on the West Walls ... [then] my schooldays ended for I was put to the bobbin wheel at eight'[12]. After that it was down to his own efforts and those of his fellow weavers, attending a night school run by an inmate of the workhouse and then joining a working men's reading room.

A rather different route to literacy was taken by another of Bough's friends, David Spedding, born in Abbey Street in 1826. His father was a butcher and landlord of the Old Black Bull in Annetwell Street. As such, he could afford a tutor for his son and then to send him to the Grammar School (also attended by two of Joseph Ferguson's sons).

As the Boughs' means fell somewhere between those of the Farish and Spedding families, their children's education probably had elements of both experiences.

Sam started school as a 'very small boy'[13], but the precise details of his formal education are uncertain. A contemporary claimed that 'in those days nearly everyone went to a dame's school. Sam might have gone to Jacky Little's in Boustead Lane'[14]. Another thought he went to a school run by Miss Thompson in Castle Street – possibly Ruth Thompson, sister-in-law of Matthew Ellis Nutter, and the niece of Robert Carlyle, both noted local artists. As she died in 1827, the academy would have had to continue in her name for some years after this to explain its appearance in the 1829 Directory. Someone else suggested he then spent some years with his older brother Joseph at Mr Wallace's establishment in White Hart Lane. Yet another contemporary claimed to have attended Nicholson's Academy in Abbey Street with him when he was 11 or 12. Then there is an unsubstantiated story that he was a pupil at the Grammar School. A later writer was sure that all the Bough children acquired 'the better part of their education' from 'a maiden lady named Cox',[15] who lived in Abbey Street, was an old friend of James Bough, and who had no other pupils except Jane Wright. She was said to have taught French and Italian to Alice, and was remembered for her fondness of cats, music and paintings. The only point on which all agree is that Sam took badly to the constraints of the classroom. Conflicting opinions start early in his life.

Whatever his formal education, Sam may have got the better part of his learning informally, through contact with his elders and by his own efforts. Long before Samuel Smiles wrote *Self-Help* there was a tradition of the working man improving himself. Sam was fortunate enough to grow up in a city where such a movement was at its peak.

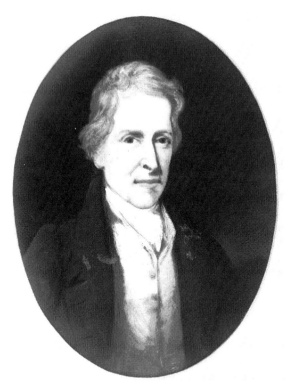

James Bough, Sam's father, by James Kirkpatrick. Tullie House Museum and Art
Gallery.

A brush with greatness, a sense of loss

Sam's upbringing was caring, if disorganized. Never the disciplinarian,
James Bough was happiest when playing with the children, putting up
swings in the back garden, or helping to erect temporary stages for
their amateur theatricals. The house had no back door, so the kitchen
window became their route into the garden. As they grew older, he
would take them on rambles through the local woods or along the
banks of the Eden. Sometimes – when business had been good – he
even hired a donkey and cart to do it in style. Less is known about
Lucy although Sam, more than the rest, inherited her physical charac-
teristics and extrovert qualities.

From his earliest days, Sam's eccentricities in dress and behaviour
were evident. As a boy, wearing 'kneebreeches and clogs, dressed in an
old-fashioned square-cut coat with flaps like a coachman'[16], he paid
little attention to neatness and convention. Perhaps this was how he
stamped his personality on the wealthier youngsters in Abbey Street.

Some certainly saw him as 'a bit cracked', while others were attracted by his ready wit and story-telling skills – traits he carried throughout his life.

Rough and ready, self-willed and quick-tempered, he was as likely to get into fights with girls as with boys. Whatever the weather, Sam was among the ringleaders when it came to wrestling, rambling or playing pranks on the likes of Billy Tate, the Cathedral porter.

In those early years, fame only touched him once, when he met Sir Walter Scott. The great writer had strong emotional ties with Carlisle, having married his beloved Charlotte Carpenter there in 1797. But when he visited the city in 1826, he was still grieving her death, two years earlier. On 3 April that year he stopped overnight on his way to London. Two months later, on the return journey, he made a longer visit, staying with an old friend in Abbey Street. Sam happened to be playing with the children of the house when Sir Walter saw him. Recognizing a personality rich enough to populate the pages of a novel, he sat Sam on his knee and talked to him. It was an event to be remembered for the rest of Sam's days. Years later, Scott was one of Bough's favourite authors, whose works he illustrated with great success.

Sam's talent as a showman began to blossom. At first this was just childish inventiveness, like the drawing of a washerwoman with two holes cut out, through which his fingers, representing her legs, trampled the clothes. He soon progressed to more sophisticated entertainments. In an empty building at the back of the house 'he gave an exhibition of paper figures. most artistically cut out and life-like – at least to the critics of six or seven. They were made to move upon a sheet lighted from behind. The audience thought it very fine. The musical part of the entertainment was provided by Anne Bough'[17].

By the time he was 12 or 13, the shows were even more ambitious. In the home of a friend, Isabella Smith of Fisher Street, the kitchen table was commandeered for a stage, turnip lanterns were the lights, sawdust was strewn around and the girls' dresses were spangled with gold dust. Sam made all the scenery and did the scene-shifting himself. He charged a penny for the privilege of seeing the show, but it all came to a sudden end when Isabella's father got home early one day in mid-performance. He objected to having his home turned into a theatre and turfed them out onto the street. The show was over. As the young audience clamoured for their money back, Sam angrily threw the coins at them and watched with contempt as they scrabbled around for them. Undeterred, the young impresario was soon in business again, operating from a cellar in Botchergate. Isabella recalled years

later, 'He was a splendid hand, but his apparatus would stick sometimes, and then he got into awful tempers'[18].

His temper certainly got the better of him when he was a guest scene-shifter at a school production of *The Forty Thieves*. Given the task of pushing a small boat across the stage hidden by some canvas waves, he was expecting David Spedding in the wings to blow resin into a candle to simulate lightning. Unfortunately, the resin ended up in Sam's eyes and, rising up on stage, he chased after the culprit. Spedding recalled another incident when he threw half a brick at Sam and was thrashed mercilessly until Spedding senior intervened.

Sociable as he was, the young Bough also needed periods of isolation. 'When the fit came on, he could not tolerate the trifling of other youngsters, but retired into himself'[19], according to another friend, Sam Jordan. Maybe the loss of people close to him goes somewhere towards an explanation. In 1832, for example – the year of Carlisle's cholera epidemic – there were three bereavements in the family. February brought the death of Jane Hallifax, his grandmother's sister. Although she was 87 and lived eight miles away in Wigton, the Hallifax family always had close links with the Boughs, and her loss was felt keenly in Abbey Street. The next two deaths were even closer to home. In July, Sam's little cousin, six-year-old Jane Walker died, and in September came the bitterest blow in his young life, when he lost his 74-year-old grandmother, Alice Carter – an 'amiable, interesting old woman'[20] who had a stabilizing presence in the Bough household.

Worse was to come. Four years later, at the end of December 1836, Lucy Bough died of breast cancer, aged just 52. She was buried on 1 January 1837 in St Mary's Churchyard, a stone's throw from Abbey Street. Her death marked the end of Sam's childhood and the beginning of the break-up of the Bough household.

Art's brief flowering

The day that Paul Nixson, marble and stone mason employed David Dunbar in his Finkle Street works was a significant one for the fine arts in Carlisle. The Dumfries-born sculptor had worked for nine years in London with Sir Francis Chantrey, and soon justified his reputation. When the *Citizen*'s correspondent visited his studio in March 1822, it felt like being 'ushered by magic into a full assembly of the heroes and sages of antiquity. Before us frowns the sturdy limbed Ajax, there is the venerable Nestor, with his flowing beard; there the wise Ulysses;

the intrepid Diomed, and the all but invulnerable Achilles'[21].

In October that year Dunbar, Nixson and a number of like minds – including Robert Carlyle and Matthew Ellis Nutter – founded the Carlisle Society for the Encouragement of the Fine Arts in the North of England. By November, the *Carlisle Patriot* could report that:

> A few persons attend each evening and gratuitously instruct students in the knowledge of drawing the human figure from plaster casts, etc. It is to be hoped that in time this useful institution will attract the notice of the leading characters in the county, in order that pecuniary support may be afforded for the purpose of procuring casts from the antique and otherwise procuring the usefulness of the establishment, so that in the course of time we may reasonably hope to see in this city an exhibition of Paintings, Drawing and Sculpture, by native and other artists which shall reflect credit on the North and contribute to its taste and instruction.[22]

The society was just one of many emerging throughout the country. At the beginning of the nineteenth century only London and Dublin boasted such institutions, but within 30 years the situation had changed dramatically. The Norwich Society of Artists led the way in 1803, with Edinburgh's Society of Artists following in 1808. Bath's large artist population and the Northern Society in Leeds came next in 1809, while the Liverpool Academy was founded in 1810. Then there were the Plymouth and the Devon & Exeter Institutions in 1812 and the Birmingham Academy of Arts in 1814. Nearer home, the Northumberland Institution for the Promotion of the Fine Arts was founded in Newcastle-upon-Tyne on 29 July 1822, just a few months before the meeting in Carlisle.

This explosion of interest in art stemmed from many sources, some national, some local. Where the founding fathers were the wealthy genteel, the espoused aims tended to emphasize the civilizing, moral and educational impact of fine art which would, they hoped, 'see even the lower classes awake to the delight arising from the contemplation of fine pictures'[23]. In the thriving industrial centres, the factory owners donned the mantle of patron with a rather less altruistic aim: to improve the design of their products, the better to repel foreign competition – although even here the combination of commerce and art was raised to the level of patriotism.

Where artists dared to set up their own academies, the aims tended to be more introspective, shaped towards the practising artist's needs. Mutual social and material support were key features, as well as the

chance to copy the old masters and see the best of their contemporaries exhibited alongside their own works. The wider audiences that local exhibitions attracted had the added bonus of earning them a few extra pounds.

The tensions between the patrons and the artists were not always constructive. Wealthy men wanted pride of place to be given to their 'old masters' and the best of the new, while the local professional, barely eking out a living, wanted the emphasis to be on his efforts. Funding and the lack of it, as much as artistic quality, played a decisive role in the lifespan of these provincial art institutions.

In Carlisle it began well enough. By June 1823, the *Carlisle Patriot* was announcing that 'Mr Nixson has voluntarily undertaken to erect in Finkle Street as part of a range of elegant buildings, THE ARTISTS ACADEMY'[24]. It measured 30 ft by 16 ft by 17 ft high, was lighted by a dome, and was ready for the first exhibition that opened on 24 September 1823. The facing was of white freestone, surmounted by busts of Wren, West and Chantrey, with a central niche showing a sculptor putting the finishing touches to a head of a goddess, said to represent the Genius of Carlisle – all the work of Dunbar.

At that first show almost 200 works could be seen, mostly 'old masters' or copies of them. Among the local artists to catch the critics' eyes were Robert Carlyle ('his chief fault is shyness'[25]), the portrait painter George Sheffield ('a young artist who gives faithful likenesses but weak on his backgrounds'[26]), Matthew Ellis Nutter ('has talent but wants courage and practice'[27]), and John Dobson (whose exhibits included 'a striking likeness'[28] of Sir J.D.A. Gilpin).

The early patrons were middle class – professional men, industrialists, printers, tradesmen – although the gentry were soon adding their backing.

> Lord Lonsdale was a contributor and a liberal patron; Mr Howard of Corby, Lord Carlisle, Mr Howard of Greystoke, Mr Brougham all lent a helping hand. The writer of this paragraph was in the exhibition rooms when Lord Brougham came to manifest the interest he took in the provision of a new and civilising source of instruction and amusement combined. He said: 'Well, I am glad I have come here. I never expected to see a sight like this in Carlisle. It is honourable to the city and especially honourable to those who have conceived, planned and accomplished it.'[29]

The exhibition was a financial success and was extended the next year to take in major London artists. Consequently the shows of 1825 and

1826 showed improving artistic standards, although by the third show the committee was trying to find ways of cutting down on the carriage costs of paintings. Only about one-tenth of the exhibits found a buyer and, after two more annual exhibitions, it was decided to hold them only every other year. In fact, there were just two more shows, in 1830 and 1833, before the Academy closed.

Increased costs and lack of funding were only part of the problem. The rapid expansion of the railways had made other, larger venues, such as Newcastle, more attractive to the better-known artists. And some of the earlier enthusiasm and idealism had gone. Two of the founding figures were no longer at the helm: Robert Carlyle died in 1825, and a year later David Dunbar, the driving force, left to visit the Carrara quarries in Italy. Although back in Carlisle by October 1827, his energies were now directed towards planning exhibitions in Dumfries, Newcastle and Durham.

In the local Directory for 1829, Dunbar is still listed as joint secretary of the Academy, along with Matthew Ellis Nutter, while Philip Henry Howard of Corby Castle was president. Membership included Dunbar's pupil, Musgrave Lewthwaite Watson, George Sheffield, John Dobson, Thomas Carrick and Thomas, George and the younger Robert Carlyle. By 1837 only Matthew Ellis Nutter of 13 Finkle Street was listed as a professional artist. Carlisle's brief liaison with the fine arts seemed over. But the decline was far from terminal.

Beginner's class

From the outset, Sam had art and artists all round him at home. James Bough acquired pictures and prints as he could afford them. John Dobson painted portraits of the whole family in return for shoemaking lessons from James. A group portrait of the children showed Sam dressed 'in petticoats, riding cock-horse on a broom-stick on which he had one day strayed from home and been lost'[30]. Lucy Bough also had her artistic admirers. She was a sought-after, if resistant, model. Both David Dunbar and the miniaturist Thomas Carrick wanted her to model for them, only to be refused. Next door, the Atkinsons were also keen art collectors.

One of the first stories of Sam's interest in art has him sketching the Abbey gateway when a passing woman remarked, 'My little man! Can you find nothing better to do than that?' Back came the reply, 'No, ma'am. What could be better than doing this?'[31] Others were more encouraging, especially Wordsworth's godmother, Mrs Lodge, who

would reward Sam for the small drawings he brought her.

Sam's journey towards art had begun with the discovery that his skills could earn a penny or pay a debt. One school friend, William Lamb, recalled how, at the age of 11 or 12, Sam drew him a portrait of Margery Jackson, the Carlisle miser, to settle some small debt. This seemed a good idea – getting paid for something you liked doing.

As Sam grew into adolescence, informal networks had replaced the grander vision of the Artist's Academy. John Dobson's night school in English Damside and James McMillan's engraving workshop in Grapes Lane became convivial refuges for those who still had a passion for art. Sam haunted both.

It was as close to a formal art education as he would get. Given his impatience with the constraints of the classroom, we should be grateful. Hours spent copying casts of ancient figures might well have lost him to art forever. That sort of discipline – and the rationale that drove it – was alien to him. In the freer atmosphere of his friends and fellow dreamers, he could choose what interested him and ignore the rest.

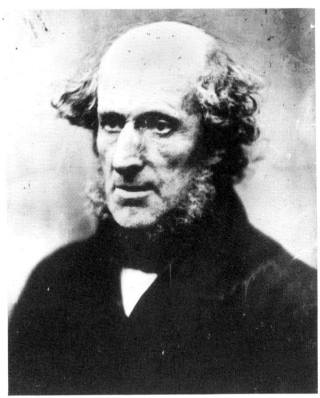

John Dobson, Sam's early mentor in art. Tullie House Museum and Art Gallery.

16

In this Dobson and McMillan were ideal tutors. Both had led hard and varied lives, had never enjoyed material wealth and yet retained a wide-ranging interest in the world about them. Men of broad experience and character, they had somehow retained the capacity to dream, in spite – or because – of everything.

John Dobson was born in Carlisle in 1799, started to learn shoemaking, then worked as a housepainter and signpainter. The *Carlisle Journal* described his way of life:

> One hour you may see him perched aloft among the crows on some old crazy fabric, fortifying the wooden spouts or sky-lights from the 'bleak northern blast' with a coat of lead colour, at the risk of his neck; the next you shall find him at his easel, giving a finishing touch to a Holy Family or an Infant Samuel for some pious patron.[32]

Among Bough's earliest identified works was, significantly, *The Infant Samuel kneeling in Prayer*. Dobson's influence should not be underestimated. One of the first students at the Artists Academy, he finally became a part-time drawing master himself. Although his enduring status as an artist suffers in comparison with Bough, he deserves much better than the dismissive comment of Alexander Fraser that 'the one specimen known to have survived him was the signboard of the *Malt Shovel* public house in Rickergate, from which it may be estimated the value of the art instruction with which Bough set out on his career'[33].

A fairer critique of Dobson is found in a description by Edward Pinnington (an early biographer of Bough) of one of his still lifes *The Lunch Table*. The details were:

> All rendered with the verisimilitude of a photograph in colour. The drawing is above question. ... His portraits are firm and 'tight', finical in respect of smooth surface finish, and probably good likenesses though flat and lacking in vitality. ... Neither he nor any of his local contemporaries tried for either totality of design, the harmonising of details in one broad effect, or to explore the subtleties of chiaroscuro.[34]

If Sam learned little from Dobson, his own limitations must be considered, not just those of his teacher. As James Bough once remarked in despair, 'John will never make a painter of thee, Sam. Thou's far too careless, and pays no attention to what he says.'[35] Dobson, like Bough, was a regular at McMillan's workshop, where 'his quiet gentle-

manly demeanour was in marked contrast with that of some of the other frequenters of the place'[36].

James McMillan was born in Ayr in the 1800s but spent most of his life in Carlisle. His workshop in Grapes Lane was a mixture of dispensary, engraving shop and meeting place for all points of view and tastes. Formally trained in nothing, he gained a reputation as a healer who concocted his own remedies and offered advice on all ailments, as much as for his skill as an engraver. He was also a political activist and a public debater, preaching from the steps of Carlisle Cross on the virtues of teetotalism (then at its peak of popularity) and taking the message throughout the county. As an orator, no one locally could better his style of blending humour and satire with his message. He was 'a most intelligent friend of the working classes, generous, sympathetic, and the possessor of a limitless fund of information'[37].

When it came to art, he had fewer admirers. 'As a landscape painter he was no mean hand, but his taste in this respect far exceeded his power of execution'[38] was the judgement of the press.

This failing apart, McMillan offered Sam three crucial gifts during those formative years. First, his personal encouragement, friendship and patronage. Second, although never more than a jobbing engraver, McMillan taught Sam the rudiments of the craft. The third, and probably most important, way in which the older man helped the young artist was in introducing him to the characters, artistic and otherwise, who frequented his shop.

The regulars became the Hatchet Club, symbolized by a small hatchet of German silver hanging above the mantelpiece. Membership was limited to those 'who distinguished themselves either by big blunders, feeble wit, bad jokes or the "long bow"'[39]. Election was 'without leave being asked or obtained'[40]. Sam might have qualified on all counts.

In terms of his artistic development, the two most influential members of this club were Robert Harrington and George Sheffield.

Harrington was born in 1805 at Carleton, near Carlisle. He had studied in London as well as at Carlisle's Academy. Another kindly, mild man, without any obvious driving life force, his benign presentation irked Sam. His art was seen as being 'exclusively imitative'[41].

The two artists would work together, with Harrington painting the animal (usually a horse) and Sam filling in the background. Of one such effort it was felt: 'The difference in the styles is very marked, the broad handling of the landscape throwing the pony forward into undue prominence, relatively to the coherency of the composition and unity of pictorial effect'[42].

18

Sometimes their artistic differences were acted out. Once, for example, when Harrington criticized Bough's technique in painting a field of grain, Sam's reply was to throw the canvas on the fire. His friend retrieved it and painted a horse over the field of grain. Sam then struck out the horse and reinstated the cornfield. Even at this early stage, he would tolerate no interference with his artistic judgement – an arrogance he would need in years to come.

George Sheffield came from Wigton and trained under Joseph Sutton, who gained some fame in Cumberland as a portrait, genre and historical painter. After working a while in Whitehaven, Sheffield moved to London and entered the Royal Academy Schools, where a bright future was predicted. When this failed to materialize, he travelled back to Wigton in 1833 and eventually set up his own studio in Carlisle. A friend of the Nutters and Carlyles, he was yet another 'well-mannered quiet man'[43]. who became noted locally for his portraits of Cumbrian worthies.

On at least one painting, Harrington, Sheffield and Bough worked together. Other local influences came from Dunbar – Sam asked permission to study his sculptures and casts – and Matthew Ellis Nutter, who gave him a few lessons.

External influences

Some visiting artists also made lasting impact on Bough, notably John Wilson Carmichael, Thomas Miles Richardson, Senior and Thomas Allom.

Newcastle-born Carmichael was a regular traveller to Carlisle in the 1830s. Although his reputation rests on his abilities as a marine artist, at that time he was still painting topographical and landscape views. Between 1835 and 1837 he made a number of sketching trips to the city, working on his commission to record *Views on the Newcastle and Carlisle Railway*, showing various stages of the construction of the first west-to-east-coast English railway. These were published as a series of 24 engravings.

Richardson, a founder member of the Northumberland Institution for the Promotion of the Fine Arts, was another visitor to the city. A loyal exhibitor at the Artists Academy, he was guest at the annual dinner in 1826 and knew most of the local artists, including the young Bough.

London-born Allom was a much travelled artist-cum-architect who specialized in topographical works published in print form. One such

was Fisher's *Cumberland and Westmorland Illustrated*, including some views of Carlisle and its neighbourhood that Sam copied. Allom also helped to illustrate the three-volume work *Westmorland, Cumberland, Durham and Northumberland Illustrated*, published between 1832 and 1835, and other works on the area. He was to play an important, if temporary, role in the life of the young Cumbrian.

Bough may also have copied from other topographical works. A later oil of Berwick-upon-Tweed, attributes its origin to 'a sketch made in 1837', but it has been pointed out that the view 'closely resembled Turner's vignette of Berwick engraved for Scott's *Poetical Works* in 1833–34'[44]. The ambiguities in his art had already begun to show – were the works originals or copies? Bough may have made his first contact with the greatest of all the artist visitors to the Border City when he was in Carlisle around 1832 to paint a watercolour view for reproduction in the same publication.

Fine art, fine houses

Apart from fellow artists, Bough also had examples of fine art all round him in the homes of local worthies. James Bough's contacts with the gentry and William Atkinson, with his high-class clients, must have helped Sam gain access to these.

The grounds of Naworth Castle, for example, were one of his earliest haunts for sketching outdoors. He even joked with his grandmother, Dolly Walker, that he had sketched the very tree from which one of her ancestors, Jock Graeme, had been hanged. When its owner, the Earl of Carlisle, heard of the young artist's activities, he made an unannounced visit to the Abbey Street house, only to find that Sam was out.

Although much of Naworth was destroyed by fire in 1844, Sam would have exhausted his interest in its art treasures before then. These included portraits of Charles I, Cromwell, General Monk, and William Howard – 'Belted Will' of Border folklore – some landscapes (one after the style of Hobbema) and *The Adoration* by Mabuse. The Earl was a patron of local artists, and Matthew Ellis Nutter did some drawings of the castle's interior.

Not far away is Corby Castle, perched high on a hill across the Eden from Wetheral. Mary Atkinson had once worked there, employed by Philip Henry Howard. He too patronized the arts and owned paintings attributed to Titian, Nicolas Poussin, Gainsborough, Allan Ramsay, John Hoppner, James Northcote and John Jackson. The Nutters had

access there, as did Sam, thanks to the Atkinson connection.

Over the river stands Holy Trinity Church, Wetheral, containing one of Joseph Nollekens' finest pieces of sculpture, the Howard Memorial to Lady Maria Howard, who died in 1789. Bough would have known it well, for he was a frequent visitor to the village.

Further afield were Greystoke Castle and Edenhall, homes of Henry Howard and Sir George Musgrave respectively. Greystoke boasted many valuable paintings from the sixteenth century onwards, with works by Holbein, Van Dyke, Daniel Mytens, William Hamilton, Canaletto and Richard Wilson. Edenhall contained a similar array of paintings, including family portraits. Bough also stayed with Lord Wallace at Featherstone Castle, Haltwhistle. A man with great interest in art, he was a friend of Colonel Maclean, who lived across the street from the Boughs.

Closer to home, there were Major Mounsey's pictures in Abbey Street. John Dobson had been employed by this 'enthusiastic collector of pictures, porcelain, enamels and bric-a-brac'[45], so Bough was probably very familiar with the Major's collection. Only when it was dispersed in 1838, after Mounsey's death, did the full extent of his accumulated treasures become apparent. There was a host of works attributed to Poussin, Holbein, Breughel, Van Dyck, Murillo, and Gainsborough, as well as paintings by more local talent: Dobson, Nutter, Richardson and Carmichael.

These and other collections owned by the local gentry gave Sam a glimpse of the wider world of art outside his immediate circle. So too did the increasing number of fine art prints and illustrated books that were becoming available. But as a friend of those early years, Richard Murray, commented: 'Even if the district had been as rich in pictures as it was poor, they would have been of comparatively little use to Bough. He went to nature for all he wanted, both his guide and his model.'[46].

Struggling for a style

For a clearer picture of Bough's development at this time, his own early efforts are the best guide. The childhood drawings of the Abbey gateway, the portrait of Margery Jackson, *The Infant Samuel Kneeling in Prayer* and *Robinson Crusoe and his Man Friday in their Hut* give no indication of his future elemental passion for land, sea and sky. Nor does the small oil of a young girl stepping over a stream. Aged about 17, the girl has a pretty if demure face, an ample figure, and is dressed

like a milkmaid. The background hills and greenery are poorly painted, the overall colours sombre. The style is not identifiable as Bough's, but long tradition gives it some claim to authenticity – Sam, it is said, gave it away to pay off a debt. These works suggest nothing of the future artist.

At some point during this period, Sam decided to offer his own art classes in the summer house in his father's garden. Among his pupils were David Spedding, two of the Wrights, and young James and Anne Bough. There was no fee, but each student had to provide their own candles and drawing materials. It ended abruptly when Richard Wright discovered them working round a charcoal stove, with neither chimney nor ventilation.

One of Sam's first sales was *Corby Castle from Wetheral Woods*, bought by William Atkinson as a sign of faith in his talents. It showed

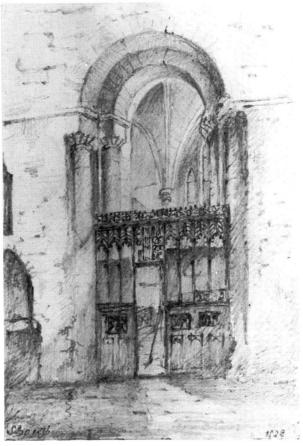

Entrance to St. Catherine's Chapel, a sketch from 1838. Tullie House Museum and Art Gallery.

a high view looking down the Eden from a clearing, given an autumnal effect.

. The earliest known dated work by Bough is the small pencil sketch of the *Interior of Fratery, Carlisle* inscribed on the reverse '6th Nov. 1837'. Two others – *The Deanery and Fratery, Carlisle* and *The Deanery and Fratery, looking North* – are also inscribed 'Nov. 1837', while the *Entrance to St Catherine's Chapel*, dated 1838, is clearly from the same series. While all of these works have a basic competence, they are clearly the product of a young man struggling for a style and still to discover his unique touch as an artist.

'The biggest fool we ever had'

Hard facts about Sam's life are as elusive as his art during this time. Days not spent drawing, painting and talking to local artists were filled with rambles through the local fells and woodlands, or making music and dancing. Bough's zest for life was too great to be satisfied by any one activity. For now art was simply part of his exploration of the world. David Spedding remembered:

> We all attended Rooke's dancing classes in Sawyers Long Room, Fisher Street, but we had more enjoyment in the summer evening dances in James Bough's garden. It was the old man's delight, and about the middle of the long walk, a round space was boarded off, sufficient for a set of quadrilles or the Lancers. Sometimes Sam played, for we used to think him quite a master of the violin, and sometimes he danced, but we all thought there was far more fun in practising in Abbey Street than in learning in Rookes.[47]

The need to earn a living became more pressing. Older brother Joseph had become a bricklayer. Not for Sam. His sharp, retentive mind marked him out as suitable for a more intellectual career. So he began working in the offices of William Nanson, solicitor and Town Clerk, when he was about 14, to obtain some form of legal training. Although both sides tolerated each other for a year or so, Sam was plainly bored stuck in an office. 'When he should be making a draft or copying a brief, however urgent the work might be, he would put it aside to decorate his pad with sketches of the chimney pots over the way or of any object which took his fancy.'[48] Another story has him illuminating the 'I' of 'In the name of God, Amen' when copying a will.

When the inevitable break came, Nanson's comment was blunt: 'Well, I think it's the best thing thou can do, my lad – for certainly thou has been the biggest fool we ever had about the place!'[49].

Whatever caused the final split, the animosity between Bough and the Nansons was short-lived. He later painted a view of *Carlisle from Etterby Scaur* for Nanson's son, said to be his first commissioned painting, for which he received £1 11s 6d. Tradition also has him producing a portrait of Margaret Routledge, later to become Mrs Nanson.

'And trudg'd up to Lunnon thro' thick and thro' thin'

> I kest off my clogs, hung t'keld cwoat on a pin
> And trudg'd up to Lunnon thro' thick and thro' thin,
> And hearing your fiddlers gud fwoks – I've made free
> To thrust myself in your divarshan to see
> Derry down, down, down, derry down.
>
> <div align="right">Ewan Clark, I Trudged up to London</div>

Bough made his first trip to London around 1838. As Ewan Clark's dialect song suggests, it was a path taken by many other Cumbrians before and since, in pursuit of fame and fortune.

Perhaps the break with Nanson was the spur Sam needed. The new plan was for him to train in steel and copper engraving at Thomas Allom's London workshop. It proved a brief encounter, mostly with Mrs Allom. Bough baulked at her interference when her husband was away – and told her so. Then there was the small matter of the £100 needed to pay for the training. As usual, Sam had travelled with more hope than means.

Down and out in London, he had to use brawn rather than brains to earn the fare home. Taking a job as a coalwhipper, he began unloading coal from the holds of colliers on the Thames into lighters, ready for transfer to the wharfside. He could hardly have chosen a harder task. It was casual labour, the whippers being employed on a daily basis by the landlords of the public houses thronging the banks of the river from Tower Hill to Limehouse. A precondition of work was the purchase of drink at the employing public house – an astute piece of business, as whipping was thirsty work.

Whippers worked in gangs of nine: four men loaded up a basket in the hold of 1.25 cwt of coal, another four hoisted it up out of the hold, and the foreman swung it over the side into the weighing machine. An

average day's work saw 98 tons unloaded, for which 8d per ton was paid. Sam claimed to have earned about 18d per day. If so, he worked with one of the tougher gangs. Too tough for Sam. After a few days, he had had enough and, with some coins in his pocket, he headed back home.

A second trip to London may have been made later that year or in 1839, according to Alexander Fraser, his artist friend of later life. It was under the patronage of Henry Aglionby Aglionby, MP for Cockermouth from 1832 until his death in 1854. Their first meeting was at the instigation of William Atkinson. Sam's talent so impressed the MP and his companion, John Henry Lance of Holmewood Common, Surrey, that they invited him to London to copy the old masters at the National Gallery. Aglionby even made his rooms in the Temple available to Sam, and Philip Howard of Corby Castle also weighed in with some help. Lance was a retired commissary judge responsible for suppressing the slave trade in Surinam, South America.

London had been the training ground for generations of Cumbrian artists, including Guy Head, Robert Smirke, Joseph Stephenson, Jacob Thompson, and Sam's two friends, George Sheffield and Robert Harrington. Harrington, in fact, had gone under the patronage of Major Francis Aglionby, a cousin of the Cockermouth MP.

The second time around, Sam made better use of his time. At the National Gallery, works by Poussin, Rubens and Gainsborough particularly impressed him. Among the copies he made were Rubens's self-portrait and Gainsborough's *The Market Cart*. His oil version of the latter was presented to an Abbey Street neighbour, Mary Sheffield, daughter of the dentist Thomas Sheffield.

Sam also went sketching along the Thames and met some fellow artists, including George Lance, painter of fruit and flowers. After some weeks working in this way, he set off for his home town once more.

On one of these journeys back to Carlisle, he travelled via Oxford and Woodstock, visiting the Duke of Marlborough's art collection at Blenheim Palace on the way. Then he met up with a band of gypsies and sketched their camp. Further along the way, he was treated to dinner at a wayside inn by some coach passengers who took pity on him. By Penrith, however, his shoe leather and his luck gave out, so he had to walk the last 18 miles to Carlisle in his bare feet. Apocryphal or not, these stories indicate Bough's egregious, sociable, and enquiring nature that saw him through so many hardships and difficulties in later years.

Professional artist, hopeless dreamer

Sam was now sure of his future – but it was still just a dream. Establishing a studio at the back of his father's house, in what had been a donkey's stable, he became a 'professional artist'.

He was not the only dreamer in Carlisle in those days. Samuel Jefferson, with his shop at 34 Scotch Street, was another man with more imagination than means – and with a passion for local history. It was an obsession he pursued ultimately to the cost of his business as a bookseller and publisher.

Jefferson was about to indulge his dream of cataloguing the history and antiquities of the city and county in a multi-volume work. The first book, *The History and Antiquities of Carlisle*, was published in 1838, using another local artist, William Henry Nutter (son of Matthew) to provide the illustrations. Sam made a copy of one of these, *Queen Mary's Tower*, that Pinnington thought 'very cleverly, in passages finely, done. The play of light upon the Tower wall is very daintily rendered'[50].

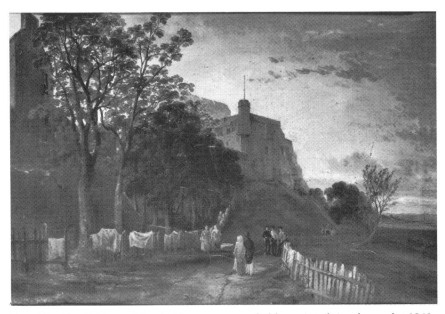

Bough's oil of *Queen Mary's Tower* was probably painted in the early 1840s. Copied from W.H. Nutter's but with a more human touch, showing the garrison's wives hanging their washing out to dry on a picket fence. Southeby's.

1838 was also the year that Bough painted Brecon Hill Tower, Kirklinton, Cumberland, once owned by John Fisher, another of his Carlisle friends, and produced an illustration from Scott's *The Lady of the Lake*, entitled *The Death of Roderick Dhu* or *The Harper*. He also painted another copy of a Gainsborough – *The Watering Hole* – on a large scale.

By now, Jefferson had recognised Sam's potential, for he owned two of his pencil sketches dated 1837 and 1838. Bough claimed that Jefferson was the first person to pay cash for any of his sketches.

When work began on the second volume, probably in 1839, Sam was commissioned to produce the major illustrations. It was the opportunity he had been waiting for. *The History and Antiquities of Leath Ward* was published in 1840 and contained engravings of nine sketches by Bough, mostly views of local churches.

The majority were engraved by John Roy, a former pupil of McMillan, who had set up his own workshop in Glovers Row, opposite the Town Hall. Two, however – *Edenhall: Interior of the Chancel of Edenhall Church* and *Interior of Greystoke Church from the Choir* – were the work of the more famous Edinburgh engraver, W.H. Lizars. The difference in treatment between the two men is striking. Roy has a much more simplistic approach, even though the originals that Lizars had to work from show a less mature artist, probably dating them before Bough's brief sojourn in the South. In general, the standard of drawing is on a par with the Carlisle Cathedral sketches of 1837.

After these sketching trips for the Jefferson illustrations, Sam painted one of his earliest dated oils, *Great Salkeld Church: Sunset in October*. It had noted on it: 'This picture was given to Charles Wright, bricklayer, by Sam Bough, Abbey Street as one of the first that he drew in 1840. he made the stretcher himself.' Pinnington described it as the work of an amateur: '...the colour is conventional – low browns and yellows, with a dash of blue in the sky'[51].

The lure of landscapes

Bough was increasingly turning to nature for his inspiration and education. His rambles through Cumberland and the Borders were always a mixture of business and pleasure. With such fine scenery within easy walking distance of Carlisle, landscapes became the natural focus of his attention.

In 1839 or 1840, for example, he made a long-planned and saved-for

excursion into the Lake District with his father. Unfortunately it rained for most of the walk to Keswick, and they had to shelter overnight in a hayloft of an overcrowded wayside inn. For the next week, James Bough struggled to keep up with his son, and returned to Carlisle exhausted.

A print published in 1840 by J. Allison of Penrith may illustrate this trip. Sam's *Keswick from Ambleside Road* was engraved by Lizars and is a remarkable advance on the quality of the work done for the Jefferson book. Although still clearly derivative, with echoes of the style of Thomas Miles Richardson, Senior, it shows an unprecedented mastery of composition and light and shade. The rainbow bending down onto the spire of St John's Church, built in 1838, suggests a connection with the wet week Sam had spent with his father, roaming the Lakes.

Another sketching trip, made in the summer of 1840 to the north-eastern lakes, was recorded in a sketchbook showing views of Gowbarrow Park, Ullswater, Matterdale, Helvellyn, Mosedale, Patterdale, Kentmere Head, Hawes Water, Mardale, Bampton, Lowther and Greystoke. Although slight in content, every pencil mark in each picture is made to count. Sam was clearly achieving a mastery of line.

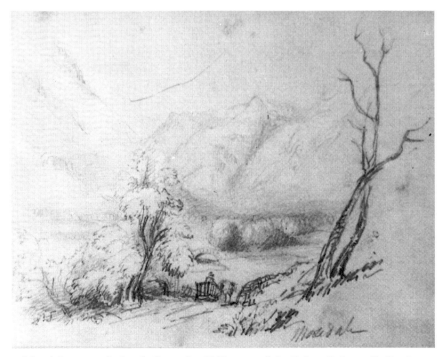

Mosedale, a pencil sketch from the 1840 tour of the Lakes. Private Collection.

Bough's passion for poetry is also illustrated in one of these drawings. *Helvellyn from the spot where the unfortunate Gough was found* commemorates one of the more macabre episodes of Lakeland history. In 1805, Charles Gough fell to his death from the precipice of Striding Edge. Months later when the body was found, his terrier, Foxey, was still guarding it. Later, Wordsworth and Sir Walter Scott, having visited the site, were moved to produce poems on the subject, and Bough's sketch may have been inspired by these, for he was a great admirer of both.

Although he was now turning increasingly towards landscapes. Sam had not totally forsaken other subjects. About this time, for example, he produced a portrait of Henry Tweddle, 'a fairly good likeness, but Sheffield helped him'[52]. This was probably the Henry Tweddle of 41 Lowther Street, who was a housepainter and glazier like Atkinson. Then there was the portrait of John Barron, grocer, tea-dealer and grandfather of Mary Barron, the future wife of Sam's older brother, Joseph. In those days Sam was a regular visitor to their home at 56 English Street, where a breakfast would be provided before he set off on a day's sketching.

A different aspect of his talents came to light in 1840, when he painted a Masonic apron for the Lodge of Free and Brotherly Gardeners for Joseph. He also produced an etching of their coat of arms, bearing the legends 'Unity, Peace & Brotherly Love' and 'Etched by Br. Sam Bough'. This particular lodge had been in existence since at least 1811, and in Bough's time it met at the Rose and Castle, on the corner of Castle Lane and Finkle Street, where Sam decorated the hall.

By now, Anne was housekeeper in Abbey Street. Alice had left home for a job in London, the result of a promise made to her mother before her death. She was 'more finely organized than any of the others, good-looking, clever and loveable, sang well and lost no opportunity of education and self-improvement'[53]. After staying with some relatives of the Boughs in London, she was taken on as governess to the family of William Harrison Ainsworth, the novelist.

Rambling Bough

Around 1840 or 1841, Sam began to give drawing lessons at John Hallifax's school at Penrith Town Head. He had to walk the 18 miles there one day and return the next. One day he decided instead to go directly from Penrith to Newcastle for an eye operation, to correct a squint. While there he took the opportunity to meet up with

Carmichael, the Richardsons and other north-eastern artists again. If this was the occasion when he presented his North-East Lakeland sketchbook to Carmichael, it would place the visit in June 1841.

Walking down Grey Street in Newcastle one day, he met Carmichael's wife with a friend. Ever gallant, he raised his hat to them – leaving its dirty straw lining on his head. When the story was retold later, Sam blushed, to everyone's amazement. Yet on other occasions, when laughed at by a friend's wife for wearing a hat without a crown, he came back quite unabashed with the riposte: 'Niver mind hoe I luik, Maggie, my lass. Theer's nowt like ventilation, ye ken.'[54]

Bough had a cavalier attitude to clothing. Sometimes he was slovenly, wearing tailored waistcoat and trousers that were too short; on other occasions he was arrayed in an open-breasted white waistcoat, with a frilled shirt front, no braces and a massive gold ring on one finger; or he would stride out in a smart straw hat and a long light, oddly-cut canvas coat.

On one of his Lakeland rambles, he met up with William Wordsworth, then in his seventies and living at Rydal Mount. The poet gave him a copy of his poems with a brief message inside. Perhaps he felt sorry for the plight of the young artist, knowing how little chance there was of making a decent living from art locally.

For a few years, however, financial reward counted for little in Bough's scheme of things. Roaming around Lakeland and the Borders, alone with his sketch pad, or merrymaking with a bunch of friends, seems to have represented the essence of life for Bough. In future times, he would look back on these few years as the happiest in his life.

One of his oddest companions on his rambles was James McMillan, the engraver. With his teetotal opinions, the diminutive Scot is said to have warned, 'If ye dinna stop drinkin', I'll hae yer body for dissection, as sure as deith.' Despite their differences, a real friendship persisted between them. When Sam was back down in London in November 1841, he sent his friend a book by William Wadd on corpulency and leanness, diet and dietetics. The inscription – 'from his devoted and sincere friend' – looks serious enough, but with Bough you never can tell.

Sam followed the evangelist throughout Cumberland, although he would slip off to the nearest alehouse once his friend got into his stride. The affection between the two men was bizarre but genuine. On one occasion in Wigton, McMillan found himself unable to walk the whole distance back to Carlisle because of some painfully tight new shoes. Sam carried him home on his back. A rare sight they must have made,

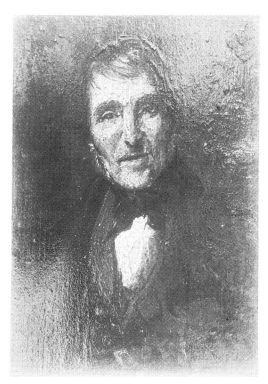

John McDougall, Bough's travelling companion in his rambles through Cumberland. Possibly by Bough. Tullie House Museum and Art Gallery.

with the older man's slight form astraddle the lean, gawky figure of his young friend.

Another regular companion of these years was John McDougall – 'Sam's servant, companion, assistant, salesman and general factotum'[55]. Born in Oban, he had served in the Ninety-First Highlanders throughout the Peninsular War, fighting at Rorica, Vimiero, Corunna, the battles of the Pyrenees, Nivelle, Nive Orthes and Toulouse. He was wounded in the retreat from Corunna, and carried the bullet in his leg as a lifelong reminder. And he had witnessed the burial of Sir John Moore in 1809.

McDougall finished his serious campaigning at Waterloo, and after Paris was occupied, he received a small pension and retired to Carlisle, where he became a handloom weaver and an ardent teetotaller. The latter made him an obvious companion of McMillan, who employed his son as an apprentice, so Sam may have met him first in the Grapes Lane workshop.

There were marked contrasts between Bough and McDougall. 'Sam

was tall, spare and loose-jointed but muscular; John was diminutive but never lost his soldierly bearing. He was prudent, thrifty and abstemious; Sam was careless, extravagant, nowise averse to good liquor, devoted to the weed and valued money for the pleasure it would bring.'[56]

Subsequently the two became well-known as they wandered through the country, using a donkey cart with tent, bedding, cooking utensils and artist's materials on board, accompanied by a large black Newfoundland dog.

Wetheral was one of their favourite haunts during these royal progresses. Years later, a visitor to the court of King Bough recalled the glory of it all:

Early in the forties he pitched his tent in a field beside a wood, between the Abbey and the River Eden, and near the path leading to St Constantine's Cells, better known locally as the 'Safe Guards'. The field is flat and the boundary on the side away from the river is a high bank. At one place the red rock breaks through and close by this is the spot where the tent was set up and where for several weeks Sam lived, sketched, painted, entertained and was lionised by the villagers and country people. . . . During the long evenings in the height of the summer the camp was a regular rendezvous of Sam's friends, and of the rustics who came from far and near, attracted by the fun. Every night there were music, dancing and singing.[57]

One time, a local clergyman who came to stand and stare at the bizarre camp was seized by Bough and dragged into an unwilling dance. When the parson finally made his escape, Sam's judgement was 'mowt ha' brains enoo' for a curate, but hadn't legs enoo' for a bishop'[58].

Then there was the occasion that Sam, in his shirtsleeves and wearing a white waistcoat and white trousers plus a red Turkish turban cap, was visited by the wife of his friend, James Kirkpatrick, and two of her friends. He apologised for the wild disarray of the camp, claiming 'some wild divels wer' here this mornin', Maggie my lass, an' they've drunk iv'ry drop we had, besides eatin' us up rump an' stump into the bargain'. But he soon brightened up when he realised that they had their own picnic with them. Later, as they shared their tea and repartee, Sam even tried to kiss one of the young women, a Miss Johnson of Dumfries, but she would have none of it.[59]

Whenever Sam's sense of the ridiculous got out of hand, McDougall kept things in proportion. William Farish recollected that Bough 'was impulsive, jovial and generous, but when disposed to go to excess,

John never hesitated to check him'[60]. Yet another close friend described how 'John was devoted to Sam, on whom he looked as a superior being, and had many a dust with camp visitors who could not be made to understand the necessity of turning out in reasonable time, so as not to encroach upon the sleeping hours of those under his canvas'.[61]

The two men rambled far and wide throughout the early 1840s and had many a tale to tell of their adventures. In one, they had been camping in the grounds of Sir George Musgrave's Edenhall estate, when their tent was attacked by an angry bull. They beat a hasty retreat.

A similar tale comes from a sketching trip made by Bough with Thomas Sewell (who would marry Sam's favourite cousin, Jane Wright), in which each claimed the heroic part when relating the story in the other's absence. According to Bough, Sewell's first thought was to put a fence between himself and the beast. 'Took it like a bird, he did. I never thowt he wur that soople,' said Bough. Sewell had it the other way round.[62]

But life was not all play during these years. On 12 September 1841 his grandmother, Dolly Walker, died. Another link with the past gone, one more step towards an uncertain tomorrow. Sam later painted her portrait from memory for one of his cousins, Samuel Walker.

Commissions and omissions

An event with another type of significance in 1841 was the building of the Carlisle Athenaeum, which was to house various local institutions, including the new Artists Academy. Its designer, local builder Thomas Nelson, commissioned Sam to produce a memorial sketch, presumably for engraving, of the laying of the foundation stone of some extensions to St Bees Grammar School on 5 April 1842. As the railway system had yet to reach West Cumberland, the journey was made by horse and gig. Nelson's plan was to introduce Sam to the Lowther family, in the hope of improving the young artist's prospects. Ever his own worst advert, when the time came for his starring role, Sam was nowhere to be seen. Eventually he was found wrestling with the labourers, and only just managed to produce the required sketch in time.

Another commission that year came from Oliphant Ferguson of Broadfield House, near Southwaite, who engaged Bough to do some sketches of the nearby St Mary's church and churchyard at High Hesket. Sam spent a whole week camping out on the job and

produced about 30 folios of the inscriptions on many of the tombstones in the churchyard. Other drawings showed the church with its Sunday congregation and the pastor in the pulpit and the exterior of the church, portrayed with 'more dash than finesse'[63].

1842 was also the year in which Samuel Jefferson published his third and, in the event, last volume of his history of the area. This dealt with the Allerdale Ward above Derwent and contained one plate etched by Bough of the *Cross in Irton Churchyard* – a detailed, if uninspired, representation.

On a lighter note, Sam ventured into the field of satire. The inspiration came from what was known locally as the 'Infirmary Squabble'. The Cumberland Infirmary had been built between 1830 and 1832, to the design of Manchester architect Robert Tattersall. When completed, there were no funds to run it, so a live-in caretaker was taken on to look after the empty building. He was found hanged one day, and this generated so much public interest that it was finally decided that something had to be done. Two doctors were recruited to get things going: a Dr Page as physician – and a Dr Birch as house surgeon – both from outside the locality. The first patients entered the hospital in 1841, and in 1842 a male patient from one of the neighbouring villages was treated there for what the medics diagnosed as hip-joint disease (*morbus coxarius*), whereas the local doctors had been declaring that his problem was rheumatism.

Then a local practitioner, Thomas Elliot, declared that decay of the hip joint was the real problem. In one version, the patient died while the doctors were still squabbling over the diagnosis and, at the Coroner's Court, the Infirmary medics had their reputation lowered even further.

Bough got the idea of a cartoon from watching the anger of a small dog he was teasing with a stick. The result was a picture of two dogs fighting over a bone (the *morbus coxarius* in question). The inscription reads 'Rheumatism, etc' and under the etching is the couplet:

> His thoughts they fitted things so well
> That which was which he could not tell.

and

> In honorem Doctorissimorum

Neither of these is a totally satisfactory version of the affair, as they do not explain some key elements in the drawing. Whatever the real

story, however, Sam published his cartoon in print form and added to his local reputation.

One other group of drawings can be placed in 1842. These are 19 whimsical illustrations to Sir Walter Scott's poem *The Lay of the Last Minstrel*, which Sam apparently did for his own amusement. At least three of these still exist, including one of a shabby street singer in nineteenth-century garb (*The Lay of the Last Minstrel*). Another shows the elfin reading the 'Mighty Book', and the third depicts the aged minstrels meeting with the Duchess.

Coming of artistic age

Of more artistic importance in 1842 were his oil paintings, only two of which can be clearly identified. The first is nothing more than a memory – *View in Cumberland* – which once belonged to John Fisher.

The second, *Workington Bridge*, can be seen as a milestone in Sam's development as a landscape painter. Possibly commissioned by Thomas Nelson, whose firm had built the bridge, it represents a dramatic maturing in his sense of composition and use of colour. All the elements that were to be a feature of his later works are there: working people relaxing or going about their business, such as herding sheep; cattle in the river; an impressive bridge busy with traffic; a fine house (actually Workington Hall, home of the Curwens); distant signs of industry – and all of this bathed in mellow early evening sunlight. But look at the sky. Already the mastery of cloud effects that was the hallmark of his mature work is there for all to see. Add to this a sensitive balance of light and shade and a soft blend of colour, and the whole stands as Bough's first adult statement as an artist. It conveys a profound sense of tranquillity not usually associated with Bough the extrovert.

Delinquent days and lost love

Despite this leap forward, Sam the man had not been transformed from a life-loving wanderer into the serious, introspective artist. He was still very much a man about town, slightly feared by the more conventional, loved by those who knew him best. John Fisher was among the latter. Sam frequently visited the chemist and druggist's shop, and there on one occasion in 1842 was moved to compose a poem in his friend's album to celebrate the joys of tobacco smoking:

The Weed
Hail, pleasant weed, whose soothing power
Beguiles full many a weary hour
 On life's dull way!
With thee time passes smoothly by:
Thou softenest down the rising sigh.
 By night or day.
And 24 more lines in similar vein.

Typical of their delinquent friendship is the story of a walk from Carlisle to Warwick village one day, where they saw the sexton digging a grave in the churchyard. On a whim they decided to be body snatchers on the lookout. So they talked to the gravedigger, asked him about the roads into Carlisle, and then wondered whether a vehicle coming up to the churchyard would be noticed. In all innocence, he said no. Sam lowered his voice almost to a whisper and asked 'Wad ten shillin' nut tempt ye, d'ye think, to leave yer spade an' pick at the end of the church to-neet?' Angrily the gravedigger headed off for the village in a professional pique. The joke over, Bough and Fisher thought it wiser to return to Carlisle across the fields, rather than by the road – the locals might be lying in wait. The grave was watched for some nights after the funeral – just in case.[64]

This broader side to Sam's humour became even more pronounced in refined circles. Even a mild man like Robert Harrington was not immune. Once in Botchergate, Bough, pushing a razor grinder's machine, accosted him with the greeting: 'Hey! Bobby, my lad! Is te nut gaen to give us a job today?' Perhaps Harrington managed a smile at his young friend's antics, but for a middle-class man of gentle disposition this was beyond the pale.

Others found it even harder. At a local dance, for example, Sam, dressed in a fashionable blue swallow-tailed coat and white trousers, spotted Miss Cust – a neighbour from the other end of Abbey Street, one of the city's wealthier families. In an off-hand manner he asked for a dance and, on her refusal, Sam came back with, 'Oh, why! I thowt it was only nebbourly-like to ax ye out to dance'. Then he stuck his hands deep into his trouser pockets and remarked sarcastically, 'Will ye hev a few mint lozenges, madam?' By the standards of the day, a calculated slight.

He had no difficulty in finding other partners, for he was a good dancer with an athletic figure. At one Easter Ball, Sam sported a 'bottle-green cut-away-coat, light trousers and a white hat. Being "the observed of all observers", the ladies in their irony all showed a

partiality for his attentions.'[65]

One young woman, in particular, was attracted to the brash young artist. According to Sidney Gilpin, Bough's first major biographer, she was the daughter of a retired doctor who lived in an old grange house near Penrith. The relationship was cut short by her parents – presumably because Sam lacked the necessary social graces and status. When the relationship was discovered, Bough was banned from the house and the young woman sent off to Europe, the better to effect the separation. Her loss lived on in his memory. For all his bluster, Sam was not a man to wear his heart on his sleeve, but the ending of this relationship hit him hard. And he never forgot her.

The struggle for consistency

In 1843 Sam was consolidating the artistic progress he had shown in the previous year, without any real advance, but the local press gave him a helpful boost. As the *Carlisle Patriot* reported:

> We have been favoured with an inspection of some beautiful drawings of Lake scenery executed by a self-taught artist, Mr Samuel Bough, son of Mr Bough shoemaker in Abbey Street. The drawings show admirable taste joined to considerable skill in colouring; and considering that they were made from sketches taken from nature, by a self-taught artist, not more than twenty years of age, we feel justified in anticipating that if proper opportunities were afforded him, Mr Bough would evince talents in landscape painting of no ordinary excellence.[66]

One of these pictures may have been *Sunset*, a small oil done around that time. Others were *Grange in Borrowdale* and *Old Oak Trees – The Woodman*, both fairly small oils. The latter comprised an 'enclosed woodland scene in gray and brown, painted on panel, with suggestions of green foliage in the left distance. The colouring is timidly reserved, but the painting excellent about a tree trunk and where a gloom is deepening up on a figure going down a glade. Throughout care is seen in every detail.'[67] In later years Bough would rarely be accused of such attentiveness to his art.

A larger oil, *View on the River Lyne*, was painted for William Atkinson that year. An ambitious and successful work, it was done on oilcloth, an indication of Sam's finances. Another painting of interest from this year is a *View of Carlisle from the North-East*, showing a fairly

standard perspective of the city, already used by a number of artists, including Carmichael. In Bough's picture, however, the two women in the foreground are the daughters of Sir J.D.A. Gilpin. Pinnington felt it was 'a concession to custom and behind the work of 1842'[68]. He also thought that a view of *Ullswater* achieved its effect 'by rule, and without the spontaneity of personal initiative is tame and uninteresting'[69]. Sam was still struggling to achieve consistency, let alone growth. It was a war he would wage for the rest of his life.

The major art event in Carlisle in 1843 was a small exhibition held at the Athenaeum. No catalogue was published, but it aroused considerable local interest. Over 7000 people visited it in the first week, and produced a committee set up to plan something on a grander scale. There is no record that Sam exhibited, although he probably did. It would be unlike him to miss such an opportunity.

The local Directory for 1844 lists him under 'Artists' as being at Thompson's Court, Green Market. This was behind the Guildhall, and George Sheffield had a studio on the opposite side of the upstairs landing. It was neither Bough's first, nor his last, since the days of the Abbey Street stable. Lack of rent probably made him move so often. His first studio after the outhouse had been in Rosemary Lane, in a building used by John Rayson, the Cumbrian dialect ballad writer, but for the next few years he was something of a moving target.

The precise order in which studios were occupied is unclear, but we know he also had a room with a bay window in Dirty Lane, off Abbey Street, then in a house adjoining the Nutters in West Tower Street (for as long as it remained tenantless), and back in Abbey Street in an upstairs room next to his father's house – which was to be his last studio in Carlisle. William Farish recalled how, when he had acted as agent for the Reverend John Hope of Stapleton Rectory, who had property in Abbey Street, he had let a room to Sam for 16d per week, with his father as surety.

From the Dirty Lane period comes the story that he painted an upright of *A Gypsy Encampment – Early Spring* – a memory of that return from London? – for Robert Bendle, attorney. When his son Joseph was sent round to pay for it, the boy was promptly invited to 'Sit yersel' doon, young fellow – sit yersel' doon – an' smoke a pipe o' 'bacca wi' me'. Sam either took to you or he didn't. Age and social standing had nothing to do with it.

In those days, there were more fasts than feasts, with Sam selling pictures for half a guinea or less, just to make ends meet. Once he got £10 for a landscape painting and celebrated with a grand dinner at the Black Swan with his friends and his father, who had been paying his

studio rent. Such a profligate attitude to money puzzled and worried the older man, who was used to counting the pennies. At the end of the evening, when Sam repaid his father the rent advanced, he was roundly rebuked with 'Tha's spent more to-neet i' eatin' an' swillin' that 'ud paid t'rent o' tha' workshop for many an' many a week'. Again, the inability to hold onto hard cash was a trait that Bough carried throughout his life, and he knew it.

Although James Bough could promote Sam's work by displaying it in his shoeshop window, there was little he could do about his son's untidiness. 'I never saw such a fellow as our Sam for leaving his brushes mucked up with dirt,' he complained in despair. 'I declare, if I never cleaned tham myself, they would never be cleaned at all.' Later success would change little in this regard.

Hope and disillusion

By 1844 Sam had finally begun to take his work much more seriously. That was the year he first exhibited at the Royal Scottish Academy (RSA) in Edinburgh, showing an oil of *Askham Mill, Westmorland*. He asked £20 for it, but probably failed to find a buyer.

On 5 June 1844, Jane Wright married Thomas Sewell, a native of Appleby who had come to Carlisle in 1833. As a wedding gift, Sam presented the young couple with an oil painting of *Shank Castle on the Lyne, Sunset*. According to Pinnington, 'The boulders in the river bed and single arch bridge are admirably drawn, and the castle stands high upon a hill against the sunset. The sky is golden and its rich brilliancy deepens by contrast the gloom of the river.'[70] The friendship between Sewell and Bough lasted a lifetime. Temperamentally poles apart, both shared some common interests and an independent attitude that gained the respect of the other.

A week later, Sam was one of the large crowd at a cricket match on Edenside between Carlisle and Northumberland. Apart from the match, there was a refreshment tent and a brass band from the Forty-Third Regiment to entertain them. As so often, Bough was mixing business with pleasure. He had been commissioned to produce an oil painting of the game by Mr Howe, one of the umpires. The end product is more interesting as an historical and topographical record than as a work of art.

Later that same month, the *Carlisle Journal* was reporting:

We have just seen on the easel of Mr S. Bough, a most promising

young artist of this city, a view of the steeple-chase on Broadfield. Some excellent likenesses have been introduced, and the picture is one of interest and beauty, and will when finished materially advance Mr Bough's reputation as an artist.

It failed to mention that Harrington painted the horses. Was that intended by Sam? The work was probably commissioned by Oliphant Ferguson, an earlier benefactor, but it does nothing to advance Bough's reputation.

On 21 June – just one day earlier than that report – a personal tragedy struck the Boughs once more, with the death in Ramsgate of Alice Bough. She was just 26 when she died of consumption. The death certificate shows her occupation as 'spinster' – the job as governess with the Ainsworths had foundered with their marriage. William Harrison Ainsworth had married Fanny Ebers in 1826, when they were both 21. By 1830 they had three daughters, but the marriage soon foundered, and in 1835 he left her. His career as a novelist had taken off, and he was being lionized at the Countess of Blessington's salon.

Within three years Fanny was dead, but on her deathbed she entrusted her children to Alice Bough, who went to look after them at their aunts' in Ramsgate. Harrison Ainsworth opposed this and took legal action to regain their custody. In a last desperate bid to keep her promise, Alice ran away with the girls, but they were discovered and the children returned to their father's care. By the end of 1838 the young girls were at boarding school in Cheshire, presumably bewildered and traumatized by so many losses in so short a time. The aunts, however, were so impressed by Alice's dedication to her charges that they gave her a home for the rest of her tragically short life. (Ironically, one of Sam's literary heroes, William Makepeace Thackeray, was a close friend of Harrison Ainsworth and devoted to the little girls.)

Cummersdale Mill is also from 1844 and again contains many of the elements of Bough's later works, depicting the coming of the industrial age to a rural environment, but without overt political comment. The print works was built in 1801, and by 1835 belonged to Thomas McAlpin & Co. It later passed into the sole ownership of John Stead, one of the early partners, who possibly commissioned the picture. The painting is a fascinating piece of local social history, mixing a rural idyll with industrial reality. It can be read both as a simple portrayal of a local scene or as an image of the new impinging on the old. Bough was never a conscious political commentator, but he understood the changing times that surrounded him.

One other commission that year came from Mrs Bond of Rosehill, for a large oil entitled *Rosehill* with 'brown foreground and grain in stook without the enlivening touch of sunny gold. On the distant landscape, however, as if in compensation, lies the sunshine out of which Bough wrought so many later wonders.'[71]

Other paintings from this time include a small oil of *A Bull Terrier*, the property of Dr Murison, an Irish medic at the Infirmary; a portrait of his friend John McDougall; a few studies of fishes – possibly inspired by Harrington's work – and a cartoon of Mr Spedding, the butcher, in the guise of Old King Cole asleep.

It would be wrong to see any radical change in Bough's lifestyle from the increasing competence of his pictures. He was still happiest when engaged in some outdoor activity – like the day's shooting over the Kirklinton estates, with his friend, James Kirkpatrick, and his father in the party too. Despite firing wildly at almost everything in sight, Sam failed to bag anything and, to save his blushes, the gamekeeper slipped him a few trophies to take home. On the way back to Carlisle, they stopped off at a wayside inn and Sam was soon involved in a brawl with the locals – a not uncommon occurrence.

On another occasion, after spending three weeks away from home on a sketching trip, he found himself outside an inn with only a few coppers in his pocket. Trusting to luck, he went inside and discovered that the fiddler had not turned up for the local dance. Sam boldly offered his services and was taken up. Soon the proceedings were in full swing, and he came away with his pockets bulging with coins.

Gradually, however, it was dawning on Sam that his passion for art could never be sustained in Carlisle. Disillusion was setting in. Much as he loved his rambling life, as a painter he would atrophy if he stayed there much longer. He had outstripped his mentors and friends. A new challenge was needed, on a larger stage.

Another artist and childhood friend was feeling similarly frustrated. James Kirkpatrick was trying to earn a living as a portrait painter – in theory a better prospect than landscape painting. Sam was a regular visitor to his house in Mary Street. Amiable evenings were spent in a mixture of talk and music-making, with Sam playing the fiddle. 'Now, Maggie, what must I play ye?' he would ask his friend's wife before striking up a tune. On New Year's Even 1844 he wrote her the words of a song entitled *The Pilgrim of Love*.

A hermit who dells in these solitudes cross'd me,
As way-worn and faint up the mountain I press'd,
The aged man paused on his staff to accost me,

And proferred his aid to a mansion of rest.
Ah! no, holy Father, still outward I rove.
No rest but the grave for the Pilgrim of Love,
For the Pilgrim of Love, for the Pilgrim of Love.

O tarry my Son, till the burning noon passes,
The grove of sweet myrtles shall shelter thy head;
The juice of ripe muscadel flows in my glasses,
And rushes fresh strew'd for siesta are spread –
Ah! no, holy Father, right onward I rove,
No rest but the grave for the Pilgrim of Love,
For the Pilgrim of Love, for the Pilgrim of Love.
No rest but the grave for the Pilgrim of Love.

It was the last New Year the friends would spend together in Carlisle.
By the middle of the next year, both Kirkpatrick and Bough had gone
their separate ways in search of artistic fame and fortune. Only one was
to succeed.

REFERENCES

1 Dorothy Wordsworth, *Recollections of a Tour in Scotland*, 1803, reprinted by James Thin, Edinburgh, 1974, p. 3.

2 Sidney Gilpin, *Sam Bough RSA*, George Bell & Sons, London, 1905, p. 2.

3 Edward Pinnington, 'Sam Bough RSA and the Art of Cumberland,' *Carlisle Journal*, 10 February 1922.

4 Mary Slee, *Older Carlisle and Round About*, Carlisle, 1917.

5 Francis Jollie, *Jollie's Cumberland Guide & Directory*, Jollie, Carlisle, 1811 p. 84.

6 Margaret Sewell to Edward Pinnington, 24 March 1908, Edward Pinnington's notes, Sewell Collection, Carlisle Reference Library.

7 *ibid.*

8 *ibid.*

9 *ibid.*

10 *ibid.*

11 William Parson & William White, *History, directory and gazeteer of the counties of Cumberland and Westmorland*, White, Leeds, 1829, p. 160.

12 William Farish, *The Autobiography of William Farish: the Struggles of a Hand Loom Weaver*, 1889, reprinted Caliban Books, London, 1996, p. 10.

13 Sidney Gilpin, *op. cit.*, p. 5.

14 Edward Pinnington, *op. cit.*, 17 February 1922.

15 *ibid.*

16 *ibid.*

17 Edward Pinnington, *op. cit.*, 24 February 1922.

18 *ibid.*

19 Edward Pinnington's notes, *op. cit.*, undated.

20 Sidney Gilpin, *op. cit.*, p. 1.

21 *Citizen*, 29 March 1822.

22 *Carlisle Patriot*, 23 November 1822.

23 *Trewman's Exeter Flying Post*, 23 October 1823, quoted in Trevor Fawcett, *The Rise of English Provincial Art 1800–1830*, OUP, 1974, p. 7.

24 *Carlisle Patriot*, 14 June 1823.

25 *Carlisle Patriot*, 29 September 1823.

26 *ibid.*

27 *ibid.*

28 *ibid.*

29 *Carlisle Patriot*, 6 December 1862.

30 Edward Pinnington, *op. cit.*, 3 March 1922.

31 Edward Pinnington, *op. cit.*, 24 February 1922.
32 *Carlisle Journal*, 6 November 1824.
33 Alexander Fraser RSA, *The Portfolio*, 1879, p. 114.
34 Edward Pinnington, *op. cit.*, 3 March 1922.
35 Sidney Gilpin, *op. cit.*, p. 7.
36 *ibid.*
37 *ibid.*
38 *ibid.*
39 William Farish, *op. cit.*, p. 64.
40 *ibid.*
41 Edward Pinnington, *op. cit.*, 3 March 1922.
42 *ibid.*
43 Edward Pinnington's notes, *op. cit.*
44 James Holloway and Lindsay Errington, *The Discovery of Scotland*, National Gallery of Scotland, Edinburgh, 1978, p. 165.
45 Edward Pinnington, *op. cit.*, 3 March 1922.
46 Edward Pinnington's notes, *op. cit.*
47 Edward Pinnington, *op. cit.*, 24 February 1922.
48 *ibid.*
49 Sidney Gilpin, *op. cit.*, p. 9.
50 Edward Pinnington's notes, *op. cit.*
51 Edward Pinnington, *op. cit.* 10 March 1922.
52 Mrs Telford to Edward Pinnington, Edward Pinnington's notes, *op. cit.*, undated.
53 Edward Pinnington, *op. cit.*, 3 February 1922.
54 Sidney Gilpin, *op. cit.*, p. 14.
55 Edward Pinnington, *op. cit.*, 24 March 1922.
56 *ibid.*
57 *ibid.*
58 Edward Pinnington, *op. cit*, 7 April 1922.
59 *ibid.*
60 Edward Pinnington, *op. cit.*, 24 March 1922.
61 *ibid.*
62 Edward Pinnington, *op. cit.*, 7 April 1922.
63 *ibid.*
64 Sidney Gilpin, *op. cit.*, p. 31.
65 William Farish, *op. cit.*, p. 53.
66 *Carlisle Patriot*, 27 January 1843.
67 Edward Pinnington, *op. cit.*, 5 May 1922.
68 *ibid.*
69 *ibid.*
70 *ibid.*
71 *ibid.*

2

Travelling Hopefully

Leaving home

The decisions Sam made in 1845 altered the course of his life. Yet the year started quietly enough. There were, for example, two small domestic portraits in oils of his close friends Thomas and Jane Sewell, produced more for pleasure than for gain, and then a small oil of *Yanwath Hall* and another of *A Hayfield, near Motherwell*.

Painting aside, in early May Sam, along with the rest of Carlisle, was preparing for the national bazaar in London organized by the Anti-Corn Law League. A major event, it attracted thousands from the provinces to support the repeal of a law that taxed imported corn, favouring the home-produced crop. In essence, a middle-class movement against the landed gentry, it was started in Manchester in 1838 by a group of radicals who argued that, in times of poor harvests, existing legislation raised the price of food and added to the problems of the poor. Free trade, they argued, was the answer. Free trade, of course, was also in the interest of the manufacturers feeding and feeding off the burgeoning industrial towns of the North.

The League used clever tactics to achieve its ends. First through propaganda, then by a sophisticated political machine (using central and local associations, full-time agents, lectures, publications, conferences, the press, and newly enfranchised voters), it created a popular campaign that had largely succeeded by 1846.

The bazaar was just one more example of its propaganda. By appealing to civic pride in local products, the League ensured that towns and cities throughout the country would be vying for the best exhibits. Carlisle was no exception, and Sam was as involved as any. As the *Carlisle Journal* reported:

> On Thursday last the articles contributed from the city and district, and which will form the 'Carlisle Stall' in the bazaar, were thrown open to public inspection in the large room of the Athenaeum, Lowther Street, and in the course of the day and evening a large

number of persons paid a visit to the collection, the price of admission being threepence. Many of the exhibits represented the staple manufactures of the city. Among the miscellaneous contributions were an oil painting of 'Ullswater', by Sam Bough, from Miss Sheffield. ... We ought not to omit to mention a painting of the city arms by Mr S. Bough which will form a conspicuous feature of the stall from this city.[1]

Sam's contribution indicates no specific allegiance, but he was too well read and astute to have been unaware of the issues involved.

More pressing matters loomed large. By now he knew his hometown would never provide the level of patronage to keep him above the breadline. His childhood friend, James Kirkpatrick, left in the hope of a better living in Newcastle as a portrait painter. Sam's letter to him, dated 4 June 1845, complains that his friend has not written since his move to Gateshead and explains that he has just returned from one of his sketching tours, collecting ideas to be worked up into saleable watercolours. He had recently finished two large otter hunts and one large view of the River Irthing:

Compositions of course; but as the good-natured flats in Carlisle do not like the labour of man's brain in the work of his hand, or, in other words, composed landscapes, each picture hath a local habitation and name. Strange beasts these are about Carlisle – these picture fanciers! You cannot call them patrons of the fine Arts ... I envy you the change in residence. You are now amongst people who can appreciate what you do...[2]

Ever generous, Bough includes a letter of introduction to John Wilson Carmichael in Newcastle:

You will find him, if time hath not changed him, a very fine fellow. ... You may rely on Carmichael introducing you to all who are worth knowing.[3]

It must have been some time since Sam had met Carmichael and the other Newcastle artists – perhaps not since 1841. He seems unaware, for example, that the younger of the Richardsons had gone down to work in London in 1843. Ironically, within a year, Carmichael was also gone from Newcastle because of lack of opportunities. And Kirkpatrick fared no better in Newcastle than he had in Carlisle. By 1850 he had disappeared from the local Directory as an artist.

Sam had decided on a different course of action, as he told his friend:

I shall leave Carlisle in the course of a fortnight or three weeks for a situation I have taken in the Theatre Royal, Manchester, as a scene-painter. Of course, you will think this is a strange step. It may possibly end in making me a rich man. The School is a good one. Stanfield and Roberts did not paint there for nothing, and I don't see anything to prevent me from doing likewise. A good salary of one pound fifteen shillings, English money, per week, is not to be despised; besides the chance of leaving Manchester for a better situation, and the sale of a picture or two to be performed when I have leisure.[4]

The choice of job, theatre and town was each to have its significance.

Manchester in the 1840s, with a population approaching 250,000, presented a dramatic contrast to Carlisle. England's leading industrial city, thanks largely to the cotton mills, it had sprawled beyond control in the first 40 years of the century. Housing extremes of wealth and squalor on a scale Bough would never have witnessed in Carlisle, he must have thought hard about his new way of life. The prize was great, but so too the competition – and the price of failure that much higher. To a young man used to the fresh air and open country of Cumberland, the smoke-choked atmosphere of Manchester had to be alien.

He asked Kirkpatrick to return his copy of Prout's *Light and Shadow*, 'as it will be useful to me in my new situation, my knowledge of architectural composition being so very small.'[5] The new job would be demanding and he intended to be prepared, with a sense of purpose previously lacking.

Carlisle had offered little by way of theatrical experience in Sam's early years, apart from what he devised for himself. William Macready's theatre had operated in Blackfriars Street since 1813, but hardly on a grand scale. Consequently Sam's application for the job of assistant scene painter in Manchester was more the product of hope than experience. He knew that this was the route taken by other successful artists. The portfolio of works he sent with his application had such an effect on Mr Chester, the architect of the theatre, that he took up Sam's case 'with much enthusiasm'. That clinched it.

Unknowingly, Sam had become involved in an experiment that attracted national attention, at least in the theatrical press. John Knowles, proprietor of the Theatre Royal, was something of a maverick himself. The theatre in Peter Street had been opened with the

47

intention of challenging the 'star system' by establishing a quality stock company, backed by good programmes and high production values. As the *Glasgow Dramatic Review* reported glowingly following the spring season in 1845:

> The move was a bold one, but in the right direction: the appeal to good taste has met with a hearty response, the public approving of it by the best of all proofs – a continued attendance. The experiment has commanded the success which it merits, the energy of the manager has been rewarded.[6]

It may also have made good business sense, for it appealed to the chauvinistic sentiment of the times.

> Mr Knowles ... true to his colours, continues to produce our standard productions in the best manner, independent of foreign aid; and the 'stars' who visit that city, including Misses Cushman and Faucit, are forced to shed their light in the minor houses. Were this principle universally adopted, theatrical affairs would soon assume a more healthy hue.[7]

But Knowles was too smart to leave everything to 'good taste' and jingoism. He hedged his bet by running a mixed programme of tragedies, plays, comedies, musical plays and pieces, burlesques, pantomime, interludes and farces and ballet.

For the next, short summer season in 1845 – Sam's first – Knowles rang the changes. It had both music and stars. And he imported a dash of London style in the form of William Roxby Beverley, leading scenepainter from the capital, to produce the scenery for a revival of *Acis and Galatea*. Sam had a passing acquaintance with the great man for, in later years, he told how Beverley, with velvet skull cap and all, painted his scenes in 'a pair of lavender-coloured kid gloves'.[8]

'My poor dear father is no more'

Bough hardly had time to settle into his new life when a family tragedy took him back to Carlisle. After suffering a stroke and an illness of just four days, Sam's father died at 21 Abbey Street 'of paralysis' on 22 July 1845, aged 51. He was buried in St Mary's church-yard on 25 July. Sam returned home hurriedly and was in Carlisle by 23 July, when he wrote to Kirkpatrick. The letter is a unique insight

48

into the real Bough, the person so often lost beneath the extravagant tales that surrounded him, the man who rarely wore his heart on his sleeve, despite all appearances:

> Jemmy, my dear, did you but know the heavy load of grief and sorrow which is weighing me down!
>
> My poor, dear father is no more. The good, the kind, the worthy old man, whose heart was always open, has gone to that land where sin and sorrow are not. Our grief is as much as we can well bear; but God has given me strength to bear up against it, and it is well.
>
> I go from hence to my situation in Manchester on Saturday. There was a little likeness of the old man which you commenced. Should that sketch still be in your possession, my dear Jemmy, by our old friendship, send it down to Carlisle. It will be a comfort to my poor sister.[9]

The day after the funeral, Sam headed back to Manchester, via the Liverpool steamer, in his working clothes, to pick up the threads of his new job. When his friend and neighbour, John Sheffield, 'pointed out the impropriety of his dress' Bough exclaimed, 'don't be so unkind to a neighbour's bairn'.[10]

Scenepainting and sadness

In early August, Sam wrote to his sister from 49 Bradford Street, his lodgings in Manchester. It was a traumatic time for all of them. Not only had they lost a father they loved, but for Joseph, Anne and younger brother James, it meant the break-up of their home. There were also problems with Joseph.

> I . . . was not surprised in hearing of my Brother Joseph's conduct. I am sorry, and rather than any difference should have occurred between you I would willingly have sacrificed everything to him. However, all will now I hope be settled and arranged. I wrote to him, and he has not yet returned me any answer. What I wish to know is how he has arranged with reference to my Father's affairs. You will request Thomas Sewell, in my name, to get all the information he can from him, and to write and tell me. You must also write yourself, and let me know how the sale went off and if there will be any necessity for my sending you money towards the payment of my Father's debt.[11]

Sam, too, felt the pressures, but was beginning to show a sense of responsibility and application that had not been part of his make-up to date. The letter to Anne shows his inner turmoil:

> I have had little spirit to write, my poor head being almost turned with one misfortune falling on the heels of another. But this I can say with some satisfaction, I have satisfied my employer, and there is a probability of retaining my situation for a year or two. My salary is increased to £2 per week; and I like my work, tho' it is laborious. I have no doubt, not the least in the world, of our succeeding as well as our best friends could wish. And when our work is done here, we can easily find employment elsewhere, as a good scene painter is always certain of employment.[12]

Behind the encouraging words, intended to raise his sister's spirits, there is a sense of pride that the quality of his work has been recognized. But the letter also indicates that the job was not to be viewed as a permanent one, even though it might last for a few years.

Sam was keen for Anne to move to Manchester to be with him, and reassured her that they would 'be both happy and comfortable. I have not met with any of the reprobate company I expected to meet with. The situation I hold compels me to live aloof from the Swinish Multitude employ'd, and I do neither drink nor keep up any connection with my fellows.'[13] He was trying to indicate that he was something of a reformed character. For now this was true, even if Anne doubted it.

The letter includes some practical instructions on the cheapest way of travelling and suggests that they can rent part of a house from his landlady, Mrs Morris, and he will get a job for young James. Friends in Carlisle and Manchester had rallied round, and Sam was keen to express his gratitude to them. One in particular, Dr Kerr of Lowther Street, was to receive a gift of a painting done jointly by Bough and Robert Harrington, perhaps in payment for a debt. Other pictures left behind in Carlisle were also to be sold to cover any debts, with the remainder being sent down to Manchester. An essential part of Bough's attitude to art is encapsulated in this: it was something he loved but, in the end, it was practised to pay for the price of living.

On 18 August, he was writing again to his sister.

> I should wish to know what steps my brother Joseph has taken with respect to the settlement of my Father's affairs, he not having

written to me. If he declines to do anything, write and let me know and I will then set about it myself. As I am determined to have everything wound up as soon as possible. ... By the by, tell Joseph that he must give you the baccy box and no mistake.[14]

As usual, there had been a change of plan. Now he was thinking to rent a house in Hulme, a healthier location than his current lodgings in central Manchester. James's health seems always to have concerned his family, and Sam commented that he was 'delighted to hear of Jimmy's recovery'. This may simply refer to a reaction to his father's death, but later events suggest otherwise.

Bough consoled his sister for not being able to get back a cast of their father's face, because 'it is of no consequence, and serves to show how far the little disposition of a spiteful person will lead him, altho' it is direct robbery. The Room being mine that it was stolen out of...'. He encouraged her to spend some time with relatives at Nichol Forest, up on the banks of the Liddel and Kershope, on the Scottish border. 'The fresh air will do you much good. If you can manage to stay there for a fortnight or three weeks, you will feel the benefit of it. I will have some place taken by the time you get back to Carlisle, and then you must come as soon as you can.'[15]

By October Sam had moved to Hulme, where Anne and James joined him at 5 Victoria Street, whence he wrote to James Kirkpatrick in Newcastle. On learning of James Bough's death, Kirkpatrick had written back immediately, offering condolences and referring to a miniature he had of the dead man. Sam's letter of 12 October started in a reflective note ('We are certain of nothing but death and quarter day; and the best philosophy is a pipe of the weed, and to forget it.'), but soon moved on to more practical matters.

You mention a miniature of my Father. Should you have time to finish it and send it to me, you will confer a great obligation. I wish much to have some remembrance of him. My dear Jemmy, you must not be offended. Tell me your charge for it, and I will send a Post Office Order for the amount. This I wish much.[16]

Adieu to painting

Sam had taken to his new craft and was pleased with his achievements to date. Perhaps he had even surprised himself.

I have been working away here at the Scenery. Our Scenes are as large as those in the Drury Lane or Covent Garden Theatres, something like forty-two feet in width; and we have them made in pieces, so that they are shoved on to the stage and stacked away when not wanted. My first scene was a hit, altho' I did not even know how it was to be set, and thought the part I had set on the Frame was the whole Scene, whereas it was only half one. It was a wood, with a rare old oak in it; and so pleased was the manager with it that he raised my salary five shillings the first week. It was my luck; but there are not many wood scenes required in a theatre. The greatest part of the work consists of chambers, interiors, and these I do not like so well. We have painted twenty Scenes in all, and out of these only three are landscape – that is a garden, wood, and open country.

We produced *Hamlet* last night, and all was painted for it. I painted a platform, moonlight, the Churchyard, and half of the chamber, palace, etc. They were all to be designed and done in a fortnight, and I was working at the Churchyard Scene when the curtain rose for the third act. Yet, notwithstanding the haste in which everything was got up, they have given immense satisfaction. I, of course, have no time for painting pictures, but will have when the Theatre is stocked, which will be sometime in the Spring of next year – so adieu to painting for a while.[17]

Among his fellow scenepainters during these times were Ian Muir, Sam Glover and Frederick Fisher (all from Glasgow), George Augustus Sala, Frederick Holding, George Gordon, Henry Bickerstaffe and H.P. Hall.

Overseeing them was Bill Channing, who rapidly helped Bough transform raw talent into a theatrical triumph. On Sundays, Channing and his wife, Emma, would visit the Boughs at their home in Hulme. It was the beginning of a friendship that would last a lifetime, and one in which Bough would later repay his debt in full to the older man.

Chester also remained Bough's champion, and Sam valued the architect for both friendly counselling and professional advice. Long after Sam ended his connection with the Theatre Royal, Chester would never allow his scenes to be painted over, because 'he considered that they could not be equalled, much less surpassed in design and execution'[18].

The Boughs did their best to come to terms with their new situation, but it was a difficult transition. Young James displayed some of Sam's talents and worked for a time as a scenepainter in Manchester. Usually he had to make do with whatever he could get, including a

job in a pawnbroker's shop. Domestic harmony at the house in Hulme did not last long, however, and Anne returned to Carlisle to scrape a living as best she could.

Work at the theatre gave Sam few chances for sketching and painting during the rest of the year, but in 1846 he did manage some time away during the summer close season to go rambling and drawing in Cumbria.

Penniless and with Carlisle as his base, he stayed at Joseph's place and ate at the Sewell's house in Rickergate, using their attic as a studio. Among the works produced there were the oils *Ullswater from Gowbarrow Park, Distant View of Lanercost, Borrowdale,* and *Grange in Borrowdale* (a study for a larger work completed in the same year).

Art and artists in Manchester

Manchester was something of a paradox for artists. Its Institution for the Promotion of Literature, Science and the Arts had been founded in 1823, with regular exhibitions held since 1827. But the governing body was mostly made up of businessmen and patrons, not the artists themselves. Consequently, the need to nurture local talent and provide Manchester-based artists with a regular income was not high on its agenda.

In 1845, a group of artists decided to try to remedy the situation, by forming the Manchester Academy of Art. William Percy, portrait painter and one of the founders, remembered later how some of them had met in a room at the Royal Manchester Institution and selected a small group to frame the constitution and elect new members. A fine set of aims was constructed:

> First – to institute a class for the study of the antique and the living model – the want of which has long been felt by the students and artists of this town as an insuperable bar to professional advancement. Secondly – to collect a library for reference, comprising history, poetry, archeology, optics, anatomy, chemistry, as applied to colour, architecture, sculpture, painting and engraving.[19]

In Bough's time, they never got beyond the first objective. 'Zanetti, an Italian, used to provide models for us. To our soldier models we usually paid eighteen pence for the first hour and one shilling for each succeeding hour,'[20] claimed Percy. There was no rich patron to help get it off the ground. Each of the 22 founding members undertook to

Sam Bough by William Percy, 1846. Tullie House Museum and Art Gallery.

produce a work for exhibition and donate the income from its sale to the Academy.

The first office-holders were Charles Allen Duval (President), Michael Pease Calvert (Treasurer) and James Stephenson (Hon. Secretary). Duval eventually made a comfortable living from his portraits and narrative pictures and formed a lasting friendship with Sam. Calvert was the brother of the more famous Charles, the landscape painter, and Stephenson was an historical and landscape engraver. Bough's initial contact was probably through his theatre connections, for both Chester (the architect) and George Jackson (the decorator and gilder) were members. Percy was introduced to Bough by the latter and they became firm friends, even producing the occasional joint painting. Later that year, Percy painted a fine watercolour portrait of Sam. Other friendships with members included Thomas Oldham Barlow, the engraver, and Charles Mitchell, the architect.

Hell-raising and hard times

With Anne back in Carlisle, Sam moved into new lodgings, and his social life began to drift back to the wild habits of his rambling days in Cumberland. Increasingly he mixed with his artistic and theatrical associates. Soon there were tall stories abounding to match any from earlier times. A fellow lodger, Robert Ross, remembered that 'Bough's habits were so irregular when living with us in Manchester, and his exits and entrances so uncertain, that he was endowed by my mother, who both loved and feared him, with the privilege of a latch key. It was no uncommon thing for me to find him in the morning lying partly undressed across the foot of the bed.'[21]

Two stories from that time illustrate the extremes of life Bough experienced. The first shows Sam the hell-raiser. While out drinking one evening with George Hayes, another artist, Bough had received a black eye from a local boxer known as 'Apple Daddy', following an altercation. Undaunted by the man's reputation, Sam laid into him, Cumbrian-wrestling style, and left him flattened. The next day he was round at Percy's house, asking him to paint over the bruised eye.

The other tale depicts the ups and downs of life – the times when money was good and then gone, times when he had to resort to all sorts of ruses to cope. On this occasion, having rather more cash in hand than usual, he treated himself to a fashionable brass-buttoned blue coat, to raise his status in local society.

When the run of luck ran out, coins in the pocket became more important than fine appearances, so the coat was sent to the pawnbroker, to be retrieved later. This happened so often that the coat became known as 'The Bank of England' or 'Fail Me Never'. Eventually the pawnbroker never bothered to open the parcel before handing over the money. On one occasion, however, Sam needed both the coat and the money. So he wrapped up an old coat in the parcel and asked his landlady to take it round to the pawnbrokers. She returned with the money, and was horrified to find the coat still with Sam.

The story illustrates more than just the hard times he had to endure. It also says something of Bough's attitude to life, which was both the cause of so many of his problems and his greatest strength.

Another of his friends from the Academy, 'Phidias' Clarke, the sculptor, shared lodgings with him at 24 Kennedy Street for a time and remembered that 'some of the wildest symposia of artistic and literary friends that had ever evoked the echoes of that decorous thoroughfare led to his retirement from the Rue Kennedy and the Manchester

Theatre Royal.'[22] Always a showman, Bough had his friend paint him in the guise of Othello.

Towards the end of 1846 or early in 1847, he was up in Carlisle again, visiting friends and relatives. Back in Manchester, he was then laid low for a long time with a bad bout of rheumatic fever. Anne came through to look after him. Financially it was a struggle, aggravated by loss of earnings from The Queen's Theatre, when Sloan, the manager, went bankrupt before Bough could be paid for some of the work he had done. As always, after a period of depression, Sam fought back.

On 2 June he wrote from the lodgings in Kennedy Street to John Fisher, his friend in Carlisle. After a brief reflection on the hardness of life, Bough the optimist once more emerges. He had been working on five watercolours for the Royal Manchester Institution Exhibition. These were *Scene on the Ashton Canal, Return from Hunting – Evening, Airey Force, Gowbarrow Park, Westmorland, Stye Head, Cumberland* and *Askham Mill on the River Lowther, Westmorland* – probably all worked up from sketches made during the previous year's ramblings.

Sam could only afford to present them thanks to the help of George Jackson, who had provided nearly £20 worth of frames. More importantly, Jackson had given him a studio at his business in 17 Brazenose Street 'and set me up with brushes and materials requisite. His kindness I cannot forget, for it was unlooked for and unexpected on my part. He gives me hopes that a few months in Manchester will establish me comfortably for the rest of my days; and he has already got me about twenty pounds in orders for pictures...'[23] Despite the superficial optimism, the sub-text of the letter suggests that Sam still had doubts about his chances of making a living as an artist in Manchester.

Slight success, stiffened resolve

For a time Bough's optimism was well placed. On 8 July 1847, he received a letter from the Institution:

> Sir – I have pleasure in stating that the Council have awarded the Heywood Silver Medal for your Picture of 'Askam Mill', No. 699 in the Catalogue, as the best Water-colour Drawing in the Exhibition able to compete for the prize, and I congratulate you on having done so.
>
> I am, Sir, your very obedient Servant, Geo. W. Ormerod, Hon. Sec.[24]

It was his first formal recognition as an artist. Even better, there was a £5 prize to go with the medal. And, better still, Agnews bought the picture before the exhibition closed.

Sam lost no time in writing to his sister Anne in Carlisle with the good news. She was either in lodgings or service with a Miss Beck at 8 Paternoster Row. He wrote to her again on 4 August, with a letter proposing a fresh start in Manchester.

After all the setbacks of the past year, he had been thinking hard about his future prospects. On the one hand, he could always make a living as a scenepainter, but the routine drudgery of the work appalled him and, ultimately, he could only be happy as his own man, not dancing to someone else's tune. Sam's skills as an artist had now been formally recognized, albeit in a small way, and opened up again the slight prospect of another, preferred life. A more calculating man would have stuck to scenepainting. Bough chose otherwise.

'It is my intention to settle now here,' he wrote to Anne from Jackson's shop. 'I do not see that I can do better, and for that end I shall take a house shortly, furnish it as well as I can, and get you to come and keep it for me. You, at the same time, can carry on your business if you like or not.'[25]

Anne's line of work is unknown, but she must have viewed her brother's 'intention' with misgivings, based on his past performance. As her own situation was just as bad, she had little to lose. Thomas Sewell had berated Sam for leaving his sister in debt. The artist was shocked to hear this: he had thought she was being helped by Joseph in Carlisle. Now he knew that both of them had financial problems, and was resolved to clear these. Stung by the rebuke from a friend he respected, and shamed at the thought of his sister's difficulties, Bough wrote with some feeling to her: 'I did not know that you were ever so badly off. I will take care that it shall not happen again'.[26]

He was also at his most persuasive. 'Mr Jackson, the only true friend I ever had here, has decided against my going into a theatre any more. And indeed I am heartily sick of theatre work and theatrical folks. But still should you wish it – for it is a more certain livelyhood than painting pictures – I am quite willing to re-engage with Knowles.'[27] No doubt he believed this at the time. Anne, much more of the realist, knew that Sam would finally do as Sam chose.

He makes it clear that Joseph did not feature in these plans. By now Sam was tired of bailing him out of his problems and paying off his bills from his time in Manchester.

Joe has disappointed me very much. When I left Carlisle it was on the understanding with him that you wanted for nothing. My long illness and the loss of time, besides the loss of the Queen's, almost ruined me. The last sovereign I received from Sloan, Joe collared to bring him home to Carlisle; and then returned and involved me with Mrs Lucas, my landlady, a worthy soul as ever lived, to the tune of £4, or close upon it ... I am now paying Joe's bill for board and lodging, while he was in Manchester, by instalments, as well as I can.[28]

As evidence of his new intent to mind the pennies and the pounds, Sam tells Anne that he has 'determined not to go on any sketching excursion this season at all, so that there will be £28 or £30 to begin with out of this'.[29] He had a number of other irons in the fire, with exhibits he had sent to the Liverpool and Worcester shows, and an Art Union raffle of a joint work by himself and Harrington.

Artists in union

Art Unions provided the provincial artist, in particular, with some extra income and the wider circulation of his work than he could achieve at the annual exhibitions, when competition often came from the best artists in the land. Introduced from Germany, they were not universally welcomed by the art establishment. The idea was simple. A committee was set up to run the Union, purchase paintings, take subscriptions for a lottery and allocate prizes to subscribers whose numbers came up in the draw. After deductions for buying the works of art in the first place and administrative costs, the balance was disbursed among the participating artists. In some Unions, lucky subscribers were allowed to select their preferred work from those purchased as part of the scheme up to the value of their prize, or to make up the difference in price themselves. Others simply allocated a painting to the winner. Engravings distributed to the less fortunate subscribers also met with a mixed reception in the art world, but apart from bringing much-needed income to hard-up artists in times of recession, the system opened up the potential for owning works of fine art to the lower middle classes. Bough was no different from other provincial artists in seeing this as one more way of earning a little more money to pay the bills.

Few of his paintings from 1847 can be clearly identified apart from the five watercolours shown in Manchester. There was a watercolour

of *Tanziermunden on the Elbe* (preparatory to his major work on the same theme in 1848); *Lanercost Abbey*; *View in Cumberland*; and *A Cumberland Trout Stream* ('painted under a bright autumnal evening effect ... the young couple seated by the side of the swift running stream, illustrates an incident in the artist's career, when his heart was aglow with love's young dream'[30]). Perhaps the latter portrays the episode with the retired doctor's daughter referred to by Sidney Gilpin.

For the next year, after Anne had moved back to Manchester, Sam tried his hardest to make his current dream come true. But the times were hard. Duval let him share his George Street studio and, to boost their meagre income from painting, they offered tuition. It was anathema to Sam, and he devised a number of strategies to avoid his students.

Among those who sought enlightenment were the Misses Mutrie, assiduous exhibitors at the Royal Academy. Years later, Ruskin was to comment of their work: 'It is nearly as good as simple flower-painting can be; the only bettering it is capable of would be by more able composition, or by the selection, for its subject, of flowers growing naturally. Why not a roadside bank of flowers?'[31] Bough could never have damned by such faint praise: he would simply have damned, right or wrong.

The worst of times

For the moment, Sam's dream proved illusory. He and Anne had to earn their money as best they could. For his sister this meant looking for work in local warehouses. Sam even tried to get taken on as a coach painter, but met with a closed shop.

In the worst of times, brother and sister would take his pictures around the streets, seeking patrons. On one occasion, after rejections by Agnew and other dealers because the market was so stagnant, they received a kindlier reception from a fellow member of the Artist's Academy, the druggist George Westmacott, having been sent to him by their friend Charles Lewis, the stationer. Westmacott gave them twice the asking price of half a guinea for Sam's latest effort and then invited them in for tea. It was a gesture of simple humanity that mattered more than the money.

Bough even returned to scenepainting, as promised, to earn a crust. It was to be a fateful contract. In the spring of 1848, Howard Glover took Mary Anne Isabella (Bella) Taylor to the Theatre Royal, Manche-

ster, to play in Loder's opera *The Young Guard*. The engagement lasted for six weeks, and Miss Taylor then returned to London to continue her training at his Dramatic Academy. Sam saw her and heard her sing, but she was unaware of him. A year later, it was a very different story.

In the search for work, Sam (and perhaps James) wandered further afield. Alexander Fraser believed that he painted dioramas in Birmingham and Liverpool – and that he had actually taken bit parts, as brigands and the like, on the stage. He was said to have played alongside Jenny Lind, when his sole duty was to hand her a glass of water. As Bough was probably Fraser's informant, it is hard to know how much credence to give this. It may just have been another tall tale.

A man of genius

Hard times honed Bough's paintings, and by 1848 he had developed a style that would stand comparison with much of his later work. They also cemented a friendship with Duval and his family that would endure.

From this year a number of works stand out. At the Manchester Institution, he showed a theatrical allusion – *Olivia's Garden* – illustrating the scene from *Twelfth Night* where Malviolio reads the love letter he imagines to be from Olivia, observed by the wags who have set him up. Naturally enough, Bough's interest was in the garden and its trees. As the *Manchester Examiner* said: 'The picture is evidently the production of a man of genius, who may aspire to and attain the foremost rank in his profession if he choose'[32]. Sam could hardly have bought a better billing.

Other pictures include two watercolours of Brougham Castle, Penrith; an ink drawing of *Cockermouth from the North*; a watercolour of *Stonehenge*; plus a picture of *Billy*, a grey pony by Harrington with a landscape by Bough. There is also a tantalizing print by W.H. Lizars of *Waterhead*, *Windermere* from an original by Bough.

Pride of place in 1848, however, must go to the large watercolour of *Tanziermunden on the Elbe*, a development of the painting from the previous year. One tradition has it as a work of pure fiction. Sam, it is said, had never been outside the British Isles, and the inspiration for the picture was said to be the Bridgewater Canal. In later years, however, his widow claimed it was the product of an earlier trip to Europe.

Around this time he also had a commission from Selim Rothwell,

another member of the Academy, to paint a view of Bolton. Rothwell, an artist himself, had climbed a high chimney to sketch the outline view, and asked Bough to colour it and work it up with light and shade. Because of the type of absorbent paper used, Sam had immense problems with this, but finally completed it. Percy added vignettes of the inventors Richard Arkwright and Samuel Crompton in the corners, and it was published as a colour lithograph, selling well locally.

As the year wore on Sam came to accept that he would never make a living from his art in Manchester. Tastes were too narrow, and patronage too thin on the ground. First Carlisle, now Manchester. He had seen enough to know that the chances of making a living from landscape painting anywhere in England outside London were slight. He might have fared better as a portrait painter, but Sam knew his limitations in that area. Nor was it to his taste. The rambling life, battling against the elements, sat uncomfortably with the refined manners of the salon. Not for Sam. Once more he was at a crossroads. It was a cold dawn when he faced up to that conclusion.

Fate stepped in. An offer of a new scenepainting job in Glasgow opened up fresh horizons. For as long as he remained in Manchester, Sam's role as an artist would always be confined to a provincial stage. A move to Scotland offered the prospect of a steady income and a national platform on which to develop his artistic skills. As with Carlisle, he had outgrown all that Manchester could offer. It was time to travel on.

Glover and Glasgow

In the last few months of 1848, Edmund Glover, one of the famous theatrical dynasty, contracted Sam to be principal scenepainter at his new Prince's Opera House and Theatre Royal, West Nile Street and Buchanan Street, Glasgow, due to open early in January 1849. It was all part of a greater scheme by the actor-manager to attract the more 'respectable' classes of local society. Theatre in Glasgow at that time had fallen into the doldrums, because of the poor standard of the productions and the quality of players engaged. Glover wanted to change all this, and converted a large hall that had previously housed panoramas and exhibitions into an elegant playhouse, seating about 1,100 people. Perhaps his brother, Howard Glover, had been impressed by what he had seen of the young scenepainter's work while in Manchester. Or maybe Edmund had witnessed his efforts at first hand.

Sam travelled north, leaving Anne behind. The prospect of a regular income for a while, and the chance to show his skills as an artist in a new city, were all that was needed to get Bough back into a positive frame of mind. James seems to have gone up to Glasgow with him, to try his luck too. Meanwhile, back in Carlisle, Joseph married Mary Barron on 4 December. There is no evidence that Sam attended.

Leaving poverty behind him in Manchester, Bough walked straight into another problem – Glasgow was in the throes of a major cholera epidemic. As a result, the theatre's opening was postponed by a few weeks. Glover managed to turn even this to his advantage, as the local press commented:

> We are pleased to learn that, in deference to good taste and correct feeling (although it is done at a very great sacrifice, certainly not less than £200 per week) this magnificent place of amusement is not to be opened until the 15th of the present month. This has been determined upon by the proprietors, solely in consequence of the present state of the public health.[33]

Public safety was a major concern in all Victorian theatres, fires were regular occurrences. Just the previous November, the Adelphi near Glasgow Green had burned to the ground. With this disaster fresh in everyone's mind, Glover took steps to reassure an anxious public by applying to the Dean of Guild Court to have independent experts examine his building. The report back was very positive: 'The perfect security and strength of the building has been fully certified and ... the public may now feel the most perfect confidence in the stability of the structure.'[34]

One of Sam's first tasks was to paint the act drop-scene of a view on the Clyde. It drew appreciative comment from the *Glasgow Herald*:

> The drop scene ... is a singularly beautiful specimen of scenic art, representing, as it does, the same subject as Naysmith, a famed Queen Street Theatre drop scene, recalls pleasing recollections of our old playhouse. We are confident that this work of Mr Bough's will of itself repay a visit to the theatre.[35]

The *Reformers' Gazette* reported that on the first night, it 'was received with the hearty applause...'[36] Once again, Sam had drawn a favourable press. It was a good start. Even better was to follow.

The best of times

The first production was Loder's romantic opera *Giselle, or The Night Dancers*. The company was under Mr Lloyd's direction, with Howard Glover brought up from London with his company of players/singers, to arrange and conduct the music. The re-scheduled opening night was Monday, 15 January 1849.

The players probably appreciated the rare luxury of a few extra weeks of rehearsal. One 24-year-old contralto certainly did. Bella Taylor was scheduled to take the minor part of the Duchess in only her second professional engagement – her first after Manchester. But, just four days before the opening, one of the leading men, the tenor Mr W.A. Payne, fell ill. His role of Albert was crucial, and Glover was desperate for a replacement. He came up with a bold, but high risk, solution. Would Bella play it? With the confidence of youth, she agreed.

Her performance was generally well received. The *Citizen* was fairly typical in its comment that for the role of Albert, 'an excellent substitute has been found in Miss Taylor. This young lady has a contralto voice of superior quality, and her song "I cannot flatter if I could" is among the best things in the piece.'[37]

It all rather went to Bella's head, so she took unkindly to the attentions of the brash, unkempt young scenepainter in a red jacket perched high above on the painters' bridge, working on a huge drop cloth. 'Look out for the paint, miss,' Sam shouted down to her, 'or you may have your pretty bonnet spoiled.' Unamused, she complained to Edmund Glover about his employee's rudeness. Her pretentious reaction only encouraged Sam to direct more verbal darts at her.

In addition to the act drop-scene, Bough also produced the scenery for Act 2 – 'A Lake, bordered by a profusion of the Lotus Flower, and the Grave of Giselle, with the Effect of Moonlight and Sunrise'. One night, when the audience saw it, they burst into spontaneous applause. Hearing this from the wings, Bella demanded of Edmund Glover, 'Why are they making such a noise? I am not on.' Given his own skills as a scenepainter, he must have enjoyed enlightening her with the information that it was for the scenery painted by the man in the red jacket.

The rest of the varied bill consisted of a ballet and a vaudeville (one prophetically entitled *Why Don't She Marry?*). It was all a great success, with Bella's efforts getting a very good press now they had got over the novelty of seeing a woman perform a leading male role. She continued in the part for about three months, until the end of the run,

alternating with the role of Lazarello in *Maritana!*.

Sam and Bella were soon meeting in more sociable circumstances. Only a select few were invited backstage, and she met him in the company of the theatre's proprietor, the eccentric Baillie Lumsden, and the leading portrait painter Daniel Macnee – friends of Edmund Glover. Later, at a party in Macnee's house, she was formally introduced to Sam. Dressed in his best on that occasion, he made a much more favourable impression on her. Edmund Glover, unaware of this meeting, subsequently tried to introduce Sam to her as 'the man in the red jacket whom...' Bella recollected years later. Before he could say any more, she 'begged him for pity's sake to stop. Having seen Mr Bough in evening dress at the Macnee's, Mr Glover's second reference to my first glimpse of him on the bridge brought before me a contrast so ludicrous that formality went out in laughter. I told Sam my first impression of him. The ice was broken and our acquaintance may be said to have begun in familiar friendship.'[38]

During the successful run of the opera, Bella developed a throat infection and had to be confined to her lodgings to recover. To her surprise, Sam was one of her visitors, showing an uncharacteristic concern for her health. The wild, rambling man was being tamed – and the interest was clearly mutual.

They began to be seen in company together. John Urie, an engraver who turned photographer in later years, told of meeting Bough at a dinner-party at Mugdock Castle, held by the tenant, James Reid of the Union Bank. Also there was 'Bella Taylor, then a petite, impulsive, rather good-looking young lady, and a rising star in opera'. Sam launched into a mischievous story of a young actress who was so beautiful that the artist Noel Paton had asked her to model for him. This had the desired effect when Bella showed her jealousy. 'He was rougher than his good nature intended,' said Urie, but added, 'he was the most infectious humorist I ever knew.'[39]

Sam had not totally forsaken his earlier lifestyle, however. The Garrick Club in McLaren's Tavern, situated just opposite the Theatre Royal in Dunlop Street, was a favourite haunt of actors and theatrical types. He was a regular here, drinking and talking with his friends Daniel Macnee and John Mossman, the sculptor. At the time, most artists in Glasgow fared little better than those in Manchester. Their status was low and, with some notable exceptions, patronage was hard to find in Scotland's commercial centre. Scenepainters and theatre people, in general, were even further down the social scale.

Bella's engagement at the Prince's Theatre was due to end when the season closed in March 1849. On 21 March she had a benefit night,

appearing as Inez in a comic opera, *The Coquette*. Sam painted some of the scenery. Two nights later the season closed with a benefit for Howard Glover. The major item was Donizetti's *Bride of Lammermoor*, with Bella supporting giving a rendition of 'The Flowers of the Forest' and the first two acts of *The Coquette*.

In the spring of 1849 love was in the air, but both Sam and Bella knew that the end of the theatre season could mean a permanent parting of the ways.

At the time Bella Taylor had her mind set on a stage career. Born in London, she came from a musical family, and had spent her early years in Cheltenham, where her father, Thomas Taylor, was a music teacher and band conductor. Later they returned to London, where he coached private pupils at their home in Milton Street, 1 Euston Square. Her brother, Gerhard, was a professional harpist, and both father and son composed music. As she grew up, the fine quality of Bella's singing voice was soon recognized and she studied opera for a year at the Dramatic Academy run by Howard Glover. His mother, then in her mid-sixties and a famous actress in her own right, taught her elocution. Bella thus had one of the best possible introductions to the theatre with connections that would have given her an *entré* to any playhouse in the country. She was also set on a career in opera, learning the harp so that she might accompany herself as required. A young talent that might go far.

More pressing, she had plans beyond the Glasgow booking. Back in London there was a new season lined up at one of the leading houses, where she would have earned at least £3 per week. Falling in love with Sam had not been part of her plans.

A turning point

A decision was needed. They got engaged and started to talk about marriage. Bella still expected to continue with her blossoming career, particularly as she had enjoyed her first taste of success. In addition, Sam's earnings as a scenepainter and aspirations as an artist seemed a poor foundation on which to build a future together.

Sam's letter to his sister Anne, dated 26 April, gives a clear sense of the haste with which he found himself heading for marriage. At the time, she was lodging with Charles Lewis in Manchester. The original plan had been for Sam to establish himself in Glasgow, and then send for Anne. Within weeks everything had been turned on its head. If Sam was surprised by the turn of events, back in Manchester Anne

knew nothing of them. Hence the tentative and overly-reassuring tone of the letter. It was probably one of the hardest he ever wrote.

> Why I am anxious that you should be in Glasgow is that I am going to get married on Monday, and I want you to be Bridesmaid. My intended asks me every day about you, and is very anxious to see her Sister. I am sure you will approve of my choice.[40]

That last sentence would have carried more weight if he had not rambled on in an uncharacteristic, effusive way to reassure his sister of her unchanged place in his affections.

> You will always find me the same brother Sam that brought you to Manchester. I still love you my dear Annie, as tenderly as ever, and I wish you to be here to live with me, and to be the same kind, good Sister you have always been.[41]

The decision to marry Bella was a very recent one, and Sam was anxious about a possible clash between two women who meant much to him.

> I ought to have told you about this long ago, but it is only a few days since I determined to get married. And tho' I have written to you, I felt rather sheepish, and didn't like to let my Raven know what was going on. Let me assure you, my dear Annie, of my unalterable love. You are my dear and only sister, and I prize your love and affection even as great as that of the woman who is to be my wife.[42]

Time proved Bough's anxiety well-founded, for Anne and Bella never really took to each other. While they shared the same house they tried, for the most part, to keep this below the surface. Perhaps if Bella had gone through the deprivations endured by Anne since the break-up of the Abbey Street home, she would have had more understanding of their differences. The same might be said of Anne's appreciation of Bella's life, which must have seemed very feather-bedded in comparison to her own. The closing sentence of the letter suggests that, even during those past few months as Sam was enjoying a degree of success and a growing relationship with Bella, Anne's life had continued to be a struggle, depending on the kindness of friends to help her financially.

There was one more hurdle to be cleared. Sam was determined that, in any marriage, he would be the sole breadwinner. Exactly what

motivated him in this is hard to say. It may have simply been a machismo streak, for in the theatrical world, working wives were commonplace. Or was it a hankering after bourgeois gentility? Given how few compromises he made to polite society in other aspects of his life, this seems unlikely. Bough travelled lightly over many of the proprieties of Victorian society, trampling some underfoot. Today's firm convictions and commitments would be forgotten tomorrow, when life threw up a more interesting challenge. But in some things he was absolute. This was one of them. Bella submitted, even though it must have been a bitter pill to swallow.

Edmund Glover also found it hard to accept. He had been resigned to losing her services at the end of the first season at the Prince's Theatre, but the news that she was to settle in Glasgow as Mrs Bough had raised his hopes that he could re-engage her for future seasons. The theatre survived on such arrangements, so why should the Boughs be any different? When he learned of Sam's attitude, the men had a 'regular row' and fell out. Sam's response was, 'we will paint no more scenery – we will paint pictures.' Fortunately the rift was not long-lived, and he continued to work for the Prince's Theatre and others over the years.

Married bliss

The wedding took place on Monday, 30 April in St Andrew's, the small Episcopalian church on Glasgow Green. Sam stood about 5ft 10in and wore a beard and moustache. Bella found him 'very good looking'. He still had 'something of the quaint, lean and hungry look of his youth'[43]. Bella was 'a slim brunette, vivacious, frank, interesting to look at rather than pretty, but with fine expressive eyes'[44]. As a friend said: 'She bewitched Sam, and he met his fate like a man'. The minister was the Rev. Dr. Gordon, fittingly renowned for his vigorous, if unconventional, preaching. Bough's wedding gift to his wife was a watercolour of *Tanziermiunden on the Elbe*, a larger version of the 1847 painting. Bella kept it for the rest of her life.

They took a flat at 36 Duke Street and were comfortable enough, although far from living in luxury. Neither had saved for this unexpected turn of events, and Bough had now committed himself to earn for both of them. Soon Anne joined them, and Sam was supporting her too. Years later Bella remembered that, in those early days, she and Sam were 'more like children playing at housekeeping than sensible people settling down into the ways of ordinary married folk'[45].

67

But he had to earn enough to keep them. So in May he was over in Edinburgh, working for W.H. Murray at the Adelphi Theatre. A playbill for the re-opening of the playhouse for the summer season, on 19 May, advertises a performance of *As You Like It* 'with new scenery designed by and under the entire superintendence of that celebrated artist, Mr Samuel Bough, who is engaged here for a limited period with the permission of Edmund Glover, Esq.; assistant painter, Mr Channing, from the Theatre Royal, Manchester'[46]. Sam's mentor was now his assistant.

Bill Channing had fallen on hard times and ill health. In future he would have to scrape his living as best he could using his many, but undervalued, talents. Right now it was scenepainting. Soon it would be bit-part acting. Later it would be engraving. As so often with Sam, once you became his friend, it was for life. So it was with Channing, as later events would prove. For now, as Sam's star was rising rapidly, Channing's was slowly sinking.

Amid all this activity, Sam somehow found time to present four works for exhibition at the RSA exhibition. They were sent from the Prince's Theatre address: *Yanwath Hall, River Eamont*; *Olivia's Garden*; *Bowden Church, Cheshire*; and *View on the River Irwell, Lancashire*. The last two were watercolours, and all were clearly the product of his time in Manchester, even if he had worked them up subsequently.

The Baggage Waggons

By October and the opening of the West of Scotland Academy (WSA) Exhibition in Glasgow, he had something else to declare: a major oil painting of *The Baggage Carts, Carlisle in the Distance*. As the *Glasgow Herald* reported:

> This is a most telling picture. ... Every touch in Mr Bough's landscape is full of interest, not one tint but serves to render the meaning of the artist more apparent. The subject is well chosen and shows that Mr Bough has studied nature with a keen relish, for the simple and the true is a faithful copy of nature. This picture will increase in value and gain more admirers the more it is looked upon. All we wish regarding it is that Mr Bough had put more finish on it.[47]

This was to be a common criticism throughout his working life: a lack of finish; a sense of haste. But this was the man. He could not be otherwise.

Now known simply as *The Baggage Waggons*, it is a large canvas that contains many of the signifiers that identify the 'essential Bough' in future years. First there is the sky and the elemental forces it contains: in the distance, a heavy rainstorm is deluging his hometown. Quite how Bough managed such technical mastery of sun, sky and cloud is the mystery of the man, but it remains a most telling and individual feature of his art. Constable and Turner had their singular impact on him – at this point Constable is more apparent – but to them Sam added a genius that was all his own. Even at 27 he had mastered this.

In his skies Sam suggested an ethereal quality that, as a man, he could only aspire to. The earth below and the people that trod on it were much more of his kind. When we lower our sights from that turbulent sky, the land below bespeaks humanity. In the distance is his hometown of Carlisle, with its most significant features delineated – Castle, Cathedral and Dixon's chimney. The perfect encapsulation of his origins – state, church and industry. A Victorian man – but not quite the average specimen.

The landscape has a hue that matches the climate of the day. In the distance is the city – a mixture of the old and the new. To the left is the ship canal – a piece of foresight that soon proved wrong-headed as the railways gained supremacy. In the foreground are the soldiers heading for Carlisle, having disembarked at Port Carlisle. No particular significance should be attached to their journey. At the time Bough produced the picture, England was not in the throes of any great civil unrest. It was simply a painting of people going about their business – only in this case the people were soldiers and they were approaching the Border city, the scene of so much warfare during earlier years. Echoes of past strife, posing no present threat – a way of life about to change. Sister Anne was the model for the soldier's wife with child. And the inevitable Bough signature: a dog in the foreground.

A smaller, less detailed oil on panel, called simply *Convoy*, shows a similar scene, except that the soldiers are approaching the viewer, not receding. It may have been a preliminary *in vivo* sketch for the larger work. Now at the Beaverbrook Art Gallery, Fredericton, New Brunswick, it offers a tantalizing conundrum – which came first? The inspiration for the subject matter of these pictures may have been de Loutherberg's *A Distant Hailstorm and the March of the Soldiers with their Baggage*, while compositionally, the larger work has similarities with Thomas Miles Richardson, Senior's *Newcastle from Gateshead Fell*. Bough may have known both of them from his travels a decade earlier.

As a colourist, other Scottish artists before and after could put

Bough to shame. But for capturing the spirit of the moment Bough was unsurpassed.

The picture was given the place of honour, yet only a month or so earlier he had sold it, unframed, for just £10 to a Mr Anderson of Renfield Street, Glasgow. Strapped for cash, Sam had been forced to trade in a buyer's market. His friend, John Milne Donald – himself a struggling landscape painter – had effected the introductions. Bough treated Bella and Anne to a cloak apiece from the proceeds. As usual, famine followed feast in the Bough household, and in the months ahead there were times when both men had to make ends meet by working as shop and office decorators, Milne Donald's first trade.

Also appearing at this Glasgow show were *Olivia's Garden* (again); *Lorton Mill, Cumberland*; *Gilnockie Tower, River Esk*; *Maryport Harbour*; and *Edinburgh from St Leonard's*. James also had a rare painting on show – *Bothwell Bridge* – with his address given as the Prince's Theatre.

Other income was derived from producing sketches for engraving. First Sam worked for R. Griffin & Co., then for the publishers Blackie & Son, and Maclure & Macdonald, engravers and lithographers. Bough's connections with the latter two companies were to span the rest of his life. He became firm friends with both Robert Blackie and Archibald Gray Macdonald, who was to prove one of his most consistent patrons during those early years in Scotland.

Sam now had three strings to his bow: landscape painting – always his first love; scenepainting, which he would never totally abandon; and prints and book illustrations that served to raise his profile and provide additional income.

Despite all the hard work, there were some lighter moments for the young couple, like the time they had a fancy dress ball at the Duke Street flat. Living in such modest circumstances was no deterrent. 'Think of the folly of trying to get up a fancy ball in such a place, but we did it and it was a great success,' Bella recalled. 'We got dresses from the theatre. Sam chose the character of the Grand Turk, so that he could smoke, and I was the Sultana. Sam sang and fiddled. I sang and harped: everybody did something, and everybody was pleased. It was a risk, but I knew no better – and perhaps it was as well I did not. We were our natural selves then, for you couldn't pretend or put on fine airs with Sam. If you did, you were sure to be pulled up sharp.'[48]

A dinner party followed shortly afterwards. Bella had to borrow a tablecloth for the occasion and hoped that Sam would not notice. It was a forlorn hope. 'I was at great pains to have everything nice. We were furnishing little by little as we could. Everything was going off capitally, when to my horror Sam began fingering the tablecloth and

then looking at me blurted out before all our guests – "Bellams! Where did you get this handsome cover?" I never felt so ashamed, for I had no cloth good enough and had borrowed it, and it was as difficult to put him off as it was to tell the truth. But it was a happy, happy time!'[49]

On 12 November, Glover opened his winter season at the Prince's Theatre. Sam's name again loomed large. The theatre had been repainted and decorated under his expert eye, and he had personally painted 'A New Drop Scene: Subject – Falls of Clyde – Corra Lynn, from a sketch taken on the spot'. The first production was *Der Freischutz*, for which Sam had also produced some new scenery. James Bough played one of the hunters, and throughout that season of opera, plays and drama, he would appear consistently in minor roles.

Less than a week later, on Saturday, 17 November, another theatre tragedy struck Glasgow. A packed house at the Theatre Royal, Dunlop Street, was watching a spectacular melodrama, *The Surrender of Calais*, when a minor fire broke out. This was rapidly doused, but the audience panicked and in the ensuing melee, 65 people died, including a three-year-old child.

Within days, Glover had arranged a benefit for the families bereaved by Glasgow's biggest theatre tragedy. On 20 November, 'for one night only', Bella made a return to the stage as Lazarillo in *Maritana!*. Over the years, she made a number of such reappearances for charities and benefits. It was an accommodation that Sam was probably pleased to make, given his earlier hard line over working wives.

Pantomime time

Glover's first pantomime, *Old Mother Shipton*, had an additional attraction for the audiences on 28 December – a moving panorama painted by Bough. It showed Queen Victoria's visit to Glasgow on 14 August, 'from views taken as near the spot as circumstances would allow him to go'. The scenes traced her journey from Belfast, across the Irish Sea, up the Clyde to Glasgow. It also had a 'triumphal arch and animated scene at the Old Cathedral from the celebrated lithographs published by Maclure and Macdonald'[50]. The whole thing ended with a view of Balmoral Castle and 'Grand National Festivities'. A book with the words to the pantomime and a key to the panorama was put on sale for 3d.

The year ended on a high for Bough. In addition to his marriage, he had established himself as the leading scenepainter in Glasgow and

produced a painting that would set a standard for his subsequent work: *The Baggage Carts, Carlisle in the Distance*. He could be excused for thinking that the hard times were behind him. But over in Edinburgh there was a harsh reminder of the thin line between success and failure – Bill Channing was now reduced to minor roles at the Theatre Royal, no longer even credited as a scenepainter. The irony – and the lesson – would not have been lost on Sam.

In January 1850, *Richard III* opened alongside *Old Mother Shipton*! Not surprisingly there was insufficient time left to show the whole of the panorama. By 23 January, they had all given way to *King Rene's Daughter* with a scene of the King's garden in a valley of Vaucluse, Provence, painted by Bough. A few weeks later, he had also produced a proscenium arch of the ancient Greek theatre 'as described by the Classic Authors' for a production of *Antigone*. No one could claim it was great art, but what demands it made on his versatility and impressive speed of production.

At the 1850 RSA Exhibition, Bough sent just one oil painting, from the Prince's Theatre – evidence of the effort involved in his theatre work. This was *Stratford on Avon* – for which he wanted 40 guineas. It proved a price too high. Scenepainting was still his best source of income at this point.

Broomielaw and the banks of the Clyde

Gradually Sam was getting back to serious painting. One of his enduring works from April 1850 was *Broomielaw Bridge*, a large water-colour purchased by Archibald Gray Macdonald. It depicts the second Jamaica Bridge, bustling with people, carts and cavalry. The Clyde is alive with small craft, passenger steamers and ocean-going sailing ships. By a trick of perspective he manages to show more than could actually be seen from his viewpoint – perhaps a ploy borrowed from an earlier work by John Knox of Old Glasgow Bridge. The subject shows Bough once more at his most effective – a landscape with figures, where both the scene and the people give meaning to each other.

Another important picture from this year is *Dunkirk*, a subject he returned to a number of times. This oil was described by Pinnington as having a 'sky of charmingly mingled opal, white, grey and blue, but the swell and subsidence of the tumbling waves is most happily and powerfully rendered and the motion of ship and boat as they roll and dip is the accompaniment of its musical motion. ... In good light which brings out the scattered note of red – a grand picture'[51]. As so

often throughout his life, it raises the question of whether Bough had actually made a trip abroad at this point, or whether he was simply using his imagination – or copying someone else. It was probably the former on this occasion.

Whenever he could find time, Sam would go off sketching along the banks of the Clyde or around Holy Loch, sometimes with Milne Donald. On one of his solitary trips, he met up with another young artist, Alexander Fraser. It was the start of a friendship that lasted a lifetime.

Fraser was the son of a genre painter and, at this point, was influenced by the pre-eminent Scottish landscape painter – Horatio McCulloch – and David Cox. He was sketching in Glen Messan, a rocky river flowing into Holy Loch, when he came upon a bizarre figure, dressed in bright orange knee-breeches, wading in the water. It was doctor's orders, a cure for corns, Fraser was told on asking. Then the tall gaunt stranger launched into an even taller story of an horrific accident to a friend while sketching in the Pyrenees. At last the truth dawned on Fraser – he was talking to Sam Bough, a man whose reputation was rapidly spreading through the West of Scotland.

Bough invited him round for breakfast at Duke Street on returning to Glasgow, but when Fraser got there at 10 a.m. no one was about. At last a young woman came in, and he helped her set the fire. Hours later, Sam finally got up, and the men spent the rest of the day together. Over the next few years the two would travel together a great deal on sketching tours throughout Scotland and England.

At the end of May, Glover launched the summer season at the Prince's Theatre, with Sam still active for him. Among the works he produced were the five scenes for an original ballet on *The Three Graces, or Canova's Dream*, followed by a scene of 'the outskirts of a village on the Austrian frontier' to accompany a light vaudeville. This played into early June when it was replaced by 'an original, grand operatic, romantic, magical burlesque spectacle' called *Taming a Tartar! or Magic and Mazourkaphobia*, for which Bough again produced the scenes. That was followed in July by *Open Sesame, or a Night with the Forty Thieves* – a 'thorough-bred, racy and romantic extravaganza', scenery 'drawn in accordance with their own peculiar views and sinister designs by Messrs Bough and Hawthorn'[52]. All good fun, but hardly fine art. Bough enjoyed it – and the money it brought – while sensing that this was not what he was really about.

That summer, Sam sent a batch of paintings down to Carlisle for an exhibition at the Athenaeum opening on 26 June. Writing to his friend, John Fisher, on 17 August, he betrays an anxiety about the

reception his work had received locally. First he asks for any newspaper reports, then a copy of the catalogue and adds: 'Let me know how the pictures are hung; and be sure to tell me whether mine are hung within reach or not.'[53]

Stratford on Avon appeared – and this time found a buyer, as well as glowing reports. 'One of the cleverest productions in the room', was how the local press saw it. 'The picture is on a large scale, and is the most successful as well as the most ambitious of Mr Bough's productions.'[54] Most of the others sold, too: *Olivia's Garden*; *The Moated Grange*; and *Inversnaid, Loch Lomond*. That left, among others, *Naworth Castle, Cumberland* ('marks of undoubted and elevated genius abound in the present work'[55]); *Tanziermunden on the Elbe* (perhaps the earlier version); and a portrait of Bella.

Finance permitting, Sam intended to get down to Carlisle with Bella to see the show. He did make some sort of excursion into the Lakes that summer. Two small sepia sketches exist from that time – *Keswick, Portinscale Bridge*, dated July, and *Eskdale*, dated September.

Imperial panoramas, irreversible change

Probably that spring or summer, with no theatre commitments, he also produced a panorama called *The Overland Mail to India* for exhibition at the City Hall. John Urie remembered how the promoter had asked him to make some wood engravings of the scenes to advertise the show. The panorama was being painted in a room in Bath Street.

> I accordingly went up to the address and knocked on the half-open door. The big, cheery voice of Sam bade me enter. On pushing the door open. I saw the floor covered with a piece of canvas. The artist, with a pot of paint in one hand and a brush in the other, was walking over the canvas, giving a swish here and a splash there at what seemed a chaotic mass of paint.
>
> I said, 'I am afraid I will spoil your picture.' 'Not at all,' he said. 'Come in; you will just give it a little extra effect.' I remember afterwards going to the City Hall to see that panorama, and being amazed at the wonderfully fine effect produced by what at close quarters seemed exceedingly rough work.[56]

He made a smaller showing at the October exhibition of the WSA. The paintings, sent from 36 Duke Street, were *Barges on the River Irwell, Lancashire*; *Broughty Castle, near Dundee* and *Institute of the Fine*

74

Arts, proposed to be erected in George's Square, from a design by J.T. Lochhead, Esq., Architect. The latter is a fascinating insight into Bough's confidence at this time – nothing was beyond his compass.

As 1850 drew to a close, Sam reached a decision that the time had come to commit himself to art. In this he was encouraged by the great portrait painter, Daniel Macnee, recognizing the young Cumbrian's potential. His support must have eased any lingering doubts that Bella harboured. When the winter season opened at the Prince's Theatre on 1 November, Bough's name no longer appeared among the credits, although James was still performing in a variety of roles. From this point onwards, the theatre would cease to be Sam's prime source of income. The decision was irreversible.

But the Boughs were still in Glasgow when the RSA Exhibition opened in February 1851, with Sam entering four pictures. For *Broughty Castle – Sunset*, a magnificent Turneresque effect, he asked a paltry 13 guineas. Dated 1850, this watercolour shows just what mastery he had now achieved over the effect of a sinking sun on sky and sea. It contains many of the hallmarks of his later marine paintings. He wanted 10 guineas apiece for *Edgehill* and *Haddon Chase*. The fourth picture was of *Glen Scaddel, Argyllshire*.

Home in Hamilton

A few months later, Sam, Bella and Anne were all settled at 14 Muir Street, Hamilton, on the fringe of Cadzow Forest. Probably no single factor caused the move there, although Sam's relationship with the Glovers had certainly cooled by then, for whatever reason. More potent forces would be the prospect of a cheaper lifestyle and the opportunity to concentrate on his art without so many social distractions.

Alexander Fraser's company was an additional attraction. He lived at nearby Barncluith, a fine seventeenth-century tower house, and for the next three years the two men worked closely together: Fraser, the younger by six years, was not simply a student to the more experienced Bough. His quieter, less assertive style served to offset the more dynamic inclinations of his friend. Many of the works they produced were joint ventures. According to Pinnington:

> Younger brethren of the brush spoke of Bough and Fraser as if there was some closer bond of union than membership of the same craft. Equally endowed by nature, they excelled in different qualities, and,

as frequently happened when one of a pair is the complement of the other, their association had the best results; for no works of either excel those produced whilst they worked together amongst the oaks of Cadzow or on the island of Inchcolm. Frasers of this period have something of the spontaneous composition of his senior, and the Boughs partake of the colour-quality of the younger artist.[57]

One of Sam's less characteristic works around this time was the caricature of *The Forest Confessional*, where a young woman confesses her sins to a fat friar, overheard by a voyeur. The legend tells all:

> A lovely lass to a Friar came
> To confession a morning early.
> In what, my dear, are you to blame
> Come tell me most sincerely.
> Alas my fault I dare not name
> But my lad, he loved me dearly.

The break with the theatre was far from total, for Bough still had to mix scenepainting with art out of financial necessity. According to Fraser he ventured further north, to Dundee and Aberdeen, in search of work in the theatre. Bough made some lasting friendships with people he met on these travels. On Tayside, for example, his work caught the eye of engineer and art collector, James Guthrie Orchar of Broughty Ferry. He became a keen patron of Sam, and later, with his coterie of businessmen/art lovers in the Dundee area, he would draw on the Cumbrian's knowledge when investing in new pictures.

Across in Edinburgh, Sam did a drop scene of a view of the Clyde for W.H. Murray at the Theatre Royal. When it was first shown, he was called on stage by a rapturous audience. Cheered constantly, Sam took his bow. As the last season of the ageing proprietor ran from 31 May to 22 October, Sam's triumph must have been during the early summer months of 1851. Perhaps that summer trip to Edinburgh was the occasion of one of his less memorable poems. He called 'A Dry Dream,' celebrating the refreshing power of his friend John Fisher's ginger beer back in Carlisle.

> There was John Fisher, as true and as kind
> As we knew him at No. forty-eight,
> He produced the tipple that we knew of old,
> And it was clear and as bright
> As we knew it in days of yore,

And as fresh and as sparkling did seem.
But just at this moment I found I awoke
And alas! it was just a dry dream –
Alas! it was just a dry dream.

Bough kept in close contact with such friends and relatives in his home town. In a letter to Fisher from the same period, he writes of the impending visit from his brother Joseph, asking his friend to get him to bring a copy of Mounsey's *History of the Rebellion in 1745* along with him, 'as I want to paint a picture of the old town, and I think I may find some subject there that would be interesting to the lieges'[58].

He may have intended to show it at a local exhibition or at the two unsuccessful ones organised in Glasgow by Robert Napier and Archibald McLellan (who had hoped to promote an Institute of Fine Art there), but the picture never seems to have materialized. When Joseph finally paid that visit, all he took was his wife, Mary, and their young son, John – hardly a year old.

John Fisher is an interesting example of the diversity of people Sam attracted as friends. To some the druggist was remembered 'for his kindness to struggling artists. ... To them all he was kindness itself, trying to secure commissions for them, helping them to sell their pictures'[59]. The Sewells, on the other hand, had little time for this branch of local society, or 'the shadier side of Sam's life' as they saw it. 'Whenever he came to Carlisle it was ever desirable to try and quietly steer him clear of that lot, and when this was successfully done, he was a different being.'[60]

Bough's enduring friendship with Fisher and the perceptions of the Sewells epitomize the effect he had on people. Sam valued who he would, finding interest and stimulation in such a range of people he must have known could never be reconciled to each other. In this he was neither exploited nor in need of protection. He saw clearly the essence of the person, whether the exterior presented as pauper or petit bourgeois, and if he valued what he saw there, that person could count on him.

That summer, Bough sent a painting to the Royal Manchester Institution for the first time since 1848 – a watercolour of *Gilnockie Tower on the River Esk – Sunset*. It was entered from 45 Rumford Street, Manchester.

The big event of 1851 for most of the country was the Great Exhibition at the Crystal Palace, opened by Queen Victoria on 1 May. By the time it closed, over six million visitors had paid to see it. Sam was one of them. He probably went down there in late summer with Bella

and Anne, staying with the in-laws at 28 Mount Street, Westminster Road. While there, he took in the Royal Academy Exhibition.

By early October, he was back in Hamilton and writing to his sister, who was still with the Taylors in London. Among the domestic details, Sam tells Anne about a new tin teapot that had no sooner been bought than it was broken 'making the twenty-fifth unfortunate Teapot that has come to an untimely end! The poor Teapot lost its spout on the third day. The old Batchelor Teapot still exists, and the Lord of Creation hopes it will last some little time yet.'[61] Sam's last comment harks back to the days when such matters as broken pots were neither here nor there to him, and life must have seemed simpler. There is a fascinating postscript to this letter: 'Try and find out Aunt Mary. Enquire at Mrs. Wilson's of the servants of Mrs. Wilson, 16 Devonshire Street, Portland Place, and let us know.'[62]

The Census for 1851 shows that Aunt Mary was Mary Blaydon, lady's maid, aged 49 and from Bath. This would probably make her James Bough's stepsister, the product of Alice Bough's second marriage, to William Carter. Mary's husband, William Blaydon, was the butler, aged 39 and a Somerset man. Head of the household was the 50-year-old widow Elizabeth Wilson, who originally came from Shropshire. The Blaydons were probably in service with her there before coming up to London.

Lack of money still loomed large, but James was leaving Glover and Glasgow to go across to Edinburgh to work for Lloyd, who had just taken over the Theatre Royal from Murray. Sam's artist friend Charles Allen Duval was visiting Glasgow, and Bough had just entered seven pictures in the WSA Exhibition. 'I have great hopes of selling something,' Sam told his sister, 'but the times are very hard. All the folks have spent all their money in going to London. ... If the exhibitions do anything in Glasgow, I hope to be wealthy this winter.'[63] It was a false hope – again – but he had some reward for his efforts.

Challenging McCulloch

The Glasgow Exhibition had a prize of £10 for the best Scottish landscape scene. Both the money and the associated prestige attracted Bough, but he was wary of competing with the likes of John Milne Donald and Horatio McCulloch. The former he respected as a formidable talent in the making, while in the latter he recognized a man at the peak of his popularity.

McCulloch was the quintessential Scottish national painter, the true

successor to the legendary John Thomson of Duddingston as the romantic portrayer of the 'land of the mountain and the flood'. A generation older than Bough, McCulloch had also worked in Hamilton and Cadzow Forest for a time, but his mature style was more studied than Bough could ever have tolerated in his own work. Fraser was a friend of both men, and his paintings reflect this.

It was Bella who eventually found the subject to match the challenge. They were out in Cadzow Forest one day when she saw some women peeling bark from trees and suggested Sam should paint them as his prize entry at Glasgow. He called it *Glade in the Forest, Cadzow*. And it won. Although the prize was small, Sam's confidence received a tremendous boost. For all his bluster, what he valued most at this point was the recognition of his fellow professionals.

Other pictures at this show were *Glen Messan*; *Kircudbright Castle*; *Bothwell Castle*; *Canal Scene, Cheshire*; *The Fisherman's Return – Sunrise*; and *The Fisherman's Departure – Sunset*, all of which have disappeared into history.

Towards the end of the year came the saddest event of all for the whole of the European art world – the death of Turner on 19 December. Legend has it that in one of his youthful visits to London, Sam was painting on the banks of the Thames with a friend when Turner passed by, looked at his work and said 'You may do'. Robert Louis Stevenson, in his affectionate memoir of Bough, recalled a 'night piece on a headland, where the atmosphere of tempest, the darkness and the mingled spray and rain, are conveyed with remarkable truth and force. It was painted to hang near a Turner; and in answer to some words of praise – "Yes, lad," he said, "I wasn't going to look like a fool beside the old man".'[64] With Turner's passing, Sam must have felt a real sense of loss for, although he never aspired to such a revolutionary approach to art, the Cumbrian had a profound respect for the achievements of the older man. The skies of his seascapes bear full testimony to this.

The turn of the year brought more problems for Bough. He was still having to work hard to earn enough to survive. James had 'a grand outbreak' in the New Year, but by mid-February had recovered and was getting on with life as a scenepainter in Edinburgh. Joseph had not kept in contact, to Sam's concern. Anne had just returned from three months in London. All of this Bough wrote in a letter to John Fisher on 16 February 1852, adding some practical advice: 'If the customer who wants to buy the little picture of Askham Mill will give five pounds for it, let him have it. If he won't, keep it yourself. It will fetch you that or more some day. And if you do sell it, just put the

money into the business. Expend it in noxious drugs for the benefit of the afflicted of either sex, and I will give you a little picture to take the place of the *Askham Mill*'.[65]

A few weeks later he wrote again, still encouraging Fisher to sell the picture. In this letter, Sam also commented that he had taken up the violin once more, but was out of practice. And he included a strangely naive sketch of himself as a child, having just had an accident in his trousers – *A Cat as trophe!* – presumably in an effort to raise his friend's spirits.

At the RSA show that year, Millais exhibited in Edinburgh for the first time, and the *Art Journal* praised the show as 'so excellent as to be classed immeasurably above any other held out of London'[66]. Strangely for a man usually so prolific, Sam entered just two paintings: *Kircudbright Castle* and *The Fisherman's Return – Sunrise* – again – suggesting that the earlier show in Glasgow had not been too successful for him.

As in the previous year, he was working long, hard days to capture the effects of the weather and the seasons in Cadzow Forest. Social life was very different from Glasgow, as few of their previous friends visited them.

The Boughs' modest home stood close to the gates of Hamilton Castle, the largest country house in Scotland, built on a grand scale and home of the Duke of Hamilton, who owned most of the adjoining forest. Inevitably, Bough got to know the local gentry. He got on better with the female of the species. Sketching in the forest one day Sam was approached by three men who, having observed his efforts, pronounced them good. Sociable as ever – particularly where his work was appreciated – Bough invited them round for a drink and a smoke. Then he discovered that one of them was the Duke of Hamilton himself, owner of the forest. Well into his eighties and of another era, the Duke soon found Sam's free and easy manner more than he could stomach. Perhaps Bough was unable to produce the required degree of deference. The contact ended in coolness.

Not so Mary, Lady Belhaven of nearby Wishaw House, who had a keen appreciation of art and was less easily deterred. On her first visit to Sam's house, she found him covered in grime from getting in coal for the fire. Once she saw his paintings, however, she understood the talent that laboured under such mundane circumstances, and later bought some of his works. Lady Belhaven also respected his opinions. When Bough discovered that some particularly attractive trees on her estate were destined for destruction, he wrote to her protesting strongly at the proposal. The trees were spared.

At the WSA Exhibition that year, Bough showed four works: *On*

the *Irwell, Lancashire*; *The Old Forest – Sunset*; *Bothwell Castle, near Uddingston*; and *Off St Andrews*. Other titles from 1852 suggest some of the other places Sam might have visited: *Sunset over Carlisle*; *Cardross Castle – Harvest Time*; *Sweetheart Abbey – A Summer Shower*; *Glasgow from Garngad Hill*; and *Willows at Bothwell Haugh*.

By the end of the year, he was back at his old trade, earning a penny as a scenepainter – this time in Edinburgh, at the Adelphi, working with James and Bill Channing for the Christmas pantomime, *The Ocean Queen*. The result was 'remarkably fine', but the show was less popular than its competitor at the Theatre Royal.

Unknown to Sam, an event that would have a significant impact on his long-term development as an artist also happened in Edinburgh that year. Robert Scott Lauder was appointed as master and director of the Life and Colour Classes at the Trustees' Academy, Edinburgh. Within a few years, drawn by Lauder's reputation, most of the promising young artists in Scotland had flocked to Edinburgh to learn from the master. In the end, the lure would prove irresistible even to Bough – but not just yet.

The RSA Exhibition early in 1853 contained only three of his works: *Barnclutha* (the property of James Rodgers of Glasgow); *Peeling Oak Bark, Cadzow Forest* (£40 asked); and *Bothwell Castle, near Uddingston* (£25). He got a favourable review in the *Scotsman*:

> Another landscape painter whose works call our attention to a new name is Samuel Bough. He exhibits three landscapes, all possessed of merit and giving good promise for the future. This native school of nature has already furnished us one artist of mean power and his fine study, No. 306 Peeling Oak Bark, Cadzow Forest, holds out good encouragement to hope for another able competitor for the laurels in the same field.[67]

Obviously Bough was still seen as an incomer in the refined atmosphere of the RSA. After all, Millais was showing there again – this time it was *Ophelia*. And Ruskin was lecturing in Edinburgh about the Pre-Raphaelite Brotherhood. Fraser's work began to show their influence. Not so Bough's.

In February, Sam wrote to Anne, who was staying with Charles Lewis in Market Street, Manchester. He had sent two pictures from the previous autumn's show in Glasgow down to Manchester, hoping for a sale. He complained of 'screwmatticks' in both his legs – due probably to the previous day's skating on the frozen Clyde. 'I never saw such a sight. I got a pair of old skates, and screw'd them on, but 'tis no use. I don't like Skating now. Too hard work for Sam.'[68]

A like-minded neighbour

At some point, Sam, Bella and (probably) Anne changed address to Bothwell Road, Hamilton. Perhaps Sam needed more space – or maybe he had simply upset his landlord. No matter – it brought him into the company of Thomas Fairbairn, fellow artist and next door neighbour.

Fairbairn had lived in Glasgow for some years before moving to Hamilton, and may even have met – or at least heard of – Bough during that time. Born in Campsie in 1820, he had his first art lessons from Andrew Donaldson of Glasgow. During 1853 he and his wife moved to Hamilton. Sam was impressed by the relative affluence he found displayed in his artistic neighbour's possessions. Sam and Bella were still trying to put together a comfortable home.

The trio of Bough, Fraser and Fairbairn was never destined to create a Scottish 'Barbizon' school, but their *plein-air* work paralleled the French artists in its emphasis on nature and what could be learned from close observation of the world about them, rather than from academic study. And their influences were similar: seventeenth century Dutch masters, such as Ruisdael, and, closer to home, John Constable. Individuals within the Barbizon group went on to achieve greater fame as a result of the singular geniuses that had contributed to it. Of the Hamilton group, only Bough possessed such a genius, and it was mostly directed towards a goal larger than art: life.

Back in Edinburgh, James had fallen in love with Eliza Frazer, daughter of a merchant from Inverness. They married on 28 February 1853 in St Cuthbert's church and lived together at 1 North St James Street. By May he was out of a job, when the Adelphi in Edinburgh burned down. 'At about a quarter to five, a workman in the theatre observed flames issuing from one of the lower private boxes next the stage, and immediately gave the alarm. In an hour's time, however, the building was in ruins.'[69] James and Bill Channing had to find new work, and Sam – for the moment at least – had lost another source of income.

Bough may have been maturing, but there was still enough devil in him to raise a storm now and then. The ancient herd of white cattle in Cadzow was one target for his high spirits. 'It was a practice of Bough's ... to go to the forest and give chase to the wild cattle waving his arms. Their way is to flee a short distance and then turn and rush down at a fierce rate. He then got into a tree and watched them.'[70]

Communing with nature was not without uninvited hazards, too. Once while sketching under a tree in the forest, he was overtaken by a thunderstorm. As the tree opposite that he was sketching offered a hollow trunk, Sam took shelter there from the rain. Within seconds,

the tree he had been under was sundered by a lightning bolt. Sam never underestimated the violence that nature could unleash at any time – a realization that features in many of his works, where humanity battles against the weather, in imminent danger of being swept away, or waits anxiously for the outcome of an unequal battle with the elements.

A major work from this time shows humanity in a different environment – where he appears to have more control over his destiny. It also reflects another side of Bough's personality – his love of the hustle and bustle of city life. *Victoria Bridge in Glasgow* is a large watercolour bought by his friend, A.G. Macdonald. As so often, Sam had to embroider reality. He shows the bridge – accurately enough – in pristine condition, but the traffic thronging it would have had to wait until 1856 before it could actually use it.

Also dating from 1853 is a fine watercolour done for Blackies of *Snowballing Outside Edinburgh University*, celebrating a great 'academic' tradition later to be engraved for them by William Forrest. This is a neglected aspect of Bough's output. Throughout his time in Scotland, he regularly (if such a word can be applied to Bough) produced work for engraving, either as illustrations for books, or for publication as prints. Forrest had a high opinion of Sam's skills, maintaining that his sketches 'always contained a leading idea, however rough or meagre in details or outline they might be, and from this cause they are all the more easily translated by the engraver'[71]. The respect was mutual, for in later years Sam would stipulate Forrest to be the engraver of some of his more prestigious illustrative work.

Later that year, Bough was showing at what turned out to be the swansong of the WSA. He submitted 11 works in all, including three watercolours. Many of them were set locally, but one of Calais Harbour suggests that Sam had made another of his spasmodic trips abroad. Two of the watercolours – of Bothwell Castle and Govan – were already the property of A.G. Macdonald.

The demise of the WSA was a sad reflection on the relative positions of Glasgow and Edinburgh in the art world. In addition, Lauder's influence as a teacher as now being felt. Many young artists were making the decision that their immediate futures lay in the Scottish capital, not in Glasgow.

'A broad, free and impressive style'

At the 1854 RSA exhibition, Bough had four works sent from his Hamilton address, all with Scottish settings. These were *Beech Trees:*

Autumn; *A November Day, near Caerlaverock on the Nith*; *Cadzow Forest Oaks*; and *Glasgow from Garngad Hill*. Of the last three, the *Scotsman* again spoke highly:

> Three excellent drawings by Samuel Bough, they are all treated in a broad, free, and impressive style, with a masterly and spirited pencil. It is impossible to speak too highly of the faithful accuracy with which the last is worked out. We wish we had a few more watercolour painters of Mr Bough's excellence.[72]

That year he was also back showing at the Royal Manchester Institution, with three works: *Sweetheart Abbey* (8 guineas asked); *Entrance to Cadzow Forest* (15 guineas); and *Beech Trees, on the Avon, Lanarkshire*.

He probably spent some of the summer sketching in the Lake District again, and produced at least one watercolour, *Langdale Pikes*. Other pictures attributed to this year include *Edinburgh from Leith Roads*; *Edinburgh from St Anthony's Chapel*; *The Thames above Richmond*; *Waterfall in Campsie Glen*; and *Bacon's Tower, Oxford – Rain Storm Clearing Off*. This may indicate the range of sketching trips he took that year – but not necessarily. Some may simply have been worked up from sketches made in earlier years.

Of these, *Edinburgh from Leith Roads* is the most significant, for it signifies a growing interest in seascapes. Perhaps after three years sketching in Cadzow, he needed a fresh challenge. His work for the rest of the year certainly suggests a changing focus of interest, as he travelled along the Fife coast of Scotland, producing pictures like *West Wemyss Harbour, Sunrise* and *Ravenscraig Castle from Kirkcaldy Harbour – Squall Off Shore*. The subject matter gives a clear indication of where Bough was now turning his artistic attention – to harbours, boats and the sea. This was to decide his next move.

Sam had exhausted the rich inspirational seam he had mined in Cadzow. He needed a fresh challenge and decided that he would master marine painting. He knew that his happiest effects were achieved at the extremes of day and climate, where land, sea and sky collided. Now he wanted to acquire a technical knowledge of boats and boatbuilders, in his striving for authenticity.

Port Glasgow and the ships

Port Glasgow was his choice. It was not made lightly. London beckoned, and he was tempted. Was the final decisive factor profes-

sional or personal? We shall never know. Sam and Bella tended to visit her parents annually, and this may have been as close as he wanted to get to his in-laws. Or he might have judged his prospects were better in Scotland, where the subjects that pleased him also satisfied his patrons. Competition in London was fierce, although the rewards were great – but to succeed would probably have meant taking to genre painting and portraiture, neither of which was his strength. Bough had also seen enough of London social life to know whether he wanted to fit in or not.

Fond farewells had to be taken of the Fairbairns. Sam tried to give Tom Fairbairn a small picture of Cadzow Forest to settle up on old debts. When his friend refused to take it, because it was worth too much, Sam presented it to his wife. 'Oh, I'll take it willingly,' said Mrs Fairbairn, 'but then he'll be sure to want it from me some day.' To prevent this, Sam jokingly inscribed on the picture 'Sam Bough, 1854 – To my dear friend, Mrs T. Fairbairn'. The two men remained friends over the years, Tom Fairbairn producing two small portraits of Bough, one of which he gave to Sam, the other he kept for himself.

The Boughs chose their new home in Port Glasgow well. Ivy Bank was a two-storey building standing high on a hill with a fine view of the Clyde. As at Hamilton, social life was fairly restricted while Sam concentrated on mastering the technique of drawing and painting sailing ships, boats and boatyards. The hard work he put in, both at Cadzow and Port Glasgow, to master the technicalities of his craft is often overlooked, submerged beneath the image of a gifted and untamed genius. In reality, Bough had genius, but he honed it by sheer effort.

They probably moved to Ivy Bank in later summer. Anne may have gone to live in Glasgow at this point or later. Thomas Sewell visited them there in the October, and Sam produced a watercolour portrait of him. There is also a humorous pencil sketch of *Sam Bough and his doggys*, dated 19 November.

His studies were soon bearing fruit. Pictures from this period include: *Port Glasgow Harbour*; *Woods Shipyard*; *Port Glasgow*; *Newark Castle* and *Devol Glen, Port Glasgow*.

On 22 December 1854, Sam wrote to his sister, who was now living at 26 Bothwell Street, Anderston, Glasgow, that he and Bella planned to spend two weeks over Christmas with the Duvals. 'So, as I should like to start tomorrow night, I wish you would come down and manage the house for us while we are away. You shall have your usual allowance, and I will do something for you in my Will.'[73] Managing the house meant looking after the cats and dogs. Although the whole is

dressed up in caring words, it hardly disguises the fact that Anne remained economically dependent on Sam, and was expected to be available on demand for such domestic duties.

Duval was now achieving a fair degree of success with his portraits and narrative pictures, raising a dozen offspring and living in some comfort in a nice house in Carlton Vale. During that visit, he produced a clever crayon drawing of Bough, which Sam gave to his sister.

At the 1855 RSA, Bough entered six pictures from Ivy Bank Cottage. These were: *Entrance to Cadzow Forest*; *Fishing Boats running into Port – Dysart Harbour*; *Gabbarts and Iron Shipyard, Dumbarton*; *Victoria Bridge, Glasgow* (probably the 1853 watercolour); *Study from Nature at Barncluith*; and *Woodhall, near Knutsford, Cheshire*. For the shipyard painting, he was asking £100 – Bough was now putting a higher valuation on his own efforts. And rightly so, for this large oil demonstrates just how well he had learned his lessons. Against a tranquil summer sky and a placid river, it shows the whole range of shipping activity, from the small boy sailing his model boat in the shallows, with women washing clothes behind him, to the construction of a large ocean-going ship. Tonally and compositionally, it represents a triumph.

But while he remained in Port Glasgow his financial prospects would always be limited, particularly since the demise of the WSA. At some point during the first half of 1855, he bowed to the inevitable and moved to Edinburgh. He would stay there for the rest of his life. Bough the artist was no longer travelling hopefully. He had arrived.

REFERENCES

1 *Carlisle Journal*, 3 May 1845.
2 Sidney Gilpin, *op. cit.*, p. 33.
3 Sidney Gilpin, *op. cit.*, p. 34.
4 *ibid.*
5 *ibid.*
6 *Glasgow Dramatic Review*, 3 June 1846.
7 *Glasgow Dramatic Review*, 6 May 1846.
8 Sidney Gilpin, *op. cit.*, p. 44.
9 Sidney Gilpin, *op. cit.*, p. 35.
10 Edward Pinnington's notes, *op. cit.*
11 Letter, early August 1845, George Coward's notebook, Carlisle City Art Gallery, undated.
12 Sidney Gilpin, *op. cit.*, p. 38.
13 *ibid.*
14 Letter, 18 August 1845, George Coward's notebook, *op. cit.*
15 *ibid.*
16 *ibid.*
17 *ibid.*
18 Edward Pinnington, *op. cit.*, 28 April 1922.
19 C.P. Darcy, *The Encouragement of the Fine Arts in Lancashire, 1760–1860*, Manchester University Press, 1976.
20 Edward Pinnington, *op. cit.*, 19 May 1922.
21 Edward Pinnington, *op. cit.*, 12 May 1922.
22 Edward Pinnington, *op. cit.*, 28 April 1922.
23 Sidney Gilpin, *op. cit.*, p. 48.
24 *ibid.*, p. 49.
25 Letter, 4 August 1847, George Coward's notebook, *op. cit.*
26 *ibid.*
27 *ibid.*
28 *ibid.*
29 *ibid.*
30 Sidney Gilpin, *op. cit.*, p. 47.
31 John Ruskin, *Academy Notes*, 1856, p. 54.
32 Sidney Gilpin, *op. cit.*, p. 57.
33 *Glasgow Herald*, 4 January 1849.
34 *Glasgow Herald*, 12 January 1849.
35 *ibid.*

36 *Reformers Gazette* quoted on Prince's Theatre Royal playbill, 1849.

37 *Citizen, ibid.*

38 Edward Pinnington, *op. cit.*, 26 May 1922.

39 *ibid.*

40 Letter, 26 April 1849, George Coward's notebook, *op. cit.*

41 *ibid.*

42 *ibid.*

43 Edward Pinnington, *op. cit.*, 26 May 1922.

44 *ibid.*

45 *ibid.*

46 *ibid.*

47 *Glasgow Herald*, 20 October 1849.

48 Bella Bough to Edward Pinnington, undated, Edward Pinnington's notes, *op. cit.*

49 *ibid.*

50 Prince's Theatre Royal playbill, 28 December 1849.

51 Catalogue of Illustrations of Scotch Art, 1896, Edward Pinnington's notes, *op. cit.*

52 Prince's Theatre Royal playbill, 10 July 1850.

53 Sidney Gilpin, *op. cit.*, p. 66.

54 *ibid.*, p. 67.

55 *ibid.*, p. 68.

56 John Urie, *Reminiscences of Eighty Years*, Paisley, 1908, p. 111.

57 Edward Pinnington's notes, *op. cit.*

58 Letter, undated, George Coward's notebook, *op. cit.*

59 *Carlisle Journal* 25 July 1922.

60 Margaret Sewell to Edward Pinnington, 29 May 1909, Edward Pinnington's notes, *op. cit.*

61 Letter, 3 October 1851, George Coward's notebook, *op. cit.*

62 *ibid.*

63 *ibid.*

64 Robert Louis Stevenson, *Academy*, 30 November 1878.

65 Sidney Gilpin, *op cit.*, p. 80.

66 Quoted in D. & F. Irwin, *Scottish Painters at Home and Abroad*, London, 1975, p. 285.

67 *Scotsman*, 2 March 1853.

68 Letter, 19 February 1853, George Coward's notebook, *op. cit.*

69 James C. Dibdin, *Annals of the Edinburgh Stage*, Edinburgh, 1888, p. 453.

70 Mary Tait to Edward Pinnington, 14 December 1896 (?), Edward Pinnington's notes, *op. cit.*

71 Sidney Gilpin, op. cit., p. 65.

72 *Scotsman* 18 March 1854.

73 Letter, George Coward's notebook, *op. cit.*

Workington Bridge, 1842, oil on canvas, 72.3 x 89.3 cm, *Tullie House Museum and Art Gallery*

Wetheral, undated, oil on canvas, 44.8 x 61.6 cm, *Tullie House Museum and Art Gallery*

Cricket Match at Edenside, Carlisle, 1844, oil on canvas, 62.9 x 89.5 cm, *Tullie House Museum and Art Gallery*

Cummersdale Mill, 1844, oil on canvas, 73.6 x 106 cm, *Tullie House Museum and Art Gallery*

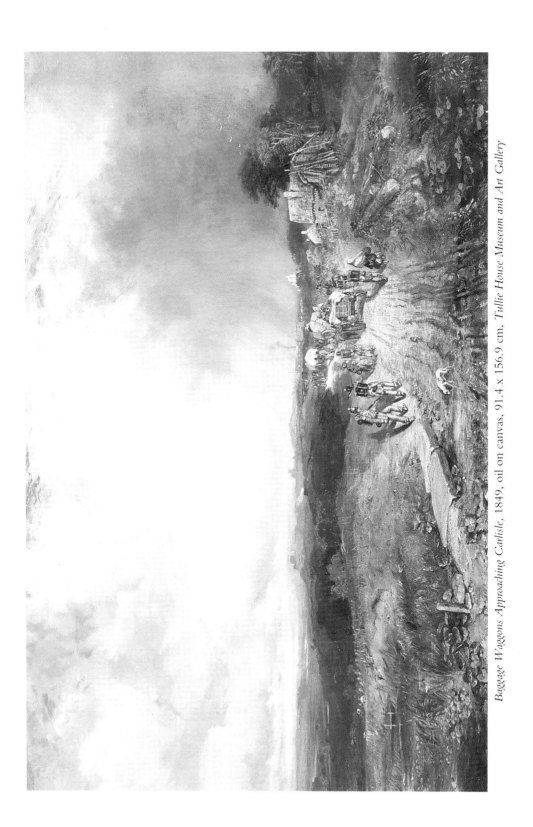

Baggage Waggons Approaching Carlisle, 1849, oil on canvas, 91.4 x 156.9 cm, *Tullie House Museum and Art Gallery*

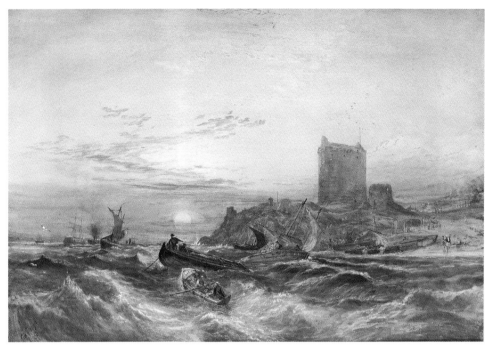

Broughty Castle, 1850, watercolour, 54.6 x 80 cm *Dundee Art Galleries and Museums (Orchar Collection)*

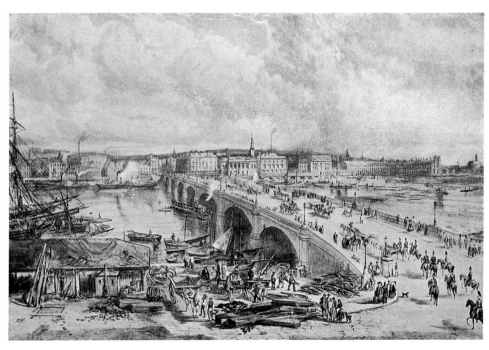

Glasgow Bridge, 1850, watercolour, 76.2 x 104 cm, *Glasgow Museums:*
Art Gallery and Museum, Kelvingrove

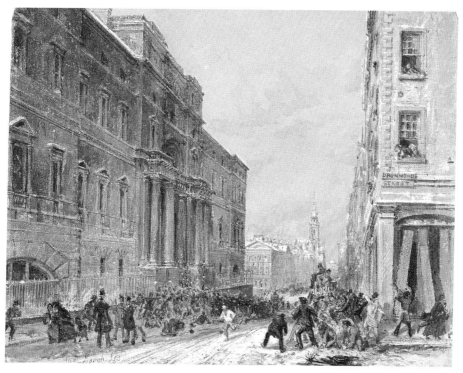

Snowballing Outside Edinburgh University, 1853, watercolour, 18.4 x 22.4 cm,
National Gallery of Scotland

Returning from the Hunt, 1855, oil on panel, 46 x 62 cm, *Sotheby's*

The Mail Coach, 1855, oil on canvas, 101.6 x 152.4 cm, *Glasgow Museums: Art Gallery and Museum, Kelvingrove*

The Solway at Port Carlisle, oil on canvas, 25.5 x 32.5 cm, *National Gallery of Scotland*

Gabbarts and Iron Shipyard, Dumbarton, 1855, oil on canvas, 134.5 x 178 cm, *National Maritime Museum*

Cadzow Burn, 1856, watercolour, 30.5 x 39.2 cm, *Tullie House Museum and Art Gallery*

Newhaven Harbour During the Herring Fishing, 1855, oil on canvas, *Tom McGowran*

3

Hurrying Through Life

A fresh start

The RSA exhibition in the spring of 1855 took place in a brand new show space, with the opening of the first phase of Playfair's design for a modern Royal Institution. It marked the start of a fresh era for Scottish art.

For many years, the development of the fine arts in the Scottish capital had been bedevilled by conflicts of interest and clashes of personality between the three major players: the Board of Trustees (aka the Honourable Board of Trustees for Fisheries, Manufacturers and Improvements in Scotland) through its Academy of Design; the Royal Institution for the Encouragement of the Fine Arts in Scotland; and the Royal Scottish Academy.

The Board of Trustees' Academy of Design could claim seniority, having been set up in 1760. It offered, at various points in its history, classes in the antique, ornamental design, pictorial colouring and life drawing. Next came the Royal Institution in 1819, comprising the great and the good – amateurs who had sufficient means to purchase their membership. Although established initially to show the works of the masters – mostly owned by the members – modern works soon had to be admitted, to make up the numbers. It proved a false dawn for the aspiring professional painter, however, and in 1826, a group of 15 artists started the Scottish Academy. From small and insecure beginnings, the Royal Scottish Academy grew rapidly and soon had to sublease rooms for exhibitions from the Royal Institution in a building it, in turn, leased from the Board of Trustees.

With the opening of the new premises, the Scottish National Gallery was born, but when the doors opened on the Spring RSA exhibition in 1855, security of tenure for the Academy was still not assured, and would not come for another three years.

This was the promising but uncertain scene that Bough thrust himself into when he got to Edinburgh. Never part of the struggle to establish a Scottish school, and not blessed with the gift of diplomacy,

he was inevitably seen as a brash newcomer by those who had battled long and hard for recognition. The move must have been between late spring and early summer, and his first address was in the Stockbridge area, comprising some rooms in 2 Upper Dean Terrace. It was both home and studio.

Soon a restless Bough was off to Argyllshire, probably with Fraser, sketching at Inverary, Loch Fyne, Oban, Loch Awe and the surrounding area. It was to be the pattern of the rest of his life. Sam could only cope with so much domestic urban bliss before he had to break out and head for the country, often leaving Bella behind.

That summer he sent pictures to the Royal Manchester Institution (*Edinburgh from St Anthony's Chapel, Arthur's Seat*) and the Liverpool Academy (*Leith Roads, looking towards Edinburgh – Wind with Tide*, 80 guineas asked; *Dysart, Coast of Fife*, 50 guineas; *Port Glasgow, Evening*, 50 guineas). The lessons learned during his time spent among the ships and shores of Clyde, Forth and Fife were now bearing fruit, but with the demise of the WSA exhibitions, he was having to try his luck further afield.

Foreign fields and a funeral

A major attraction in Europe that year was the Paris Exposition Universelle. Unlike the 1851 Crystal Palace Exhibition, it made a serious attempt to reflect the fine arts, as well as more commercial interests. It attracted a number of Scottish artists, including Daniel Macnee, who was praised as one of the best portrait painters of the British school by Theophile Gautier. Another of Bough's favourites, Clarkson Stanfield, was awarded a gold medal of the first class for three of his exhibits. Bough visited, and also went to Belgium that summer.

While he was abroad, older brother Joseph died at Allen Wood, Wetheral, near Carlisle on 6 July, leaving Mary his widow to care for three young children: John was almost five, Lucy just three and Ann a one-year-old baby. Joseph was only 36 years old and probably succumbed to tuberculosis. Over the coming years, Sam would make financial provision for them all – a typical, unheralded caring trait in him, despite the rough air of irascibility he may have presented to the wider world. As he could not get back in time for the funeral on 10 July, Bella went in his place.

By August he was back in the Lakes, this time with Fraser and another friend, George Hume, editor of the *Scottish Free Press*. A train

to Windermere, a boat to Newby Bridge and a leisurely ramble to Ulverston brought the first part of the trip to a close. Sam's antics that evening with the girls in the kitchen of their hotel almost got them turned out. Next day, at the ruins of Furness Abbey, Bough and Fraser got down to some serious sketching but, at the hotel in the evening, Sam reverted to his rough and rowdy manner. Unable to tolerate the embarrassment, Hume headed back to Edinburgh, leaving the two artists to complete their planned journey. Two small watercolours of *Peel Castle, Morecambe Bay* are probably from this trip, one showing a morning view, the other an afternoon scene.

The friends then headed north again, across the river Duddon; along Wast Water (bathing naked in the lake while a rainstorm raged around them); over Stye Head Pass and down into Borrowdale. They stopped off in Carlisle to see the Sewells and Marco Dessurne, an artist friend from Glasgow who was trying to make a living in Cumberland. With his wife and baby, he had settled in Cecil Street but was so hard up that they could offer Bough and Fraser nothing by way of food. Typically, Bough stayed on in Carlisle to try to get Dessurne some work through his own friends there. As a start, Sam got him to draw a portrait of himself for Thomas Sewell. (Within a few years, Dessurne had resettled in Glasgow, having failed to make his mark south of the Border.)

When Sam got back to Edinburgh, there was news from his sister in Glasgow that James was unwell again. He wrote back hurriedly on 28 August: 'I have your letter of last night, and I am real sorry to hear that you have a cold and sore throat. And about Jim, I hope there is nothing serious the matter with him.'[1] His younger brother was still mixing scenepainting with bit parts on the stage in Glasgow, and was owed some money by one of the theatres. Towards the end of his letter, Bough gives an indication of the possible motivation behind his sudden trip to the Lakes: three of Bella's relatives had been staying with them for nine weeks. They left for home the day after he got back.

Bella adds a friendly postscript, suggesting that she was still settling into their new home in Edinburgh.

I dare say you think me very neglectful, but I have been wanting to see if there was any chance of me or Sam getting over to Glasgow, as I should like to have a chat with you. I have been very busy getting my house in order – I wish you would come over and see me, it seems such a while since I saw you. ... When you see Jim give my love to him. I have not called to see Eliza's mother yet, and

I don't think I shall. [Eliza was James Bough's wife.] . . . let me know when you can get over for a few days, and I shall be delighted.[2]

The rest of her note is full of domestic details, but is of interest because it is a rare surviving example of a direct communication between Bella and Sam's sister.

Back to school

By now the impact of Robert Scott Lauder was being clearly felt, as a growing number of promising young artists were attracted to Edinburgh. What marked him out as different from other, more traditional, teachers was his insistence that the drawn object must be shown within its context; that correctness of line was not the only important feature of art.

Eventually Sam decided there might be things even he could learn from the man, and made a start at his classes in the winter of 1855, on the recommendation of William Borthwick Johnstone, RSA. William McTaggart recollected Bough's brief attendance at the antique class. 'I remember him as he sat with his drawing, a great bearded man. The rest of us were mostly boys. He would be over thirty. He was not at the class longer probably than three to six weeks.'[3] In fact, although scheduled to start on 1 November, Sam failed to show up until 6 November. Attendance after that was sporadic, and when he left the class on the evening of 3 January 1856, he never went back. Despite the poor role model he presented the rest of the students, Lauder recognised his talents: 'There is a man who, one would think, hardly knows his right hand from his left, but he's a perfect genius.'[4] The two men remained firm friends, out of mutual respect for each other's talents.

Almost a stranger amongst us

By the spring exhibition of the RSA in 1856, Bough was starting to gain wider recognition for that genius. He had seven works on show, and the *Scotsman* commented favourably:

From amidst the group of younger landscape painters, we may be excused for singling out Samuel Bough, the more particularly as he is almost a stranger amongst us. In his picture 'The English Village – Winter Afternoon' . . . we recognise at once the hand of a master.

92

Who that has travelled the Great North Road in the Royal Mail of Auld Lang Syne has not passed through his identical village, with its droves of oxen, its ducks, bulldog and all? The very sight makes us young again. We certainly have not seen a work for a long time which has given us more pleasure ... Mr Bough, in the present picture, has combined the effect of sunlight with snow, and, by the judicious combination of warm colour and stirring incident has infused so much of animal enjoyment into the scene, that it exhilarates one to look at it. ... We have heard it said that Mr Bough is too clever, but could not find it in our hearts to wish him less so, and hope, that many future Exhibitions will witness his further progress and success.[5]

The *Courant* was rather less gushing about his efforts:

We could wish to see him pay more attention to the aerial, evanescent, and ever changing character and forms of clouds, as it prevents him from presenting us with such stiff formalities, as those which disfigure the sky, of that otherwise meritorious performance ... 'Newhaven Harbour during the Herring Fishing'. Although we admire the grouping of the figures and the skilful management of the boats and shipping in this picture, we cannot compliment the artist upon his local accuracy, and we were somewhat surprised on referring to the catalogue to find it marked as Newhaven, the pier in particular, seems to us a great deal too long.[6]

Bough's love of artistic licence clearly left this critic unmoved – as did the prices he was getting for his pictures. Sam wanted £30 for this one.

Mr Bough's merits have been fully recognised and richly rewarded by the Edinburgh Associations (Art Unions) who have already bought three of his pictures, at what we cannot but think very high prices.[7]

The other five works were: *Herring Boats going to Sea*; *Edinburgh from Bonnington* (£32 asked); *West Wemyss Harbour – A Gusty Day* (£50); *Bridge End, Kilmacolm* (£30); and *A Mill on the River Lowther, Westmorland* (£50).

By then Sam and Bella had moved the short distance to 5 Malta Terrace in Stockbridge. They lived there for the next decade, as Sam's

popularity continued to rise.

For the first time he even had a painting at a Royal Academy (RA) show in London. *Tarbert Harbour, Loch Fyne – Sunset* was a product of his 1855 tour with Fraser. To the Liverpool Academy, he sent *Highland Cattle Crossing the Elchaig, Argyllshire* - also a product of that ramble.

Bough had not totally forsaken his beloved Cadzow, however, as a fine watercolour of *Cadzow Burn* demonstrates, with its lumber wagon caught in mid-stream, reminiscent of Constable's *Hay Wain*.

Italy, the Holy Land and 'Spanish' Phillip

He made one of his occasional forays into European landscape in 1856, with a small watercolour of an Italian scene, probably a book illustration for Blackies. (This may be the picture that turned up at the 1880 Bough and Chalmers retrospective exhibition in Glasgow, entitled *Modena during the Austro–Italian Campaign*.) There is no evidence that Bough ever actually went to Italy – although many of his contemporaries did – but that would not deter a man with such an inventive and retentive mind. He never went to the Holy Land either, but that proved no obstacle to him producing illustrations for some of Blackie's biblical publications, such as the *Imperial Bible Dictionary* and *Garner's Christian Cyclopedia*. Two undated watercolours, *The Tower of Said* and *Tiberias on the Sea of Galilee*, represent this aspect of his work.

That summer Sam spent a considerable time in the south of England, working hard with Fraser in Guildford, Surrey, and then moving on with Bella to nearby Brook Lodge, Holmwood Common, Dorking – home of his old patron John Lance. There he had a fine old time instructing Miss Louisa and Miss Eliza, Lance's daughters, in the finer points of sketching and socializing. A peaceful, rural view in oils of *Holmwood, Dorking*, was one product of this sojourn.

Next they went to London. As Sam wrote in August to his sister in Glasgow, 'and then I had a week in London, at Bella's blessed relatives; and if ever I go to stay with them again, damme, that's all.'[8]

But the time spent in London was not totally wasted. He had visited an old acquaintance, John Phillip 'the famous Spanish painter'. Phillip was a native of Aberdeen, whose genre paintings took on a new light and colour when he travelled to Spain in 1851 for his health. At this point, his best work was yet to come, but his reputation was already established. Bough met him first with James Cassie in a back-of-beyond Scottish hotel in the Aberdeen area some years earlier. Again cast as an outlandish figure, pretending this time to be a 'Yankee on

tramp' or 'travelling in the steel pen trade' (depending on whose recollection you believe), Sam finally acknowledged who he was and, after a convivial night, the men remained friends. The event may have occurred elsewhere in the Northern Highlands, or Oban or Inverary – a not unusual uncertainty over many of the stories surrounding Bough's life.

As Sam wrote of his London encounter with Phillip to John Lance:

He asked to see my sketches and the result was that he exchanged a picture of his with me for my sketch of the windmill and I swapp'd the sketch of yr farm for a lot of fine proof engravings by Barlow. This was doing a bit of business as I would have given Phillip the sketch for a ten pun note and his picture that I have got which by the way is a portrait of your most obt. as large as life – is worth a vast deal more.[9]

Sam Bough by John Phillip, 1856. Scottish National Portrait Gallery.

Phillip had introduced him to his social circle – Bough found them 'very nice fellows who were all very kind and complimentary'[10].

Phillip's portrait of Bough is a striking one, with the Iberian influence very marked. As Sam told Anne, 'It's very like me, and an awful bla'guard I look'.

From London he moved on to Manchester, to get his pictures ready for hanging at the Royal Manchester Institution, showing *Stoke Lane, Guildford*, and *Newhaven Harbour during the Herring Fishing* (a prize picture of the Edinburgh Art Union). They were hung well and produced 'what is better a lot of commissions for things to go on with during the winter.'[11] While it rained in Manchester he produced a large tempera picture that sold for £20. He also looked up some old contacts, as a letter to his sister shows:

> I found all our old friends well excepting Mrs. Westmacott, who I hear has lost her wits. I didn't see her. Mrs Hucklebridge looks charming, and was as she always is. Poor old Charley [Lewis] is very lame, and can just limp about, but he is very jolly. The Duvals are all right. Miss Mina as industrious as ever, and still slightly afflicted. The rest of them seem only a little bigger and a little stupider, or more properly, more abstruse. Mrs Hucklebridge wants you to come up, so if you like I'll stand the tin for an excursion for you.[12]

Next he headed for Derbyshire, 'but the weather was very bad and very little could be done for I only got one sketch during the week ... I pass'd up a very beautiful valley call'd Edell near Buxton and the folks thought that I and my crony were Railway Surveyors and as they seemed to have a notion that a Railway up to the head of the valley would be a good thing for them they were mighty civil. Of course we were carrying out the Grand Diddlesex Junction Scheme and rare fun we had.'[13] Clearly a situation made for Bough's love of gulling those who could be gulled.

The 'crony' was probably William Donaldson Clark (better known as a pioneer Scottish photographer) who ran a printing works at Hayfield. Sam probably knew him from his Manchester days, and they were certainly close friends when Clark had managed a Turkey Red fabric printing works in Dumbarton. His letter to Anne dated 19 August was written from the print works office, and at that point he planned to be home by the end of the week. In the event, Bella headed home and Sam continued his rambles for a few weeks more, going back to Manchester 'and just treated myself to a look at the Belle View Gardens ... where there is all sorts of fun from pitch and toss up to

96

Manslaughter with a sham Sebastopol & fireworks in the background.'[14] He finally got home on 3 September.

Rapid recognition and a row

On 12 November came the best news of the year for Sam: he was elected an Associate of the RSA. That same day he wrote off to Anne, then living at 245 High Street, Glasgow, to tell her the good news. It was remarkably rapid recognition for a man who, only nine months earlier, was 'almost a stranger amongst us'.

Despite his Bohemian ways and unpredictable manner, it seemed that the Edinburgh art establishment had taken him to its heart. Not for long. Within a matter of months he had alienated half the RSA, and all because of a wager with his friend Horatio McCulloch.

McCulloch, of course, was the man Sam had beaten against the odds for a £10 prize at the 1851 Glasgow exhibition. Seventeen years Sam's senior, he was also the most successful landscape painter of his generation, and only the previous year had been awarded £350 by the Art Union of Glasgow for a picture taking third prize. Large in stature physically as well as artistically, McCulloch was also considered 'simple minded as a child', i.e. not a man given to deviousness.

The trouble started over supper one evening at Malta Terrace. Sam and Bella were entertaining a group of friends when the conversation turned to artists and whether or not they should specialize in one particular form of painting: portraits, landscape, historical, marine or genre. No doubt drink had lubricated the conversation when McCulloch turned to his host and said, 'You are clever, Bough, and can paint, but you couldn't paint a history picture.' Sam, of course, could not refuse such a challenge, so the wager was taken. The prize for the winner would be a supper for 12, to be purchased by the loser.

When the RSA opened its doors for the Spring Exhibition in February 1857, exhibit number 470 was Bough's response to the challenge. Hung on the line was *The Philosopher of San Souci*, purporting to be Frederick the Great attacking some of his ministers for the way they had mismanaged a law suit. It showed the king 'with uplifted cane, over one of the judges prostrate on the floor. Two others seek refuge behind a screen, while a fourth is approaching in supplicant attitude as if to bespeak the Royal clemency. A fifth has disappeared, all but a leg and foot, on the left of the picture, and a little Italian greyhound is manifestly shivering under the table'[15].

The picture turned out to be something of a *cause célèbre*. As the

The Philosopher of Sans Souci, 1857 – the source of Bough's long dispute with McCulloch. Sotheby's.

Scotsman said, if he had only added 'as performed at the Olympic Theatre' after the title, 'the joke would have been plain enough, and we could have enjoyed the fun amazingly, but as a serious attempt we cannot view it with equal favour.'[16] It then proceeds to attack the historical accuracy of the scene, but acknowledges Hogarthian qualities.

The *Courant* thought even less of it: 'It is totally unworthy of Mr Bough's reputation, and must surely have been intended either as a caricature, or to mystify and puzzle the public.'[17] Sam was asking £50 for it, and the picture sold, with another being commissioned.

McCulloch seems to have agreed with the newspaper reviews for, when Bough tried to claim his prize, the Scot told him, 'I'm not going to sit down with your friends'. Looking at the picture now, the fact is that, morally if not technically, McCulloch was right. It was the beginning of an animosity between them that would last a decade and only be resolved by a dramatic deathbed reconciliation.

Bough had seven other pictures on show at the exhibition. Some, like *Furness Abbey, Lancashire*; *Lane Scene, near Guildford*; *The Holmewood Common, Surrey*; and *The Port of London* reflect his rambles

98

of the previous two summers. The others had a more local flavour: *The Hay-Waggon*; *Moonlight on the Avon*; and *Verderer and Fallow Deer*

Of all of these, *The Port of London* seems to have drawn the most favourable reaction, showing 'remarkable skill in composition, and power and facility of drawing, the sky is admirably painted, the only weak point is the colouring which is too light and chalky.'[18]

James Bough also showed at the RSA exhibition that year, for his one and only time. The subject, *Little Red Riding Hood*, was sent from the Theatre Royal, Edinburgh, where he was still trying to make a living, despite the problems of the previous year.

In May, Bough wrote to John Lance with a complimentary ticket for a private view of some Scottish Art Union pictures. At that point he thought he might be down in Dorking during the summer, but not before a planned trip to the Orkneys with Bella and some friends in mid-July.

Manchester and Norway

The Manchester Art Treasures Exhibition was the major event of that year. It had a considerable impact on the development of a number of artists. What London had done in 1851, Dublin in 1853 and Paris in 1855, Manchester planned to do better in 1857. A suitable site was found eventually at Old Trafford – one of the few areas where flowers could still grow in such a polluted environment – and the nation was scoured for suitable works of art. When Prince Albert opened the show on 5 May there were 16,000 exhibits to be seen.

Bough visited with Alexander Fraser and possibly Thomas Sewell. Sam was much taken with a painting by William James Muller, who had died at a tragically early age in 1845. He was also impressed by the array of contemporary talent from France and Holland among the exhibits, ancient and modern, from Britain and the Continent. While there he stayed with his friend Duval, who was now earning a comfortable living with his portraits, and looked up some of his friends from his earlier days in Manchester.

At the Royal Manchester Institution Show, he had just one picture – *An English Village – Winter*, for which the asking price was a dramatic £200. He also sent four works to Liverpool.

Another excursion into Europe was made that year – this time to Norway. With a group of friends, Sam took a small steamboat, the *Nicola* across the North Sea, disembarked to do some sketching and then picked up the boat further along the coast. Among his fellow

Travelling in Norway, Bough's etching of his 1857 trip. Private Collection.

travellers were Donald MacGregor, MP for Leith, and Thomas Swan, one of the famous dynasty of livestock auctioneers of Edinburgh.

Of the few paintings known to have been produced from the trip, *Travelling in Norway* is the most interesting. Bough produced an etching of it for himself and a few friends. The print is fascinating for a number of reasons. First it shows Bough's mastery of scenic effects – mountains, clouds, torrents rushing down hillsides, and the overall sense of a thoroughly wet and miserable day. The latter starts to edge towards caricature in the figures racing down the mountain road in their horse-drawn carts. There's no mistaking Bough in the lead cart, hunched up against the wind and rain. This gives a clue to his motive for the prints – they were probably originally intended as keepsakes for the intrepid group who made the journey with him.

New friends, old foes

This would also be the year that Sam became acquainted with the Gamgees and George Clark Stanton, probably through their mutual theatrical connections, the Wyndhams.

John Gamgee had arrived in Edinburgh the previous year to lecture at William Dick's Veterinary College, but soon became disenchanted with his mentor's outdated attitudes towards animal welfare. So he set up on his own – the New Veterinary School – with the help of his father Joseph. Soon most of the Gamgee family, who had spent many years in Italy, were settled in the Scottish capital.

They were followed from Italy by a lovesick young Englishman, George Clark Stanton, who had fallen for Clara, the beautiful young daughter of Joseph and Mary Ann Gamgee. Stanton hailed from Birmingham; he had studied art and been apprenticed to the silversmiths Elkington and Mason. He showed promise, so they sent him to Florence to learn more. It was the making of his life and the unmaking of a silversmith.

Stanton was a talented artist, 'a brave, industrious and clever man, but had no push or ambition'[19]. Sam took to the hopeless romantic and suggested that, if he wanted to succeed as an artist in Edinburgh, he might find a small shop in the High Street, near Parliament House, and set up as a barber. After a few weeks, he should then put one of his busts in the window to be seen by a passing judge, who would say, 'By God, that's not bad for a little barber' and immediately become his patron, thereby guaranteeing his future. But Stanton was never to make his fortune from fine art, although he was a talented draughtsman. Instead he established himself as a respected sculptor, illustrator for the likes of Nelson's the publishers, and produced fine anatomical drawings to accompany the scientific writings of the Gamgees, as well as teaching at the Life School.

Another life-long friendship embarked on around this time was with David Macbeath, a wine merchant by trade who also owned a fishery on the Tweed as well as property and land. The two had become acquainted by chance at Newcastle races. On that occasion, Sam and his friends Balmer, a miniaturist, Henry Shields, an actor, and Dr Raines had missed the horse racing because they had become so engrossed in a side-show. An enduring product of this meeting is an affectionate portrait of Macbeath's three children (Anne, Ellen and Eliza) and which, judging by their ages, must have been produced around 1857/8. It is set against a rocky coastline on a fine bright day and, in the judgement of Lindsay Errington 'is as fresh in its handling

of light and shadow as anything being produced in France at the same period.[20]

One other event that would have given Sam particular pleasure in that year was the election of Alexander Fraser as an Associate of the RSA. On the domestic front, all was not well. Tensions between Bella and his sister were apparent, and on 15 December Sam was again trying to keep the peace between them as he wrote to his sister in Glasgow:

> Whenever you think of coming to see me, come without writing, just come off as it suits you. You know, or ought to know, that yourself and whoever you may bring with you, are and will be, as long as I have a house, heartily welcome to the best of it...[21]

At the 1858 RSA exhibition, Bough's animosity towards McCulloch took a fresh twist, perhaps out of some sense of jealousy that his own talent was still not being fully recognised. As the *Scotsman* commented: 'Our landscape painters, particularly the younger artists, display marked improvement, but as usual Horatio McCulloch decidedly takes the lead.'[22]

The older man had produced a painting of *A Moonlighted Highland Glen*. Bough offered *Glen Messan – Moonlight*. So similar were the two works they split the Academicians and the art public down the centre. On this occasion the *Scotsman* came down firmly in favour of the Scot, having first damned the Cumbrian with measured praise:

> All the works exhibited by [Bough] are very clever and artistic. It matters not what subject he takes in hand, landscapes, marine views and Border forays are all characterised by extreme cleverness of execution. None of them ever rises to the height of a great picture, and possibly for his great facility and want of individuality of character they fail to make much impression on the mind presenting as they do subjects that have been painted from immemorial by artists quite as able as Mr Bough and the materials for which are to be found in abundance without much travel. In this respect Bough contrasts strongly with McCulloch, who may be said to be the first great painter of Highland scenery, and whose works all bear the impress of an original and master mind.[23]

The allegation of parochialism levelled at Bough is surprising when he is contrasted with McCulloch. At this exhibition for example, apart from Scottish scenes Sam showed paintings from Cumbria, Kent, London and Norway. McCulloch, on the other hand, was renowned

for his resistance to venturing outside Scotland.

The report goes on to comment that Bough's *Glen Messan – Moonlight*, while possessing 'his usual dashing execution, though coarser than usual, is false in colour and worse in sentiment. The details also are poor – the stones in the foreground having the appearance of paving stones, and the whole scene looking like a "get-up" for the nonce.'[24] He was asking £40 for it.

Bough was accused of plagiarism, and even a friend maintained Sam knew what McCulloch was painting before he produced his own scene, although neither man had actually seen the other's work.

Another newspaper suggested that the two camps, 'like the Orangemen and Ribbonites of Ireland, hold in great contempt such people as ourselves, who are partisans of neither.'[25] This report, however, concludes with views of the Bough camp: 'McCulloch will have his reward at present, but his pictures will be forgotten; while Mr Bough will rise above every attempt to keep him down and have his pictures appreciated by an unprejudiced posterity.'[26]

Sam seems to have descended to a small-minded level in his conflict with McCulloch, even going so far as to get his bulldog to snarl at the other's small Skye terrier, and insisting on taking his dog into the Academy on 'touching-up' days, in defiance of the rules, just because McCulloch took his. This was petty behaviour and did nothing to win him friends in the Edinburgh art establishment.

Another of his paintings, *A Border Raid* also drew criticism because of its similarity with Gourlay Steell's *How the Macgregors Lived and Died*. Furthermore, in giving Bough's picture a poor position, the hanging committee was accused of trying to annoy both the artist and Lord Murray, who had commissioned the work.

Some works fared better. *Travelling in Norway* was on show and subsequently ended up in the possession of Thomas Swan, while four others had been lent by their owners.

Ruskin is riled

The Weald of Kent drew favourable comment and had been purchased by the Royal Association for the Promotion of the Fine Arts in Scotland (RAPFAS). One newspaper report used it to enlarge on Ruskin's statement of the natural law that the eye cannot focus simultaneously with equal detail on foreground, middleground and background.

As in some degree illustrative of this, let us refer to Mr Bough's clever picture of 'The Weald of Kent'. There the sand-quarry and windmill are the salient points to which the artist's eye was directed and he has rendered these with much power and effective colour, but knowing that his doing so was incompatible with any strength in the foreground, or much expression of definite form, he has kept it low in colour, and of an unobtrusive hue, thus giving due prominence to the object that fell within the focus of his eye. Turner, in such a case, would merely have indicated the foreground with a few broad suggestive generalisations, and indeed Mr Bough though right in the main, has given us more finish in the foreground, than is consistent with nature.[27]

Usually Bough was criticized for too little finish!

The reviewer then commented that 'the natural principle is diametrically opposed to Mr Waller's practice.' He was referring to Waller Paton's *Month of the Wild Water, Inverglas, Loch Lomond*.

With great pretensions to truth in its elaborate detail, we cannot but look on the personal picture as unsound in principle and untrue to nature. ... It follows that if the foreground is finished clearly and simply, showing that the eye of the artist was directed to that point, the middle distance and the distance must have appeared to him at the same moment confused and indistinct.[28]

As Waller Paton and his more successful brother, Noel, were devotees of the Pre-Raphaelites, Bough had, unwittingly, become associated with an attack on the whole movement.

The *Scotsman*'s critique brought a rapid response from Ruskin, in defence of his friends.

Such a lovely picture as that of Waller Hugh Paton's must either speak for itself, or nobody can speak for it. ... If, in that mighty wise town of Edinburgh, everybody still likes flourishing of brush better than ferns, and dots of paint better than birch leaves, surely there is nothing for it but to leave them in quietude of devotion to dot and faith in flourishes...[29]

That year at the RSA exhibition, the art lovers of Edinburgh had been given plenty of opportunity to form their own opinions. On show were a number of Pre-Raphaelite works, including Millais' *Autumn Leaves* and *The Blind Girl*, and Dyce's *Titian's First Essay in Colour*.

104

Although the Pre-Raphaelites had first made their mark over a decade earlier and were now pursuing very personal styles, they were still capable of attracting devoted followers, and by the mid-1850s a number of younger Scottish artists, including some of Bough's friends, had become interested in their approach.

William McTaggart, 13 years Sam's junior and still developing an individual style, was one of those influenced. That year, he spent three months making a detailed study of a burn on Kintyre – an act that would have been total anathema to Bough. Nor did the Pre-Raphaelite colour sense appeal to him. At that time his maxim was 'throw away all bright colours and use greys' – very much the message of Robert Scott Lauder. Where he would have stood fast alongside them was in their emphasis on learning from nature, outdoors, not in the studio. But this was hardly unique to the Pre-Raphaelites: Bough and many like him had been practising this for years. Where the young London-based artists had seen it as a rebellion against the Art Establishment, for Sam and his like it had been a spontaneous response to their surroundings and the lack of access to any formal art education.

Bough may have made another of his foreign forays in the early part of that year, for among the five works he showed at Manchester, there was a scene off Texel, in north-west Holland: *Dutch Herring Buss running out of Port – Stiff Breeze* for which £40 was sought. Four also went to Liverpool – all Scottish scenes, of which *St Andrews* at £35 was the most highly priced.

One action of the RSA that won his full approval was the banquet held on 3 September in honour of two of the artists he most respected: David Roberts and Clarkson Stanfield. Roberts was given the freedom of his native city and a silver medal from the Academy, while Stanfield was presented with a Diploma and bronze medal. Sam would also have been pleased to see another friend, Robert Herdman, honoured with election as an Associate of the RSA.

Breaking away – Forth, Fife and East Lothian

Whenever he became tired of the niceties of life in the Scottish capital, Bough would head off along the Forth estuary with his paints and sketchbooks. The growth of the railway system on both north and south banks made for rapid and pleasurable excursions. Around this time, many of his works draw on the natural beauty and small harbours of East Lothian and Fife for their inspiration. The islands of Inchkeith and Bass Rock all feature strongly. In East Lothian and

down the coast to Berwick, Canty Bay, North Berwick, Tantallon Castle, Whitekirk, Cockburnspath, Fast Castle and St Abbs Head were some of his favourite haunts. Across the Forth, in Fife, he was equally at home at Aberdour, Kirkcaldy, Ravenscraig, Dysart, West Wemyss, St Monance, Pittenweem, Anstruther, Cellardyke, Crail, St Andrews and up as far as Broughty Ferry, Dundee. From the 1850s onwards, these were his most inspirational places for portraying the collision of the elements and man's need to brave them, if only to survive.

So keen was he for realism in his work that he arranged for an Edinburgh fishmonger to keep him informed whenever bad weather was imminent at Canty Bay. Once the news reached him, he would dash for the railway station and get off six stops later at Drem station, where the branch line would take him to North Berwick. On arriving he would walk the last few miles down to Canty Bay, hoping not to have missed the best of the worst of the weather.

Sometimes the game proved not worth the candle. Once, getting to Canty Bay only to find the weather was far from stormy, he cursed the 'false prophets' but then settled down in the local inn to enjoy a beer and smoke his pipe. At other times he would book his lunch at the inn, set off sketching and then forget to return – so that weeks later he had to settle his bill.

Bough became a familiar figure around Canty Bay. In those days it comprised a few fishermen's cottages and an inn. Sam befriended the small community, and they took to him. At that time, George Adams was landlord of the inn and owner of the largest boat. John Kelly and Andrew McLean used his boat during the season. At other times, Kelly rowed Sam across to Bass Rock, where he could both sketch and indulge his fondness for gannet eggs.

Whatever release he found in such journeys, Bough could not escape the harsher realities of life for long.

'I thought my heart would break...'

On 5 January 1859, he wrote to his sister in Glasgow with some sad news. Bella and Sam had been spending Christmas down in Manchester when he had been summoned to Preston, where his brother James had 'gone quite out of his mind'. The story has it that James had been attacked and robbed while in Manchester, and that the trauma from this caused his breakdown. While this is possible, there are indicators across the years that he may also have been suffering from some form of recurring mental illness, perhaps of a manic-depressive nature.

Bough's letter to Anne gives a vivid sense of the distress involved:

Poor fellow! he spoke in his wanderings often of you, and was very anxious about all his friends; very kindly and gentle and childish, but nevertheless dangerous. I was – woe is me! – compell'd to have him put into confinement, and, as I could do no good by remaining, went back to Manchester.

On Sunday, his poor little wife came, and as Jim had been violent they had put him into a straight jacket. This, I suppose, nearly broke her heart, for on Monday night she took him out, and had him back to his lodgings. I arrived in Preston with Bella, and was awfully shocked to find that she had done this ill-considered thing. Of course, she soon saw, when she had him out, the impossibility of his remaining at large, and we had to take him back yesterday.

God knows how it will terminate. I fear that there is little room to hope for a chance of his recovery. God Almighty help him and all of us! I thought my heart would break when I left him. Poor, poor fellow! his fits and delusions are most sad. I can't bear to think of him, and yet out of my mind I cannot get him.[30]

At that time James and Eliza were living at 21 Wilfred Street, Preston. The records of Lancaster Asylum show that he was first formally admitted on 13 January, 1859, suffering from a 'monomaniacal' disorder which lasted for two weeks. Its supposed cause was 'unknown', but Sam's fear was proved true, for James never fully recovered. Presumably he was not there long enough on the first occasion to be considered officially admitted.

The RSA exhibition contained 10 of Sam's works in 1859, mostly local in their subject matter. Four referred back to his earlier days in Cadzow and Barncluith, two were scenes of Edinburgh, and two were the result of his trip to Holland. The others were of a hayfield and a coastal sunrise.

Of the Dutch scenes, *Texel Roads – Stiff Breeze*, lent by RAPFAS, was probably the same painting he had sent to Manchester the previous year. The other Dutch scene – *Sun Rising over Fog Banks, Dutch Shipping, etc.* – was on sale at £50. But he was asking considerably more – £120 each – for two other pictures: *A Hayfield* and *Edinburgh from Leith Roads*.

For the former, Anne was said to have stood as the model for a figure of a woman holding a rake and of a mother sitting with a child on her knee. The *Scotsman* thought it 'the best picture we have yet seen from his hand, it displays his usual broad and dashing execution, and

the details ... when viewed at a proper distance, have all the truth and force of reality.'[31]

The *Courant*, however, did not share this view: 'It is a charming, fresh, bright, transcript of nature – the handling of some of the trees in the middle distance is, however, careless and heavy, and the sky – the feeblest part of the work – does not sufficiently recede'.[32]

Edinburgh from Leith Roads was also commended by the *Scotsman* as 'a masterly production'[33] while the *Courant* again saw it rather differently: 'We do not so much like [it] – the sea is somewhat leaden and the sky hard. That fishing boat, too, laden with the picnic party, is leaning over in a most unaccountable and perilous way, although her sail is not hoisted, and the passengers are all huddled together on the weather side.'[34]

Despite this carping, the *Courtant* did recognize Bough's stature:

Few of our landscape painters display more variety – and less mannerisms than Mr Bough – his versatility, dash and power of handling are remarkable, but there is occasionally evidence that these qualities may degenerate into carelessness, and that his firm solid impasto may be exaggerated into heaviness. But in all he does, there is proof of power, of attentive study of nature, of a fine eye for colour, and a rare feeling for aerial perspective not often combined in the works of a single artist.[35]

A change of studio, a hint of war

By this time, he may have already set up his studio at 24 George Street, although his paintings were still being entered from his home address.

That March Edinburgh celebrated the opening of the new National Gallery, and during the year, Hugh Cameron, McTaggart, and John Crawford Wintour all became ARSAs. His contemporaries were catching him up. Some were already outstripping him: Erskine Nicol, elected ARSA just one year ahead of Bough, became RSA that year.

Another interesting, if not high quality, work from this year saw Sam as social commentator across in Glasgow, with his gouache of *Widening the Clyde*. The scene is a strangely rural Govan, but the activity of the workmen shows the constant need to widen and deepen the river as the demand for larger ships and bigger cargoes grew throughout the century.

In Manchester, he showed seven works, and at Liverpool one. At the

former his highest asking price was £60, while at the latter he was looking for £50.

July brought a happy event to celebrate, with the marriage of Fanny Gamgee, youngest daughter of Joseph and Mary Anne Gamgee, to Sam's friend D'Arcy Wentworth Thompson, a fellow Cumbrian. Thompson's family hailed from Maryport, but he was born in 1829 on his father's ship as it approached Van Diemen's Land with a cargo of convicts. Given such a singular start in life, a similar future might have been anticipated. After studying at Pembroke College, Cambridge, he became a master at the Edinburgh Academy, teaching Classics. At the time he was living at St Bernard's Crescent, close to the Boughs in Malta Terrace. Sam, appreciating his genuine learning and conversational skills, introduced him to the convivial company of the Gamgee household, where Fanny, 10 years his junior, fell for him. Meanwhile George Clark Stanton, temporarily despairing perhaps of ever saving enough to marry his Clara, had headed back to Italy to be with Garibaldi's forces in their invasion of Sicily.

There was even a hint of war in the Edinburgh air. On 4 August an open meeting held in the Academy Council Room sent a buzz of excitement through the younger members of the artistic fraternity. They had gathered to consider founding a Rifle Volunteer Force, in response to the perceived expansionist threat posed by Napoleon III in France. Sam was there, along with Alexander Fraser, Robert Herdman, John Faed, James Drummond, Hugh Cameron, William Quiller Orchardson, William (Fettes) Douglas and 11 lesser mortals.

John Pettie, all of 20 years old, gives a clear sense of the eager anticipation felt by some of the company, in a letter to McTaggart dated 28 August:

As to the Artillery Corps, it is fairly set going ... [I] went in one day to meet them all at the Military Academy, Lothian Road, where they are getting just now private drill. Mr Douglas, the great mover, told us that the Lord Provost was ready to embody us when we numbered fifty into an Artillery Corps. ... The night I was there it was capital. There were all the artists mostly that were in town, and would be likely to join – Sam Bough, Drummond, Douglas, a good many of the young fellows, and one or two engravers. ... Will you join? You must. Such splendid prospects we have of being stuck behind a stone dyke and peppering at an enemy. They talk of the Government fortifying Inchkeith for us.[36]

McTaggart was persuaded to join, but fortunately the 'splendid

prospects' never materialized. What did was much debate about the most appropriate uniform and a degree of drilling. Bella remembered that Sam had been a volunteer artilleryman for a while, but then gave it up because 'it made him nervous'[37].

On a happier note, the grand theatrical event of the year was in November, with the visit of the great soprano Teresa Titiens and an Italian opera company, fresh from her English success the previous year. Sam, through his theatre contacts and by force of personality, soon became a friend.

Good Words and a universal genius

The New Year saw the launch of a magazine that was to prove significant in the lives of many a Scottish (and English) artist – *Good Words*. Alexander Strahan was only 25 when he published his monthly competitor to Thackeray's *Cornhill Magazine*. In true entrepreneurial style, it was aimed at a much wider public than the *Cornhill*, and at 6d a month was within range of the lower middle class, the sort of person who aimed for self-improvement. Furthermore, Strahan had a visionary's approach to the use of illustration. From small beginnings, his magazine soon gained mass circulation. It was to play an important role in the lives of a number of Sam's friends in the coming years.

At the 1860 RSA exhibition Bough – as usual – received an appreciative but not totally uncritical press. For the serious artist needing to grow his reputation, the major exhibitions and the press reports that emerged from them were important sources of publicity, for good or bad. These, apart from word of mouth, were the main advertisements open to the likes of Bough, who was depending on selling his work for a livelihood. Consequently, Sam took both seriously. The exhibitions were a way of gaining professional, as well as popular, recognition. As regards the journalists, he never fooled himself that their views should be swallowed whole, but understood the role they could play in promoting his work.

The *Scotsman*, for example, had him as 'well known to be a universal genius', and then added 'we do not say so ironically, but in sober truth. He can paint anything and everything, and all equally well, though portraiture is perhaps the branch he least affects or excels in except as a connoisseur.'[38] It drew particular attention to *Within a Mile of Edinburgh Town* and *Entrance to Cadzow Forest*.

The *Courant* described him as 'that versatile and clever artist', but again tempered praise with less positive comments. Of his works on

show, 'many ... exhibit a high degree of merit, while others show a hardness in the treatment of the sky and a slovenliness of execution inexcusable in a painter of Mr Bough's remarkable abilities, and almost unrivalled power of handling'[39]. It then supported its argument with reference to specific pictures:

'The Way to the Forest' is cold and grey in tone, and the treatment of the light seems to us rather arbitrary, but the landscape is a fine one in spite of these defects. 'Haughhead – Haymaking' is another clever picture and 'Springtime – The Old Forest Well' is superior to both ... 'The Thames at Chiswick' is a powerful and poetical moonlight. But better than any of them, we like 'The Vale of the Avon' – quite a little gem, of which we see by the catalogue [Thomas Nesbit, the auctioneer] is the lucky possessor.[40]

Springtime – The Old Forest Well was purchased for 60 guineas by the RAPFAS. Of *Within a Mile of Edinburgh Town*, a later critic described it as 'not a Constable, not a Turner, not an impression but a simple song in paint'[41].

A lack of mission

For the most part, Bough was hitting the right note consistently with the picture-buying public, yet he still attracted criticism from the experts. 'Iconoclast' lamented Bough's lack of 'mission':

Leaving now high fulfilment and high promise behind, let us notice an artist who can neither be said to promise or fulfil but who performs prodigies of art notwithstanding. ... A poor critic is at once angry at and charmed with him. ... He creates a figure with three daubs of a brush, but with all his carelessness, recklessness and unconsciousness, one cannot help a certain feeling of amazement at the cleverness, versatility and audacity of the man. ... These rude sketches of his possess a force, a freshness, and a poetic feeling, which we may look for in vain in several of the more carefully elaborated works of his contemporaries. ... For versatility he stands alone in Scotland.[42]

But for all the admiration, some moral flaw must be found:

We fear that he does not feel sufficiently the sacredness of art. Nay,

111

judging from his pictures we are convinced that his love of art is essentially an ignoble and vulgar love – that he practices it because it satisfies his untrained and fugitive love of beauty, that it produces him hard cash and during exhibition time, tickles him with laudatory newspaper paragraphs.[43]

'Iconoclast's' views produced a response from 'Maulstick' said to be:

Tendered in all respect and from a deep sense of the injustice he [Bough] is doing his great and versatile genius by adhering to his attractive but unsatisfactory style. Powerful and striking his pictures undoubtedly are, but 'stagey' withal: they savour rather much of the footlights; and are not yet such as will delight and instruct 'the coming generations'. … Overcharged with dash and vigour, they lack that subtle element of tenderness which nature infuses into her works.[44]

Bough's reply to both critics might have been unprintable. Clearly he was in a no-win situation, yet the comments of 'Iconoclast' have a truth in them. Nothing in Bough's work speaks of an abstract or spiritual aspiration. Each age, and individual, must make a singular judgement on the relevance of this. In essence, Bough's art is one of total honesty. What you see is what he was, artistically and as a man. There is no evidence that he ever wanted to be more. He was simply trying to earn a living by doing something that pleased himself and others.

Furthermore, because he is remembered as an artist who made a name as a scenepainter, there has been a tendency for over a century to attribute his style to this experience. It might just be more accurate to suggest that his natural approach found equal expression in the theatre and on the easel.

His young friends McTaggart and Pettie were also being complained of for their lack of 'finish ' – perhaps a habit acquired from Bough.

Undeterred, that year Sam also showed five works at Manchester and three at Liverpool. He wanted £100 for his oil painting of *Newhaven Harbour* at Manchester and £50 for his *Cadzow Forest – Sunset* at Liverpool.

In May tragedy struck his friend D'Arcy Wentworth Thompson. Just days after giving birth to their son, Fanny died of scarlet fever. It shattered her husband, and Sam must have been one of the many who worried about his reaction. (Eventually in 1864 he resettled into a new life in Ireland, leaving the younger D'Arcy in the care of the Gamgees.)

Refusing Queen Victoria

The highlight of the Edinburgh social calendar that summer was on 7 August, when Queen Victoria and Prince Albert reviewed the Scottish Volunteers in Holyrood Park. On a fine afternoon, over 22,000 men from all over Scotland and the North of England paraded on the plateau, with crowds thronging the hillside of Arthur's Seat. Among them were the artists, by now constituted as No 1 Company of the City of Edinburgh Volunteers (Artists' Company). That morning, Pettie and McTaggart had conned their way into helping fire the midday salute to the Queen from the Half Moon Battery at the Castle. Bough was otherwise engaged, for he produced one of his most successful works in recording the afternoon's events. His *Royal Scottish Volunteer Review* proved an inspired piece of popular art. Engraved by W.E. Lockhart, the print sold well.

Even greater fame beckoned – only for Bough to spurn it. For Queen Victoria ordered that his original be brought to her at Holyrood Palace and, moved by what she saw, asked for a copy. London artists would have given their palette arm for such a commission. Sam refused. As he commented to a friend: 'The Queen is a very dear lady, and, as her loyal subject, I love her very much, but I couldn't paint another *Edinburgh Review*.'[45] One view was that his artistic 'genius' would not allow him to repeat a work of inspiration. A more accurate conclusion might be that he would have been bored out of his mind trying to reproduce so many thousands of people on a single canvas. Once was enough. After that it was up to the engraver.

On 8 August Sam painted a small oil portrait of Tom Sewell, up in Edinburgh to see the Review. The contrast could hardly be greater. One day he was recording an event of great civic pride, on the next a small domestic picture of a friend. The portrait probably gave Bough the greater pleasure.

As the year wore on, Sam's spirits got lower. James remained in Lancaster Asylum and was getting no better. Recognition in Edinburgh was still not what he thought it should be. And he missed his Cumbrian Fells, particularly Warnell. He confided in a fellow Cumbrian, William Henry Hoodless, that he longed for a small property around Sebergham or Caldbeck, but knew that Bella would never endure such isolation. Lack of financial security and the fear of being disabled by a stroke – as had killed his father – also haunted him.

There were hightimes with Hoodless, too – like the introductory visit he and Samuel Hallifax, the sculptor and Bough's relative, made to Edinburgh. They travelled from Carlisle station, with Hallifax

sporting a wideawake hat, flowing cape, pistol in his belt and silver-mounted walking stick in his hand. Even Sam's eyebrows must have raised a fraction at the sight of them. Hoodless was so encouraged by Bough that he studied at the Edinburgh School of Art from 1857–60.

Superficially, Sam maintained his extrovert demeanour, but a sense of financial insecurity took him back to the theatre for hard brass. That winter, he 'expressly' painted a scene outside King Arthur's Tavern at Wyndham's Queen's Theatre for its pantomime, *Jack the Giant Killer* opening on 21 December.

'If Jim had only lived. . .'

January 1861 brought more than cold weather. It brought the worst news. On 21 January, James died in Lancaster Asylum of 'general paralysis', aged 36. Sam felt the loss sharply. Even though he had found his brother difficult at times, the affection that was between them was never in doubt. As he confided to a friend, 'If Jim had only lived ... I'm certain he wad ha' made an artist.'[46]

James Walker Bough left little material evidence of his life behind him. Only two works are known to have been exhibited during his lifetime – *Bothwell Bridge* at Glasgow in 1849 and *Little Red Riding Hood* at the RSA in 1857. A small portrait of him was said to have been painted of him by Francis Cruikshank, a contemporary who attended the Trustees' Academy from 1845 to 1852. Few other works are remembered – a drawing of *A Roadside Cottage* (once owned by Mary Bough), a *River Scene* and *Near Musselburgh – Arthur's Seat in the Distance*.

Sam had clearly been driving himself hard that winter, for in February he had 10 works on show at the RSA, mostly coastal scenes – and four already had owners, including Erskine Nicol. The *Courant* particularly liked his 'two large and clever pictures' – *Pierhead at Aberdour* and *St Andrews: 'When the stormy winds do blow'*, preferring the latter. He was asking 100 guineas for the Aberdour scene.

The *Scotsman* was lavish in its praise:

The universality of Mr Samuel Bough's genius does not require much comment. No subject comes amiss to him, and works that would break the hearts of half the profession, and keep them pondering for years, are to him mere child's play. A few week suffice for their incubation and birth. As the recorder of passing events no one can approach him.[47]

114

Most years the Boughs spent some time in London with Bella's family, and on this occasion, Sam may have taken the opportunity to cross the Channel again to do some sketching at Dunkirk. At the Royal Manchester Institution show he entered *Dunkirque, looking into the Upper Harbour*, and was asking £100 for it. At the Liverpool Society of the Fine Arts he had *Dumbarton Castle on the River Clyde* (80 guineas asked) and *Dutch Trawlers beating to Windward* (£50). He was still prepared to try his hand at other types of picture, however, as his portrait of his friend, Dr Douglas Reid of Helensburgh, demonstrates.

On 11 April, Sam wrote to his sister, who was visiting Carlisle:

> If you want some money, ask Tommy Sewell to give you as much as you require, and I will remit to him ... Bella is keeping better in health. She seems quite strong. Her temper is much as usual, 'sometimes smooth, and sometimes rough'.
>
> We are all going to Perthshire to Glen Almond, as I have had the offer of a nice cottage there [owned by one of his patrons, Robert Horn, the advocate]. So if you come home soon, and would like to go there you can. I think we'll shut up house, and take the stock [the cats and dogs] with us into the country. We shan't move for a month at least.[48]

Like so many of his plans, this came to nought, yet there is – again – a sense of Sam trying to tread a difficult path between the two women.

Going home and a marriage

Sam and Bella also spent some time in Carlisle and Wetheral that year. Perhaps James's death had re-awakened Sam's longing for his home area – and maybe he hoped Bella would come to share his love. If so, it was in vain. They stayed at the Crown Inn, Wetheral, and between social visits to Mary Bough and her family, the Sewells and his friends in Carlisle, Bough also found time to do some painting along the banks of the Eden, rekindling the happy days of his youth. Bella liked Mary Bough, so presumably did not mind Sam's continued financial support for his brother's widow and children.

Towards the end of the year there was a happy event for Sam, when his sister married William Gray, a master baker who also lived at 5 Malta Terrace, on 5 November at Trinity Episcopal Church in Edinburgh. Anne had seen Sam through the hard times in Manchester and, after his marriage to Bella, must often have felt that she was

simply there at their beck and call. In marriage, at the very least, she would no longer be financially dependent on them.

Glasgow strikes back

The most significant event in Scottish art during 1861 was the founding of the Glasgow Institute of the Fine Arts (GIFA). It foreshadowed the gradual decline of the RSA as the dominating force in the lives of Scottish-based artists. Sam tried for his moment of glory – only to be rewarded with a poor hanging. As the *Glasgow Herald* commented, most of his paintings were 'hung so far above the line as to be beyond the reach of close examination'. These were *Glasgow Bridge*, *Victoria Bridge* and *Near Cambuslang* (all the property of A.G. Macdonald). It might have been Glasgow's way of admonishing him for deserting to Edinburgh, or maybe they felt that he should have tried harder to produce more innovatory work and not simply rest on old laurels.

A letter to the Editor, dated 23 November, offers another fascinating prospect. In commenting on the good positions given to the works of John Graham Gilbert, John Ballantyne and Taverner Knott, it wondered, 'Does the fact of the three last named gentlemen being in the hanging committee account for their pictures being on the line?'[49]

By 1861, Bough was working in a much freer and less conventional style than his earlier watercolours show, for all their competence. It was to be the pattern of the rest of his working life: the gradual transition towards a more impressionistic style. Sam's rapid brush strokes were not a sign of carelessness. They were precisely a mirror of the man; what he was trying to convey – speed, change and movement. Life.

At the turn of the year, he had comparatively little to offer at the RSA show. Only five works were submitted. Two were clearly from his time in the Wetheral area during the previous year: *On the Eden at Corby Castle* and *A Ferry on the Eden*. *The High Street* showed a typical Edinburgh scene. Sam obviously thought highly of it, for he was asking £125, and the *Courant* liked it: 'Assuredly a more vivid and faithful picture of the grand old street – the backbone of our old town – was never put on canvas.'[50]

Another of his exhibits caused some confusion. *The Drave between North Berwick and the Bass*, rated at £150 was, according to the *Scotsman*:

> A powerful and striking composition of boats engaged in the herring fishery betwixt North Berwick and the Bass. The pictur-

esque subject, vigorous handling, and powerful effect of the light and shade – for there is little variety in colour – all combine to constitute this a very effective telling picture. If the effect is intended for morning – and the fishermen at North Berwick as well as elsewhere during the 'drave' cast their nets in the evening and take them up next morning – the sun would seem to have risen in the wrong quarter, i.e. the West.[51]

But not even Bough expected that level of artistic licence to be allowed. He was not trying to redefine the flight of the planets, but simply to capture the fleeting moment of light and shade and movement. Not surprisingly, a later edition of the newspaper corrected the misreading:

A friend writes us that we were mistaken in supposing that the sun … was in the wrong quarter, as he knows all about it, from the view having been taken "from the front of the East Links at North Berwick, at my garden gate". Our friend is probably correct as to the sun being in the proper quarter – i.e. the East – though we have not had the opportunity of verifying the fact, but he is obviously in mistake as to the point from which the view was taken, as the picture itself proves incontestably that the view must have been taken from the water, and from the position immediately in front of the boats…[52]

Given such a pedestrian approach to art, small wonder that Sam sought solace other than in the experts.

The *Courant* provided something of an oasis in an artistic desert. By now, it had been won over totally to his talent:

Mr Bough has been very successful in accomplishing the difficult task of grouping together into an agreeable and effective composition, the mass of vessels of various descriptions which he has introduced into his picture. In this he has been much assisted by his perfect knowledge of all the various detail of shipping – a knowledge which we should wish to see more generally diffused among the marine painters of the Scottish school.[53]

Never to let them know where you go

The Manchester Exhibition of Watercolours also proved that he was on top form. He sent seven pictures, two of which already had owners.

The rest all sold on the first day. As Bough wrote to his friend David Macbeath at his home in Old Charlton, Kent, on 4 May, 'All bought by a sagacious dealer, who perceives that I am a genius, and wisely invests his money in my performances. In this he does wisely, and I sincerely pray that others of his honest and honourable fraternity be guided by his laudable example, and that I may be able to preserve my constitution and treat my friends with superior grub and tipple when they come to see me.'[54] His *Dysart on the Fife Coast – Sunset* won the Heywood gold medal for the best watercolour.

In the early months of 1862, Bough and his friend Thomas Nesbit, the Edinburgh auctioneer, had been staying with Macbeath at his other home at Nunlands, an isolated settlement just north of Whiteadder Water in Berwickshire.

When he got home, Bella complained that she had suffered such a cold that 'had I left my address she certainly would have sent for me'. Then he added, 'You see what a good thing it is never to let them know where you go to when you leave home.'[55] Although written with some sense of amusement, it is clear that Bella did not share her husband's love of art and rambling, nor – in some instances – his taste in friends. By now love's first flush had long since given way to affection and a mutual toleration of each other. In many ways, Sam sought – and got – the best of both worlds: the bachelor's freedom to roam as he chose, but with a wife at home to look after the house and the pets.

Macbeath's was the type of hospitality that Sam warmed to.

I am now slowly recovering the use of my faculty, and hope by a course of bread and water to come round and be fresh for you again. ... Nesbit and I picked up a most delightful old reprobate on our trip home from Berwick, a most ancient and venerable senior, who talked wisely and wickedly, and put Thomas into fits of laughter, and caused your humble servant to wish (he being a dissolute orphan) that the said ancient and venerable individual would adopt him. You'l[l] very likely know the party – Mr. Wilkie, who dined here with us yesterday, tells me he's a Col. Hay of Dunse Castle. May he live a hundred years – may his heart never ache – and may I have an opportunity of cultivating my morals under his superintendence.[56]

Nesbit was in failing health, and although the trip to Nunlands had helped, overwork soon took its toll and he was ordered to take a further break at the spa waters of Bridge of Allan in Stirlingshire.

It was all to no avail. A short time later he died, and Bough was writing to Macbeath again – this time about the funeral arrangements. 'You are aware that all is over with our poor dear Thomas. As you will possibly be coming to the Funeral, I write to say that I have a bed at your disposal, and will be glad if you will put up with me. Poor Tom, his son, is, I fear, nearly over with it also. How very, very sad! We are all in the dumps.'[57]

The drift to London

Soon, Bough was saying goodbye to another friend – although this time it was simply a temporary farewell. John Pettie, young and ambitious, found the Edinburgh art world too limiting and decided to uproot down to London. Bough, 17 years his senior, must have recognised something of his own youth in this young man in a hurry. In 1860 and 1861 Pettie was encouraged by the reception given to two of his pictures – *The Armourers* and *'What d'ye lack madam? What d'ye lack?'* – at the Royal Academy, and decided to take the route followed by so many Scottish artists before and since.

Orchardson had already gone to London. And – perhaps more significantly – so had Strahan's *Good Words*. The monthly publication had proved a great success with its mixture of articles sacred and secular, accompanied by quality illustrations from some of the best artists of the day. Its circulation was soaring, and it offered the prospect of a regular income for those artists invited to contribute. Pettie was paid £10 for each woodblock drawing and, having moved to London, shared a house with Orchardson and (from 1863) Tom Graham, who had studied with them in Edinburgh and is best remembered for his pictures of figures in landscapes.

Sam made one of his own rare sorties into the RA exhibition that year, with his *Dutch Brig Drifting from her Anchors* – but there is no sense that he was seriously considering following his younger friends at this point. He had established a comfortable living among the Scottish art public, and although he liked to visit London, the lure of the mountains and streams was still too strong.

The last picture that Pettie completed before leaving Edinburgh was *Cromwell's Saints* – an unholy trinity of characters including a telling portrait of Bough. As Martin Hardie, Pettie's biographer, commented years later, 'As a character study he did few things better than this realization, of the "old decayed tapsters" and other vagabonds of Cromwell's "lovely company" in whose ranks was supposed to be no

blasphemy, drinking, disorder or impiety.'[58] Sam was a natural for such company.

As a parting gesture, the picture almost proved Pettie's quietus. At the time his studio was in the glass-roofed Shorts Observatory, with a fine view across the Forth. Taking time out from finishing the picture for a rest and a smoke, his solitude was shattered when the body of a young girl, who had been climbing on the roof, fell through the glass ceiling onto the stool where he had been sitting. She was badly hurt, but survived. Pettie might not have been so lucky had he still been sitting there.

Sam was exhibiting at Manchester again that year, in September and October, to a mixed reception. His small oil of *Cramond, Firth of Forth* was acclaimed by the *Manchester Times* as 'a little gem'[59] but the *Guardian* introduced a more salutary note by commenting that it was one of the few of his works that actually pleased. Once again, he was 'doing a Turner', with a gloriously setting sun casting long shadows on the fishing families unloading their boats.

Alexander Fraser was elected a full member of the RSA that year. Sam would have been delighted for his friend, but might just have pondered why he still failed to find favour, when his popularity among the art-buying public was far greater than Fraser's.

Pushing up the prices

The pictures that Sam entered for the Glasgow exhibition in the winter of 1862–63 suggest that he had also spent a considerable amount of time that year travelling in the Western Highlands. Perhaps he had been stung by the treatment meted out to him the previous year, and this was his way of saying 'Remember me?'

He entered 20 paintings, including 14 watercolours. Of these, no fewer than 13 depicted Western Highland scenes or Glasgow. These ranged from Oban, the Isle of Mull, and Staffa, to the Sound of Sleat, Loch Alsh, Skye and Loch Ness. For good measure, he threw in one of his Cadzow pictures. He also showed two Dutch scenes, one of Greenwich and two oils of Aberdeen and Edinburgh, for which he was asking £120 and £125 respectively. The view of the Scottish capital – *Edinburgh from the Canal – Sunrise in Vapour* – is a particularly powerful example of Bough's capacity to capture atmospheric effects.

At the RSA show in 1863 he had nine entries. Of these, *Auld Reekie – Twilight* attracted most attention. Sam wanted 200 guineas for it.

Each year he was steadily pushing up the price of his best works. The *Scotsman* felt that:

> If it is a sign of a man of genius to be capable of investing an old subject with general interest, Mr Bough may fairly lay claim to that distinction. ... Mr Bough's picturesque eye for effect and dexterous execution seems admirably adapted for subjects like the present where finish and local colour are partially merged in breadth and power of general effect.[60]

The *Courant* was just as impressed by this 'noble landscape': 'The drawing and composition of this picture are masterly, and well deserve attentive study.'[61] A later report concluded that it was 'unquestionably one of the most remarkable and poetical pictures in the exhibition.'[62] Also on show and of interest, as evidence of his hoarding capacity – both mentally and in a physical sense – was *Berwick on Tweed – From a Sketch made in 1837*.

Sam was pleased with the treatment he had received from the hanging committee, although a letter to his friend Macbeath, dated 18 February, shows his annoyance at having been passed over once again for full membership of the RSA.

'You'll see by the newspaper,' he writes, 'that the beasts of Royal Scottish Academicians have shoved me aside again. Of course, I have to grin and bear it.'[63] But he expects his dead friend Tom Nesbit to be shaking a ghostly fist at them in the afterlife.

The mortal hatred of Noel Paton

In the same letter Sam reports with a delicious sense of pleasure that 'I have earned the mortal hatred of Noel Paton and his kidney, by beating him in a design for the adornment of the North British Insurance Company, which is now being engraved in London.'[64] Paton was the brother-in-law of David Octavius Hill, long-time Secretary of the RSA and a potent force on the Edinburgh art scene. Hill worked as tirelessly for the advancement of Noel Paton as he did for the RSA – and he might have been equally useful to Bough, if Sam had not managed to alienate him. That year Robert Herdman was elected RSA – another younger man being advanced before Sam. Erskine Nicol added to the haemorrhaging of Scottish art talent by going off to work in London.

As usual Bough was working hard, but had been afflicted with 'a

dozen boils (some on my backside); so that I was too much occupied with sad thoughts of my latter end, and other matters, to write to anybody...'[65] He had almost finished a small picture of Dysart Tower for Macbeath and wrote with some satisfaction 'capital it looks'[66].

He hoped that Macbeath would be able to collect it that Saturday, along with some other work he had been doing for the family:

> Tommy and Nelly [Macbeath's daughters] are to understand that the four sketches in the one frame are a joint property, the first married to have the lot. So they must be good girls, and cultivate the Graces and Capers, not forgetting cookery, and get married as soon as possible. I may add that should any accident put me into the position of a single man, I am at the immediate disposal of either of the young ladies who may honour me with her commands.[67]

Although joking with a friend – both girls were still young children – something of Bough's attitude to other women comes through. Over the years he acquired a reputation as a 'Gay Lothario', although there is no evidence to show that he took this beyond social niceties. It may suggest that he found his relationship with Bella unsatisfactory, or perhaps it was simply part of his personality.

In May, Bough was across in Canty Bay again, enjoying the Bass, the beer and the company for a week. He had planned to continue over to Nunlands, but did not quite make it. As he wrote to Macbeath on 4 June:

> As I fully intend to try down again, I hope to look you up. But my present intention is, as soon as I can manage it, to go to the Trossachs, and to try some Highland stuff, and then when the midges come on d——d bad, to go to the coast ... I don't see any chance of eating whitebait with you at Greenwich this summer ... Will you be here before you go to London, as I should rather like to see you?
>
> The Bishop of Aboyne (the old B———), you know, who married Jane Brown, is quartered at Gayfield Square. I saw Mrs. Nesbit the other day, and she told me they were there, and when I made a face at the news, she made another...[68]

He closes with news of the dispute that was going on over their dead friend Nesbit's estate, ending with a clear indication that his own philosophy of life, although challenged, had remained unchanged across the years: 'and spend your tin on a little sound licquor, wherewith to

comfort your poor perishable corpse – than have such d——d rows about it after you are gone!'[69]

A commission from Langholm

In August, his long-time friend in Carlisle, John Fisher, wrote to say that Joe Taylor, an acquaintance from their youth, wanted to commission a painting of an otter hunt from Bough. Taylor was in partnership with Alexander Reid in Langholm, where their large woollen mill was one of the major employers in the area. Both were wealthy men by the standards of the area. Sam's response to Fisher was positive:

> I shall really be glad to paint the picture of an Otter Hunt for Mr Taylor. It's a subject I delight in, and I'll come down to Langholm, or anywhere else in the otter hunting district he desires, and do it. I have a little picture to paint on the Lyne, near Bolton Fell End, and hope to get to it after the 15th or 16th of October. Till that time I am fix'd fast as a thief in a mill, with work I have on hand.[70]

He also throws in some casual comments about Bella that show the variations in his relationships with different people – and says something about his true feelings. In essence, Sam never escaped from the easy friendships of his youth, nor ever wanted to. Polite society was not what he was about, and here he shows more than usual his real self.

> The old woman is well and fat and d——d saucy. She was always that you'll say. But she sometimes in quiet evenings, talks about you and the old times ... I have seen many with better prospects than either of us come to woeful grief and sorrow. I can't forget old playmates and companions. The lads of the village are still lads to me, tho' time and luck have made many changes. I feel their success with pleasure, and sorrow for their ill luck.[71]

Sam followed up with a letter to Taylor himself on 27 August. For a painting 22 × 32 inches, he wanted £40, 'and I make this condition that if you don't like the picture when it is finished I shall not require you to take it. ... It is a long time since I have seen you but I have still a lively recollection of Carlisle in our daft days...'[72]

In fact Sam never made the journey to Langholm that year, and the picture was finally painted in 1864. He seems to have changed his plans a great deal that summer. The paintings suggest that he made a trip to

the Orkneys, rather than the Trossachs. Later, he was also planning to visit France to paint the Vintage around Epernay or Bordeaux, but the idea had to be shelved.

On 3 September he wrote to Macbeath at his Old Charlton address, about some pictures for a London exhibition being organised by a Mr Wallis. 'I am most anxious to do something for it. ... After his kindly remembrance of me, I would be a sinner if I didn't try something. Of course, it's hard work with me, and has been so since I saw you. I've sent a lot of things to Liverpool and Manchester, and if I have ordinary luck, I should become a rich man by Christmas.'[73] Still dreaming of the big break – but working hard at the same time to make the dream come true. Then he added a bit of gossip:

> When one's hard at work one doesn't hear much news. Poor Mrs. Nesbit is being slowly murdered by her kind hearted sisters or driven into a Lunatic Asylum. Blast them all! They're wearing the poor old soul to pieces![74]

Sam's strength of feeling on the subject is obvious. He hated to see people he cared about put upon by those he considered lesser mortals.

At Manchester that year he had on show six pictures, including two major oil paintings – *The Pier Head at Aberdeen* and *Lindisfarne, Holy Island – Misty Sunrise*, asking £120 and £100 respectively. The latter failed to sell, but is of interest because among the figures of fishermen and their wives stands Sam himself, in muffler and slouch hat, with his white bulldog nearby. He subsequently reworked some parts of the picture and sold it to his friend Captain Lodder for £50.

A month later, the RSA opened a special exhibition of Scottish paintings to which Bough sent four pictures, all the property of Robert Horn.

November brought bad news from Cumberland, with the death of his niece, little Lucy Bough, at the age of 11. That same month Sam was engaged to paint the act drop-scene for the New Theatre Royal.

A bold attempt

At the Glasgow Show in the winter of 1863–64, he exhibited only two works in the end: a watercolour of *Edinburgh from Calton Hill* and an oil painting, *The Upper Pool of the Thames – Sun Rising Through Vapour*. The latter won a 30-guinea prize for the best landscape, coast or sea view, and was one of the pictures selected by RAPFAS to be

engraved for its subscribers. The engraver was William Miller.

The award was well received by the *Glasgow Herald*'s critic who wrote:

> Few, if any, will be disposed to quarrel with the decision. The picture in question exhibits to great advantage the characteristic excellence of Mr Bough's style. It was a bold attempt to undertake the delineation of such a scene as is presented by the port of London. ... The success which Mr Bough has achieved, however, amply justifies his choice of a subject, and shows the peculiar adaptation of his genius to that department of landscape in which human activity form a conspicuous feature. ... The work is characterised throughout by that graphic power which enables Mr Bough to express his thought with a few careless looking dashes of his pencil, and, on the whole, we are disposed to think it one of the best pictures which have yet issued from his prolific studio.[75]

At the RSA show in 1864, Bough had eight paintings hanging, all either Scottish or Cumbrian scenes. The *Scotsman* noted he was 'remarkably strong this year ... furnishing indubitable [proof] of his talent and assiduity.'[76] For their critic the key work was '*The Clyde from the Roman Camp at Dalziel* ... quite a beatific vision of this beautiful scene. Rich and harmonious in colour, fine in tone, and masterly in execution, it is beyond doubt one of the finest landscapes in the Galleries and is another proof of the talent and versatility of the artist.'[77]

For the *Courant*, however, *The Prisons of the Bass* was 'the greatest work in the present exhibition in point of poetical conception and vigorous execution. The colouring too is excellent, for, though low in tone, it is harmonious, and well suited to the character of the scene.'[78] Sam wanted £150 for it. But there was a problem, the newspaper complained:

> This picture – so powerful, so poetical, so every way creditable to the Scottish school is hung about ten feet from the ground so that the effect of the perspective is totally destroyed, while in 405 a huge piece of tawdry mediocrity occupies the place of honour beneath it. In fact the two pictures are hung exactly in the inverse ration of their merits.[79]

The 'tawdry mediocrity' seems to have been D.O. Hill's *View of Stirling*.

The politics of hanging

The critic of the *Courant* launches into a magnificent harangue on the failings of the hanging committee.

> We don't at all mean to say that they have wilfully endeavoured to keep down and discourage rising merit, or to give undue prominence to official position than to artistic excellence. We consider them incapable rather than corrupt, and of that incapacity there are abundant proofs.[80]

Bough had suffered further from their incompetence in the hanging of his watercolours. That year watercolours, along with architectural drawings, had been placed for the first time in the entrance room, and it was noted that the quality of these exhibits was markedly better than in other years. Bough's work was 'in all respects admirable', but his '*Cora Linn* is disgracefully hung, being placed beside a large architectural design with a huge white margin, which kills the drawing.'[81] The critic felt that pride of place should go to McCulloch's *Loch Achray* and Bough's *A View Near Hamilton*. 'We never felt the impression of light more powerfully conveyed than by the latter picture.'[82]

In a later edition, the same critic was again lamenting the lack of recognition of Bough's watercolours, because they had not been bought by RAPFAS:

> Who have thrown away their money upon drawings not possessing a tenth part of their genius or power of handling. It is but poor encouragement to an able artist who has endeavoured to enrich our Exhibition in watercolour drawing – always its weakest department – to find his efforts neither appreciated nor rewarded and work inferior in every respect preferred to them.[83]

Sam seems to have taken his 'poor encouragement' lightly, for on 22 February, he was writing to Macbeath in high spirits. 'I have had capital luck this Exhibition, I have sold upwards of £300 worth, and hope to do some more business.'[84]

Bough was also a lender at that year's exhibition, showing a *Study of a Dog's Head* by George Clark Stanton, promoting his friend's interests. This was probably the picture of Spring, a bull-terrier and a constant companion of Bough during the mid-1850s on his painting excursions. It had died while being operated on by John Gamgee, and

the picture was painted as a keepsake. Stanton had returned from Italy towards the end of 1860 and, by now married to his beloved Clara, was struggling to establish himself in Edinburgh. Another of Sam's favourite dogs, Madame Sacchi, a white bulldog who became something of a trademark in many of his pictures, was portrayed by James Cassie, better known for his seascapes. The bitch had been a gift from a friend in Birmingham, Horace Woodward.

The prickly side of Sam's nature still caused problems from time to time, as when he managed to upset James Innes of Ayton Castle, a friend of Macbeath. Innes had called at Bough's studio one day with a friend, a housepainter who made the mistake of being too free with his views on art. As Bough found these ill-informed, he adopted his brusque manner for getting rid of unwelcome guests, claiming he had no pictures for sale, and offered them a beer and a pipe to smoke. Innes felt slighted and complained to Macbeath. So in April 1864, Sam wrote to his friend, 'I'm glad you've seen Innes. I remember him calling, but I don't think I was uncivil. If he thought so, I can only say I'm sorry.'[85] (Innes, years later, made a wise investment when he bought *London from Shooters Hill*.)

In July he finally made it to Canonbie to start on Joe Taylor's otter hunting picture, seizing the opportunity to get down to Carlisle to see John Fisher. He also received a strange commission from the nuns of St Margaret's Convent in Whitehouse Loan, Edinburgh. This was the first Roman Catholic convent established in Scotland since the Reformation, and had initially faced considerable local resistance. Over the years, the charitable work of the convent had won over its opponents, as had the efforts of its founder, Bishop James Gillis. When he died in 1864, the nuns, realizing they had no picture of him, asked Sam to remedy the situation from memory, which he gladly did out of respect for the man and his achievements. Although not a Catholic, Bough had often enjoyed his sermons at St Mary's Cathedral in Broughton Street and the sung liturgy (with orchestral accompaniment) that the bishop had introduced.

At some point during that year, John Nesbitt, a marine painter living in Edinburgh, became one of Sam's painting companions around Canty Bay and the Fife coast. Bough also painted an act drop-scene of *The Clyde from Finlayston* for Glover's Dunlop Street Theatre, Glasgow.

Another significant event in 1864 was the death of John Watson Gordon, founder President of the RSA. As a portrait painter, his perception of Bough's skills might have been lacking. But his successor, George Harvey, was a respected landscape painter who was

initially well-disposed towards Sam and could have advanced him at the Academy.

Unfortunately, over the coming years Sam displayed his usual capacity for alienating those who might most help him, and made an enemy of Harvey also. One story has him hanging a blank canvas alongside a Harvey painting at the RSA and then returning on finishing day to match himself against the older man's picture – a sign of utter contempt. Although there was a touch of Turner about the trick, it also showed clearly that Bough was no politician.

Towards the end of 1864, Sam moved his studio to 2 Hill Street. It was to be his last workplace.

That winter at the Glasgow show, he had nine pictures. They had a mixed reception. The *Glasgow Herald* thought his *Loch Achray* was:

> ...in many respects an admirable work. The middle distance, for instance, with the afternoon sun hanging over the wooded hills that border the loch, is vigorously and effectively rendered. The foreground, however, is comparatively feeble, and it is probably owing to this that the picture seems to lack distance.[86]

The newspaper goes on to say that he 'has given us several first-rate watercolours, including a view of *Cora Linn* of unrivalled power and spirit.'[87] It needed to be, at £100 for a watercolour.

A close call, and behaving badly

Early in 1865, Bough had a brush with death and a battle with the RSA. On 13 January, he was at a matinee performance at The Queen's Theatre, talking to George Lorimer, a local builder, when Sacchi, his bulldog, wandered off. Sam went in search of her. It probably saved his life.

The trouble started when the theatre's gas lighter accidentally set fire to some scenery. He and others tried valiantly to isolate the burning canvas, but the flames had already taken hold elsewhere. The heat of the inferno drove them back. Within 15 minutes the whole theatre was ablaze and the fire had spread to the adjoining church. Lorimer stayed behind, trying to rescue a man trapped under some fallen masonry, when the wall fell in and killed both of them. In all eight people died, and Sam could so easily have been added to that number.

Less than a month later, he was at loggerheads with the RSA. It started when the Council, having just sent out invitations for the

annual dinner, discovered that Bough was a Pursuivant – a largely ceremonial office of state messenger, for which a fee was paid. Some felt it an unworthy activity for an Associate of the RSA. Accordingly on 7 February, Secretary Hill wrote briefly to Sam, 'I am directed by the President and Council ... to inform you, that when they gave me instruction officially to invite the Academicians and Associates to the Annual Dinner which takes place in the Gallery on the 10th instance, they were not aware that you held the position and discharged the functions of a Pursuivant.'[88]

Sam replied the next day that they clearly did not understand the honour of holding such an office 'in Her Majesty's Household. ... However should the Academy think my holding such office under Her Majesty and the Royal College of Arms for Scotland derogatory to their dignity, there is nothing to prevent me retiring from the same.'[89]

If he had calculated that the RSA would not risk offering a slight to the Crown by requiring him to resign the office, he was wrong. Back came the reply on 9 February: 'If the Council are to infer from the last part of your letter that you desire their opinion as to the propriety of retiring from the office in question, they have no hesitation in giving a unanimous opinion that you should do so.'[90]

Other issues were making demands on the Council's time, like who should sit where at the annual dinner. After much debate, they finally settled on the seating plan and 'directed that each gentleman at the dinner should have his name written on a card and placed as now arranged, unless altered by the Council or [Dinner] Committee.'[91]

An unrepentant Bough went along to the dinner on 10 February in rebellious mood. Looking at the seating arrangements, he decided he preferred the place allocated to old Mungo Burton, a fellow Associate, and promptly switched the cards without asking. When the matter came to the Council on 16 February, they took a dim view of his enterprise, but were still preoccupied with resolving the matter of the Pursuivancy.

Sam had taken their correspondence to George Burnett, Lyon Depute of the Lyon Court, Scotland's Royal College of Arms, where he was Dingwall Pursuivant. This was escalating things on a grand scale. The argument was simple – by casting a slur on Bough's status as Pursuivant, the RSA was also offering an insult to the whole institution of the Lyon Court.

Burnett took up cudgels on Bough's behalf, writing back to the RSA. In a lengthy letter, he outlined the duties of the office and listed eminent citizens who had held it. The Lyon Depute concluded by

explaining, 'The Pursuivant, whatever his birth, is as soon as he becomes a Herald, legally entitled to be designed as "Esquire", a designation which you are probably aware, though given by common courtesy to a large class of people in this country, is restricted in law to a comparatively small number.'[92] The letter was addressed to D.O. Hill, *Esq.*

This led the RSA to look for legal advice before responding. Fortified by this, Burnett was sent a rebuff by Hill on 20 February: 'I am instructed by the Council of the Royal Academy to say that, with all respect for your office and for you personally, they cannot recognise but on the contrary must repudiate, your right to interfere in the affairs of the Royal Academy, and particularly in questions betwixt the Academy and its members; and that all correspondence with you on the subject is declined.'[93] Despite protests from Burnett, the RSA held firm to its line. Then they turned their attention to Bough, and on 28 February wrote asking for an explanation of his behaviour at the dinner. Sam simply ignored it.

At the RSA that year, he had 12 pictures. As the *Scotsman* commented, he painted 'anything and everything equally well, completing his work in the time which other men ruminate over the size of the canvas. In all cases the great secret is to know what to do, and Bough has an intuitive perception in this respect almost amounting to inspiration.'[94]

In the Trossachs was his preferred painting – he wanted £200 for it. The *Scotsman* thought it 'richer in local colour than is usual with the artist, and is more carefully finished.'[95] The *Courant* was even more forthright:

> If anyone wishes to know how a Highland hill ought to be painted, let him go and study this picture. There is not a hill in this exhibition to compare to it, and in spite of the pictures hung close to it being nicely calculated to destroy its proper effect, its merits cannot fail to arrest the eye.[96]

Another interesting entry from this show was *The Painting Room at the Old Adelphi Theatre* – 'and it is a disgrace to the hanging committee to have hung so clever a picture in so wretched a place'[97]. Sam only wanted £20 for this.

He also had another hayfield on show but, as the *Scotsman* said, 'we would recommend Mr Bough to drop this subject for a time, as we have had rather too much of it.'[98]

The newspaper also offered its readers a veritable scoop, the equiva-

lent of an interview with one of today's media personalities. For on 28 February, it reported that:

> Dropping into Mr Bough's studio the other day, we were much delighted with a large picture which he has now on the easel, nearly completed – a commission we believe from a gentleman in the south of Scotland. The subject is The Vale of Teith looking towards Ben Ledi and the Pass of Leni [in the Trossachs]. The grand features of the picturesque and lovely landscape have been transferred to the canvas under the effect of bright sunshine, which imparts every object an additional charm. ... If this picture when completed, realises the promise it now holds out, we have no hesitation in saying that it will be the greatest work this able artist has yet produced. Mr Bough, we understand proposes to exhibit the picture in the next exhibition of the Royal Academy [which he did].[99]

Finally – the Otter Hunt

Sam had also – finally – almost completed the commission for Joe Taylor: *An Otter Hunt – So Early in the Morning*. As he wrote to his friend on 1 February:

> It's a pretty good thing and gives a fair notion of the noble sport "so early in the morning". The view is taken immediately below the Hollows bridge ... I made the most d–mnable attempt at portraiture of yourself. ... Such of my cummiss as have seen the picture think it stunning and profess to admire it much. I think it's a pretty good notion of a misty fine Summer's morning but whether you'll like it or no I don't know. I can only say I have done my best. ... Of course all the dogs and men are queer in the picture but that I must hope to mend when I get it out of the Exhibition and have the respective bipeds and quadrupeds before me. Some good honest creature had taken a fancy to my sketches of the dogs and nobbled the blessed lot and I had to depend on my memory for them. The photos of the men were useful to some extent but ... a soul like yourself looking his best is a mighty different thing from Mr Joe looking heated and jolly with his hounds in the morning.[100]

The bridge is also known as Gilnockie Bridge, and among those splashing through the water behind the dogs in the painting is Sam himself.

On 30 March he wrote again to Taylor, reminding him of a 'lively remembrance of a promise' that he would send him sufficient material to make a tweed suit. Only then does he come to the painting: 'Your picture meets with a more than usual amount of criticism on the part of the fine and fancy in Edinbro' – some say it's the finest thing they have ever seen. Others swear it's d——d bad.'[101]

A few days later Taylor replied – he could remember nothing about a promise of suit material 'but at the same time it is very likely I did'. Perhaps, on Sam's earlier trip to Canonbie, both had been too befuddled by their celebrations to have a clear recollection. Nevertheless, Taylor sent him through sufficient material for jacket, vest and trousers. Of the painting he wrote, 'I can assure you it has caused quite as much [criticism] amongst the country fanciers. ... Your best plan would be to bring it out here to finish and stop for a month or so ... at the end of May or June.'[102]

By April, Sam was in Castlemilk, Dumfries, doing sketches for a hunting picture. He wrote to Taylor, saying he planned to go down to Carlisle after this and hoped to get across the Langholm to see him. The material was being made up into a suit in readiness for his trip to London.

One other interesting picture from 1865, because of its associations, is the watercolour *Lady Ruthven's Monkey*, painted at Winton House, Pencaitland, East Lothian. Mary, Lady Ruthven, was the older sister of Lady Belhaven, whom Sam had befriended during his Hamilton days. Both women had a keen appreciation of art and were accomplished painters in their own right. Mary Ruthven was a remarkable woman, widely travelled, remembered for her great generosity and personal eccentricity. She was a good conversationalist with a lively mind, and very outspoken. She was 'partial to the society of persons with marked idiosyncrasy of manner'. Bough was an obvious candidate.

The sisters would visit him at his studio in Hill Street and, as Sam only ever kept one chair there for visitors, so as not to encourage too many, Lady Belhaven was left standing around for a while. Bough, suddenly remembering his duties as a host, enquired kindly, 'Oh Lady Belhaven, have you nothing to sit on?' 'Plenty, Mr Bough,' came the reply, 'but nowhere to put it.' It became a standing joke among Bough's circle. Whenever someone wanted a seat, they would simply say 'Now, Lady Belhaven...'

The episode has a sequel in a later story told of Lady Ruthven. On a private view day at the RSA, she and Bough were wandering through the galleries, making acerbic comments as they progressed, when they

came upon a painting of some female nudes. 'Ah! Mr Bough, I declare the man who painted these poor things has given them nothing to sit upon!' While those who overheard sniggered unknowingly, Sam and the dowager understood the real joke.

Bough had a standing invitation to visit Winton House, and painted many pictures there and in the Pencaitland area. Sometimes he was asked to take his cello with him for entertainment. (Lady Belhaven died in 1873 aged 83, Lady Ruthven survived until 1885, when she died aged 96.)

At some point during that year, he produced a magnificent large oil of *St Monance* that challenges every critic of his handling of colour. It stands as one of his masterpieces. Also from that year, is a much slighter watercolour of *Bass Rock*, significant because its style foreshadows his impressionistic work of the next decade.

Towards the end of 1865, the saga of *The Otter Hunt* was concluded. On 6 December Sam wrote to Taylor, commiserating on the death of his father and giving a rare insight into a softer, kindlier man. 'I too have loved and lost in my time and know well what 'tis to miss the kind familiar face that looked all lovingness thro' the young days of my life, that brightened at our good luck or looked sad at our misfortune.'[103]

On a more businesslike note, he complains that a chronic cold has kept him at home and worries about completing a commission for their mutual friend, Mr Jardine. Then comes the close. 'If I don't feel better – this has kept me from visiting Langholm, a thing I much wished, and you will have to wait for the warm spring days ere I can venture down to finish my work – if you send me the money for the picture it will be acceptable as money generally is – I forget what price we agreed for the picture but that I must leave to yourself.'[104] Within a few days, Taylor had paid 40 guineas and Sam responded gratefully on 11 December promising that 'I will make my appearance in Langholm and try and improve the picture in the matter of likenesses'.[105]

Bough had also been doing some scenepainting again. When Wyndham opened his replacement for the Queens Theatre, destroyed earlier that year, he had painted the act drop-scene.

Sam had cause to be grateful for money from any source. 1865 had been a difficult year. He had got into a financial mess, perhaps through unwise investments. But two days after receiving the money from Taylor, he sent £20 through to Mary Bough, apologising for the delay in forwarding the money, and making light of his own circumstances.

Called to account by the RSA

Towards the end of 1865, the old dispute with the RSA raised its head again. On 28 December, Hill wrote to Bough: 'The Council of the Royal Scottish Academy, being now engaged in making preparations for the Exhibition and opening Dinner, have directed me to send you copy of a minute of the Council of 16th February last which refers to you. They now request me to ask from you some explanation of the circumstances there noted.'[106] Sam may have hoped the whole affair of the switched dinner tickets had been forgotten, but it was a forlorn hope.

The next day he wrote back that the 'circumstances referred to in the Minute concerns Mr Burton and myself only. If that gentleman requires any explanation he can apply to me for it.'[107] It was an attempt to play the RSA at its own game: if it refused to allow a place for the Lyon Court in the dispute, he would likewise deny them a role.

Having considered his reply, the RSA decided to bring matters to a head. On 4 January, the Council wrote back that in asking for an explanation,

> they were acting in the way most favourable to Mr Bough for he had taken upon himself to interfere with and break through arrangements made upon anxious consideration by a committee appointed under the direction and subject to the approval of the Council. ... In calling therefore merely for an explanation they gave Mr Bough an opportunity of making an apology or giving an explanation which might have enabled Council to get over the difficulty placed in their way by the aforesaid Minute. The only alternative was to report the Minute to the General Body, a proceeding less favourable to Mr Bough, as it would probably be taken into consideration in connexion with other complaints made to them against him.[108]

So they referred the case to a General Meeting, called for 8 January 1866. The next day, Hill advised Bough of the outcome:

> The Meeting, confining themselves to the matter remitted were unanimously of opinion that the Council were entitled and indeed bound to take up the subject detailed in the Minute of 16 February, and that they did so at the proper time. ... The meeting therefore instruct the Council to demand from Mr Bough an ample and explicit apology.[109]

Alexander Fraser had tried to argue for a more moderate approach, claiming that such an extreme action would do more damage to the RSA than to Bough. Waller Paton countered with a technicality – by claiming that Fraser had no right to vote because he had yet to submit his Diploma picture.

By this time, the case was something of a *cause célèbre* in Edinburgh. There was some suggestion among friends that he would be better treated in London, but Sam remained steadfast in his allegiance to Scotland.

He finally resolved the matter on 10 January 1866, by writing to the RSA that:

> Since the matter has been brought before a General Meeting of the Academy, I have no hesitation in complying with their demand, and do now express my regret that I should have inadvertently interfered with last year's dinner arrangements – not then being aware that these had been made upon anxious consideration by a committee appointed under the direction and subject to the approval of the Council.[110]

He must have enjoyed writing that last comment, the words clearly calculated to show his disdain for the pettiness of the whole affair.

Six days later, in a letter to Edward Duval, the son of his old artist friend in Manchester, he was in triumphant mood:

> I've had such a Jerusalem row with the RSA, and beat 'em, Sir. Wanted to turn him out – tried – and couldn't manage it – and I have them now. if they don't hold their blasted jaw, I'll print all their d———d letters; and wouldn't that be Pye, for an intelligent and discerning Public?[111]

Bough had another jibe at Hill's expense later that year, when the RSA Secretary finally finished his massive picture of *The First General Assembly of the Free Church of Scotland*, 23 years after starting it. With over 450 portraits included, many of people who had died in the interim, artistic effect was inevitably sacrificed for historic record. When he saw the end product, Sam sarcastically compared them to 'potatoes all in a row', although Sir George Harvey valued it at 3,000 guineas.

Artistically, Bough had an ever-increasing estimation of his own worth that was borne out by the art-buying public. At that winter's Glasgow exhibition, he was asking £200 for *The Drove at Sunrise – Hoar Frost* (said to have been painted to prove he could depict cattle as

well as Gourlay Steell who specialised in animal painting), and 200 guineas for *The Broomielaw from the Bridge – 'Let Glasgow Flourish'*. His third work – *In the Trossachs* – already had an owner in John Moffat.

Of the Broomielaw picture, one critic commented that:

> Such a subject is well adapted for the display of Bough's peculiar powers, and perhaps we are not far wrong in saying that it is in harbours, and scenes of that description, that he appears to greatest advantage. ... The picture is full of life and movement and gives an excellent idea of the scene, the only inaccuracy being, perhaps, the introduction of so many brilliant colours in the dresses of the steamboat passengers.[112]

A towering success, seeking security

At the RSA in 1866, Sam had nine works on show, five of which already had owners. Of these, *The Tower of London* had the greatest impact. As usual these days, the *Scotsman* warmed to his efforts.

> The busy mart of the world is here represented under ordinary circumstances, with a spirit and intelligence peculiar to the artist. ... The execution of the water could not have been surpassed. Unruffled by any wind its upheaving motion is caused only by the turn of the tide, which runs very strongly, and Mr Bough seems to have caught and registered this peculiar effect at the critical moment.[113]

In March, keen to establish some financial reserves, he put 150 water-colours up for auction at Thomas Chapman's salerooms and waited anxiously in Jimmy Baines's chop shop below, drinking to calm his nerves as the works went under the hammer. They brought him around £1000 and gave him sufficient capital to even contemplate buying his own home for the first time in his life. Presumably to help supplement his finances, Bough was also across in Glasgow, painting an act drop-scene for the Theatre Royal, representing the lower Clyde seen from the high ground near Langside.

On the road again

That summer Bough was travelling again. There was another trip to Dunkirk from Leith; a visit to London (probably just to see Bella's

family); a sketching tour of the Orkneys, and a journey down the Fife coast. Perhaps the fact that 2 Hill Street was undergoing a major refurbishment was an added incentive. As Sam complained, 'My studio has been in a damned mess the whole season.'[114]

The trips were productive, however. At Manchester he wanted 155 guineas for an oil of *Dunkirk Harbour* and warned Macbeath to 'look out for a sensation picture in the Royal Academy exhibition, next May, of Kirkwall Cathedral'.[115]

But it was not all hard work. There were lighter moments, such as the invitation Sam received to join the Monks of St Giles, a select literary social club that limited its membership to around two dozen. The qualifications for membership were 'respectability, intelligence, humour and the power of entertaining' and the unanimous approval of all other members. Men from a wide range of professions were recruited – including academics, doctors, merchants, lawyers and writers. The club met in an upper room in St Giles' Street on the first Monday of most months. After a brief business meeting, they would settle down to a frugal supper and then take it in turn to offer literary contributions, before drifting into anecdotes, recitation and song. At 11 p.m. the meeting ended.

Bough's 'monastic' name was 'Sambo', and he remained an active member for the rest of his life. At his suggestion, the tradition was established of providing a children's ball annually on St Valentine's Day, at which Sam and his fellow 'monks' appeared in monastic garb.

A sad event from this year was the death of John Milne Donald, after a few years of ailing health and mental illness. He never attained the recognition of some of his contemporaries, but Bough's judgement that, had he lived, his friend's work might have surpassed his own would have been echoed by many of his fellow artists. Sam donated *Edinburgh from the Canal* to an Art Union for the benefit of his widow and family.

Another loss was the death of old David Dunbar, the sculptor who had played such a leading role in establishing the Carlisle Artists' Academy over 40 years earlier. Again Bough's generosity is brought to light. Towards the end of his life, Dunbar fell on hard times, and when Sam learned of his plight during a visit to Edinburgh, he invited him round to his studio the next day and gave him a new suit of his own. The story shows the hardness of the world in which Bough lived and worked. One of the giants of his youth thus reduced to accepting charity – neither Bough nor Dunbar would have missed the irony.

These deaths and the other events of 1866 made Bough think more seriously about his own mortality and the need to provide for Bella

and his relatives if he died. For the previous decade he had worked hard, played hard and travelled constantly, driven either by his sheer love of the open air or an unhappy home life – perhaps both. In the process he had risen to the stature of one of the leading landscape painters in Scotland – and the prices he could command for his work reflected this. The public acclaim was there, only professional recognition was lacking. But the fear of financial insecurity still haunted him.

The sale of his works earlier in 1866 was a distinct attempt to accumulate capital, yet he knew that unless it was soon invested he would simply fritter it away on himself and friends. The pace of his travels seems even more frantic than usual, almost as if he was running from himself. There can be no doubt about his sense of responsibility towards Bella but, by now, their marriage seems to have offered little by way of emotional support for either of them. Perhaps the lack of children had something to do with this, although we shall never know whether this was through choice or circumstances. Given Sam's obvious love of children, it seems likely he would have chosen to have a family if this had been possible. We know less of Bella's feelings on which to base any judgement. Socially they were known as good hosts who threw excellent and entertaining dinner parties, but those closest to them knew of the tensions that existed. In future years these would become more apparent.

Towards the end of 1866, Sam seems to have decided it was time to knowingly commit himself to a course of action that would shape the rest of his life.

REFERENCES

1 Sidney Gilpin, *op. cit.*, p. 96.

2 Letter, George Coward's notebook, *op. cit.*

3 Edward Pinnington's notes, *op. cit.*

4 *ibid.*

5 *Scotsman*, 15 March 1856.

6 *Courant*, 18 March 1856.

7 *ibid.*

8 Sidney Gilpin, *op. cit.*, p. 98.

9 Letter to J. H. Lance, 4 September 1856, collection of Rachel Moss.

10 *ibid.*

11 *ibid.*

12 Letter, 19 August 1856, George Coward's notebook, *op. cit.*

13 Letter to J. H. Lance, *op. cit.*

14 *ibid.*

15 Mrs Reid to Edward Pinnington, undated, Edward Pinnington's notes, *op. cit.*

16 *Scotsman* 28 February 1857.

17 *Courant*, 10 March 1857.

18 *ibid.*

19 Ruth D'Arcy Thompson, *The Remarkable Gamgees*, Edinburgh, 1974, p.90.

20 Lindsay Errington, *Sunshine and Shadow, the David Scott Collection of Victorian Paintings*, Edinburgh, 1991, p. 35.

21 Letter, 15 December 1857, George Coward's notebook, *op. cit.*

22 *Scotsman*, 13 February 1858.

23 *Scotsman*, 23 February 1858.

24 *ibid.*

25 Sidney Gilpin, *op. cit.*, p. 122.

26 *ibid.*

27 *Scotsman*, 20 February 1858.

28 *ibid.*

29 Quoted in Julian Halsby, *Scottish Watercolours 1740–1940*, London 1986.

30 Letter, 5 January 1859, George Coward's notebook, *op. cit.*

31 *Scotsman*, 12 February 1859.

32 *Courant*, 22 February 1859.

33 *Scotsman*, 12 February 1859.

34 *Courant*, 22 February 1859.

35 *ibid.*

36 Martin Hardie, *John Pettie*, London, 1908, p. 33.

37 Bella Bough to Edward Pinnington, undated, Edward Pinnington's notes, *op. cit.*

38 *Scotsman*, 21 February 1860.

39 *Courant*, 1 March 1860.

40 *ibid.*

41 Catalogue of Illustrations of Scotch Art, 1896, Edward Pinnington's notes, *op. cit.*

42 Criticism of Sam Bough, 1860 – Iconoclast and Maulstick, Edward Pinnington's notes, *op. cit.*

43 *ibid.*

44 *ibid.*

45 John Sewell, Introduction, Edward Pinnington, *op. cit.*

46 Sidney Gilpin, *op. cit.*, p. 127.

47 *Scotsman*, 1 March 1861.

48 Letter, 11 April 1861, George Coward's notebook, *op. cit.*

49 *Glasgow Herald*, 23 November 1861.

50 *Courant*, 19 February 1862.

51 *Scotsman*, 27 February 1862.

52 *ibid.*

53 *Courant*, 19 February 1862.

54 Sidney Gilpin, *op. cit.*, p. 133.

55 *ibid.*, p. 134.

56 Letter, 4 May 1862, George Coward's notebook, *op. cit.*

57 Letter, undated 1862, George Coward's notebook, *op. cit.*

58 Martin Hardie, *op. cit*, p. 30.

59 Quoted in Kim Sloan, *Victorian Painting in the Beaverbrook Art Gallery*, New Brunswick, 1989, p. 82.

60 *Scotsman* 19 February 1863.

61 *Courant*, 14 February 1863.

62 *Courant*, 21 February 1863.

63 Sidney Gilpin, *op. cit* p. 136.

64 *ibid.*

65 Letter, 18 February 1863, George Coward's notebook, *op. cit.*

66 *ibid.*

67 *ibid.*

68 Letter, 4 June 1863, George Coward's notebook, *op. cit.*

69 *ibid.*

70 Letter, 22 August 1863, George Coward's notebook, *op. cit.*

71 *ibid.*

72 Letter, 27 August 1863, Edward Pinnington's notes, *op. cit.*

73 Letter, 3 September 1863, George Coward's notebook, *op. cit.*

74 *ibid.*

75 *Glasgow Herald*, 22 January 1864.

76 *Scotsman*, 13 February 1864.

77 *ibid*.

78 *Courant*, 10 March 1864.

79 *ibid*.

80 *ibid*.

81 *Courant*, 13 February 1864.

82 *ibid*.

83 *Courant*, 21 March 1864.

84 Sidney Gilpin, *op. cit.*, p. 141.

85 *ibid*.

86 *Glasgow Herald*, 18 February 1865.

87 *ibid*.

88 Letter, 7 February 1865, RSA Library.

89 Letter, 7 February 1865, RSA Library.

90 Letter, 9 February 1865, RSA Library.

91 Minutes of RSA Council Meeting, 9 February 1865, RSA Library.

92 George Burnett to D. O. Hill, 13 February 1865, RSA Library.

93 Letter, 20 February 1865, RSA Library.

94 *Scotsman*, 17 February 1865.

95 *ibid*.

96 *Courant*, 4 March 1865.

97 *Courant*, 17 February 1865.

98 Quoted in *Carlisle Journal*, 21 February 1865.

99 *Scotsman*, 28 February 1865.

100 Letter, 1 February 1865, Edward Pinnington's notes, *op. cit.*

101 Letter, 30 March 1865, Edward Pinnington's notes, *op. cit.*

102 Letter, 3 April 1865, Edward Pinnington's notes, *op. cit.*

103 Letter, 6 December 1865, Edward Pinnington's notes, *op. cit.*

104 *ibid*.

105 Letter, 11 December 1865, Edward Pinnington's notes, *op. cit.*

106 Letter, 28 December 1865, RSA Library.

107 Letter, 29 December 1865, RSA Library.

108 Minutes of RSA Council Meeting, 4 January 1866, RSA Library.

109 Letter, 8 January 1866, RSA Library.

110 Letter, 10 January 1866, RSA Library.

111 Letter, 17 January 1866, George Coward's notebook, *op. cit.*

112 *Glasgow Herald*, 10 March 1866.

113 *Scotsman*, 17 February 1866.

114 Sidney Gilpin, *op. cit.*, p. 149.

115 *ibid*.

4

Journey's End

Chelsea or Gomorrah?

Late in 1866, Sam was planning a move to London, looking to rent a house in Chelsea. In the end, he decided – for all time – to cast anchor in Edinburgh. As he wrote to Macbeath in November:

> I've lots of news for you. The Chelsea house wouldn't fizz. It would have cost £400 to get in, and what with rent, insurance, and repairs over £100, and that was more than I cared to pay. So I've determined to stay here, and have bought D.R. Hay's house at Morningside – a perfect gem of a place. D.R. was a queer old beggar, but had wonderful good taste, and this was his pet work. There's dining-room, drawing-room – opening into a "wopping" conservatory – terraces, fountain in garden, five bedrooms, library, two-stalled stable, and coach house. The feu is only £4-6s, and I've got the lot for £1,200.
>
> The folk here are a rum lot. Why the house didn't fetch more I can't say. There was this against it. D.R. didn't go much to kirk, and kept a concubine or two. Madame kicked out the notion of my buying it on account of the wickedness of the late proprietor. Of course, I have to pull out and scrape the tin together, and to do that without distressing myself, I've determined to sell off all my pictures, and furnish with prints.
>
> I couldn't get anything ready for Wallis, as I was up to the eyes with work. After leaving London, I went to Orkney, and did some sketching there. ... Then I had a turn at the Fife fishing towns, where the population is amphibious and the females whores – which fact you ascertain by all who have baskets with them, and all who haven't.[1]

The property Bough bought was 8 Jordan Bank in Jordan Lane,

Morningside, with a fine view across the burn to Blackford Hill and the Braid Hills. (The adjacent properties, on either side, would be acquired later.)

David Ramsay Hay, who died on 10 September 1866, was similar to Bough in his disdain for polite society. A decorative artist and author who had been responsible for the interior of Holyrood Palace, he was also a friend of Sir Walter Scott.

Local worthies must have feared the worst when Sam threatened to re-name it 'Gomorrah Villa'. For Bough the decision was a major statement of intent. Edinburgh would be home for the rest of his days.

Understandably, the purchase of his new home distracted him from his studio temporarily. At the Glasgow show of the winter of 1866–67 Bough was in restrained mood, with only three pictures on display. What he lacked in quantity, he made up for in quality. Of these, *Off Tantallon Castle* drew particular acclaim from the press:

> The artist has here got hold of a subject after his own heart – an angry-looking sea, still seething and tumbling from the impetus of a recent storm. The wild sweep of the waves, on which a boat rocks uneasily in the foreground, is rendered with great spirit and freedom. The sky, too, more particularly along the troubled horizon, is powerfully painted, though the colour in the rift through which the sun is breaking, might with advantage have been less yellow ... one of the best things Mr Bough ever produced is the watercolour drawing ... 'Glenlyon – Springtime'. In watercolour this artist seems to revel with peculiar freedom, and through that medium he generally secures a transparency which we miss in his oil painting. Visitors of the Edinburgh Exhibition should take care to see the marvellously spirited sea pieces which he has in the North Room.[2]

Bough was certainly well-represented at the 1867 RSA exhibition, with eight works. The *Courant* appreciated his watercolours, in particular:

> As it takes Mr Bough as long to paint [a watercolour] as to paint a large work in oils – like the St Monance in the South room, for example – for which he [will] get four times as much money, we are the more obliged to him for enriching the watercolour department – always the weakest in our annual exhibition...[3]

143

A sense of frustration

The *Scotsman* also commented favourably, but with a sense of frustration

> There is not an artist connected with the Academy capable of greater things than Mr Bough. There is not one who so makes one sigh over his want of time to give his great capabilities full justice.[4]

Of *The Bass* it says:

> By the great force of his genius, in a few magical broad touches, he makes this symbolism affect our imagination as only a painter here and there can do, and, therefore, he wins at once general admiration and praise. ... If he could only take the pains to see, and give the labour to tell what he has seen, he has power beyond most to do it.[5]

Other paintings were well received. Of *St Monance – Fife*, the *Scotsman* said:

> The rays of the setting sun cast a glow over the whole picture, and seems to animate the fishermen busily engaged in preparing their boats and tackle for departure upon their nightswork. The wives are eagerly forwarding their husbands' expedition. The conception and painting are both excellent.[6]

Sam was less pleased with the initial treatment his *St Monance* had been given, for he wrote politely to the President and Council, 'I beg respectfully to call your attention to the position in which my picture of St Monance is hung and to request that you will take into consideration my earnest desire to have it hung on the line or somehow lower.'[7] The 'earnest desire' was probably closely related to the £250 he wanted for it. After inspecting the picture, the Council agreed it should be lowered four inches.

The effort on the house and the two exhibitions was more than Bough could stomach, as he confessed to Macbeath in February:

> I was so jolly tired with my Winter work that I bolted off to Glasgow, taking Bella with me, and didn't leave word where my letters were to be sent, and so I had a week's peace and quiet – that is, we dined out every day with tip-top folks, and had real jollification.

144

I didn't see London this summer. I did Paris by way of Dunkerque, from Leith and back. I had to cut it fine, as my House nearly cleared me out. ... Tell me what the money is and I'll tell you whether I can stump up the money or drawings. I hope to have plenty of the first by May, as I have lots of pictures to sell both here and in Glasgow.

I hope my dear Mrs Macbeath and the three Graces, who dance around her, and whose nightcaps she ties, are well. My missus is getting so fat you'd hardly know her. A Glasgow lady told me, 'she had an arm like a leg' and so she has.[8]

On 7 May he wrote to Mary Bough.

I heard that you were trying for Harraby Hill [the matron's job at St Cuthbert's Workhouse, Carlisle], and that you had got it, for which I gave God thanks. I've been terribly hampered for money this last six months. And the House I have bought, when I got into it, I found that I would have to make lot of alterations, before I could live in it, and that has fairly cleared me out. [Bella later estimated that, by the time they had got it how they liked, it had cost £4,000.][9]

The same letter suggests the shape of things to come now that Bella had a setting to match her love of entertaining:

Bella ... has both her sisters with her, the sister's husband, and the bairns, blast them! and a d———d houseful there is, but they all go next week, so the Lord be praised![10]

Of Mary Bough's two surviving children, John was sent to Blencowe Grammar School, near Penrith, and Ann Lucy (Nan) would soon go to live at Jordan Bank with Sam and Bella.

Later in May, across at Braco Castle in Perthshire, he wrote to Macbeath, who had been away in Spain, that he hoped to be in London by the end of the month. Bella had been left behind to oversee the workmen in the house. 'I've been painting in oil since the [RSA] Exhibition commenced, and intend to have one hundred and fifty things ready by the end of this year. This last week I have been back in watercolours. I think it a good practice to take a turn at either as the notion may suit.'[11] Clearly he was feeling the financial pressures of home ownership. Even for Bough, such an output must have made great demands on his physical and mental energies.

He also tried to find work with John Willis for a young Arthur

James: 'from what I've heard of him, and from what I know, I have the very highest opinion of him. So if Mr. W. can give him a berth, he'll do me as great a favour as I could wish for'[12]. The young man was probably the grandson of William James, who had been a radical Whig MP for Carlisle and knew the Boughs. Young Arthur subsequently spent some time at sea before going to Jamaica to oversee the family estates.

A deathbed reconciliation

On 26 June 1867, Horatio McCulloch died – but not before he and Bough had achieved some sort of a reconciliation. For when the Scot was dying, he is said to have asked Sam to complete an unfinished picture for him, to help his widow pay her taxes. Tradition has it that, among McCulloch's last words, were 'he's a good fellow, Bough, a kind fellow'.

Two other deaths from that year that must have also saddened Bough were those of Clarkson Stanfield and John Phillip.

On a lighter note, the Boughs were able to begin the pattern of entertainments at Jordan Bank that were to mark the last decade of Sam's life. In August, for example, the Sewells visited with their young family. Soon it became known throughout local society as a place for excellent hospitality – provided Sam took to you. As one regular visitor said, 'he was a kindhearted and delightful man to those he liked and to those who fell in with his ways. But woe to the snob or upstart who tried to patronise him.'[13]

At the Glasgow show that winter he wanted £300 for his oil of *St Monance – Fishing Boats going to Sea*. His other six pictures were all watercolours – ranging in price from £25 to £60.

The 1868 RSA exhibition also saw him showing a preponderance of watercolours, but also a major oil of Borrowdale, Cumberland, which he had priced at £150 – half of what he was usually asking for such large works; it was soon snapped up. Perhaps he was so strapped for cash that a sure sale at a knock-down price was preferable to the anxiety of being left with an overpriced masterpiece on his hands. The *Courant* particularly liked his picture of *North Berwick Harbour*, lauding it as

one of the finest watercolours in the exhibition. ... The great heaving waves dashing up in long and seemingly irresistible swell against the thick walls of the harbour, are quite marvellous in their truth and power of effect, and the dark threatening sky and grey

146

pitiless sea with the gaunt form of the Bass Rock towering up in the distance, are in Mr Bough's best manner.[14]

Sam had another dig at the Academy that February when he wrote begging 'most respectfully to call your attention to a breach of your regulations respecting the mounts of water colour drawings, and to object to the white mount upon the picture by Mr Mackry contrary to your instructions...'[15]. The fact that the painting of the Prince Consort was the property of the Queen had not escaped his notice – nor that of the RSA. Sam was up to his old tricks, trying to ensnare the Establishment into insulting the monarchy – shades of the Pursuivancy dispute. The Academy neatly sidestepped the whole issue on the basis of 'good taste', and the President 'undertook to explain this to Mr Bough in the Gallery.'[16]

A few days later Sam got his comeuppance when William Crawford ARSA wrote complaining about his treatment in relation to Bough. 'I beg to call your attention to Section VII Article 3 contained in the Book of the Constitution and laws of the Royal Scottish Academy which says "No Member shall contribute more than nine of their works to the Annual Exhibition".' Sam had eleven works on show and Crawford wanted to know why, 'as last year, this law was made an excuse for the rejection of two of my works in a manner not agreeable to my feelings.'[17]

In May he lost another of his old mentors with the death of John Wilson Carmichael. Gradually all the artists that Sam had admired in his youth were quitting the scene, promoting Bough and his peers to the fore.

Illustrating Burns, touring Germany

Bough made a further venture into the world of book illustration, providing four pictures for *Poems and Songs* by Robert Burns, published by William Nimmo, with engravings by Paterson. The scenes depicted were *By Allan Stream, Bruar Water, My Heart's in the Highlands* and *The Brigs of Ayr*. None of these show Sam on top form, but as usual his portrayal of the elements is masterly – only for the figures to let him down.

He also harked back to a former glory when, in July, he painted the *Review in Queens Park, Edinburgh*, notable for being the first at which breech-loaders were used.

That summer, Sam, Bella and the son of their friend Bailie

147

Alexander D. Mackenzie, a heating engineer and local builder, took a boat from Leith to Hamburg on the first step of a tour through Germany. The younger Mackenzie, who remembered Jordan Bank fondly for its 'balls and parties, Sunday dinners and smokes with Bough in his den'[18], acted as guide and interpreter for the trip. No sooner were they at sea than Sam had his watercolours out, trying to capture the effect of sunlight on the waves from the deck.

From Hamburg, they travelled down to Sondershausen, where Mackenzie had been brought up, and stayed a fortnight there before moving on to Dusseldorf to meet some mutual friends, the Bartels. Sam did a watercolour sketch of the Rhine, which he donated to their hosts. While there he was introduced to all the major German painters in residence there, but this proved no spur to his inspiration for, throughout the rest of the journey, he seems to have contented himself to pencil sketches.

Sam caused his hosts and his young friend considerable embarrassment throughout his time in Germany, mostly because of how he dressed. It was very hot, and Bough took badly to this. As ever he sought the simplest and most practical solution: a loose jacket, white baggy trousers, and a grey billycock hat from beneath which emerged a cabbage leaf to keep his head cool.

Moving on to Frankfurt, he created a commotion by wanting to inspect the muskets of the soldiers outside the guardhouse. This interest was misconstrued and, as he had no German and the soldiers no English, young Mackenzie had to intervene and avert a minor international incident.

After visiting a few more towns and doing some sketches in the Hartz Mountains, the party move on to Cologne before heading for Paris. Sam and Bella stayed there for about 10 days, while Mackenzie rented some rooms for himself, planning to stay longer. Inviting him to their hotel for dinner one evening, Mackenzie turned up to find only Bella waiting. After a further delay of two hours, they decided to dine without Sam. Finally at 10 p.m. he turned up with the explanation that he had spent the day at a fair in Asnieres, where he had lost track of time among the stalls and sideshows.

Once back home, he was soon declaring that the scenery in the Rhineland was no match for that of Scotland and the Lakes. Of the two sketchbooks he made of the trip, one was lost, and only one painting is known to have emerged – *A Swollen Torrent, Hartz Mountains* – which he showed at the next RSA exhibition.

He tried his luck once more at the RA with a watercolour of *Cader Idris*, as well as sending another – *Don Quixote* – to Manchester. He

also ventured across to the Leeds National Exhibition with yet another watercolour – *Huntsmen and Hounds coming Home – Frosty Night approaching*. At Glasgow that winter he had three watercolours and a major oil, *Loch Achray* priced at 200 guineas.

Overindulging and underachieving

Christmas 1868 seems to have been a particularly festive time for Sam. On 26 December he was writing to a friend in Aberdeen, David Fraser, who had the Granite Marble Works there:

> There's more eating and drinking going on here, than's good for some of us; and I myself (having dined out twice this week, and had a big dinner at home yesterday) feel that I would very gladly live on the County allowance, as administered in Smith's Temperance Hotel, on the Calton Hill, for sixty days, than be in for more feasting.[19]

Both men clearly liked their liquor and their food, but Bough was feeling distinctly out of sorts.

> The weather is sloppy and muzzy, and not particularly bright; but I manage to pull thro' a little work. I'm not well. A cold that I caught some time in the beginning of the season, still bothers me and keeps me miserable.[20]

Ill-health, especially colds and aches deriving from his insistence on sketching *en plein air* whatever the weather, was to feature increasingly over future years. Although something of an occupational hazard for all landscape painters, Sam seems to have found them particularly difficult to shake off.

Perhaps this explains why he was not on top form at the RSA show in 1869, when he had seven pictures on show. The major works were *Skiddaw from Wattenlath* (200 guineas asked) and *The Fortalice of the Bass* (priced at £150). The *Scotsman* found the former 'in many respects a beautiful picture', but felt that this time his oils were, overall, 'rather disappointing'. After describing the beauty of the scene represented, it commented that 'nevertheless, it must be said that the picture is weaker than is Mr Bough's wont'[21]. Once again, Sam was guilty of using his imagination, trying to create an impression rather than fine detail. The art critics of Edinburgh were not yet ready for such an approach.

March saw Sam writing to one of his childhood friends, David

149

Spedding, now 'Reverend', a contact re-established after many years. As ever, he offered an open house to old friends:

> I have had a queer life of it since we were boys together but I remember those days very freshly. Your dear kind mother who was of the very salt of the earth and your sister and yourself – I shall surely come and see you if I happen d.v. to be in Westmorland this summer but may I not anticipate that pleasure by seeing you and your wife in Edinburgh while the exhibition is open...[22]

Ignored and rejected

Denied his due recognition by the RSA, Bough looked for it elsewhere – only to be further thwarted. The 'Old' Society of Water Colour Painters was established in 1804 as a reaction to the Royal Academy's failure to give due recognition to this medium. Among its more accomplished members had been David Cox – recommendation enough for Bough. But his application for membership was rejected – an astonishing piece of parochialism directed against the man who by now was the leading watercolourist in Scotland. His use of bodycolour and his Bohemian lifestyle have both been advanced as reasons. Neither is an adequate explanation.

In May he was writing to his friend Edward Duval, making light of his failure but not ready to accept it as final. 'I tried on the Old Water Colour Society, but it was no go. Will you make enquiry, and let me know if you think I have a chance there?'[23] For a man not known to underestimate his abilities, this is an amazing display of humility. Perhaps it shows that, in middle age, Sam was at last realizing that the financial security he so needed for himself. Bella and his family depended on some sort of official recognition.

The same letter to Duval is generous towards the success of his friends – 'I'm glad to hear of the Governour's [Charles Duval] and your success in the RA. I did not send, and from what I hear I'm right glad.'[24] He did send to Manchester, however, through Duval, one oil (*Newhaven*) and a watercolour (*Norham Fair*).

Painting a panorama

That year he was back painting a panorama – this time of Scottish scenes for Duncan Maclaren of the St Andrews Hotel, Edinburgh. He

produced about 24 pictures (some harking back to previous works) that were then translated into the panorama by the Gordons, a father and son team of scenepainters. The finished product was shown in Edinburgh and then in other Scottish and English towns, without achieving the desired financial success. When it got back to Edinburgh, Sam stepped in with the assistance of David Duncan to touch up the whole production.

Captain Charles Lodder, a retired naval commander, part-time painter and long-time friend of Bough, remembered the event:

> The canvas was spread on the floor, and the artist had several buckets of colour washes. He used brushes such as sailors have for tarring a ship's side, with handles about three feet long! The artist meanwhile walking over the canvas, and daubing away like a man white-washing a wall. But the effect when hung up was astonishing.[25]

Sam had lost none of his skills as a showman.

He spent July and August back in his home town with Bella, staying with the Sewells and doing some preparatory sketches for the next year's exhibitions. This included a trip across to the Isle of Man. While in Carlisle, he was invited to dinner with the mayor and corporation at King Garth. Something of a guest of honour, Sam rose to the occasion by promising to leave 'some memorial of what I can do as a "decorator" to the Town Hall. I have had it in hand for a year or two, and it shall be completed.'[26]

That year, the Sewells were also at Jordan Bank. Other significant events were MacWhirter's decision to settle in London, and D. O. Hill, after another attack of rheumatic fever, finally resigning his post as Secretary of the RSA in favour of William Fettes Douglas.

At the Glasgow show that winter, Bough had five exhibits, including a watercolour of *Oak Trees – Cadzow Forest* for £100, an old theme but a high price for this medium.

Rapturous reviews, troubled times

As 1870 drew nearer, Sam was approaching his forty-eighth birthday. For most men a time of consolidation, regrets for a lost youth, an established position in society and the hope of a comfortable old age. Not so Bough.

1870 was to be a significant year for two new friendships, with a young woman and a young man, who in their different ways had an

important impact on Sam's life and our understanding of it.

First, however, there was the RSA exhibition, at which Sam showed only five works, but drew rapturous reviews. He was truly back in form. As the *Scotsman* put it:

> To Mr Bough and Mr Peter Graham must be assigned the highest position among our living landscapists – and of the two, Mr Bough is the more original. He is possessed of such a fertility of genius that we are always prepared for something new and remarkable from him and he has the rare faculty of rendering almost every sort of natural effect – with equal ease. Painting with dash and rapidity and showing a partiality for great scenic effects, he occasionally devotes too little time to finishing touches, yet he shows he can finish to great purpose when he sets about it.[27]

Bough was asking 200 guineas for *On the Solway* and £150 for *Canty Bay* ('a perfect picture, with a character of infinity about it worthy of Turner himself'[28]). *Skye* was already owned by the auctioneer, Thomas Chapman – 'This admirable picture is the least finished of the three, yet we would not wish a single touch of it to be otherwise than it is'[29]. The two others depicted a whale that had beached at Longniddry, a little piece of local history.

Unfortunately, he was also back in another sort of form at the RSA annual banquet. On 11 February, Sir George Harvey was complaining that Bough's behaviour 'had been such that it was impossible to let it pass in silence, or ignore it. ... He interrupted the speakers – hissed, made outrageous noises and ridiculous grimaces, and twice, he, as Chairman had to reprimand him, and it showed the feeling of the company strongly that he was long and loudly applauded for doing so'[30].

Perhaps this was the occasion he commented to friends after the President's speech, that 'All you have to do is to report Sir George Harvey verbatim to show the world what a damned fool we have got for a President.'[31]

Robert Herdman thought it was simply a question of whether Sam should be 'reprimanded, suspended or expelled'[32]. Secretary Douglas weighed in with the view that 'the language Mr Bough habitually used was so filthy, and he understood from many complainants that it was not less so at the dinner, that no gentleman could bear witness against him, it was so impossible to repeat his words'[33].

The Council thought he should be suspended, but decided to leave it to the vote of all Members and called a General Meeting for 16 February. When this failed to produce a clear course of action, the

Gypsy Encampment Near Furness Abbey, 1856, oil on canvas, 66 x 107 cm, *Sotheby's*

Whitekirk Sands, 1857, watercolour, 52.1 x 66 cm, *Dundee Art Galleries and Museums (Orchar Collection)*

View of a Manufacturing Town, watercolour, 19.1 x 32.1 cm, *British Museum*

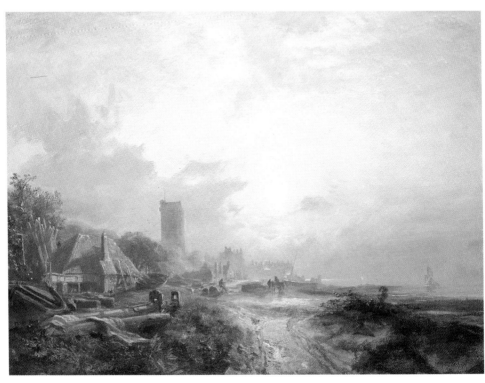

Dysart Harbour, oil on canvas, 44.5 x 59.7 cm, *Kirkcaldy Museum and Art Gallery*

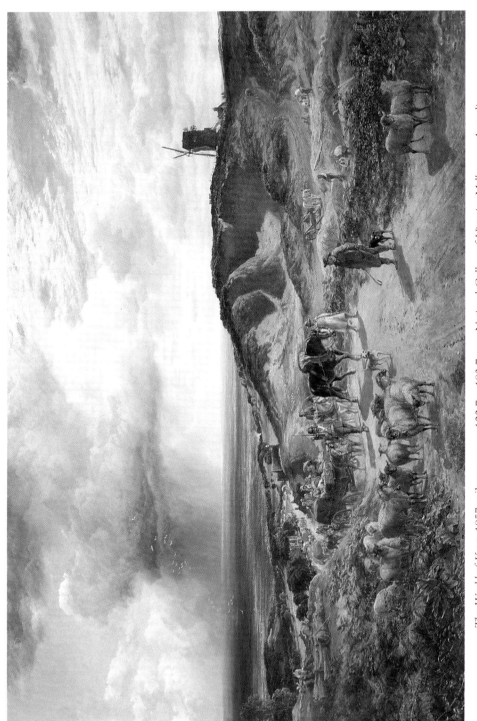

The Weald of Kent, 1857, oil on canvas, 122.7 x 183.7 cm, *National Gallery of Victoria, Melbourne, Australia*

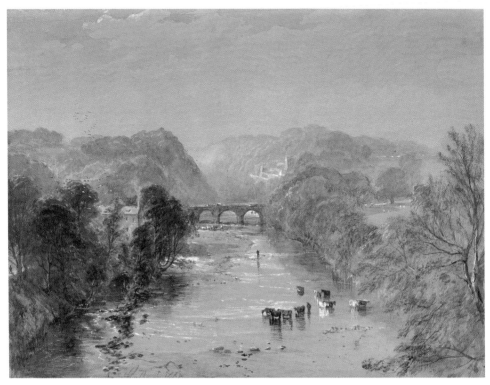

Barncluith, 1859, watercolour, 34.3 x 45.7 cm, *Glasgow Museums: Art Gallery and Museum, Kelvingrove*

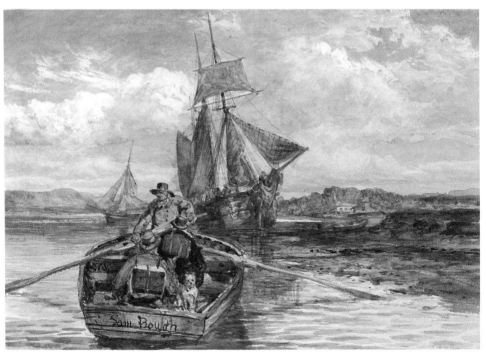

Glencaple Ferry, River Nith, watercolour, 18.4 x 26.7 cm, *Rachel Moss*

Royal Volunteer Review, 1860, oil on canvas, 118.1 x 179 cm, *National Gallery of Scotland*

The Dreadnought from Greenwich Stairs. Sun Sinking into Vapour, 1861,
gouache on canvas, 89.5 x 69.2 cm, *Private Collection*

Dunkirk Harbour, 1863, oil on canvas, 102.9 x 90.2 cm,
Glasgow Museums: Art Gallery and Museum, Kelvingrove

Edinburgh Castle from the Canal, 1862, oil on canvas, 101.6 x 127 cm, *Richard Green*

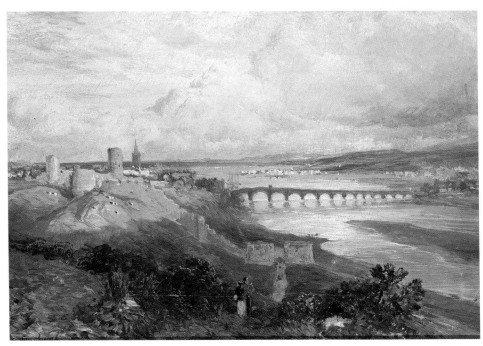

Berwick-on-Tweed, 1863, oil on canvas, 20.1 x 29.2 cm, *National Gallery of Scotland*

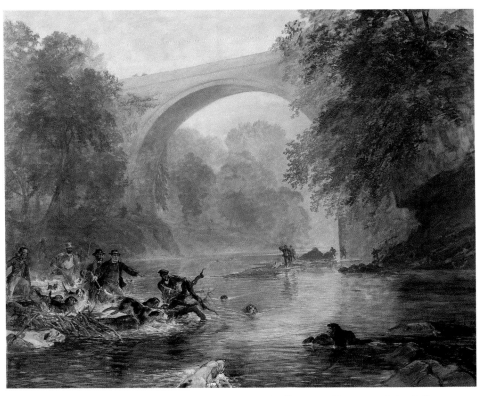

An Otter Hunt, oil on canvas, 94.9 x 118.4 cm, *Tullie House Museum and Art Gallery*

matter was referred to George Bruce, their law agent, to check with Sheriff Monro that they were acting 'strictly within the law, including the matter being laid before the Solicitor General and the Dean of Faculty'[34].

The debate hinged around the true meaning of 'suspension'. The Council decided it should exclude the Member suspended 'from all the Rights and Privileges of Membership except the claims on the Pension Fund'[35]. But still they wanted some authoritative legal backing for this view.

Then Bough tried to influence the proceedings. On 24 February, Cosmo Innes wrote from the Advocates Library to Sir George Harvey that 'I come on behalf of Mr Bough, but also with the hope of saving you and our friends of the Academy from a move that seems impending and which I am sure they would wish to avoid'[36]. A meeting was held with Innes, but this produced no resolution. By 7 March a final letter had been drawn up for the Solicitor General and the Dean of Faculty.

Early in April the matter remained unresolved, and Sam wrote to Secretary Peddie asking 'when and where can I see the Minutes of Meeting (General and Council) of the Royal Scottish Academy relating to "Mr Bough's conduct".'[37] Peddie responded by refusing him access to the Council minutes dealing with his case pending their being 'finally adjusted'.

On 18 April, Harvey wrote to Peddie suggesting that they arrange a meeting with the Dean of Faculty and Solicitor General, but that they should first call a meeting of the Council, comprising Noel Paton, Herdman, Douglas and Lees.

On 25 April Peddie reported to the Council all of the preceding events. The meeting had taken place with the exception of Douglas, and after hearing the evidence, the Dean of Faculty and Solicitor General said they would want to see Sam.

Then things went quiet so, on 11 May, the RSA asked Secretary Peddie to pursue the matter, but when it was discovered that the Dean of Faculty and Solicitor General were in London, it was agreed to delay any letter. By mid-June there was still no response, and it stayed that way across the summer months.

A durable friendship

Of more lasting interest to Bough was the enduring friendship he established early that year with a young amateur artist, Mary Tait. She

Gifted amateur artist Mary Tait first met Bough in 1870 and remained a lifelong friend. Private Collection.

first met him soon after she began copying paintings at the National Gallery in 1870.

> I remember him as a big, broad, picturesque-looking man, dark hair and a sunburnt face, always wearing spectacles. His dress usually a brown velveteen coat or light tweed suit. Very often a red handkerchief knotted loosely round his neck. He was very frank and kindly, though somewhat brusque in his manner and his hearty laugh could be heard as he met with friends in coming up the rooms. The second day of my copying he came in. I recognized him from his photo. He came directly and gave me some advice about a watercolour of Turner's I was copying. Afterwards he chose each picture in my course of study, at the same time lending me both oil and watercolours of his own, for work at home.[38]

'Home' was Somerset Cottage, a large rambling old house where she had moved as a young child with her sister and brother, Peter Guthrie

Tait. It was owned by their uncle John Ronaldson, a banker with a keen interest in the sciences. Bough would already know her brother through their mutual friends among Edinburgh's past and present academics, D'Arcy Wentworth Thompson and Fleeming Jenkin. At the university, Tait was Professor of Natural Philosophy and Jenkin was its first Professor of Engineering. Along with the Gamgees, and the theatrical people such as the Wyndhams, they helped make up the varied social and intellectual fare that was essential to Bough.

From that time until Sam's death, Mary Tait was a regular visitor to his studios and would go with him on his sorties into the art world, looking for engravings of the likes of Hobbema, Ruisdael and Rembrandt, who were his particular favourites.

She paints a telling portrait of another Bough, the artist who loved to encourage young talent – a perspective often overshadowed by the tall tales of his Bohemian persona. As she wrote later:

> I saw a great number of young painters who came to his studio for advice which he gave in the readiest and most cheerful manner. ... At exhibition times, many brought their pictures. Whatever he was engaged in he was at their service. He would take down his own picture, put up theirs and go over it carefully with them. ... He used to say after some of them left, "We won't see him again for another year!" His advice was often asked...[39]

On one such occasion, Sam advised a young man with talent to spend a few years in Paris studying drawing. At great sacrifice, the artist's widowed mother paid this – but the investment proved worthwhile, for the young man subsequently got a good job on one of the London papers. He sent Sam a black-and-white sample of his work, which Bough proudly showed Mary Tait. This pride in the young man's victory over hardship 'was the cause the story was told me, as Mr Bough never spoke of anything he had done'[40].

Spring 1870 saw the sale at Thomas Chapman's auction rooms of the finished drawings for the previous year's Scottish panorama. The 24 pictures brought a total of £383 5s, which Sam, with his usual need for hard cash, must have found helpful.

May brought the death of David Octavius Hill after a long battle against rheumatic fever. Hill's passing severed another significant link with the founding fathers of the RSA, but Bough's path to the status of full Academician was still not clear.

Travelling to Holland, a trip to Iona

Summer took Sam across to Holland again (from which emerged a fine picture of *The Boompjes, Rotterdam – Sunset*), but more significant was the shorter journey he made to Iona in July and August.

Bella was with him on this trip. Among a number of other interesting companions was a 20-year-old from a famous family, Robert Louis Stevenson. On 5 August Louis wrote home excitedly from the Isle of Earraid:

> Hitherto, I had enjoyed myself amazingly; but to-day has been the crown. In the morning I met Bough on board, with whom I am both surprised and delighted. He and I have read the same books, and discuss Chaucer, Shakespeare, Marlowe, Fletcher, Webster and all the old authors. He can quote verses by the page. ... Altogether, with all his roughness and buffoonery, a more pleasant, clever fellow you may seldom see...[41]

The young Robert Louis Stevenson, whom Sam befriended on the steamer to Iona. Lady Stairs House.

The talk drifted to Louis' theory that travelling alone opened up the prospect of new friendships. He was obviously pleased by the artist's response that this was because he had 'such a pleasant manner, you know – quite captivated my old woman, you did – she couldn't talk of anything else'[42].

In fact, Louis was no stranger to Bella. In June that year he had staggered into Jordan Bank, a levelling rod stuck in his leg. Bella had been duly solicitous for his welfare and fell for his youthful charm. The accident had happened while Louis was on a field trip with Professor Fleeming Jenkin in the Braid Hills. His mother recorded that Bella 'is very kind and takes a great fancy to Lou' – no doubt based on her son's recollection of the events. Sam also knew the Stevensons, for in the 1860s they had commissioned him to do a picture of Muckle Flugga, the most northerly lighthouse off the tip of the Shetlands.

Sam's party, travelling from Portree on the *Clansman*, had already been observed by another young man, Edmund Gosse, who likewise wrote home that they 'fairly took possession of us, at meals they crowded round the captain and we common tourists sat silent, below the salt. The stories of Professor Blackie and Sam Bough were resonant.'[43]

Some of the travellers, including Bough, Blackie and Louis, disembarked at Iona to spend the evening there. Sam at once started sketching, regaling them with tales (tall and otherwise) of his life in Cumbria.

At 5 p.m. they all headed off to the Argyll Hotel, hungry for dinner. When it finally arrived, the 'nice broth' advertized turned out to be rice soup. Sam spoke for all of them when he said, 'I imagine myself in the accident ward of the Infirmary.' Eventually the main course of fowl was served, and both men roared with laughter at its sorry appearance. 'There's an aspect of quiet resistance about the beggar that looks bad,' complained Sam as he sweated over carving a piece for Louis. In the end both had to admit defeat, but not before Bough complained to the landlady that the bird 'was the grandmother of the cock that frightened Peter'. They paid up and got out, hurrying back to Earraid.

Louis remembered that journey vividly: 'Sam Bough and I sitting there cheek by jowl, with our feet upon our baggage, in a beautiful, clear, northern summer eve'[44].

Earraid was the base for the men building the lighthouse on Dhu Heartach, a vicious outcrop of rock some 15 nautical miles south-west of Mull. By 1870 the once-tranquil islet had become a hive of industry,

with a great gash carved in the hillside where granite was quarried. One reason for Louis' journey was to report back to his father on the progress being made with the lighthouse, which he dutifully did.

Bough also inspected progress and produced a fine painting of the scene with the weather in a friendly mood, shown at the 1871–72 GIFA exhibition. In fact, the whole trip seems to have inspired the artist as, over the next five years, he painted a series of important pictures based on his sojourn in Iona. These included *The Western Shore of Iona*; *The Graves of the Forgotten Kings, Iona*; *Iona, looking North up the Sound of Mull* and *Tourists at Iona*.

A true Bohemian

While Gosse had to wait another four years to establish a friendship with Stevenson, Sam took to him immediately, and on their return to Edinburgh, the two kept in contact.

Given the family pedigree, there were strong pressures for Louis, despite his fragile health, to follow in the footsteps of a dynasty of great lighthouse builders. He had experienced the laboratory of Peter Guthrie Tait and the engineering lectures of Fleeming Jenkin (a family friend) – both among the most enlightened scientific thinkers of their time. All to no avail.

The real influence on his life was cousin Bob Stevenson, mercurial, fresh from Cambridge and wanting to be an artist. Between them they developed a concept of 'the true Bohemian' that might have been devised with Bough in mind. He was the man who

> lives wholly to himself, does what he wishes, and not what is thought proper, buys what he wants for himself, and not what is thought proper, works at what he believes he can do well and not what will bring him money or favour.[45]

The rest of the definition was pure Bough.

> A Bohemian, for as poor as he may be, is always open-handed to his friends; he knows what he can do with money and how he can do without it, a far rarer and more useful knowledge; he has had less, and continued to live in some contentment; and hence he cares not to keep more, and shares his sovereign or his shilling with a friend.[46]

Lack of cash in hand and a sense of enquiry led Louis into some of the

less respectable drinking houses and the brothels of Edinburgh. Apart from sexual adventure, it was part of finding himself as a person, confirming that literature and not engineering was his guiding star.

Sometimes, when Louis was ducking out of home pressures at Heriot Row, he would bunk off to Swanston Cottage. Then the two men would meet at Buckstane Farmhouse, midway between their respective homes, to enjoy Mrs Romanes' scones and talk about anything and everything.

At other times, they would drink in one of the howffs Louis frequented. Their companions were a motley group, the 'afternoon society' of serious drinkers. This included Henri Van Laun, French teacher and author; Samuel Edmonstone, the publisher; Charles Mackay, a jeweller; Victor Richon, 'scholar and gentleman'; and another Frenchman called Eugene Marie Chantrelle, who turned out to be something of a serial killer. (Years later Louis would describe them all as 'victims to the kindly jar' and compare their capacities unfavourably with his current companion, King Kalakaua I of Hawaii, who would down six bottles of champagne in the afternoon 'as a whet for dinner'[47].)

Trying times

As an eventful summer passed from autumn into winter, neither Bough nor the RSA knew the outcome of his proposed suspension. Sam got on with business as best he could, and at the GIFA show that year had four exhibits, three of views in Cumberland and one of the Thames at Hungerford.

In November, the RSA managed to engage the Dean of Faculty and the Solicitor General in discussions once again, and finally got them to support the proposed suspension. This information was put before a General Meeting of the RSA on 23 December. The minutes record that, having considered the advice given by such learned referees, the meeting was:

> desiring only to protect its members from annoyance and its meetings from unseemly incidents and having regard to the fact that the suspension has now been virtually in force for a period of nearly nine months resolves to restore Mr Bough to his position as an Associate on his making such an apology as the circumstances, including the security of the Academy's dignity and comfort in the future, seem to require.[48]

By Christmas Eve, Bough knew that things had gone against him, as he wrote to Macbeath about the furore:

> Only think, the Solicitor General and the Dean have, I am told, given a decision against me, and all in favour of the Academy. What a d———d business. I'm vexed enough but it hasn't interfered with my work ... I've had no communication from the Academy, with the, to them, glad tidings, but I suppose I shall hear on Monday.[49]

On 28 December, Secretary Peddie drafted a letter to Sam detailing the final verdict:

> It is my painful duty to inform you that at a special General Meeting of the Royal Scottish Academy held on 16 February last to consider complaints of improper conduct on your part, especially on the occasion of the Annual Dinner on the 10th of the same month the following resolution was unanimously passed: "That in terms of the Laws, Art. 32. Sect. 2 Mr Bough was suspended during the pleasure of the Academy."
>
> I have also to inform you that at a General Meeting of the Academy held on 1st March 1870, the above minute of the official meeting of the 16th February, having been read and approved of the following resolution and unanimously passed: "That the Academy in coming to the resolution to suspend Mr Bough have done so on the understanding, and as advised by Counsel, that suspension carries with it deprivation of the following rights and privileges viz.: right of access to Academy's Library, Books or Pictures or to inspect the Academy's Minute Books, or to have his work exhibited at the Annual Exhibition or to avail himself of the three days for varnishing viz. upon any works of his which may be admitted to the Exhibition or, finally to participate in the funds of the Academy. At the same time the Academy is desirous if it is competent to it, that Mr Bough should notwithstanding his suspension be admitted to share in the privileges of the Pension Fund on the same conditions as other Members."[50]

On 29 December, Bough wrote back to Peddie:

> I have to acknowledge your letter of this date intimating my suspension as a member of the Royal Scottish Academy. I should have been glad had an apology which Messrs Cosmo Innes, Forbes Irvine

160

& Professor Lorimer were formally empowered to make on my behalf been offered to the Academy and accepted as of course it would have been more satisfactory to me to have been permitted to express the regret I afterwards felt for the unfortunate circumstances which happened on the occasion in question.[51]

Bough's letter was submitted to a General Meeting on 11 January. His apology was accepted, and on 13 January Peddie was instructed to write 'intimating removal of suspension and restoration of the privileges of an Associate.'[52] That meeting had also addressed the ticklish problem of the next – by now imminent – banquet of the RSA. Should they take the risk and invite Bough to it? James Drummond moved that he should be asked, and was supported by Peddie. Harvey sat on the fence, hiding behind his Presidency, but the motion was carried anyway.

McTaggart, now a full Academician and elected to the Council, recollected that the action had little detrimental effect on Bough's standing. 'In reality he was hardly suspended at all. Before all the preliminaries were gone through, legal authority obtained, etc., it was December before intimation of his suspension could be made. He apologised in the same month and was at once re-instated.'[53] The minor irritation (to Sam) would have been more than offset by his election as a member of the Glasgow Institute of Fine Arts, that same year.

On 16 January, having been informed that he was to be reinstated, Sam wrote to the RSA with his 'best thanks for the frank and favourable view they have taken of my case'[54].

Despite the dispute, the press still sang his praises. But Sam remained circumspect about all the plaudits his pictures continued to receive, as he indicated in a letter to Thomas Sewell, dated 18 March 1871: 'All newspaper criticism should be taken with some little reservation – here it's the fashion to praise everybody.'[55]

Sewell had written with news of another family bereavement in the death of Sam's cousin, Tom Wright (Jane Sewell's brother), and his response shows both Bough's essential humanity and lack of cant. 'I'm really sorry that poor Jenny's kind heart should be wrung by this. I can't say calamity for poor Tom had so thoro'ly estranged himself from us all that he had passed as far as I was concerned into an utter stranger. I don't wish to say anything hard about the poor little beggar but we have no reason to grieve for him...'[56]

As usual in these epistles, Sam ended with an exhortation to his friends that they should visit him. At some point that year the Sewells

did, taking their young family with them. In those days, Jordan Bank was at the very edge of Edinburgh, with the Toll Bar and Braid House – a good mile away – as the only buildings in view. Sam was especially proud of his terraced garden boundaried by a bramble-covered bank overlooking the kitchen garden. Of a morning he would be up early, making a tour of his estate, watching the flowers grow, before setting off for his studio.

He was better represented at the RSA show the following spring, with nine works portraying Scottish and Cumbrian views. Again, he was on top form: 'Mr Bough's landscapes have, as usual, a dash and a freedom that none of his brethren can come up to, they show an intimate acquaintance with nature in her most diverse aspects and a knowledge which seems instinctive, of how to produce any given effect.'[57]

St John's Vale, Cumberland drew particular comment: 'It is seen at a glance to be a work of genius both in conception and execution'[58]. Even better was *A Sunny Day in Iona*:

> Few artists could have made a good picture of Mr Bough's materials. ... The spirit of this scene, under a glow of midday sun not too bright for a summer day in Scotland, has been transferred to canvas by Mr Bough with a knowledge of effect that, had he produced nothing else, would stamp him as a man of genius.[59]

Mary Tait recalled that the whole sky was done in a single painting 'scarcely occupying an hour'[60].

The National Census carried out at Jordan Bank Villa on 3 April 1871 shows an interesting group in residence. Apart from Sam (aged 49) and Bella (47), there is Nan their niece (17), described as a 'scholar'; two servants – Georgina Simpson (26) and Margratt Harris (18) – plus an unexpected visitor in William H. Nutter (50), landscape painter of Carlisle. Clearly Sam kept his links with the artistic friends of his youth.

On the fringe of society as it was, Jordan Lane had one essential commodity – the local public house, a favourite watering hole of carters, thirsty after a long journey to the Scottish capital – and Sam. On the corner of Morningside Road and Canaan Lane stood the hostelry variously known as the *Rifleman*, the *Volunteer Arms* or the *Canny Man's Arms*. The 'Canny Man' in question was James Kerr, the owner, and the 'Volunteers' were members of the Edinburgh Volunteers (to which Bough had belonged briefly) who practised their shooting skills on nearby Blackford Hill. When new premises were

opened in 1871, Sam was commissioned to use his artistic skills to paint an oil of a rifleman, and followed this up with a double-sided oak inn-board on the same subject.

That summer, Sam ventured once more to exhibit at the Royal Academy, with *Sunrise on the Coast: North Berwick*, and won wider recognition when his fine *Borrowdale* of 1868 was engraved for the *Art Journal* by William Richardson.

At the GIFA exhibition that winter, Sam showed just four works. Apart from the *Dhu Heartach Rock*, there was also *Port-na-Coriah, Iona*, accompanied by a poem from Professor Blackie commemorating St Columba's landing in 650 AD. Sam wanted £157 for this.

As the year drew to a close, tragedy struck again, with the death from tuberculosis of his nephew, John James Bough, aged just 21. Since losing his brother Joseph, Sam had taken a keen interest in his children's welfare. He had paid for John's schooling, first at Blencowe and then under a Mr Irving. As he approached manhood, John had grown dramatically, reaching almost 6ft 5in. At first, he was apprenticed to the engineering firm of Pratchitt Brothers, but then went to work for Richard Sowerby at Harraby to learn farming.

When he heard of John's death, Sam wrote to Mary Bough on 26 December:

> I pray God may give you strength to bear this heavy load now put upon you. ... You must write and tell me on which day this week the Funeral will take place, and I will come to it. I enclose you a cheque for ten pounds, which you will get cashed at Carlisle, and with the money you must pay such necessary funeral expenses as will have to be incurred.[61]

This is an unlauded side of Bough's personality. Where he could, he did good by stealth and, where his family were concerned, never shirked his responsibilities.

Sometimes a more direct approach was needed, as in February 1872, when he wrote to the RSA Council begging them to help the poverty-stricken family of MacLeod, an animal painter whose death had just been announced. It worked, as £25 was awarded to the widow.

As ever, he enjoyed pricking the pretentious. So when an intense journalist visited his studio, Sam advised that he was painting *The Destruction of the Cities of the Plain* with a criticism by Dr Guthrie – all of which duly appeared in print, despite being total fiction.

High prices and a helping hand

His major picture for the spring 1872 RSA show was *London from Shooter's Hill*, an important work reminiscent of *The Baggage Waggons* of 1849 in its scale and treatment, with soldiers and their waggons marching towards the distant city, but this time 'under a sultry summer sun'. The art critic of the *Scotsman* could identify Charlton Park, Greenwich Park, Greenwich, the Isle of Dogs, Woolwich Common, with St Paul's in the distance. 'Along with this literal accuracy, we have the highest artistic qualities. The sky is, as usual, excellent.'[62]

John Nesbitt, a friend and fellow artist, told how Sam had produced it from a few scratches in a notebook which he then filled out from memory. The original sketch had been made during a walk with his friend Macbeath.

On a different scale altogether is the small watercolour dated April 1872 of *Braid House near Morningside*, showing the place where Sam and Robert Louis Stevenson passed so many happy hours.

Bough was now beginning to benefit from consistently high prices for his paintings. Captain Lodder found that when the price of a small picture reached £30, he could no longer afford his friend's work. The comment is borne out in a letter from Sam to Macbeath at Old Charlton in Kent. In it he refers to a commission he has just finished for a mutual friend, John Willis. 'A good pen'orth he gets in it. I could have sold it easily for £200, again and again.'[63]

That summer he exhibited two pictures at the RA – *A Sunny Day in Iona* and *Winton House, East Lothian* – *A Frosty Morning*, the home of his friend, Lady Ruthven. Perhaps this was the time that Millais promised to look after his interests and see justice done. As Sam wrote jokingly to Macbeath, that 'may mean, hung as high as Haman.'[64]

On his way back from London that year, he stopped off at the Sewells in Carlisle, and a few months later, they repaid the visit with a trip to Edinburgh.

In July, Sam's oil of *Burgh Marsh* was raffled by Thurnams in Carlisle, tickets being five shillings apiece and the proceeds going to the Carlisle Dispensary, struggling as ever for finances.

During November, his generosity was again being called on to help out the widow and family of an acquaintance from his Manchester days. Henry James Holding had died of consumption in Paris at the age of 39, leaving his family destitute. Ford Madox Brown and Dante Gabriel Rossetti were among those who donated drawings for sale to help them out. William Percy wrote to Bough, asking him to do

164

likewise, and Sam willingly obliged – but with certain provisos.

I once met poor Mr. Holding, and am sorry to know that his family are ill off. I will send a drawing to help, either next week or before Christmas; but I should like to feel sure that the drawing would go the right way.

I once before sent some drawings to Manchester, for the benefit of an artist's widow, and the gent I consign'd them to stuck to them, and liberally handed over to the poor Lady a five pun' note.

Say, must I send the drawing to you? There's one on the committee I wouldn't trust as far as I could throw a Bull by its tail!

I am pleased to hear from you, for I still remember old and pleasant times; but I seem to have drop'd out of my old Manchester connection altogether. Poor old Duval is gone! But I see my gifted friend Mitchell is still foreward; and Selim [Rothwell] has taken another to his Harem, the blessed old Turck.

Is there any chance of your coming north? I should be very glad to see you. I enclose you my effigy [a photograph]...[65]

The letter suggests something of a sea-change in Sam's links with Manchester, now that old Duval was dead. Bough would have felt that loss particularly keenly, given the length and depth of their friendship. But true to his word, within a few weeks, he wrote back to Percy:

I have sent off this afternoon, addressed Brazenose Street, the drawing for Mr. Holding's family. I don't put any price upon it, but it should fetch twenty guineas, as I have sometimes seen drawings of mine, of that size, fetch at auction.

The inscription on the dexter corner [Painted for the benefit of the Widow and Children of the late H.J. Holding] is not intended for any of the committee; but if I had put it on some drawings I once sent to a friend to be sold for the benefit of poor George Anthony, his wife and family would have been none the worse. And should you see a gent from Oldham, which his name it is Mattinson, call his attention to the said inscription.

I wish you would come down here for a few days, I would be really glad to see you. Generally I look upon artists as shit, but I have in your case, dear Percy, made an exception, which I hope you'll appreciate. Give my remembrances to the Gifted One, and if you see Selim kick his arse for me...[66]

As so few of Bough's own letters survived him, it is rare to see him

express himself so forcefully – yet this is much more like the real Bough, talking to an old and trusted friend, than many of the other 'polite' letters. And the drawing did well for the Holding family, being bought for £35 by Frank Hampson, a solicitor.

Sam was again in print that year, with some woodblock engravings by W. Ballingall of his east coast scenes used to illustrate *The Shores of Fife*.

At the winter GIFA show he had just two works on display, but wanted high prices for them. The oil of *The Clyde from Bishopton* was available at £250, while his watercolour of *Stye Head Pass, Borrowdale, Cumberland* was priced at £200.

Eight of his works were on show at the RSA that year, although seven already had owners. The eighth – *The Western Shore of Iona – Here St. Columba landed A.D. 565* – was available at £250. And at Dowell's auction rooms, an earlier painting of *Whitehaven – Sunrise* fetched £200 – ten times the price when it had been originally painted. Again, the prices asked and obtained indicate a significant rise in his popularity.

In March he was writing to the son of a friend, John Fraser in Aberdeen, apologizing for not being able to get to his impending marriage: 'I am so hard push'd with my London picture that I can't possibly get away'[67]. As a wedding present he sent the bride a black-and-white drawing of Tam o'Shanter pursued by the witches.

Working out of doors

Bough was down in Caldbeck in May, sketching the church before slipping over to see Sammy Hallifax at Sebergham. He complained to Thomas Sewell about the weather, but waxed lyrical about the residents of Caldbeck. 'They are a nice moist lot here from morning till dewey eve and on till the witching hour of night. When the policeman tells them to shut up shop the bibbing and lushing goes on – and the fratching and chaffing matches are not to be described...'[68]

In June he was across in Anstruther, where he drew a portrait of old Mrs Robertson, the landlady of his usual watering hole. He was up in Auchintoul in July, fishing and sketching; he planned to stop off and see the Frasers in Aberdeen on his way down to London. Sam and Bella stayed with her family, while Nan went back to Carlisle, to the Sewells. One of the products of that trip was *On the Thames: Thunderstorm clearing off*, shown at the RSA the next year.

On 9 August, Sam was writing to the Sewells in a contented frame

of mind. 'I made up my mind this summer to work out of doors, and I have so far done so. But don't you think that I shall miss my diggings in Cumberland ... I go back to Scotland as I want to do some Braemar stuff, and it's cheaper to go back to Aberdeen by a return ticket than to journey any other way.'[69]

In those day, Bough was one of the best customers of the railway companies, with his rapid travels up and down the whole country. Without them, his hurrying through life would have been at a much

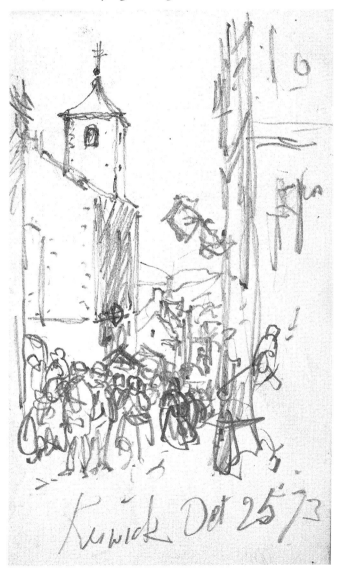

Sketch of *Keswick* made in October 1873. Tullie House Museum and Art Gallery.

more leisurely rate. The steam age was ideally suited to his restless energy.

The same letter also refers to a drawing of the old oak parlour at Thornbarrow, wanted by a Mr Robinson. This was one of a series of pictures he had painted of Thornbarrow Farm, near Hutton in the Forest – a place he had reason to remember from his youth. When Mr Robinson's father razed the house, the oak panelling was taken to Green Lane, Dalston, and presumably Sam's drawing was needed to show how it had all fitted. 'Tell Mr Robinson ... that I will gladly help him fit up the old stuff – it was a pity that his father pulled the old home down. A very small matter would have put it to rights.'[70]

October saw him at the George Hotel, Keswick, trying to cope with the dramatic changes in the weather. As he wrote to the Sewells:

> Today it's been simply damnable. I lost my hat near the Grange Bridge in Borrowdale – a sudden puff of wind sent it skimming into the middle of the stream and the water was too big for me to try wading so I let it go. ... The wind and hail bullied me as I have never been bullied before. Nevertheless I got two scrambles that will be useful.[71]

He was back up home in November, apologizing to Thomas Sewell for not having written sooner. McMillan the engraver had sent Sewell a picture of Cadzow for Sam to sign, which he did – thereby enhancing its value. When Sam asked for payment for the signature, the owner demurred and, through Sewell, Bough appears to have bought it back.

Sam was finding a growing demand for his work as book illustrations. That year, Blackie published six engravings of his paintings representing 'authentic views of important Bible localities after Van de Velde and earlier artists'. The RAPFAS collection also contained an engraving of his *View from Richmond Hill* to illustrate Scott's *Heart of Midlothian*.

An instinctive felicity

A hectic year ended at the GIFA show, with Sam asking a dramatic £750 for *St Monance – Day after Storm* (a price too high) and £150 for *Cadzow Forest – Spring-Time*. Of the former, one critic saw the influence of Muller in its broad treatment:

In this picture the artist shows himself, as usual, a thorough master in his own style. He expresses all he aims at with the utmost ease and precision. He has an acute perception of the pictorial in nature and though defective in his details, he accumulates objects so that the eye does not too exclusively rest on any one thing. ... There is a coarseness and want of delicacy, especially in the sky, that must strike everyone. There is also a chalkiness in the lights and an opaqueness in the shadows which are not pleasant. Though Mr Bough repeats himself, as indeed all painters do, it is with constant variations, not unlike that of a skilful musician on a familiar air, and always with an instinctive felicity which avoids dullness.[72]

At the RSA exhibition in 1874, he had nine pictures, including a watercolour of *Skye* owned by Bella and an oil of *Crosthwaite Bridge, Cumberland*, for which he was asking – and apparently got – £400. Bella further distinguished herself as a patron of the fine arts with the loan of a marble of *Girl and Tortoise* by George A. Lawson.

In February he produced a number of small watercolours, including *View in John Pettie's Garden, St John's Wood* (presumably sketched on an earlier visit) and *Cloud Effect* plus pencil sketches of *Election Time: United We Stand*; *On the Beach, Musselburgh* and *Otter Hound*.

April saw Sam and Bella celebrate their twenty-fifth wedding anniversary with a great gathering at Jordan Bank Villa. They seem to have sorted out their respective lives long before this. Bella had no great interest in art, and Sam, through the device of his studio in Hill Street, managed to keep the two parts of his life – work and home – successfully separated insofar as he wanted this, in many ways still clinging to his bachelor habits. She sometimes felt aggrieved at his commitment to his own family and Cumbrian ties; he tolerated the London trips to her family as part of marital duties.

But it would be a mistake to underestimate the affection that remained between them, or his concern for her welfare, should he ever cease to be able to provide for her. Across a lifetime he had come to understand that he could never hold onto money – it was alien to his nature. So, as a safeguard against outrageous fortune, he had begun to invest in material possessions – jewellery for Bella, pictures, china, art, furniture, prints, books – almost anything that might accumulate in value and protect her and his family against the day when he could no longer pay the bills.

In August he had a letter from an old friend who was to play an important part in his future – Daniel Macnee, writing from Glasgow. One of the few to resist the exodus to the Scottish capital, Macnee had

demonstrated that talent can win through irrespective of fashion. Even greater times were ahead, but the warmth and the humility of the man shines through his letter, dated 14 August 1874.

> Have you a small sketch or engraving of a reasonably distant [view] of Edin. which you could kindly lend me, I think a view from the north or southwest, or north west, or any point that would come well in the back ground of this whole length portrait which I here sketch. I have been labouring at the trees and the sky and wishing I had your ready hand, skill and knowledge to get over it cleverly, but not having those I work lumberingly and clumsily, however as I have promised to get the picture finished at once I shall esteem it a favour if you can lend such a view of Edin. as I mention, I don't care how slight it is.
>
> I learned you were in London the day you left and was sorry I had not had the luck to meet you. I heard your picture [London from Shooters Hill] very much praised by several RAs... I send this to Edin. on the chance of your being there but I daresay you are off somewhere getting a fresh supply of nature for the season. Are you to be in the west? We shall be delighted to see you and Mrs Bough if you come...[73]

At the peak of his powers

As 1874 drew to a close Sam was at the peak of his powers, but still learning. In the wider world of art, significant others were coming to the fore, not least the Impressionists, who had their first group exhibition in Paris that year, and, in Holland, the Hague School, whose works were now appearing in Scotland.

The great champion of the Impressionists, the art dealer Durand Ruel, had opened a London gallery in 1870 that survived until his financial crisis of 1875. And during the hostilities of the 1870 Franco-Prussian war, Daubigny, Monet and Pissarro had taken temporary refuge in London. Although the French art system was very different from the British, Bough and his artist friends were well aware of these works from their travels to continental Europe.

Both sets of artists suffered the same complaints from their respective art establishments – lack of 'finish'; too much emphasis on catching the spirit of the moment, rather than the mundane literalness of every detail; and a choice of subject that lacked any overtly heroic or classical features. But whereas the French banded together in an identifiable group, Bough and his younger friend, McTaggart, ploughed individual furrows.

The situation symbolizes the difference between the two political systems. In France, both before and after the proclamation of the Third Republic, the State played a significant role as an arbiter of taste and promoter of national pride through the fine arts. In Britain, the State's interest centred largely around design and manufacture, with fine art being left to the vagaries of the market place. In this context, Bough continued to seek high prices for his best works, asking £500 for *Crosthwaite Bridge, near Keswick*, exhibited at the GIFA show that winter.

Of the Hague School, Sam would have seen examples of their work in both Edinburgh and Glasgow during the 1870s. Like his friends McTaggart and Orchar, Bough was an admirer.

'I am lucky in getting it...'

The ultimate vindication of Bough's persistence in Edinburgh came in 1875. He was finally elected a full Academician of the RSA, to fill the vacancy left by the death of William Smellie Watson. But it was far from unanimous. His brief note home to Bella on 10 February, immediately after the election, says it all:

> Dear Bellum,
> The Election is over and I am lucky in getting it – 13 voted for me, 5 against. I will try to be home at 6.
> Sam[74]

Bough was right. He was lucky. There were still plenty in the Edinburgh art establishment who would have denied him justice. In celebration, he produced two small watercolours of a *River Scene in Cambridgeshire* and *Dingwall, Rosshire* both dated 10 February and signed 'RSA'.

The next day he headed back to Carlisle – significantly – to be with his old friends. Sam knew that the honour had come too late in his artistic life – he was now 53 – to make much difference, although it guaranteed a reasonable pension for Bella if he died before her.

At the RSA show, he presented nine works, with *Peel Harbour, Isle of Man* on offer at 450 guineas and *Eagle Crag, Borrowdale* available for £300. He followed this up with *Yanwath Hall, Westmorland*, along with a watercolour of *Canty Bay* at the RA. Of the three pictures he sent to Manchester, one was of *Yanwath Hall*, for which he wanted £350.

Another small watercolour from that year was *The Trossachs, near*

Trossachs Hotel, indicating a visit there. And, in October, he produced a watercolour of *Druid's Circle Near Keswick*. In general, Bough's movements that year are harder to trace than usual.

Perhaps in celebration of his friend's success, Daniel Macnee painted a portrait in oils of Bella, later to be engraved, showing a middle-aged woman, well fleshed and fashionably dressed, with a confident, almost self-satisfied smile.

Disaster at Cellardyke

On 26 October, Secretary Peddie was writing to Bough, pointing out that, as an Academician elect, he should have submitted his Diploma work by 1 October. He risked having his election declared void if he could not show good reason for the delay.

On 1 November Sam wrote back full of mock humility, claiming to have been 'utterly ignorant of the existence of the law', apologizing 'for having inadvertently done anything ... negligent or disrespectful'[75]. Within a week he had presented an oil of *Edinburgh from Bonnington*, looking for all the world as if it was worked up in a hurry from a sketch of a much better painting of the same name. (It was unanimously accepted, and by 21 December, Sam was already a Council member.)

November also saw tragedy strike one of his favourite haunts on the Fife coast. The herring fleet from Cellardyke and St Monance had been fishing off the Norfolk coast when, returning from Great Yarmouth and Lowestoft, it ran into a storm and five boats sank, with the loss of 37 men. An appeal fund was launched by the local MP, Sir Robert Anstruther, Bart., and Sam was among the first to respond. He 'most generously offered his magnificent painting of *St Monance* ... to be raffled for in Edinburgh and the value (100 guineas) remitted to the Trustees of the fund'[76]. The painting was a watercolour, showing a stormy scene of fishing boats putting out to sea. Other artists soon joined in, spurred on by Bough and his drinking friend, Samuel Edmonstone. In all, the fund raised £7,000.

At the GIFA show that winter, he harked back to his first meeting with Robert Louis Stevenson in *McLean's Cross, Iona*, asking £200.

1876 started badly for the RSA with the death of Sir George Harvey on 28 January. Given his earlier judgement of the President, Sam can hardly have been distressed, but when, on 17 February, his friend Macnee was elected as the replacement and finally moved to Edinburgh, he would have been well pleased.

On 21 February, he was writing to Macbeath with the latest news – the weather was terrible, both he and Bella had colds, and young Nan had been bundled off to Carlisle with whooping cough. A mutual friend, W.H. Logan, had taken over a theatre in Edinburgh, which Sam thought would do well. He was hoping to get down to London in May, in time to watch the Derby. And James Faed was planning to engrave Bella's portrait by Macnee.

For the 1876 RSA exhibition, Sam presented seven works, including his Diploma picture. All bar one already had a home. The most dramatic was *The Rocket Cart*, showing a ship foundering off the Isle of Wight, while local fishermen and women struggle in the face of the gale to push the rocket cart into place to attempt a rescue. Again, Bough is at his best when showing humanity struggling against the elements. He also played patron of the arts again, lending his cabinet oil picture of John Linnell's *The Potato Field* and John Pettie's *Mrs Taylor* (possibly Bella's mother). He also showed – for the last time – at the RA, with *Kirkwall Harbour, Orkney*; he had two pictures at Manchester, and *A Rocket Cart* at the Liverpool Autumn Exhibition.

Bella Bough from Faed's engraving of Macnee's picture (1875).

Home at Jordan Bank

By now Jordan Bank Villa had become a major focus of Bough's life. They had acquired the two adjoining properties, producing a frontage of around 100 feet, with 22 rooms, including a 36-foot conservatory, with fig, myrtle, ivy, clematis and jasmine, looking out across a croquet lawn and flower garden terraced into a fruit and vegetable garden, leading into the fields of Egypt Farm. Sam took a great pride in his garden and would rise early to walk around it before breakfast, no matter how heavy the previous evening's celebrations had been. As Bella said it was 'open, spacious, free – an ideal artist's home'[77].

Indoors, she had a music room, in which hung Sam's wedding present, *Tanziermunden on the Elbe*, and whose ceiling had their initials carved in it. Sam had his den, lined with Hogarth prints, which became something of a centre of social life for Bough's circle of male friends and acquaintances, especially on Sundays after dinner. He

Sam Bough and his family in the garden at Jordan Bank. Tullie House Museum and Art Gallery.

174

produced a small pencil sketch of himself in his smoking room entitled *On the Lord's Day, April 23rd, 1876*.

Over these years, Jordan Bank Villa was also the scene of many dinner parties, entertaining up to 100 guests. They had five public rooms, including a dining room decorated in gold and heliotrope. Sam shone as host on such occasions, putting everyone at ease, but was at his best on more intimate get-togethers with a few friends. Sometimes Bella sang and played her own accompaniment on piano. At other times Sam would sing in his deep bass voice and play the violin or cello.

He also revelled in having children around the house. At one children's party Sam had his artist friend John Nesbitt dress up as a bear, with himself as keeper. He beat a drum, proclaiming the bear a very intelligent animal that understood his commands. And to demonstrate this, Nesbitt rolled around on the floor as requested. D'Arcy Wentworth Thompson's son, Dadu, thought the parties at Jordan Bank 'more "good fun" than anywhere else'[78].

Sam also surrounded himself with animals. He told Mary Tait that as a young man he had always had dogs, sometimes very big ones. 'He used to say he would not have big ones any more, as when they were old he couldn't "make of" them on his knee as he could with little ones! At Jordan Bank there were five dogs and two cats, a parrot and for a time a raven which I think was accidentally killed...'[79].

In June, July and August, he was back on the Fife coast sketching, possibly with Robert Noble, a fellow artist – the two are remembered in Buckhaven around this time. Perhaps this was also the trip that produced a watercolour of *St Monance* that shows a marked loosening up of what was already a broad style. It is a brilliant essay in freedom, yet crammed with detailed observation. A picture like this clearly demonstrates McTaggart's debt to Bough.

Back in Edinburgh, W. H. Logan wrote to Macbeath in August:

Sam Bough I have frequently seen of late parading Princes Street, with an immense straw hat, suggestive of Obi or Three Fingered Jack. ... On the day on which the inauguration of the Livingstone statue took place – one day last week – Howard and Saber met him, as usual, in Princes Street, in his eccentric costume; and they were in the act of conversing with him, when he espied a swellishly dressed gentleman, accompanied by a lady passing. With the utmost nonchalance, Bough stopped them, and taking the swell by a button of his coat said, 'What 'ill ye tak to let me pent you? I could mak money out of you, (I know I could!)' It is needless to say that the swell was

indignant. Meanwhile, Howard and Saber brushed [past] lest a scene should ensue.[80]

He made another strong showing at the RSA in 1877 with seven paintings, including *The March of the Avenging Army*, showing the invading Scottish army crossing the Solway after the victory at Bannockburn in 1314. A later critic thought it 'marvellous in imaginative power of conception and superb force of handling. Light upon watery sands brilliant and effective. This is his greatest subject...'[81] It had been bought off the easel by John Grieve for £550, the largest amount Sam ever received for a painting during his lifetime. Bella lent his painting of *Mary McGee*, and Sam played patron again with Alexander Fraser's picture of *Sunshine in Springtime*. He also had an oil of *Cadzow Forest* on show, which may have been what is now called *Summer Evening, Cadzow* – a glorious essay in colour, demonstrating a freshness that some wrong-headed critics suggest he had lost by now.

There was little real sunshine in Bough's life that spring, but among the exhibits that took his fancy that year was Millais' *Sir Isumbras at the Ford* (painted in 1857). He stood long in front of it, commenting on its beauty of subject and treatment to Mary Tait. The picture of a medieval knight carrying two young children across a stream on his horse may have been how Bough wanted to see his own life: as a hazardous journey in which he steadfastly supported those who depended upon him. Maybe he just missed having children of his own.

He was certainly still keen to encourage young talent whenever he saw it. Tom Scott RSA, the watercolourist, was a case in point. Born in Selkirk in 1854, he finally joined the antiques class at the Trustees' Academy in Edinburgh in 1877. Perhaps reminded of his own late (and rapidly aborted) start in a formal art education, this 'rough old tyke' looked at Scott's efforts and then 'walked with me up and down the statuary gallery, and commented on the leading points of the figures and groups. He left without a word to anyone else. This was repeated on several occasions. He was always kind-hearted'[82].

A howling wilderness

Towards the end of March, Bill Channing died. His eyesight and general health had been failing for some years, but Bough had helped him earn a living during these times by producing pencil sketches of Edinburgh for the old man to work up. Sam would countersign them, thereby ensuring a sale.

As usual when doing good, Bough made light of it, claiming they only took half an hour to produce. Mary Tait, however, recalled how she watched him spend the best part of a morning on one. Sam visited his old friend in Leith on most Sundays and ensured that his last few years were happy ones, keeping the old man busy with work and proud that he was not dependent on charity.

In death, he did the last service for the man who had helped him so much in earlier times, by arranging his funeral 'on a dreary day in early spring'. 'I saw him that afternoon,' wrote Mary Tait, 'and he seemed to be a good deal affected by his death.'[83]

In April, the RSA tried to add Sam's Diploma painting to its collection in the National Gallery of Scotland, only for it to be rejected by the Board of Trustees on the – truthful – grounds that it was not up to his usual standard.

> Mr Bough begged to say that although with all deference to the Honourable Board he did not agree with them in their opinion of his picture of "Edinburgh from Bonnington" he would yet do his endeavour to meet their views by painting another picture instead of it to submit to them for their approval.[84]

On 2 July, away on a sketching trip, he wrote to a friend for 'two copys of Wilsons photo cast of my mug and a yard and a half wide tracing cloth ... the weather is not very favourable for work.'[85] A few days later, he wrote to Macbeath from Blairhoyle, near the Lake of Menteith in Stirling, where he had been sketching for two weeks. Death was still much on his mind.

> I've had woeful ill-luck this last twelve months. Twenty of my most intimate friends all off in that short time. It began with Dr Thatcher, then Willie Mackenzie, Bob Jones, Sandy Russell, etc., etc. My heart aches at the thought of such a terrible clearing out. They were all fellows with something in them. "Men of rare parts and varied excellencies." Another such a year and the world will be to me a howling wilderness.[86]

They were prophetic words. Within a year Bough was on the brink of that wilderness.

Later in July, to escape his demons he travelled north to Stornoway on the Isle of Lewis and Harris in the Outer Hebrides with, among others, Colin McCuaig, an accountant, and James Ferrier, an artist friend. At Greenock Sam took the opportunity to sing a duet with the

stationmaster. In Stornaway, they stayed at the Imperial but dined on board the yacht of one of McCuaig's friends.

Then they were across in Garynahine, Sam sketching. In the evenings he entertained a shooting party who offered to subscribe five guineas for one of his pictures. With admirable restraint he thanked them and said that his affairs were all dealt with by an agent in Glasgow to whom he sold his sketches at 60 guineas (total fiction, of course). They wanted to know how long it took him to produce a picture. An afternoon, he said. Would that they could do the same, they said. 'Oh, I'll teach you,' said Bough, 'but it all depends if you can take it up.' His sarcasm was apparently lost on his audience.

Then there was a sketching competition between Sam and Ferrier (no mean artist), where the company voted in favour of the latter. Sam acquiesced, presumably out of contempt.

For all his bonhomie, Bough still seems to have been in a depressed frame of mind during this trip. The language of his letter to Mary Tait during August, gives some sense of his mental state: 'I now write from this wilderness – for it's a treeless landscape, peat and rock – long lochs and grey skies, some Druidical remains ... I have made ten drawings, good, bad, indifferent, which you shall see when I come back to town.'[87]

Across that summer he worked on illustrations for William Paterson's six-volume edition of *The Works of Robert Burns, in Poetry and Prose*. Engraved by William Forrest, Sam's contribution in 1877 included an illustration of the birthplace of Burns and of the farm of Ellisland, with the bard lying on a bank composing 'Mary in Heaven'. As Burns was one of his literary favourites, this must have given him some pleasure.

On 17 August, he was writing to Paterson from the Port Arthur Hotel in Garynahine, amused at Forrest's reception of a version of *Tam o'Shanter* for the Burns publications:

He'll groan and grunt all the more, the more he's pleased with his work. I think he'll make a good thing of it, in black and white. I didn't send you the proof of "Tam" but I'm sure it will require nothing of my hand, for the old Growler is sure to make a better thing of it than the original drawing.[88]

Bough went on to comment on his surroundings, but showed less of his true feelings than he had to Mary Tait.

This is a wild country. No trees. Peat bogs, rocks, lochs, and salmon

fishing, enough to satisfy even you ... I shall get away from here some time next week, but where I go I don't know. I think I will take a turn in Skye, but meanwhile the weather will have much to do with it.[89]

At Manchester he had four works, including a view of *West Wemyss Harbour* dating from 1854 – a fascinating insight into how his 'commercial' style endured across two decades and how he was still pleased to claim it as his own. With his friend Macnee as President of the RSA, Sam was also achieving a level of official recognition – he, Fraser and MacTaggart were all Council Members, with Sam and Fraser being joint Curators of the Library.

Travels to France and Belgium

That September, in a year of frantic activity, he ventured abroad again, this time with his niece Nan and young Tom Chapman, son of the auctioneer. They sailed from Leith to Dunkirk with Captain Taylor on the *Marie Stuart*. Sam helped the skipper complete a drawing of the ship's saloon and was in great form throughout the journey, adorned in his broad-brimmed straw hat, and treating both young people as if they were his own children. From Dunkirk they went on to Bruges, Ghent and Brussels before reaching their goal of Antwerp, where Sam had intended to see the Rubens Festival. They missed it by a day, but he was impressed by the works of Frans Hals. The whole trip was more holiday than work, and he seems to have sketched very little except in Dunkirk and Brussels.

Towards the end of October he was working hard, trying to bail out Bella's brother-in-law, Mr Hierons, from financial difficulties, by working up a number of watercolours brought from London, which were then sold to clear the debts.

As autumn drew into winter, his health began to fail and on 31 December he made his will, naming Colin McCuaig, William MacTaggart and James Young Guthrie, a solicitor, as his executors. Just five days later he had a stroke.

The beginning of the end

On 4 January 1878, Paterson and Forrest called in to see him at the studio in Hill Street, where he was hard at work on illustrations for the

179

Burns book. It was very cold and he was working without a fire. (Emma Kennedy, who looked after his studio, had bronchitis and Sam would not ask her to make a fire for him.) He worked through until 10 p.m. that evening, then went home, worn out.

The next morning, a Saturday, he looked in on Nan's room as usual but said nothing. At breakfast he was drawn and had difficulty in speaking. Then he went for his walk around the garden before setting off for his studio. Realizing all was not well, Bella tried to keep him there, getting ready to go with him to the studio, while Nan went off for the young Dr Thatcher. Just as they set off, they were met by the doctor at the head of Canaan Lane. Bough was encouraged into the doctor's cab, taken home and confined to bed. Ever the professional, Sam managed to scrawl a message on an envelope he had in his pocket: 'Go to the studio. Emma will give you my letters. The drawing on the easel put into the covers and take to Mr Paterson in Princes Street'. Presumably the message was for his niece, Nan, or one of the servants. The letters were important. As later events showed, Sam needed to keep two aspects of his life clearly separated.

Within a week, Sam had had enough of it. He sent a message to Mary Tait, asking her to bring an outline she had made of one of the Burns book illustrations to Jordan Bank on Monday, 14 January. For a few weeks he worked at home, sketching around the domestic fireside, getting about with a stick, but still looking ill. Before the end of the month, he was back working in his studio, and at the beginning of February he dropped in to see the Taits at Somerset Cottage, on his way to a football match.

Externally, at least he seemed to have made a good recovery. The paralysis of his face muscles proved temporary, although he continued to have difficulty in articulating and swallowing. His family, however, had been told that he was suffering from a tumour, but it is unclear whether Sam truly understood the facts about his illness. To those who knew him best, he seemed a changed man.

Tragedy struck again before February was out, with the death of Sam's friend, George Paul Chalmers, who was attacked and robbed while returning from the RSA banquet. Left lying unconscious at the bottom of some stairs in Charlotte Square with a severe head wound and a fractured skull, he died in hospital on 20 February. Chalmers had been one of the brightest hopes of Scottish art, noted for the freedom of his style and colour, whether in landscape, genre or portraiture. His death was felt as a national loss. He was buried three days later in Dean Cemetery, where most of Scotland's greatest artists turned out to mourn him. Bella led a group of young girls (children of the artists) as

they laid white flowers on the grave.

At the RSA show, he had seven pictures on show, with the top price being asked for *On the Avon, near Bristol* at £120 – modest by his recent expectations.

In March there was a happy event when Sam was elected Vice President of the new Scottish Society of Painters in Watercolours that had just been founded in Glasgow. He was pleased with the honour, as he wrote to Craike Angus, 'Isn't that a lift for me?'[90]

But on 7 March, he confided to Mary Tait that he would never see another Christmas. Years later, she remembered how he was 'all that year softer and gentler in his manner than he had ever been before'[91]. His artistic skills remained undiminished, however.

Among his pencil sketches from that time is a portrait, dated 7 May, of Eugene Chantrelle on the first day of his trial for murder. A member of Stevenson's 'afternoon society' of drinking friends as well as a regular visitor at the Gamgees, Chantrelle was a refugee in Scotland, having fled France and England because of his homicidal activities. But

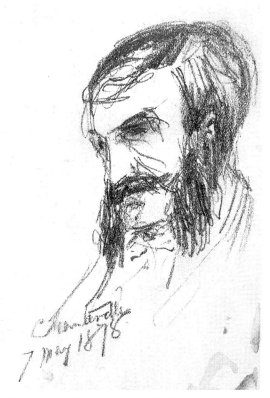

Eugene Chantrelle, sketched by Bough shortly before his execution in 1878. Tullie House Museum and Art Gallery.

death had become a way of life with him. So even in Edinburgh, his toasted cheese and opium suppers served as a prelude to the demise of four or five more, the last being his wife, which was why they hanged him on 31 May. He was 18 years older than Elizabeth Cullen Dyer, and the marriage had been one of convenience, due to pregnancy. His violence, drunkenness and financial problems made her short life unhappy. Only months earlier he had insured her for £1000 against accidental death, which is what he initially tried to claim. He died still protesting his innocence. Bough knew him well, and his sketch, probably drawn from memory, conveyed 'a swift impression of character, downcast, deceitful eye and weak but cruel mouth'[92].

Towards the end of May, Sam went across to Wicklow for a week, trying to rid himself of the blackness that was enveloping his life. Instead he caught a cold that he found hard to shake off. This may have been a holiday with his Irish friend, James Moore, consultant surgeon at the Belfast Royal Hospital and a gifted amateur watercolourist. Moore had done his medical training in Edinburgh, but that was some years before Bough arrived there, so it is unclear how they

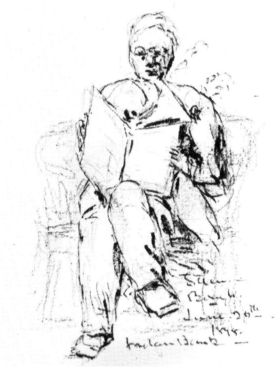

Sam Bough at Jordan Bank drawn by his friend, Dr James Moore, 26 June 1878.
Ulster Museum, Belfast.

actually met. Perhaps it was on a later visit by the Irishman to Scotland, or on one of their many journeys throughout Britain or Europe, for both men were inveterate travellers. Certainly it was more than a passing contact, for Moore's art shows the breadth of treatment normally associated with Bough's work.

In June, James Moore stayed with Bough at Jordan Bank. There is a slight but significant pen and pencil sketch, dated 26 June, by him, showing Sam, clean-shaven, smoking his pipe and reading a book, barely recognizable. Over the next few days, the Irishman was sketching at Loch Katrine, in the Trossachs, and then at Greenock. Maybe Bough went with him.

By early July, Sam and William Paterson were travelling south to get more illustrations for the next Burns volume in the poet's native area. They journeyed via Carlisle, and broke the trip to watch George Steadman, the Cumberland wrestler, win his sixth heavyweight prize. Then they dropped in on Thomas Nelson, the builder, who had bought Friars' Carse, a house north of Ellisland with strong Burns connections. It had been the home of Captain Robert Riddell and his wife, Elizabeth, and Burns was a regular guest there until his infamous re-enactment of the Rape of the Sabine Women, which led to a total severance of the friendship. Nelson was a successful businessman and an early patron of Bough, profiting from the growth of the railways in the Borders. He was still grieving the loss of his son, James, who had drowned off the south coast of Australia a year earlier, when his boat, the *Geltwood*, hit a submerged reef in a hurricane and went down.

On reaching Dumfries, Sam got to work. This may have been the trip when he also went across to Ayr with some friends. Once there, the whole band got to drinking and merrymaking into the early hours of the next day. Bough going at it as good as the rest. In the morning, when the others raised their befuddled heads and struggled down to breakfast, Bough was nowhere to be found. His bed had not even been slept in. In the middle of their consternation, Sam strolled in with his sketchbook. Rather than go to bed, he had decided on an early sketching ramble around the area and, climbing Newart Hill, had got the view that became the frontispiece of Volume Five of Paterson's series.

Sam was also working on an illustration for Robert Louis Stevenson's *Picturesque Notes on Edinburgh*, showing a distant view of the city.

On 5 August, he started on a watercolour sketch of Appleby Church that he never finished. It was sub-titled 'Each in his narrow cell for ever laid' and may represent his last sketch from nature. Death was increasingly in Bough's mind.

By 17 August he was back in Edinburgh, writing to Thomas Sewell from The City Club, an address of convenience, enabling him to correspond with whoever he chose in total privacy. Sam reminded his friend of the Glasgow Loan Exhibition (to assist the Royal Infirmary) finishing at the end of the month and urged him to come up with Jane to see it. He had reason to feel pleased, as no fewer than 18 of his works, spanning almost 30 productive years, were on display. The letter ended on a positive but untruthful note, claiming that 'all are well here'[93].

No time will change what is here

Another letter, dated 19 October, paints a rather different picture and perhaps explains why he used the device of The City Club for certain correspondence. It is written to Miss Fanny James, living at Mrs Sherwen's in Scotch Street, Whitehaven. The contents raise a thousand questions, most of which will probably remain unanswered.

My Dear,
 I had your kind letter and I cannot tell you how I feel your kindness in writing me. 'Tis too true that I have been very ill, and I am still much troubled with asthma; but I won't lay up, and I think I am better working.
 I have arranged to sell one hundred Drawings in December, and my time is much taken up in getting them ready. I have hopes that it will put me into funds for some time. I lost a lot of time thro' illness, last Autumn and Winter. For many months I could do nothing; but I can now work, not quite as well as ever, but well enough.
 My face is now straight, and the muscles of the cheek in working order. I can wink with my right eye as well as ever; but I can't whistle – so it's no use your saying – Whistle and I'll come to ye my lad – And then – even if I could, you wouldn't come. But be it as it may, no time will change what is here. The old metal is still the same, and will be till it corrodes out of sight.
 I have been thinking what I shall send you. I have hit on what will be useful, and you may expect a parcel on Tuesday or Wednesday.
 I send you the papers daily, and when they do not arrive, then you may say I am ill.
 I wish I could be near you to cheer you up. I hope I may see you

[before] the year goes out. Your Mother and Aunt are kind, and I love all yours who are kind to you.

Now I tire with writing, and though I have much to say, will say it another time. God bless and keep you.

[Not signed][94]

It is an insight into a hidden aspect of his life – a long-standing love for another woman. The letter is a rare example of Sam opening up totally to someone. It shows a tenderness, but also a resignation to the realities of everyday life – and a depth of feeling that art critics found lacking in his work.

Fanny James was obviously much more than a friend. Why else would he need to resort to the device of sending the Edinburgh papers to her on a daily basis, so that she could know of his continued well-being? His health was clearly failing, much as he tried to disguise it, and there is a sense in this letter of Sam talking to the one person, across all the obstacles of time, distance and separation, who truly understood him.

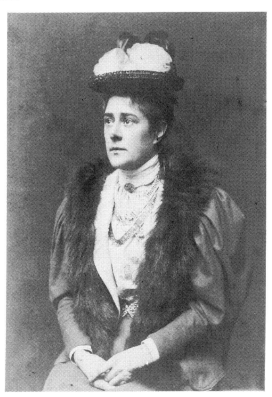

Nan Bough, Sam's niece. Tullie House Museum and Art Gallery.

185

Who was Fanny James? She seems to have been known in his circles in Edinburgh, which suggests she may have lived there at one time. His niece, Nan, recalled that he was a 'very great admirer of gentlewomen, courteous', and had a 'fine appreciation of really good women – Miss Tait, Mrs Lees, Miss Fanny James...'[95]

She had even been considered as a music tutor for Nan, before Bella put her foot down. A Miss Hutchinson was engaged as a daily governess as soon as Nan arrived in Edinburgh. Initial training in music was provided by Bella, but then Sam thought of sending her to Miss James. Bella doubted his motives, thinking that it was merely a ploy to give Sam an excuse to visit Fanny. Consequently, Nan was pressurized into saying that she would rather stay at home and be taught by Miss Hutchinson. In fact, what Bella said was that if Nan went to Fanny James, Nan would never return to Jordan Bank. And his young niece can have been in no doubt about the agenda for, on one occasion, she actually wrote to her uncle, warning him that Bella had intercepted a letter from Fanny James.

A contemporary indicated that she was an 'old sweetheart', which suggests that the relationship dates back to Bough's Cumbrian days. This ties in with Sidney Gilpin's story of a 'young lady, handsome, highly accomplished and well-connected' and a thwarted romance that left Bough with 'far more pangs and heart-burnings than any mishap or love adventure he afterwards experienced'[96].

Gilpin claimed that her father was 'a retired physician, and the owner of two or three estates of land – [who] lived at an old picturesque grange house near Penrith'[97]. Thornbarrow, comprising a 'dwelling house ... orchard, the garth and gardens' matches this description precisely. About three miles north west of Penrith on the road to Hutton in the Forest, it had been the home of the James family since the early eighteenth century. Fanny's family lived there during Sam's youth. Her father, Hugh James, was a surgeon, the son of Thomas James of Hensingham Hall, near Whitehaven. He married Caroline Anne Franklin from London, and they had at least four children. Frances Emily (Fanny) was born in Liverpool in 1822, while Henry William came along in 1834, Edward Sherwen in 1837 and Lucy Anne by 1839 (by which time their father had retired from medicine). The latter two were certainly born at Thornbarrow and were the youngsters with whom Sam became a 'great favourite'. This would place the beginnings of their relationship around the early 1840s.

The James estate contained a grange house, Thornbarrow Farm, of which Bough had produced four watercolours as a young man – two

interiors and two exteriors. Tantalizingly, one of the interiors shows a young woman standing by a window – might this be Fanny?

When Sam wrote to Fanny in 1878, she was living with her widowed mother, then 78, at 113 Scotch Street, Whitehaven, the home of her aunt Caroline Sherwen, aged 76 (probably her father's half-sister). She had been there at least from 1871, and they were all still there in 1881, but of Fanny's early or later life there seems no hard evidence.

Beyond this point facts are being distorted into wish fulfilment. We shall probably never know the real nature of the enduring relationship they had. What cannot be doubted is the strength of feeling that existed between them.

This may explain why he wanted his friends to destroy any of the letters he sent them. Margaret, Thomas Sewell's daughter, maintained that 'he charged those near him, whenever they found one to burn it at once.'[98] Salty language apart, there is little in the few surviving letters to warrant such a concern, unless, of course, he was concerned that some might contain comments of a compromising nature – and for Sam, this could only have meant a desire to protect people for whom he cared most – like Fanny James and Bella.

Over the years, there had been growing indications that all was not well in the Bough marriage. His odd asides to friends and relatives in his letters may appear light-hearted, but they speak of an underlying tension at home. Then there is the fact that Sam loved children but the marriage produced none. This may simply be due to a fertility problem on either Sam or Bella's part, but it can hardly have helped their relationship. Mary Tait, who had close enough contact with the whole family in Edinburgh to know the real state of affairs, described it as an 'uncongenial and certainly not elevating companionship he endured for yearly 30 years'[99]. Once the first thrill of marriage was over, Bella shared few of Sam's interests apart from their joint home, but as most of the extant comments are from Sam's apologists, it is impossible to give a balanced view of the picture.

Bough's letter to Fanny James is also a significant indicator of his real state of health. The watercolours he was working hard on were for a sale at Chapman's on 7 December. The plan was to raise enough capital to enable him to winter in the south of France, in the hope that this might alleviate his condition. Mary Tait recollected how 'it was only with an effort he could speak of leaving Edinburgh and he quickly changed the subject'[100].

The catalogue was already printed, advertizing the fact that Sam would be 'leaving Edinburgh for some months', describing the

paintings as 'all showing Mr Bough's well-known characteristics in versatility of subject, boldness of effect and brilliancy of execution'[101]. In fact, the catalogue contained a wide range of works dating from 1847 to 1878. But by the time the auction date arrived, Sam had been dead for nearly three weeks.

His friend, Sir Daniel Macnee, was close to completing Sam's portrait – it was finished just three weeks before his death. The picture showed Bough dressed in a brown suit with a crimson buttonhole, wearing a short grey beard and moustache, bespectacled, with an apparently healthy air and no trace of the illness that was in its last, fatal stages.

Early in November, however, the final blow fell. Emma Kennedy found him early one morning, in his studio, his back pressed against the wall and in a bad way. 'I'm done,' he told her, 'I'll never be here again.' He went home shivering before noon and took to his bed. Bella nursed him for two weeks but apart from a brief respite, his condition deteriorated.

It was not an easy death, as Chapman explained in a letter to Macbeath:

Certification of Bough's last work by Bella – the unfinished oil of a *Distant View of Carlisle*. Tullie House Museum and Art Gallery.

Poor Bough suffered a great deal at the end – for a fortnight – indeed before. And certainly Mrs Bough did not spare herself. He got everything that skill and care could do.[102]

On Tuesday, 19 November 1878, the *Scotsman* commented 'we regret to say that no improvement can be reported in the condition of Mr Sam Bough. On the contrary his illness has yesterday assumed so serious a form that no hope was entertained of his recovery.'[103]

At 5.45 p.m. that evening, Sam died. Dr Thatcher certified that death had been the result of a 'prostatic abscess' which produced 'syncope'. In current terminology, this would probably be diagnosed as cancer of the prostate and, given the lack of pain control techniques in those days, he would not have had an easy death.

Back in his studio, the picture on his easel was an unfinished oil of a *Distant View of Carlisle*, reminiscent of *The Baggage Waggons*. At the end, Bough had returned to his origins. But it is a landscape devoid of people. By now Sam was on his own. His personal journey had reached its end.

REFERENCES

1 Letter, 10 November 1866, George Coward's notebook, *op. cit.*
2 *Glasgow Herald*, 9 March 1867.
3 *Courant*, 9 March 1867.
4 *Scotsman*, 2 March 1867.
5 *ibid.*
6 *ibid.*
7 Letter, 11 February 1867, RSA Library.
8 Letter, 10 February 1867, George Coward's notebook, *op. cit.*
9 Letter, 7 May 1867, Edward Pinnington's notes, *op. cit.*
10 *ibid.*
11 Sidney Gilpin, *op. cit.*, p. 153.
12 *ibid.*
13 Sir A.C. Mackenzie to Edward Pinnington, 15 August 1897, Edward Pinnington's notes, *op. cit.*
14 *Courant*, 26 February 1868.
15 Letter, 11 February 1868, RSA Library.
16 Minutes of RSA Council Meeting, 11 February 1868, RSA Library.
17 Letter, 17 February 1868, RSA Library.
18 Sir A.C. Mackenzie, *op. cit.*
19 Sidney Gilpin, *op. cit.*, p. 158.
20 *ibid.*
21 *Scotsman*, 4 March 1869.
22 Letter, 14 March 1869, Edward Pinnington's notes, *op. cit.*
23 Sidney Gilpin, *op. cit.*, p. 161.
24 Letter, 10 May 1869, George Coward's notebook, *op. cit.*
25 Sidney Gilpin, *op. cit.*, p. 160.
26 Sidney Gilpin, *op. cit.*, p. 159.
27 *Scotsman*, February 1870.
28 *ibid.*
29 *ibid.*
30 Minutes of RSA Council Meeting, 11 February 1870, RSA Library.
31 Edward Pinnington's notes, *op. cit.*
32 Minutes of RSA Council Meeting, 11 February 1870, RSA Library.
33 *ibid.*
34 Minutes of RSA Council Meeting, 17 February 1870, RSA Library.
35 Minutes of RSA Council Meeting, 28 February 1870, RSA Library.
36 Letter, 24 February 1870, RSA Library.

37 Letter, 6 April 1870, RSA Library.
38 Mary Tait to Edward Pinnington, 14 December 1896 (?), Edward Pinnington's notes, *op. cit.*
39 *ibid.*
40 *ibid.*
41 Robert Louis Stevenson to his parents, 4 August 1870, quoted in Bradford A. Booth and Ernest Mehew (ed.), *The Letters of Robert Louis Stevenson, Volume 1*, Yale University, 1994.
42 *ibid.*
43 Quoted in Louis Stott, *Robert Louis Stevenson and the Highlands and Island of Scotland*, Stirling, 1992, p. 33.
44 Robert Louis Stevenson, 'Memoirs of an Islet' in *Memories and Portraits*, London, 1912, p. 77.
45 Robert Louis Stevenson, *Lay Morals*, London, 1914, p. 60.
46 *ibid.*
47 Robert Louis Stevenson to Charles Baxter, 8 March 1889, quoted in DeLancey Ferguson & Marshall Waingrow, *Robert Louis Stevenson's Letters to Charles Baxter*, Yale University, 1956.
48 Minutes of RSA General Meeting, 23 December 1870, RSA Library.
49 Letter, 24 December 1870, George Coward's notebook, *op. cit.*
50 Letter, 28 December 1870, RSA Library.
51 Letter, 29 December 1870, RSA Library.
52 Minutes of RSA Council Meeting, 13 January 1871, RSA Library.
53 Edward Pinnington's notes, *op. cit.*
54 Letter, 16 January 1871, RSA Library.
55 Letter, 18 March 1871, Edward Pinnington's notes, *op. cit.*
56 *ibid.*
57 *Scotsman*, 28 February 1871.
58 *ibid.*
59 *ibid.*
60 Mary Tait to Edward Pinnington, 14 December 1896 (?), Edward Pinnington's notes, *op. cit.*
61 Letter, 26 December 1871, Edward Pinnington's notes, *op. cit.*
62 *Scotsman*, 1 March 1872.
63 Sidney Gilpin, *op. cit.*, p. 168.
64 *ibid.*
65 Letter, 30 November 1872, George Coward's notebook, *op. cit.*
66 Letter, December 1872, George Coward's notebook, *op. cit.*
67 Sidney Gilpin, *op. cit.*, p. 174.
68 Letter, 15 May 1873, Edward Pinnington's notes, *op. cit.*
69 Letter, 9 August 1873, Edward Pinnington's notes, *op. cit.*
70 *ibid.*
71 Letter, 20 October 1873, Edward Pinnington's notes, *op. cit.*
72 *Glasgow Herald*, 20 February 1874.
73 Letter, 14 August 1874, Edward Pinnington's notes, *op. cit.*

74 Letter, 10 February 1875, Edward Pinnington's notes, *op. cit.*

75 Letter, 5 November 1875, RSA Library.

76 G.T. Clarkson, The Scottish Fisheries Museum Trust, to P. Hitchon, 31 August 1978.

77 Edward Pinnington's notes, *op. cit.*

78 Ruth D'Arcy Thompson, *D'Arcy Wentworth Thompson, The Scholar Naturalist 1860–1948*, London, 1958, p. 15.

79 Mary Tait to Edward Pinnington, 14 December 1896 (?), Edward Pinnington's notes, *op. cit.*

80 Sidney Gilpin, *op. cit.*, p. 181.

81 Catalogue of Illustrations of Scotch Art, 1896, Edward Pinnington's notes, *op. cit.*

82 Edward Pinnington's notes, *op. cit.*

83 Mary Tait to Edward Pinnington, 14 December 1896 (?), Edward Pinnington's notes, *op. cit.*

84 Minutes of RSA Council Meeting, 20 April 1877, RSA Library.

85 Letter, 2 July 1877, RSA Library.

86 Letter, 6 July 1877, George Coward's notebook, *op. cit.*

87 Mary Tait to Edward Pinnington, 18 December 1896, Edward Pinnington's notes, *op. cit.*

88 Sidney Gilpin, *op. cit.*, p. 187.

89 *ibid.*

90 Letter, 7 March 1878, Edward Pinnington's notes, *op. cit.*

91 Edward Pinnington's notes, *op. cit.*

92 Edward Pinnington's notes, *op. cit.*

93 Letter, 17 August 1878, Edward Pinnington's notes, *op. cit.*

94 Letter, 19 October 1878, George Coward's notebook, *op. cit.*

95 Edward Pinnington's notes, *op. cit.*

96 Sidney Gilpin, *op. cit.*, p. 32.

97 *ibid.*

98 Margaret Sewell to Edward Pinnington, 29 May 1909, Edward Pinnington's notes, *op. cit.*

99 Mary Tait to Edward Pinnington, 14 December 1896 (?), Edward Pinnington's notes, *op. cit.*

100 *ibid.*

101 Catalogue of a Collection of Watercolour Drawings, 7 December 1878, T Chapman & Sons, Edinburgh.

102 Letter, 2 December 1878, George Coward's notebook, *op. cit.*

103 *Scotsman*, 19 November 1878.

5

All That Remains

A heavy rain fell

The funeral was on Saturday afternoon, 23 November. The rain that fell heavily throughout did not stop the crowds gathering along the route from Jordan Bank to Dean Cemetery, to pay their last respects to a man as large as his myth. Sam went out in style.

About 2 p.m. the mourners assembled at Jordan Bank, where the Very Rev. Dean Montgomery officiated at an Episcopalian service in the drawing room. The body was inside three coffins, the outer being of panelled oak. A raised brass plate carried the simple legend: 'Samuel Bough, born at Carlisle 8th January 1822; died 19th November 1878'.

The hearse was drawn by four Belgian horses, followed by 16 mourning coaches (including six from the RSA) and 14 private carriages, including that of the Lord Provost. From Morningside Road the cortege passed up Bruntisfield Place and into Lothian Road. There, opposite the West Church, it was joined by a number of Glasgow artists and other friends – there had been a public invitation for all those who knew him as a friend to join in. It was all a far cry from the little shoemaker's shop in Carlisle where life had begun 56 years earlier.

At the entrance to Dean Cemetery, the eight pallbearers took the coffin from the hearse and carried it on their shoulders to the graveside for Dean Montgomery to read the burial service. The eight were Sir Daniel Macnee, Dr Douglas Reid (an old friend from Port Glasgow days), William Gray (Anne's husband), Thomas Sewell and his son, Archibald Gray MacDonald (one of Sam's first and most loyal patrons), Alex Young and William Forrest, the engraver.

The list of mourners reads like a 'Who's Who' of Scottish art and society. From the RSA there were, among others, William Brodie, William Fettes Douglas, George Hay, Robert Herdman, William Ewart Lockhart, William McTaggart, James Dick Peddie, John Crawford Wintour and George Clark Stanton. David Murray and

Joseph Denovan Adam were among those representing the Scottish Society of Watercolour Painters. Many were his friends, others he had crossed at one time or another. For this moment they were united in remembering a unique and enduring talent.

The local press reported:

> After the grave had been covered in, a little girl, a niece of Mr Bough's (Miss Hierons, London), placed on the turf a large wreath of camellias and chrysanthemums, while about a dozen other wreaths were deposited by various friends, including a chaplet of immortelles sent by Lady Macnee.[1]

The RSA had already consigned Sam to posterity at a Council meeting held the day after his death. It was a generous, if formal, farewell:

> That Mr Bough was a man of great intelligence in many ways, with an extensive knowledge of English literature, very considerable musical ability, great conversational power, and a most tenacious memory, no one could be long in his company without discovering. But above all, he was truly and essentially a painter, and although with his great versatility of talent he could turn his abilities to more than one branch of art, it was in landscape that his great strength lay. ... No aspect of nature seemed to come amiss to Mr Bough. The sea in calm and in storm had a great part of his affection; but he was equally at home in the fertile valley and wild mountain side. In watercolour art Mr Bough was considered by many to have no rival. It was his first love and his last. He also produced many fine works in oil, which always secured conspicuous places in our exhibition, and were deservedly admired for dashing freedom of execution, sterling merit in composition, and consummate pictorial effect of light and shade. A man of such undoubted power and varied excellence as Mr Bough it would be difficult to find, and it would be even more so to find one who concealed under such a rough exterior so warm a heart, ever more ready to do a good deed than to say a kind word. He was best understood by those who had known him longest and most intimately.[2]

The press in Scotland and Carlisle had a field day writing his obituary, with column after column given over to describing his life and art, producing amazingly detailed biographies at short notice.

The news soon travelled further afield. On 25 November, for example, Mr Bartel wrote to Bella from Dusseldorf:

I am quite struck down. Your dear beloved husband, my dear kind friend Mr Bough is dead. It's horrible to believe, and still we must ... who would have guessed the mournful fact but two months ago when we all enjoyed still the satisfactory happiness of being with the late kindest of all men.

Poor, poor Mrs Bough, I pity you from all my heart and don't even try to find words to express you mine and Mrs Bartel's deepest sympathy; the loss for you before all, but meantime for his numerous friends and for art is too great to be expressed in poor words.[3]

Despite the odd grammar and halting English, there can be no doubting the sense of loss conveyed by his German friend.

Such a turn up

The body was hardly buried when the trouble began. Sam had made his will 11 months earlier, naming three trustees: James Young Guthrie, a solicitor at the Supreme Courts, William McTaggart, his artist friend, and Colin McCuaig, a chartered accountant and actuary. Guthrie's firm had drawn up the will and he was to act as agent.

On the evening of the funeral, the three men met at Guthrie's house and instructed Alexander Dowell, the auctioneer, to make a valuation of Sam's belongings. This was bitter blow to Thomas Chapman, fellow auctioneer and a close friend of the Boughs. Not surprisingly he had assumed he would be asked to carry out this last task for his friend. On 2 December he wrote bitterly to Macbeath:

I should have sent you last week some news of poor Sam, but there has been such a turn up that we are all upset. Perhaps you have got news. If not, Mr Bough made a settlement eleven months ago, thro' a queer lawyer here – who seems to have got round him – as he does others – no friend at all.

One clear half goes to Mrs Bough, other half to Miss Bough, and one thousand left in trust, income of which goes to Mr Bough's sister, and reverts to Annie. ... The reason [for Dowell doing the valuation] afterwards assigned being that I was too intimate and a creditor. Surely the latter was an advantage. Mrs Bough was never consulted nor Annie either, and of course the trustees did not need to do so. Both wrote urging that we should be employed, but no heed was given. I have no idea that we shall get anything to sell

thro' the trustees. Guthrie who is factotum having some dislike to me.

Mrs Bough and Miss are agreeing very well, and wish to sail in the same boat. Each has employed an agent, and both of them have got good ones. I wish the estate had been in such hands. Mrs Bough has been treated as if she were a bankrupt and a felon, neither heart nor favour having been shewn her. If even moderate kindness had been shewn, and we employed, there would have been nothing but peace. It is melancholy to see affairs in such heartless hands.

What the upshot of all is to be we must wait for. One thing is sure. Mrs Bough is Roused, and you know that a person may be led rather than driven.[4]

It was not what Sam had intended, although the terms of his will made some strife inevitable. What he had clearly been trying to achieve was a fifty-fifty split between Bella and the Boughs, after certain deductions – payment of debts, funeral expenses, legacies for the servants, etc. – had been made. To achieve this he had stipulated that the whole of his estate be sold and converted into cash. This inevitably meant that Bella and Nan would be homeless. So on top of the grief at losing Sam, both had to cope with an uncertain future and a group of trustees who seemed insensitive to their worries.

Dowell's valuation of the contents of Jordan Bank Villa amounted to £8,308 7s 6d and when other assets, such as insurance policies, were added, the total value of the inventory came to £11,705 18s 6d. Once this was registered in the Court Books of the Commissariot of Edinburgh on 1 March 1879, the trustees could dispose of the estate.

A collector's dream, a widow's nightmare

The bulk of Bough's possessions was dealt with in a massive sale at Dowell's in 18 George Street, over six days between 15 and 21 April 1879. The sheer volume of items was staggering. The catalogues read like a list of everything a Victorian collector could possibly want. Bella and Nan must have felt as if the trauma would never end. Not only had they lost their home, but all the old familiar trappings were now under the hammer.

The first day of the sale was given over to glassware, china and furniture. There were 36 lots of crystal glass (mostly multiple items); 80 lots of china, Delft, and the like; 125 lots of furniture, bronzes, clocks, etc. and 14 lots of silverware. Even the carpets and rugs went.

The day ended with the sale of a hat rack and stand!

On 16 April came the sale of his engravings. They give an impressive insight into the breadth of his artistic interest. Turner, Landseer, Hogarth and Wilkie were all there in force, but so too were a host of sixteenth, seventeenth and eighteenth century artists. Among his contemporaries he had prints of Horatio McCulloch, Erskine Nicol, George Paul Chalmers, John Phillip, Noel Paton, and Thomas Faed in a total of around 1,000 framed and unframed.

The third day comprised around 200 of his 'cabinet of paintings by various artists'. By far the most heavily represented, with 24 pictures, was Tom Clark, a contemporary landscape painter who had died just two years ahead of Bough. Among his other friends, Alexander Fraser, George Clark Stanton, John Milne Donald, Charles Lodder, Daniel Macnee and John Phillip were all there. One of the Phillips was the portrait of Bough from 1856. There was also another portrait of Bough and dog, artist 'Unknown' (this is now attributed to Sam himself). The collection also contained a small watercolour by James Bough – *Near Musselburgh – Arthur's Seat in the Distance*.

Day four began to get down to the real business – the sale of Bough's own works. This was given over to minor works, sketches, watercolour studies and artists' materials. Prices seem ludicrously low: the highest amount paid was for some early drawings, which went for £13 2s 6d. The lowest amount paid was a paltry two shillings for the artist's proof engravings of some of his works.

On the fifth day, over 160 of his 'principal' works – watercolours and oils – went under the hammer. Chapman went to law to stop the sale of one of the small watercolours – *Iona* – arguing that Sam had given him the painting in exchange for a Dresden enamelled snuff box. At first the sheriff granted an interim order to stop its sale, pending proof of ownership. This must have been provided by the trustees, for the picture was included in the sale and fetched £62. Among the other watercolours, *The Red Lion Inn at Knowsley: the Stage Coach coming in* fetched the highest price at £231, followed by a small picture of *Burns' Cottage* that cost £135 10s. Other items of interest include a watercolour of *Tanziermunden on the Elbe* (£105); a book of military costumes drawn by Bill Channing (five guineas), and a small oil by John Linnell, *The Potato Field* ('Of Mr Bough's Collection, it was his favourite picture'), that brought most of all – £262 10s. Sam's last, unfinished oil, *Distant View of Carlisle* went for £31 10s.

None of the prices was particularly high – but in fairness, few of the works he had left for sale were truly in the category of 'principal' paintings, even though they were of good quality. Dowell's had used a

degree of licence in their description. In fact, as many of them had been scheduled for the sale at Chapman's on 7 December 1878 to pay for Sam's planned winter abroad, Thomas Chapman's sense that he would be the loser in the final disposal of things proved right.

On the final day, Bough's library was up for sale. There were 370 lots, many multi-volumed. Topographical prints were a favourite subject, including a host of engravings after Turner, and some from Allom and Carmichael. Sam's favourite author, Thackeray, was also well represented, with 28 volumes of his works, and there were 70 volumes of the *Edinburgh Review*. At a more personal level, Sam still had a copy of Prout's *Hints on Light & Shadow, Composition etc.* – the very work he had sought desperately from John Kirkpatrick as he was about to embark on his scene-painting career in Manchester. And there were 15 volumes of RAPFAS engravings, mostly from Burns and Scott, containing some fine examples of Bough's work. Sidney Gilpin, Bough's first major biographer, was also well represented, with four volumes of *Songs and Ballads of Cumberland*.

A commodity on the art market

In August 1879, the first piece of Bough memorabilia went on sale. William Grant Stevenson, the Edinburgh sculptor, produced a small terracotta statuette of Sam in typical pose, pipe in one hand, the other stuck in his trouser pocket. The *Scotsman* felt he had captured the essence of the man:

> Attitude and action alike are capitally hit off – so much so indeed, that even as seen from behind, the figure will be readily identified by those who were familiar with the bluff original. Some might have preferred a design which, without loss of character, had leaned a little more towards refinement; but there will be no lack of appreciation for Mr Stevenson's racy literalism.[5]

That same month, a large monument was in place at his grave, designed by William Brodie. This had been funded by subscriptions organised by a committee under Sir Daniel Macnee. Made from New Galloway granite, standing almost 10 feet high and weighing about six tons, the monument carries a bronze relief portrait of Sam, surrounded by bay leaves, and at the base there is a bronze palette with brushes and crayons.

Chapman salvaged something from the ruins of the disposal, when Bella asked him to handle the sale of her own 68 works produced by

Sam. 30 of them were 'jointure drawings', i.e. pictures given to her at the time of her wedding to be sold on in the event of his death. Many were relatively small and insignificant in the whole canon of his works, but there was the major painting of *Tanziermunden on the Elbe*, described in the catalogue as 'the chef d'oeuvre of Mr Bough's Works in Watercolours'[6]. It brought £194 5s. The total raised almost £7,000, but by far the greater proportion went to those private owners whose works comprised the second half of the sale. Among the most important of these were the oils of *The Baggage Waggons approaching Carlisle* (1849, £388 10s), *Cadzow Forest with Cattle* (1852, £320 5s); *Bacon's Tower, Oxford – Rain Storm Clearing Off* (1854, £246 15s) and *Windermere – the Regatta* (1865, £236 5s)). Of the private watercolours, *Lanercost Abbey* (1847, £141 15s) was the most successful. Chapman, knowing that Bella's pictures were, for the most part, not in the first rank of Bough's works, probably felt that he was helping Bella by setting up the private sale to follow on from hers, thereby ensuring a good turnout.

In November that Diploma picture was causing problems again, when it was again excluded from the transfer of RSA pictures to the National Gallery of Scotland on the grounds that it was not 'an adequate representation of the work of the artist and that it would be doing injustice to his reputation'[7]. Although Sam had moved from being a real person to a commodity on the art market, he could still cause controversy.

And soon there was a trade in Bough forgeries. In July 1880, for example, the *Scotsman* reported a case that had come before the Edinburgh Sheriff's court, when J. W. Cochrane, picture restorer, took an action against John Tipping, auctioneer, for the sale of a fake 'Bough' for £16. On appeal, the defendant was vindicated on essentially the 'buyer beware' principle, when Tipping argued that he had been unaware of the forgery at the time of the sale and Cochrane had not asked for any verification of the work.

1880 was also the year of the major Bough and Chalmers retrospective in Glasgow. Around 400 works were collected for the August event – roughly half from each artist. Some of Bough's best-known oils and watercolours were on show, but the tone of the reviews is more measured than in his heyday. His colours were felt to suffer in comparison with Chalmers', but otherwise the works were said to 'assert themselves by felicity of composition, vigour of handling, and general force of effect'[8] although his watercolours were judged more attractive, 'where he often seemed to attain even greater breadth of effect, and that not infrequently with a natural truth and translucency

of tint not usually secured by him in the other medium'[9].

Examples of his work also appeared at other major exhibitions including the 1886 International Exhibition of Industry, Science and Art in Edinburgh, the Glasgow International Exhibition of 1888 and the 1891 Glasgow East End Industrial Exhibition.

The next major retrospective of his work took place in 1896 at Tullie House, Carlisle; what had once been home to the rich industrialists of Abbey Street was now the City Corporation Art Gallery. The show opened on 14 July, with a special ceremony attended by a mass of civic dignitaries and citizens who were addressed by Canon Richmond. Bella was there, and so was Nan, along with other relatives and friends.

The 184 examples of Bough's pictures and drawings – major and minor – across the whole of his working life, had been painstakingly gathered by the curator, Robert Bateman. There were also four portraits of Sam by William Percy, John Phillip, Sir Daniel Macnee and John Pettie (showing Bough as a lord-in-waiting of Cardinal Wolsey). The exhibition remained open for 10 weeks.

The old house in Abbey Street finally gave way to the new in 1896 also. The owner of the property, William Donaldson, placed a commemorative tablet high on the wall of the new property, with the simple inscription: SAM BOUGH, R.S.A. BORN JANY 8TH 1822 – REMODELED 1896, W.D. A few years later he brought out a range of souvenirs, including teapot stands, plates and a pitcher and basin, showing Bough's birthplace.

Nan had returned to Carlisle after the break-up of the home in Jordan Lane and was living with her mother at 11 Brunswick Street at the time of the 1896 exhibition. She later married John Hodgson, a local architect of some standing, and died childless in Hayton, just outside Carlisle, on 9 May 1907. Anne Gray, Sam's sister, lived on in Edinburgh with her husband, and died there.

Bella moved to 30 Broughton Place, Edinburgh, where she lived with her sister Elizabeth and niece Caroline Hierons and died on 30th April 1900. She was 76, and the cause of death, as certified by Dr Thatcher, was a combination of bronchitis, pneumonia and heart failure. The sale of her effects shows just what straitened circumstances she had been reduced to. Her general possessions brought £185, and other – silver plate, jewellery, pictures and marble and plaster busts – were valued by (ironically) Alexander Dowell at £53 1s. When insurance policies and Sam's RSA pension were added, her total estate amounted to £333 12s 6d – a far cry from the gravy days at Jordan Bank.

REFERENCES

1 *Scotsman*, November 1878.
2 Minutes of RSA Council Meeting, 20 November 1878, RSA Library.
3 Letter, 25 November 1878, Edward Pinnington's notes, *op. cit.*
4 Letter, 2 December 1878, George Coward's note book, *op. cit.*
5 *Scotsman*, 18 August 1879.
6 Catalogue of the Entire Remaining Drawings in Watercolours, 29 November 1879, T Chapman & Son, Edinburgh.
7 Minutes of RSA Council Meeting, 6 November 1879, RSA Library.
8 *Scotsman*, 3 August 1880.
9 *ibid.*

6

Bough's Biographers

The liveliest horror

'Sam was perfectly consistent all through, in having the liveliest horror of anyone keeping his letters, with a view to using them after his death for biographic purposes,'[1] wrote Margaret Sewell, daughter of Thomas Sewell, to Edward Pinnington in 1909. Both were lamenting the lack of the good examples of Bough's letter-writing style, reputed to have been as entertaining as his conversation, when the mood took him. Had he something to hide? Or was it just his general distrust of words? Certainly he may not have wanted his relationship (whatever it was) with Fanny James to be publicized. Most of his friends seem to have respect his wishes and destroyed his correspondence with them. Those letters that do remain are fairly innocuous.

Pinnington had been working on a biography of Bough since 1896, at the suggestion of William McTaggart. Born in England and living in Scotland, he was a journalist by trade, who already had a major biography to his name in his life of George Paul Chalmers. Robert Bateman, curator of Tullie House, thought it a good idea: 'a life of Bough would be very interesting and instructive, and the longer it is delayed the more difficult it will become. The late Mr George Coward of Carlisle wrote a *Life of Bough* which I think is likely to remain in manuscript'[2].

The Gilpin version

George Coward was a printer and bookbinder, who produced a number of volumes on Cumbrian songs and ballads, among other books of local interest, under the pseudonym of 'Sidney Gilpin'. He was also a friend of Bough, an admirer and collector of his work, and had, over a number of years, pulled together the basis of a biography

on Sam from anecdotes and facts. To do this he had talked to his friends and relatives in Carlisle, Manchester and Scotland. When he died in 1892, the book remained unpublished. Consequently, the field seemed open for Pinnington to do a more 'serious' version of Bough's life. Although there had been a number of magazine articles produced on Bough's life by this time, nothing approaching a full biography was available.

Pinnington interviewed Bella at length and pursued any other potential informant with the doggedness of a true journalist. It started positively with the Carlisle Exhibition of 1896, where Pinnington made some valuable contacts and arranged for many of the works to be photographed. A year later he had a significant article published in *Good Works* and was able to announce that the full biography would be published by T. & R. Annan of Glasgow, who had handled his work on Chalmers.

As a journalist with a track record and committed to his subject, Pinnington seemed likely to succeed. In Carlisle he established close contact with Richard, Margaret and John, the children of Thomas and Jane Sewell. The correspondence between them was to endure until his death. It gives a fascinating insight into the key players in the biography, but also into his own sad life.

Insomnia, depression and some progress

Soon, problems were emerging. Pinnington's own health was shaky, as he suffered from insomnia and depression. It stopped him producing the quality of work he knew he was capable of. In 1899, however, he was recounting some of the practical difficulties he was facing in making use of the information he had:

> Other things have militated even more seriously against rapidity of progress. Sam's' domestic and Academic relations are subjects requiring the most delicate manipulation. Upon the former I need not dilate. They can neither be wholly omitted nor glossed if introduced, for they were known unto all men. His quarrel with the Academy was the talk of Edinburgh. I have been remonstrated with in this fashion – 'any reflections on the Academy will open up questions of Bough's conduct and morals, which for his sake, you had better let alone.' I have been refused information as to the grounds of the charge against him, the method of its presentment to the Academy, and the result in votes. On every point I have been

met with an unreasoned, mulish refusal. Would they give me a copy of the minute dealing with the case? No. Would they allow me to peruse their records? No. Between ourselves, I have in spite of the obstructions, probed the business to the bottom, know its alpha and omega, and all the letters between them. If I don't tell what I know, existing misapprehensions will be perpetuated. If I tell the whole truth the RSA will be held up to ridicule. Its dignity, and not Bough's reputation, is in danger.[3]

In 1900, he considered himself lucky with the death of Bella. As he wrote to Margaret Sewell:

The blank she left behind was, all things considered, lamentably small. Her great fault, and one which led many good people to avoid her was a form of affectation which led her at times into constructive untruth ... I cannot conceal from myself the fact her death removed an encumbrance from my work as a biographer. This is not due to my being at greater liberty to say what I like, but at freedom to say as little as I like about her, as an influence on his life.[4]

The next year he ran into legal problems with two newspapers, over some other piece of work. He thought about suing them and then decided to leave Scotland and settle in Carlisle with his wife and boys, where he thought he could take over the job vacated by Bateman at Tullie House and finish the book. Nothing came of the plan, and he stayed in Scotland, living in Auchtermuchty.

In September 1905, a setback occurred for Pinnington – Gilpin's book *Sam Bough RSA* was finally published at 7s 6d by George Bell & Sons of London. Disorganized, full of tittle-tattle and anecdote (some misinformed), it was easy to rubbish, and Margaret Sewell, among others, did. For those of us who come after, it has remained the only accessible detailed life of Bough for 90 years. Its importance cannot be overestimated – without Gilpin's efforts so much valuable evidence would have been lost forever. We make no apology for drawing on it for both inspiration and information.

The book sold badly, however. Three years later, when Pinnington contacted them for permission to use the manuscript, Bells replied that they had not been involved in editing the book, had no control over copyright, and that – because demand was so slow – they had returned the remaining stock to the owners, G. & T. Coward, printers in Carlisle. Cowards subsequently gave him permission to draw on the text.

A couple of years later, in 1910, Pinnington had actually produced the first three chapters of his book. 'T'aint much like old Gilpin, but then he is hopelessly, helplessly, manifestly wrong,'[5] was his message to Margaret Sewell.

Pinnington and a drink problem

By December 1912, a more serious hindrance had emerged, for Pinnington was writing from Ward 8 of the Dysart Combination Public Hospital at Thornton in Fife, with a drink problem. McOmish Dott, the art dealer, tried to help and wrote informing Richard Sewell of the situation:

> My objective in writing you is to see what can be done to get Mr Edward Pinnington set up in such health as to give him strength and heart to get to work again. ... The doctor ... informs me he has greatly improved since coming here in December but he still suffers from nervous-sleeplessness. ... There is no doubt the surroundings and want even of a 'smoke' not to speak of decent books (not too heavy) are against his recovery. Can you do anything practical to help to this?[6]

Richard Sewell hoped that a reconciliation between Pinnington and his estranged family would solve the problem, but McOmish Dott soon disabused him of this. His family had had enough of him. The Sewells then planned to have Pinnington stay with them, to aid his recovery, but Margaret took seriously ill and this idea was postponed indefinitely.

A year without a spring

In June 1914, a depressed Pinnington, still in hospital, was writing to Margaret Sewell with a strong sense of rejection. The book was to be shelved.

> 1914 has been a year without a spring. ... So the Sam Bough goes with the rest leaving the field clear, and also hopelessly bare. My fear was that in cutting that particular bit of wreckage adrift, it might on its way downstream have scratched, perhaps even wounded, you and yours and so have added to a load of regrets already heavy.[7]

Then there is a break in the surviving letters until 4 December 1921, when John Sewell wrote to Pinnington, thanking him for entrusting the manuscript to his care, advising that a centenary exhibition in Carlisle in 1922 was out of the question, and suggesting that he might instead want to place a commemorative article in the local press. The envelope came back stamped 'deceased'.

On querying this, Sewell received a letter from Mr Smellie, Governor of the Hospital, advising him that Pinnington had been dead six months.

> [He] took suddenly ill on Wednesday afternoon, about 4 o'clock, 22nd June [1921] and died that same evening at 8 o'clock, the cause of death being certified, Epilepsy and Heart Failure. He appeared to be in his usual health and was engaged up to 4 o'clock with his writing in connection with some of his books. I understand his wife carried out all the funeral arrangements, and [he] was interred at Auchtermuchty.[8]

What came after

All of Pinnington's papers and notes were eventually lodged by the Sewell family with the Jackson Library at Tullie House. There they remained largely unstudied until we started work on this book. It began life as an article to commemorate the centenary of Bough's death, but broadened into a much larger project as we realized just what a wealth of information Pinnington had accumulated. That was in 1977, and at times it has seemed as though Bough's biography was fated never to be published.

Just like Pinnington's attempt, it started well. We were fortunate to acquire a copy of Gilpin's book from Harry B. Close, grandson of another famous local artist, Thomas Bushby. But he brought with him something even more valuable: a scrapbook of newspaper cuttings taken from the old *Carlisle Journal* in 1922. They were the unedited chapters of Pinnington's biography, submitted for publication by John Sewell. It was soon evident that Pinnington had only managed to write the first half of his book. What had happened to the rest of it? Carlisle Reference Library provided the answer in the form of bundles of notes and photographs – all that remained of Pinnington's efforts. Without these and the Gilpin book we would all know very little about Bough. We owe a large debt of gratitude to both men. We also received

positive encouragement from a number of people. In particular, Margaret Tait (grand-niece of Mary Tait) provided invaluable help and enthusiasm in the early days of the research.

After collecting a mass of information, a start was made on writing our version of Sam's life. Then life – and several deaths – intervened. The whole work was put to one side, awaiting the day when time and circumstances seemed right once more.

And so it stayed until late in 1994, when a phone call from Rachel Moss, an art dealer with a special knowledge of Bough's work, resurrected the whole venture. She knew of some major exhibitions of his work being planned in 1995, and thought it would be an opportune time to produce the biography. Unfortunately it proved impossible to get the book out in time for these, but, having added considerably to our original knowledge with new research and pursuing fresh lines of investigation, we felt this was the time to see it through to the end. *Sam Bough RSA: The Rivers in Bohemia* is the outcome. We hope that Bough would have approved – but we doubt it.

Apart from setting Sam's life in a clearer light, we hope to have achieved some sort of recognition for Edward Pinnington, whose efforts deserved better than to lie hidden away for over 70 years. It would be nice to think that someday, someone prompted by this book might wish to produce a sensitive and sympathetic study of Pinnington himself. The man deserves it.

We have also been able to add much new data from our own researches – information that would simply not have been available in Pinnington's time. In doing this, we received generous help from many organizations and individuals who gave information and support over the years. We are pleased to acknowledge our debt to them.

The art galleries and dealers include Aberdeen Art Gallery and Museum; Abbot Hall Art Gallery, Kendal; National Gallery of Victoria, Australia; Art Gallery of New South Wales, Australia; Beaverbrook Art Gallery, Fredericton, New Brunswick, Canada; Bourne Fine Art, Edinburgh; Dundee Art Galleries and Museums; Lady Stairs House Museum, Edinburgh; The Fine Art Society Ltd, London; The Fitzwilliam Museum, Cambridge; The British Museum, London; Glasgow Museums and Art Galleries; Richard Green, London; McLean Museum and Art Gallery, Greenock; Kirkcaldy Museum and Art Gallery; Moss Galleries, London; Laing Art Gallery, Newcastle-upon-Tyne; City Art Gallery, Manchester; The National Gallery, London; National Gallery of Scotland, Edinburgh; National Maritime Museum, London; Scottish National Portrait Gallery, Edinburgh; National Portrait Gallery, London; City of Nottingham

Art Gallery; The Scottish Fisheries Museum Trust Ltd, Anstruther; The Tate Gallery, London; Ulster Museum, Belfast; Victoria and Albert Museum, London; Whitworth Art Gallery, Manchester; York City Art Gallery; The Royal Collection Trust, London; Bristol Art Gallery; Shipley Art Gallery, Gateshead; and, of course, Tullie House Museum and Art Gallery, Carlisle (with particular thanks to Melanie Gardner and her colleagues) and the Royal Scottish Academy, Edinburgh (especially Joanna Soden).

Other institutions include Bath Reference Library; The Record Office, Carlisle; Central Library, Edinburgh; The Mitchell Library, Glasgow; India Office Library and Records; Central Library, Manchester; Office of Population Censuses and Surveys, London; Principal Registry of the Family Division, Somerset House, London; Scottish Record Office, Edinburgh; Register Office, Carlisle; Register Office, Penrith; Lancashire Record Office; Scottish Television Ltd; J. and G. Innes Ltd, St Andrews; The National Trust; Clark Scott-Harden; and Carlisle Library (with particular thanks to Stephen White and colleagues).

We also acknowledge the assistance of the following tourist boards: Hereford, Guildford, Clyde Valley, East Lothian, East Kent, Cumbria, Dundee, Scottish Borders, Dumfries and Galloway, St Andrews and North East Fife, and the Scottish Tourist Board.

Among the individuals who have helped are: John Johnson-Hetherington; M. Mitchelhill; the late Rex Gregson; Jeremy Godwin, E. Mehew; David Angus; Agnes Calder; K. Curry; C. Curwen; Craig Mair; A. G. Main; Irene Morrison and her sister (grand-nieces of Mrs Sam Bough); Howard Naylor (Cumbria Auction Rooms); Elizabeth Padkin; Peter Perrin; A. Sutcliffe; Ruth D'Arcy Thompson; H. W. Hodgson and Doris Savage. Particular thanks are due to Harry B. Close, Dr W. P. Honeyman, Rachel Moss, Dennis Perriam, Mary Rigg, Margaret Tait and Mr E. Wilkinson (formerly of Carlisle Reference Library).

Thanks also to members of our family and friends, who have given encouragement and support across the years.

We hope they feel the end product was worth their effort. The failings are all our own.

REFERENCES

1 Margaret Sewell to Edward Pinnington, 29 May 1909, Edward Pinnington's notes, *op. cit.*

2 Robert Bateman to Edward Pinnington, 17 July 1996, Edward Pinnington's notes, *op. cit.*

3 Edward Pinnington to Margaret Sewell, 14 November 1899, Edward Pinnington's notes, *op. cit.*

4 Edward Pinnington to Margaret Sewell, 18 December 1900, Edward Pinnington's notes, *op. cit.*

5 Edward Pinnington to Margaret Sewell, 16 November 1910, Edward Pinnington's notes, *op. cit.*

6 P. McOmish Dott to Richard Sewell, 1 May 1913, Edward Pinnington's notes, *op. cit.*

7 Edward Pinnington to Margaret Sewell, 1 June 1914, Edward Pinnington's notes, *op. cit.*

8 C. F. Smellie to John Sewell, 1 February 1922, Edward Pinnington's notes, *op. cit.*

APPENDIX A

Bough and his Art

Seize the day

Nothing in Bough's work suggests any great theory of art. His paintings lack that peculiar Victorian sense of the symbolic, spiritual or philosophical. There is neither an attempt to instruct nor to uplift.

Bough certainly had a religious sense – both superficially, in his subscription to conventional Christianity, and in a more basic understanding of a life force that he loved to be part of and portray. But it would be wrong to assume that his driving energy stemmed from anything but his love of life. His art was secular, neither spiritual nor materialistic.

Sam left no treatise, no books, no diaries, not even any letters that tell us what he saw as the purpose of his art. The fragmented asides that lodged in the memories of friends shed more light on his technique than on anything else. The method is the man – a thought worth holding onto.

With Bough, the bad must be taken with the good, for only in both can you approach his totality. 'Seize the day' best describes his attitude to life – and his art. In his insatiable appetite for living and painting, he was consistent.

By common consent there were two sides to his personality, as defined by his times. On the one hand there was the immensely well-read, intelligent, witty, convivial and most generous and sensitive of friends, who took life lightly. On the other there was a boorish, hard-drinking, argumentative, mercenary, small-minded, squanderer of talent, who failed to demonstrate any saving spiritual or poetic values in pandering to the marketplace; bedevilled at times by the dark side of his humanity. At times, the man was both disturbed and disturbing.

As with everything else, however, what you see depends on where you stand. Relativity was true, even before Einstein formulated his equation. So polite society in Carlisle and Edinburgh sighed that Sam did not always live up to his 'better self' as they saw it. Others, living closer to the edge, took him as they found him. That was how he wanted it.

Edward Pinnington spent over 20 years looking for the essence of Bough's life, and finally admitted defeat. In a letter almost approaching despair, he wrote to Mary Tait:

> Bough always strikes me as a man hurrying thro' life, either to get away from something, to reach something, or simply because the road was uninteresting and bored him. I seem to have a key to his character but not to his life. He does not appear to have cared a brass farthing for money, luxury, honours or fame. What then was his object and what was his ideal?[1]

Mary Tait's response was both unhelpful and profound.

> I'm inclined to think that this is just one of the mysteries which are in the mind of every human being, more especially a man of genius, which the outside world can only guess at, not know. From occasional remarks Mr Bough made I know he thought much and deeply of many things, but beyond these expressions there is always something that can never be known. I cannot pretend to fathom the depths of his thoughts.[2]

Perhaps only a soul as free as Robert Louis Stevenson's could approach a real understanding of him. His affectionate obituary hit just the right note (see Appendix B). Bough the true Bohemian had all the qualities ascribed to such a person by Louis – and much more. 'A man who lives wholly to himself, does what he wishes and not what is thought proper ... knows what he can do with money and how he can do without it'[3].

Even this fails to reflect the full complexity of the man, for Bough was concerned with money as only someone who has endured long periods of poverty can be – not as a measure of success or social standing, but simply to provide a sense of security for himself and those he cared for.

This was why he over-produced as an artist, delivered below-standard work, and reverted to styles, themes and even dates that had proved most financially rewarding. But money, in itself, was never the driving force.

The lighthouse invites the storm

Like Lowry's lighthouse, Bough invited the storm. He needed the rough weather, stormy skies and choppy seas of the Fife coast more

than a rural summer's day in Surrey, although he could enjoy both. The contrast of light and darkness, sunshine and rain, were essential to his sense of being alive.

It seems that Bough only really lived in his art, for there is nothing in his personal life that explains the stark intensity of conflict he translates into so many paintings. It suggests that, while he loved life (and used art to finance that love), the closest he came to fulfilment was through painting. There is a sense that, in life (for all his appetites) he never achieved what he most hoped for – which will forever remain undefined. His restless travelling can be seen as a means of avoiding having to spend too long alone in his own company and his sense of failure.

Two thousands years earlier, Seneca came closest to the answer when quoting Socrates: 'How can you wonder your travels do you no good, when you carry yourself around with you? You are saddled with the very thing that drove you away'. Bough never escaped from the demon – himself – that drove him. But to liven up the journey, he painted the scenes along the way. We should be grateful, for it has left us a rich legacy of paintings full of energy, movement and speed, that tell us much about the man as well as his times.

While Bough the person remains something of an enigma, despite the larger-than-life aspects of his character, his work is visible and enduring evidence of the artist.

Most of the earlier critics of his work were contemporaries who knew the man, had seen many of his paintings and understood intimately the context in which he worked. Consequently, their views have a particular relevance in helping us understand Bough's artistic stature in his time and immediately afterwards. In what follows we have selected comments that reflect their views of his strengths and weaknesses.

The battle and will to survive

His most expressive pictures have a bite and an edge to them – a frosty day, a bitter wind, a rough sea. Bough invites you to feel what the struggling figures in the picture endure. Not as a political or social comment but, at a much deeper level, simply as human beings. The battle and will to survive is how we know we are alive. Only while we feel pleasure and pain can we be sure of this. Sam understood this essential truth in his bones.

For all his shortcomings in portraiture, people were an essential part of his landscape. As William Darling Mackay, a fellow artist writing in

1906, commented, Bough's name was still a household word throughout Scotland nearly 30 years after his death. Then, he added astutely:

> He painted all sorts of subjects within the domain of landscape, but he is never happier than when he deals with the hurry and bustle of the crowded wharves and quays of great seaports. ... Often the smaller canvases were of the finer quality, and one characteristic, large and small had in common, the ease and appropriateness with which he managed the introduction of figures. Whether he is dealing with land or sea, the populous city or rural seclusion, his figures, single or grouped, are not only right as regards the composition of the picture, they are in the attitude or action that accords with their occupation, or the want of it.[4]

Bough's sense of figures in the landscape was unsurpassed. This was what he was about: we are placed on this earth and have to struggle to survive, knowing that ultimately we will fail. What we struggle against is nature. Sam understood this and tried to show it – not in any rational sense, but in a much more visceral way.

His skill as a draughtsman is often overlooked too, although commentators as disparate as Robert Louis Stevenson and Peter McOmish Dott acknowledged its importance. Stevenson observed how Bough was 'proud of his drawing and certainly rendered the significance of natural forms.'[5]

McOmish Dott, art dealer and supporter of William McTaggart, was writing around 1910. His critique is worth reading in detail (see Appendix C), as it helps explain the tone of many later evaluations of Bough's work, where his approach has been seen with the benefit of hindsight, in terms of what came after. As he knew Bough and his circle, he speaks with a personal authority. Despite reservations about many aspects of Bough's style, he still acknowledges the status of the man – and the reasons for it.

> Where then does Bough's power as a great artist lie? It lies fundamentally in his draughtsmanship and all that follows from it, and, in a secondary degree, in the truth and beauty of his tone. No Scottish landscapist has approached Bough in the characteristic significance of his drawings: – his personal interest in things seen was primarily in their shapes, structure and movement. His eye memory (as Alex Fraser often recounted to me) was abnormal and furnished him with thousands of 'motives' to work with....[6]

All of which was true, but hardly touches on what Bough the man brought to his art. A century on, it is hard to restrict him to the technicalities of his craft. These things concerned him, but others mattered more.

Colour is an area where his work is most often said to be lacking. Yet even here it all depends on which picture you look at and your own preferences. His palette was of its time, so there is little point in comparing it with the future Scottish colourists who were still then learning their craft.

His Cumbrian artist friend W. H. Hoodless remembered that Bough had told him to throw away all bright colours and use greys. To Mary Tait he decried the use of body colour (but typically neglected to take the advice himself) and suggested a very limited range of colours for her palette: yellow ochre, raw umber, raw sienna, burnt sienna, Vandyke brown, light red, crimson lake, vermilion, Prussian blue, cobalt and ivory black. 'Put in gamboge, if you like, to make up the dozen,' he conceded, then added, 'but take my advice and never use it.'[7] McTaggart, for one, disagreed with his strictures on the yellow pigment. And emerald green was anathema to Sam.

McOmish Dott was dismissive of Bough's colour sense:

> To me the quality of his colour in oils is distinctly commonplace. Even in his watercolours it rarely passes the boundary line of general truthfulness to arrive at aesthetic or emotional beauty.[8]

Within his (sometimes) limited colour palette, others saw Bough's mastery of tone as second to none – such as Mackay, writing about *The Broomielaws* of 1861:

> Over a warm, yellowish ground, rather lower-toned than the sky above, the scene has been wrought in an almost monochromatic scheme of warm greys, stronger as it nears the spectator and directly under the sun. Only in the immediate foreground is there anything like positive colour, in the costumes of the passengers on board the nearest boat, the pennon at its bow, and already deadened by the intervening atmosphere, the red paddle of that beyond. The subject is realised by justness of tone, an absolute knowledge of the forms of the various objects and surfaces represented...[9]

Pinnington was another champion of Bough's handling of colour, tone and chiaroscuro:

> In a good light a few scattered notes of red make themselves felt,

and lend warmth and brilliancy to the blue, gray, opal, and white of the sky. The sunlight falls across the surging sea, giving it life and heaving motion. ... The moonlight view of Carlisle Town Hall is an exquisite example of the delicate differentiation of tint and tone necessary to the true treatment of varied lights, whether artificial or natural, whether moonlight or sunlight...[10]

In reality, Sam did not always get his colour right, but most of the criticism misses the point. When he wanted a painting to be an essay in colour, he could be dramatically successful. But much of what he was trying to convey was about energy and motion, and he should really be judged against this standard. Most of all, if you would understand Bough's approach to colour – and how sometimes he triumphed magnificently, and how he sometimes failed dismally – look at as many of his works as you can.

En plein air

Bough did much of his preliminary sketching outdoors. Mary Tait went with him on some of his excursions and recalled that:

> In sketching from nature after his outline was made he stopped working for a considerable time smoking, and watching effects more carefully. While he was painting if a suitable figure came into the picture he at once took a pencil and put it in, securing as he said both its proper place and proportions. His sketches from nature were usually done on half-sheet Imperial of Whatman's thick paper. I have seen him finish one completely in a day, working from between 11 and 12 to about 5 with a short interval for lunch (sometimes milk from a farm near) and the usual period of studying his subject – after the usual wash of yellow ochre, he put in the shadows throughout the picture and so could work on for several hours always keeping the effect. He was very particular in choosing a point and went over the ground often and carefully before he was satisfied. He always carried a notebook in which he jotted down subjects or figures...[11]

Not quite the slapdash Bough that is so often portrayed, instead a thoughtful professional. But then there is Stevenson's testimony to contradict things! Writing to his cousin Bob in 1883, he remembered Bough's method of work:

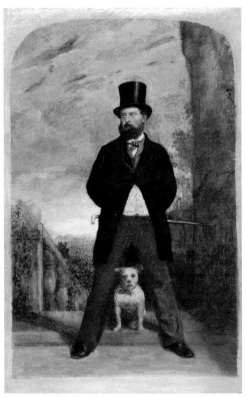

Self Portrait with Dog, Madame Sacchi,
oil on canvas, 59.7 x 39.3 cm,
Tullie House Museum and Art Gallery

Brough Sands Church, Winter Morning,
oil on canvas, 55.9 x 45.7 cm,
Private Collection

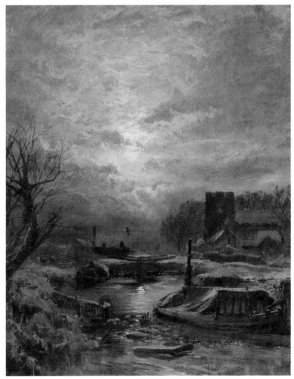

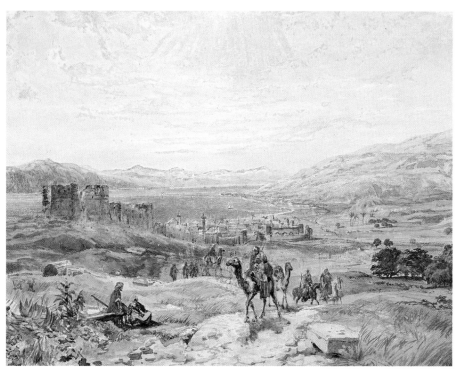

Tiberias on the Sea of Galilee, watercolour, 20.3 x 30.5 cm, *Manchester City Art Galleries*

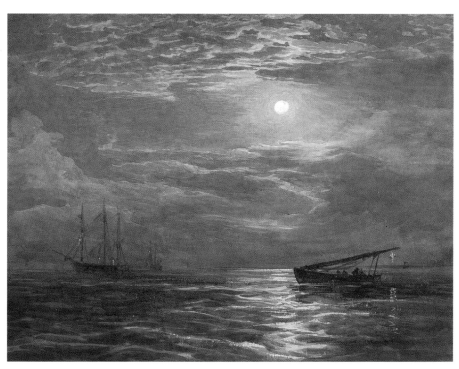

Shipping by Moonlight, watercolour, 27 x 36.5 cm, *Private Collection*

Quiraing, Skye, 1867, oil on canvas, 63.5 x 106.5 cm, *Sotheby's*

Brough Sands, 1869, watercolour, 46.4 x 74.9 cm, *Private Collection*

Borrowdale, Cumberland, 1874, watercolour, 35.6 x 50.8 cm, *Private Collection*

Peel Harbour, Isle of Man, 1875, oil on canvas, 78 x 122 cm, *Sotheby's*

Cellardyke, 1875, watercolour, 34.3 x 48.9 cm, *Private Collection*

St. Monance, Fife, 1876, watercolour, 35.6 x 52.1 cm,
Glasgow Museums: Art Gallery and Museum, Kelvingrove

Burns's Cottage, Alloway, 1876, oil on canvas, 101.8 x 145.7 cm,
Glasgow Museums: Art Gallery and Museum, Kelvingrove

Sam Bough by Sir Daniel Macnee, 1878, oil on canvas, 74.9 x 62.2 cm,
Glasgow Museums: Art Gallery and Museum, Kelvingrove

Summer Evening, Cadzow, 1877, oil on board, 33.7 x 26.6 cm, *Flemings Collection*

Each in his Narrow Cell Forever Laid - Appleby Church, 1878, watercolour, 62.6 x 50.2 cm, unfinshed, *Tullie House Museum and Art Gallery*

Distant View of Carlisle, 1878, oil on canvas, 33.8 x 54.6 cm, unfinished, *Tullie House Museum and Art Gallery*

There is but one art – to omit!. . . It is the first part of omission to be partly blind. Sam Bough must have been a jolly blind old boy. He could turn a corner, look for one-half or quarter minute, and then say, 'This'll do, lad.' Down he sat, there and then, with whole artistic plan, scheme of colour, and the like, and begin by laying a foundation of powerful and seemingly incongruous colour on the block. He saw, not the scene, but the watercolour sketch. Every artist by sixty should so behold nature. Where does he learn that? In the studio, I swear. . . . He learns it in the crystallisation of day-dreams; in changing, not in copying, fact. . .[12]

Both were right of course – that was the nature of Bough.

Speed of execution

Phenomenal speed of execution is part of the Bough legend. John Urie maintained that Sam could often explain a thing with his pencil more quickly than by words. He would dash off a pencil sketch and – 'There, that's what I mean.'

Mary Tait agreed that he was a remarkably quick worker. 'I have seen him set up a number of pieces of cardboard, and then go round them making a dash with his brushes at each in succession. In this way he rapidly sketched at the same time, half-a-dozen different pictures, in less time than an ordinary man would have taken to paint one.'[13] Interesting as a party piece, but hardly calculated to lend gravitas to the artist.

Mackay also recollected that:

His best pictures were struck off at a white heat. Stories almost incredible are told of the speed at which he worked. A clean canvas would be taken to his studio in the morning, and before night it was consigned, a finished picture, to some purchaser or forwarded to an exhibition. Of some landscape work of more recent times this might not seem much to say, but Bough's pictures were crowded with detail and the keenest observation of natural effects. Within the four corners of his frames there was seldom any space to let.[14]

Speed and carelessness should not be confused. The speed with which he worked was essential to the energy and movement he captured in paint.

A workshop in disarray

Sam looked on his studio as his workshop and treated it as such, working in constant disarray. He generally got there between 10 and 11 a.m. each morning. He painted very intently, and carried on with his work while talking to any friends who dropped by. 'In the early stages of a large picture, however, he had to give his undivided attention to his composition. He would be silent for a long time, $^1/_2$ to $^3/_4$ of an hour, quite absorbed in his work...'[15]

At 24 George Street, the studio had no side windows but was lit by a skylight in a largish room plain as 'a joiner's shop', possessing two pine cabinets and a desk, with bare boards and a gas heater. On an old oak chair sat a one-eyed bulldog, resting on a red cushion, surrounded by a model fishing boat, portfolios of prints, photographs, sketches and canvases. Sam would paint sitting down, smoking and working largely from memory, but never above consulting an engraving. Visitors such as Wyndham would drop by for a crack. Hoodless remembered that, although he was extravagant on materials, his palette was the dirtiest he had ever seen.

His studio at 2 Hill Street was similarly chaotic. It comprised a large room, two floors up, with a roof light and closed windows. A dark carved bookcase stood by the windows, covered on top with odds and ends. Pictures faced the wall, and the chairs generally had something strewn over them – papers or books he had been reading. Once he got as far as purchasing a Turkey carpet, with the notion that he would improve the amenities of the studio. It never was laid – instead it stood in a corner acquiring layers of other bric-a-brac, and ended up with his sister. As Mary Tait said, 'His mode of work would hardly have done with a carpet as he worked with a large full brush in watercolour, especially in laying on the first wash of yellow ochre. Latterly he had wax cloth laid down.'[16]

Not bound by any rules

The canvases he used came straight from the shop. In producing an oil painting, he would start with a careful outline in charcoal and then lay in his colours over the canvas. He aimed to hit the colour as correctly as possible in the first painting, according to Mary Tait:

I suppose he used medium as I have seen it on his board but he certainly used a great deal of turpentine. I know his painting of

sunset skies was quite simple. Yellow ochre was his principal yellow. He often 'scumbled' finished pictures with it. He worked very rapidly. ... He was a very close worker. When I first knew him he stood at his easel generally smoking, and in hot weather without his coat.[17]

His approach to watercolours was also simple.

He stretched his paper carefully, first made a most careful outline, then a wash of yellow ochre in almost every case. He used to say ... it gave something solid to work upon. For cloud shadows he used lamp black, and raw umber and for shadows from trees and other objects he mixed ebony black and cobalt or French blue varying it for a warm or cold effect. He liked transparent colours and the lights left out, very much more than either rubbing out or using bodycolour. It was on this account he was so very particular about a correct outline. However, he was not bound by any rules. I have seen him paint a picture without any pencil outline at all, and on one occasion when the subject was a seapiece, found the horizontal line absolutely correct, though he had used no measurements! (I don't remember seeing him even use a rest for his hand. He had two sticks in his studio.)

In the same way he worked on millboard and used opaque colour for all the lights. He said with certain subjects it had a good effect. In copying this style of work he expected me to use white paper and get up the tone. He used to say the simpler the palette the better the work.[18]

Freedom and broadness of handling

Watercolours are generally seen as Bough's real strength and also his greatest contribution to Scottish art, particularly in their freedom and broadness of handling, which paved the way for McTaggart and a later generation to develop into twentieth-century maturity. Comparing him to David Cox, Mackay acknowledged that Bough lacked the latter's purity of colour, 'but in other directions he outstrips his great predecessor. On one occasion, at an exhibition where his work had been placed near that of Cox, he was heard remarking, with a self-satisfied chuckle, "Aye, Davie, lad, that settles the matter between you and me".'[19]

Writing in the *Portfolio* in 1879, P. G. Hamerton focused on *Cellar-*

dyke Harbour, Firth of Forth – Sunset as a fine example of Bough's technique:

> The paper itself seems to have been nearly white, but so broadly washed with watercolour, after the manner of some of Turner's Alpine studies, as to have the appearance of warmly-tinted paper. The first wash secured the yellow lights upon the clouds which were reserved when the shaded areas were added, and the blue of the sky is evidently washed over the yellow. The dark cloud was put in last of the details of the sky, and the high lights were got by scraping and washing out. It is a grand sky, and painted with the most consummate technical knowledge and decision. The water, too, is excellent as a study of near ripple and distant breezes. The sails of the boats are red (reflected in the water), and there is a fine play of colour between the purple grey of the houses, the red sails, and the bluish smoke that rises from the fishing boats. The stones of the jetty are greenish towards the foreground, and the sailor who is leaning on the parapet has blue trousers and a red cap. The figures are sketchy in the extreme, but keep their places well. There is no attempt in this work to push drawing to the point of refinement; provided things come in tolerably good relative proportion it is all that the artist appears to care about: but the colour and poetic effect of the scene are admirable, and it is a merit rather than a defect that the painter should have made no attempt to get beyond the easy and natural expression of the simple watercolour wash.[20]

Hamerton also commented on another unusual facet of Sam's work – rare among watercolourists – an ability to paint night scenes, 'a subject more often suited to oils and technically difficult in watercolour.'[21] Not for Bough.

When it came to oils, in the judgement of his contemporaries and subsequent critics, Sam lacked a consistent mastery of the medium. Yet when the mood took him, his sunsets and sunrises could hang creditably alongside Turner's. James Caw in 1908 saw the quality of his best oils and the limitations of his others, when he wrote:

> Painted with extraordinary verve and directness in very liquid pigment, used in rather a watercolour manner, and combining much detail with great effectiveness of ensemble, they also exhibit his virile and forthright craftsmanship at its very best... but... as he was not a colourist of a high order, the white mixed with his tints to secure height of pitch affects the tone and harmony of the result and makes

it somewhat common. This defective sense of colour became still more marked in the rather vicious greys of his later pictures, many of which are melodramatic and unworthy of his talent.'[22]

Throughout Bough's working life, however, it was his oil paintings that gained him most attention and patronage from the art-buying public.

Who influenced him?

Bough took his first steps in art just as Carlisle was coming to the end of an ambitious but ultimately doomed attempt to establish itself as the major centre for the fine arts in the north of England.

Local artists, such as Matthew Ellis Nutter, David Dunbar, John Dobson, Robert Harrington and George Sheffield, were all there to pass on their knowledge to him. In addition, the influence of Northumbrian artists, such as Thomas Miles Richardson, Senior, and John Wilson Carmichael, can be found in the work of his youth. David Roberts and Clarkson Stanfield were also admired.

For the rest, Bough's education in the techniques of the professional artist depended on studying the original works, copies and prints in the country houses of the neighbouring gentry and, on a few brief visits to London, what he saw at the Royal Academy. This gave him the chance to study the styles of the great European, as well as British, artists.

Early influences can be suggested and their impact seen in his first efforts, but they in no way explain the explosion of ability that emerged, almost fully formed, within a few years of leaving his home town of Carlisle.

In *The Baggage Waggons* of 1849 we have the mature artist comfortable in handling broad effects on a large scale, evoking his powerful emotional response to the elements in a wonderful sky that at once carries the dark threat of danger and the promise of a brighter future.

Once into his stride, it is impossible to track his development in a linear way. A style that seems to relate to one decade can re-emerge a dozen years later, or he can very consciously hark back to an earlier era when the mood takes him.

In terms of major artists, Ruisdael, Poussin, Rubens, Gainsborough, Hobbema, Constable, Turner, Wilson, Copley Fielding, Muller and Cox all had their impact on him over the years. Bough never stopped learning, however. His work with Alexander Fraser and Thomas

Fairbairn in Cadzow was certainly mutually instructive, as were his friendships with John Milne Donald and William McTaggart. (The mutual respect and influence between Bough and McTaggart is rarely truly acknowledged in Scottish art histories.)

Others he thought highly of included Horatio McCulloch (despite their feud), George Paul Chalmers, John Crawford Wintour ('a genius and ought to do some great painting'[23] in Sam's judgement), Colin Hunter and, especially, David Murray.

He was certainly aware of the work of the Barbizon School ('Corot is the only name I remember him mentioning,' wrote Mary Tait, adding, 'and that not admiringly'[24]), but Alexander Fraser confirmed his admiration for the French School. Even higher in his estimation were the Dutch artists of the Hague School, particularly Israels and Maris, whose pictures began appearing at the Edinburgh and Glasgow exhibitions during the 1870s. In some of Bough's later works there is an increasingly impressionistic development of what was already a fairly free style, and it may be that some of their influence had rubbed off on him. McOmish Dott certainly wished that it had when he wrote: 'My own notion is that had Bough lived alongside of Mauve and Maris we would all acclaim him as one of the very ablest masters of tone'[25].

Was Bough, then, simply the sum of others' influences? Some critics would have us believe so. We prefer the assessment of the man who organized the Bough and Chalmers retrospective and knew his work intimately, Robert Walker.

> From first to last Bough was always himself; he followed no other man, and he practised no academic rules because he had not learned any. Whether he would have been a better painter had he received a thorough artistic education is a question which it would be idle to discuss.[26]

So many and contradictory opinions

In art as in life, Bough split opinion in two. No one, it seems, could remain indifferent to him or his work. Pinnington rightly wrote: 'There are few men, if any, of whom so many and contradictory opinions have been formed.'[27] That will probably remain his destiny. This essay itself shows the impossibility of making a single statement about his art that cannot immediately be countered with an opposing one, each with its validity.

His contemporaries had few doubts about his enduring greatness, deficits notwithstanding. How then to explain his relative lack of standing today? Perhaps too often the character has obscured the artist.

The fact that he was an Englishman who produced all his mature work in Scotland may have counted against him in an oddly parochial way. Historically, he has been ignored by the English art world in its general dismissal of things Scottish. The Scots, however, have also tended in more recent times to play down his relevance. It was not always so. In 1879, P. G. Hamerton could argue that:

> Bough's mind was essentially synthetic; he did not see things one by one, but in their mutual relations, so that they all blended together in artistic unity, and this is what distinguishes, par excellence, the real artist from the student.[28]

Walker in 1896 acknowledged:

> Some of the most recent developments in the practice of Scottish painters will, if carefully examined, be found to owe not a little of their character to the methods of Bough and the example he set.[29]

Pinnington, writing in *Good Words* in 1897, maintained that:

> He rose above the conventions of his predecessors, and painted not only what he saw but what he thought and felt. In rendering atmospheric effects, particularly those prevailing in broken weather, when the sunshine is dashed on sea and land in flakes, when the wind is high and mists are gloomy and dank, he had for many years no rival. And, further, in suggesting what no artist could paint, he filled the great blank in the earlier landscape art of Scotland.[30]

In 1906 Caw recognized that:

> Bough's position and influence in Scottish painting deserves frank acknowledgement here. In his lifetime he was perhaps the most popular landscape-painter in Scotland – more popular than Wintour, Fraser, McTaggart, men whose art was informed by a rarer spirit and cast in a finer mould. And this popularity was common to painters and public alike.[31]

Even by 1910 the grudging McOmish Dott still had to accept that:

from the very fact that his 'reports' are obviously intelligent and vigorously graphic he may justly be described at the most popular of our landscape painters. ... On the other hand Bough, as artist, has far finer capacities than those obvious ones on which his 'popularity' rests. His pictures are full 'of character' a quality difficult to define in words, but readily recognised through sympathy and experience.[32]

From that point until more recent times, the Scots have seemed less willing to accept his place in the development of their national art, perhaps due to his Englishness, although there are signs that a more-balanced judgement is at last emerging. In 1986, for example, Julian Halsby suggested that any faults 'seem insignificant compared to his achievements as an energetic, yet sensitive watercolourist, who more than anyone else, influenced Scottish watercolour painting away from the conventions of mid-century, towards a fresh *plein air* style'[33].

And Martin Hardie, writing in 1990 about Bough's 'almost Boudin-like lightness of palette' suggests that 'a re-examination of this neglected artist is overdue'[34].

Even his home town of Carlisle has been slow to accord him the status he deserves as its greatest artist.

We hope this book might in some small way help to restore him to a more appropriate standing as the most popular 'Scottish' landscape painter of his time, and a major figure in the transition of Scottish art from the older, McCulloch school of painting to the impressionism of McTaggart and those who came after.

Probably the best that he could do

Perhaps Robert Louis Stevenson, of all Sam's contemporaries, was closest to Seneca and Socrates in his understanding of the man and the artist. His final judgement has stood the test of time:

> There was an impression of power in the man and his work that led hasty judgements to expect more than ever he accomplished, the best that he has left is probably the best that he could do.[35]

But that 'best' left some wonderfully exciting pictures for posterity – and a memory of a uniquely attractive character. As Bough's legacy of life and art shows us, there are Rivers in Bohemia.

REFERENCES

1 Edward Pinnington's notes, *op. cit.*
2 Mary Tait to Edward Pinnington, 14 December 1896 (?), Edward Pinnington's notes, *op. cit.*
3 Robert Louis Stevenson, *Academy*, 30 November 1878.
4 W. D. Mackay, *The Scottish School of Painting*, London, 1906, p. 299.
5 Robert Louis Stevenson, *Academy*, 30 November 1878.
6 P. McOmish Dott to Edward Pinnington, 17 November 1910, Edward Pinnington's notes, *op. cit.*
7 Sidney Gilpin, *op. cit.*, p. 150.
8 P. McOmish Dott, *op. cit.*
9 W. D. Mackay, *op. cit.*, p. 301.
10 Edward Pinnington, *Good Words*, September 1897, p. 604.
11 Mary Tait to Edward Pinnington, 14 December 1896 (?), Edward Pinnington's notes, *op. cit.*
12 Robert Louis Stevenson to R.A.M. Stevenson, October 1883, quoted in Sidney Colvin (ed.), *The Letters of Robert Louis Stevenson, Volume 2*, London 1911.
13 Edward Pinnington's notes, *op. cit.*
14 W. D. Mackay, *op. cit.*, p. 299.
15 Mary Tait to Edward Pinnington, 14 December 1896 (?) Edward Pinnington's notes, *op. cit.*
16 *ibid.*
17 *ibid.*
18 *ibid.*
19 W. D. Mackay, *op. cit.*, p. 304.
20 P. G. Hamerton, *Portfolio*, Vol. 10, 1879, p. 113.
21 *ibid.*
22 James L. Caw, *Scottish Painting 1620–1908*, Bath, reprint 1975 (1st edition 1908), p. 189.
23 Mary Tait to Edward Pinnington, 14 December 1896 (?), Edward Pinnington's notes, *op. cit.*
24 *ibid.*
25 P. G. Hamerton, *Portfolio*, Vol. 10, 1879, p. 113.
26 Robert Walker, *Magazine of Art*, September 1896, p. 426.
27 Edward Pinnington, *Good Words*, September 1897, p. 598.
28 P. G. Hamerton, *op. cit.*
29 Robert Walker, *op. cit.*, p. 425.

30 Edward Pinnington, *Good Words*, September 1897, p. 604.

31 James L. Caw, *op. cit.*, p. 190.

32 P. McOmish Dott, *op. cit.*

33 Julian Halsby, *op. cit.*, p. 116.

34 Martin Hardie, *Scottish Painting 1837 to the Present*, London, 1990, p. 28.

35 Robert Louis Stevenson, *Academy*, 30 November 1878.

APPENDIX B

Obituary by R. L. Stevenson

This obituary notice first appeared in the *Academy* on 30 November 1878.

A Cumberland man, and born in the legendary city of Carlisle, Sam Bough (as he delighted to be called) died in Edinburgh on November 19, aged fifty-seven. This is not only a loss to art, but the disappearance of a memorable type of man. Spectacled, burly in his rough clothes, with his solid, strong, and somewhat common gait, his was a figure that commanded notice even on the street. He affected rude and levelling manners; his geniality was formidable, above all for those whom he considered too fine for their company; and he delivered jests from the shoulder like buffets. He loved to put himself in opposition, to make startling, and even brutal speeches, and trample proprieties under foot. But this, although it troubled the amenities of his relations, was no more than a husk, an outer man, partly of habit, partly of affectation; and inside the burr there was a man of warm feelings, notable powers of mind, and much culture, which was none the less genuine because it was not the same character, not altogether concerned in the same fields of knowledge, as that training which usually appropriates the name. Perhaps he was a little disappointed with himself, and partly because he loathed fustian, partly because he did not succeed in living consistently up to the better and more beautiful qualities of his nature, he did himself injustice in the world, and paraded his worst qualities with something like a swagger. To borrow a metaphor from the stage with which he was long connected, he preferred to play his worst part because he imagined he could play it best. It was only when you got him alone, or when, in company, something occurred to call up a generous contempt, that you became clearly aware of his sterling, upright and human character. Such manifestations his friends were as little willing to forget as he seemed shy of offering them. He would display a sneering enmity for all that he thought mean or bad, and a quiet and genuine delight in all that he thought good. To students he

227

was even exceptionally kind and helpful. He had an open hand, and came readily forth from his cynical out-works at any tale of sorrow. He had read much and wisely; and his talk was not only witty in itself, but enriched with the wit and eloquence of others. He played the violin, sang with spirit, and had a remarkable gift of telling stories. It was a delight to hear him when he spoke of Carlisle, Cumberland, and John Peel, the famous hunter; or when he narrated his own experience – cobbling shoes beside his father, gipsying among the moors to sketch, working in the docks as a porter, or painting scenes and sometimes taking a part at local theatres. As we say of books that are readable, we may say of his talk that it was eminently hearable. He could broider romance into his narratives and you were none the wiser; they would all hold water; they had the grit and body of reality, the unity of a humorous masterpiece; and the talents of the novelist and the comedian were pressed together into the service of your entertainment.

His sentiment for nature was strong and just; but he avoided the subject in words and let his brush speak for him.

He was a massive, heavy painter, and liked broad effects of light. His colour was apt to be a little cold and dead. Yet he had a remarkable understanding of sunlight and certain aspects of summer atmosphere in the North, which perhaps lent themselves to the defect of his treatment. He was proud of his drawing and certainly rendered the significance of natural forms. Among his more important works in oil I may mention *Shipbuilding on the Clyde*, *Borrowdale*, *Canty Bay*, *St. Monans*, *Kirkwall*, and *London from Shooter's Hill*. But his name is more eminently connected with the practice of watercolours. The man's unshaken courage and great muscular power seem to have more directly found expression in this field. It was a sight to see him attack a sketch, peering boldly through his spectacles and, with somewhat tremulous fingers, flooding the page with colour; for a moment it was an indescribable hurly-burly, and then chaos would become ordered and you would see a speaking transcript: his method was an act of dashing conduct like the capture of a fort in war. I have seen one of these sketches in particular, a night piece on a headland, where the atmosphere of tempest, the darkness and the mingled spray and rain, are conveyed with remarkable truth and force. It was painted to hang near a Turner; and in answer to some words of praise – 'Yes, lad,' said he, 'I wasn't going to look like a fool beside the old man.'

His activity was indefatigable; he worked from nature; he worked in the studio; even at home he would have a piece at his elbow to

work upon in intervals of music and conversation. By many it was supposed that this industry had a commercial motive, and injured the quality of his production; and it is true that Sam Bough was pre-occupied about material necessities, and had a rooted horror of debt; but he thoroughly enjoyed his art, and, perhaps, still more the practice of it; and although there was an impression of power in the man and his work that led hasty judgements to expect more than he ever accomplished, the best that he has left is probably the best that he could do.[1]

[1]Robert Louis Stevenson, *Academy*, 30 November 1878.

APPENDIX C

An Art Dealer's Critique

Peter McOmish Dott succeeded his father in running the firm of Aitken Dott & Son, art dealers, established in Edinburgh in 1842. Aitken Dott had known Bough and his artistic contemporaries very well, the son to a lesser degree. Towards the end of 1910, Edward Pinnington had a correspondence with him that produced the following critique of Bough's work. In an earlier letter, the dealer confesses that Sam's art is not to his taste, as he favours the generation of Scottish artists who came after him. The critique should be read with this in mind, but nonetheless, offers a valuable insight into a contemporary art professional's view of Bough.

I respond with diffidence because my personal bias in art is such that much of what Bough achieved so powerfully and successfully does not greatly move or interest me. Straightaway I hold him to be one of the greatest – and certainly the most 'popular' – of Scottish landscapists, yet his firm grip of 'actuality' and the whole range of his effective art appear, to me, accompanied by such a lack of high emotional and musical quality as to fail in reaching one's heart.

It was in thorough consistency with Bough's native love of 'narrative facts' that he decided almost at once to join in with his naturalistic contemporaries and steer clear of the idealistic school, represented by Thomson, McCulloch, Wintour and others; and a close examination of his evolution as an artist will disclose his early leaning to the watercolour medium greatly furthered this naturalistic tendency: – (parenthetically it may be here noted to his credit that he was the first artist in Scotland to secure general respect for water-colour as a serious art medium.)

Considering in the first place Bough's technique – a part of the language of art which often reveals the more intimate and delicate emotions of a painter – I see no evidence that he ever evolved any fresh or original technical methods, or 'touch' expressive of his personal emotions in face of nature.

To me, his technique is intelligent and purposeful but also insensitive and conventional, being in fact largely secondhand: his brushwork in oils is reminiscent of Constable, Muller and others, and in watercolours he seldom gets beyond David Cox's drawing master's conventional touch. The same limitations are visible when he 'talks in colour' – again one misses any signs of that newness of vision or emotion which drives painters to reach out for a fresh language of expression such as we see in Israels, Monticelli, McTaggart or Alex Fraser – one feels for instance that a vivid enjoyment of gem like bits of local colour makes of Fraser's technical methods a sincere personal language.

And if Bough's work is searched for 'colour' in its deepest significance, where it becomes the vehicle of fine human emotion, or of mysterious and beautiful imagination, the search ends in disappointment. To me the quality of his colour in oils is distinctly commonplace. Even in his watercolours it rarely passes the boundary line of general truthfulness to arrive at aesthetic or emotional beauty.

We have therefore, looking at his work as a whole to pass over his 'coloury' and somewhat scenic efforts, and arrest our attention on colourless grey-toned oils and especially on his interpretations of grey weather effects in watercolour to find Bough at his best.

Where then does Bough's power as a great artist lie? It lies fundamentally in his draughtsmanship and all that follows from it, and, in a secondary degree, in the truth and beauty of his tone. No Scottish landscapist has approached Bough in the characteristic significance of his drawing: – his personal interest in things seen was primarily in their shapes, structure and movement. His eye memory (as Alex Fraser often recounted to me) was abnormal and furnished him with thousands of 'motives' to work with where a more slenderly endowed man would grope for few and perhaps find none: – clouds at rest, in easy motion, or angry action; clusters of fishing boats; a crowded village fair; the ever changing lines of a river's banks; all and everything came easy to hand to this artist with his strong grips of the actual shapes and make of things. Naturally this faculty led to the dramatic and picturesque in composition and here Bough's art instincts never fail him – (unless where now and again he overcrowds his canvas with 'material').

Therefore in his pictures we almost invariably find his main theme in light and shade is laid down in masterly fashion, then beautifully broken up by numberless minor variations which are ordered with a clear eye to picturesque effect. His drawing can scarcely indeed be called beautiful, but rather powerfully significant,

and is quite exceptional in its width and scope, and purposeful directness.

Coming now to the truth and beauty of his tone; before we can do proper justice to Bough's powers in this regard, it is necessary to remember that natural illumination and atmospheric values were at a low ebb among his contemporaries – Corots and Marises were not with us then. If we take our stand in front of a really fine silver or grey drawing we feel at once that the artist has observed keenly and enjoyed greatly the charms of light and atmosphere; the 'mother' light penetrates everywhere and the shadows are of 'one family' and lie truly in their planes. My own notion is that had Bough lived alongside of Mauve and Maris we would all acclaim him as one of the very ablest masters of tone.

To sum up, in very summary fashion – the reasons why I admire and do not admire the art of Sam Bough: – I feel there is a fibre of 'commonness' running through his colour, his technique and general artistic outlook which goes deep down into the emotional foundations of the man's nature and permitted him to send forth to the world works far inferior to his real 'best'.

Thus it comes about that a good half of his work is never touched by poetic imagination or fine melodious feeling. In too much of it he remains at the level of a graphic journalistic reporter of Nature, yet from the very fact that his 'reports' are obviously intelligent and vigorously graphic he may justly be described as the most popular of our landscape painters.

On the other hand Bough, as artist, has far finer capacities than those obvious ones on which his 'popularity' rests. His pictures are full 'of character' a quality difficult to define in words, but readily recognised through sympathy and experience. There rise from the heaped up mass of his achievements the distinctive aroma of 'maleness' – resulting from a strong will, and a penetrating, sane and athletic intellect.

If his art is void of deep or high imagination, of poetry, of emotion and is even limited in aesthetic charm, it is also free from all taint of effeminacy, cant and 'pose'.

His works show him to have been that rare phenomenon 'a real man'; a lively observer and true lover of nature whose beauties (as revealed to him) he interpreted in a spirit at once vigorous and sincere.[1]

[1] P. McOmish Dott, *op. cit.*

APPENDIX D

Major Exhibitions of the Works of Sam Bough, RSA

Carlisle **1850**	***Exhibition of Paintings and Sculpture, The Athenaeum*** Stratford-on-Avon, Birthplace of Shakespeare Olivia's Garden, Malvolio finds the letter – vide Shakespeare's Twelfth Night Inversnaid, Loch Lomond The Scene of Wordsworth's Poem to a Highland Girl 'This fall of water, that doth make A murmur near the silent lake, This little bay, a quiet road That holds in shelter thy abode.' Edgehill The Moated Grange Glen Scaddel, from Invercaddel, Ardgower, Argyllshire Haddon Chase – Haddon Hall in the distance – Derbyshire Tanziermunden, on the Elbe. Rain storm clearing off Naworth Castle (not in catalogue) Portrait of Bella (not in catalogue)
Edinburgh **1844**	***Royal Scottish Academy*** Askham Mill, Westmorland
1849	Yanwath Mill, River Eden Olivia's Garden – Twelfth Night Bowden Church, Cheshire View on the River Irwell, Lancashire
1850	Stratford-on-Avon
1851	Broughty Castle, Sunset Edgehill Haddon Chase Glen Scaddel, Argyllshire
1852	Kircudbright Castle Sunrise; the Fisherman's Return

1853	Barnclutha
	Lent by James Rodgers, Esq, Glasgow
	Peeling Oak Bark, Cadzow Forest
	Bothwell Castle, near Uddingston
1854	Beech Trees, Autumn
	A November Day, near Caerlaverock, on the Nith
	Cadzow Forest Oaks
	Glasgow from Garngad Hill
1855	Entrance to Cadzow Forest
	Fishing Boats running into Port: Dysart Harbour
	Gabbarts and Iron Shipyard, Dumbarton
	Victoria Bridge, Glasgow
	Study from Nature at Barncluith
	Woodhall, near Knutsford, Cheshire
1856	Herring Boats going to Sea
	'Wives and mithers maist despairin'
	Ca' them lives o' men'
	Lent by Robert Horn, Esq
	Edinburgh from Bonnington
	West Wemyss Harbour: a Gusty Day
	Newhaven Harbour during the Herring Fishing
	Bridge-end, Kilmacolm
	An English Village: Winter Afternoon
	A Mill on the River Lowther, Westmorland
1857	The Hay Waggon
	Lent by the Dean of Faculty, John Inglis
	Moonlight on the Avon
	Lane Scene, near Guildford
	The Port of London
	Furness Abbey, Lancashire
	Lent by Robert Horn, Esq
	The Holmewood Common, Surrey
	Verderer and Fallow Deer
	'When the hoar frost was chill
	On moorland and hill,
	And fringing the forest bough.'
	The Philosopher of Sans Souci
1858	Inch Colm, looking West
	Lent by J A Dunlop, Esq
	A Border raid
	Lent by Hon Lord Murray
	Glen Messan: Moonlight

Naworth Castle
Lent by Robert Horn, Esq
The Thames, from Hungerford
Lent by James Caird, Esq
The Weald of Kent
Lent by the Association for the Promotion of the Fine Arts in Scotland
Inch Colm
Travelling in Norway
The Sands at Sunrise, Whitechurch
Lent by James Horn, Esq

1859
In Cadzow Forest
Lent by Robert Horn, Esq
Lane at Barncluith
Edinburgh from the Island of Inchcolm
Edinburgh from Leith Roads
Sun rising over Fog Banks, Dutch Shipping, etc
Oak Trees breaking into Leaf
Lane at Barncluith
A Hay-Field
Texel Roads: a Stiff Breeze
Lent by the Association for the Promotion of the Fine Arts in Scotland
Sunrise on the Coast

1860
The Way to the Forest
Haughhead: Haymaking
Springtime: the Old Forest Well
The Thames at Chiswick: Moonlight
The Vale of the Avon
Lent by Thomas Nesbit, Esq
Early Morning: Fishing Boats unloading
 'Within a mile o' Edinburgh Town'
Lent by William Christie, Esq
Buckhaven: the Last Gleam
Lent by P S Fraser, Esq
Leven: Sunrise
Lent by R S Wyndham, Esq

1861
Twilight
Lent by William Laurie, Esq
Tarbert Harbour, Lochfyne
Lent by William Laurie, Esq
Inchcolm: Moonrise
Broughty Castle in the Olden Time

235

Lent by John C Bell, Esq
The Pier-head at Aberdour
St Andrews: 'When the stormy winds do blow'
Lent by Donald Roy Macgregor, Esq
Aberdour from the West
Dutch Galliot in Aberdour Harbour
Lent by Erskine Nicol, Esq, RSA
Holmwood Common
Aberdour

1862
On the Eden at Corby Castle
Lent by William Laurie, Esq
Hoar Frost
Lent by J C Bell, Esq, Broughty Ferry
The High Street
A Ferry on the River Eden
The Drave between North Berwick and the Bass
 'Here's to the herring, the king of the sea'

1863
Auld Reekie: Twilight
Berwick on Tweed, from a Sketch made in 1837
Lent by J Charles Bell, Esq, Dundee
On the Marr Bank, Sunrise
Ankerstrom, on the Zuyder Zee
Dream of Hellas
Lent by George Patton, Esq
The Beach at Sunrise
Dysart Tower: Water Sunset
Lent by John Faed, Esq, RSA
A Canal Scene
Dordt

Exhibition of Works of Deceased and Living Scottish Artists
Inchcolm
Lent by Robert Horn, Esq
Cadzow Forest
Lent by Robert Horn, Esq
Newark Castle
Lent by Robert Horn, Esq
Forest scene
Lent by Robert Horn, Esq

1864
Cora Linn, on the Clyde
Tantallon Castle: Rain-Storm clearing off
Ulleswater, from Barton Fell

The Clyde, from the Roman Camps at Dalziel
A Salmon Weir on the Eden
The Prisons of the Bass
Fishing Boats at Sunset
Through the Wood

1865 The Tower, London, from the River
A Storm
Lent by John Brash, Esq
The Painting Room at the Old Adelphi Theatre, Edinburgh
Off the Fife coast
Lent by Thomas Chapman, Esq
An Otter Hunt: 'So early in the Morning'
Lent by J Taylor, Esq, Langholm
A Trout Stream in Cumberland
Edinburgh, from the East: Early Morning
Lent by Alex Young, Esq
Newhaven
Lent by J C Mackie, Esq
In the Trossachs
Hay field
Holy Island Castle
The Woods in Autumn

1866 Tarbert, Loch Fyne
Lent by John Mill, Esq
The Sound of Mull
Lent by W D Clark, Esq
The Bass: Morning after a Storm
Lent by Alex Young, Esq
The Tower of London
A forest glade
Dina and her young Family
Lent by Dr Thatcher
A Cheshire Canal
The Vale of Teith
Lent by Robert Jardine, Esq. MP
The Dog in the Manger

1867 Fox breaking Cover
Kirkwall Habour
 'Twas when the seas were roaring'
Lent by H Bruce, Esq
West Wemyss
Lent by J G Orchar, Esq
Benledi

The Bass – vide Old Mortality
On the Scheldt: Antwerp in the Distance
Lent by H Bruce, Esq
North Berwick
Lent by J Reid, Esq
St Monance, Fife
 'Fishers went sailing into the mist
 Out into the west as the sun went down'

1868 The Forth, from the Abbey Craig, Stirling
Partridge shooting
Lent by R M Jones, Esq, Leith
Saint Monance
English Travellers in Norway
Lent by Thomas Swan, Esq, Braid
Brook at Limefield
The Ross near Hamilton
Canty Bay
Calgarry, Mull
North Berwick Harbour
The Thames, from Greenwich
Borrowdale, Cumberland

1869 Skiddaw, from Wattenlath
The Fortalice of the Bass
A Swollen Torrent: Hartz Mountains
Cader Idris
Ruins on Inchmahon, Isle of Menteith
A Windy Morning: Loch Leven
Dunstanborough Castle: a Storm

1870 Whale ashore at Longniddry
Head of a Whale
Lent by Prof Turner
On the Solway
Skye
Lent by T Chapman, Esq
Canty Bay

1871 Canty Bay: Fishermen playing Ninepins
Saint John's Vale, Cumberland
Lent by Thomas A Smieton, Esq, Panmure Villa, Broughty Ferry
A Summery Day in Iona
Lent by Mr Strahan
A Highland Glen in Ross-shire
The Beach at Sunset
The Broomielaw, Glasgow

Lent by George Girle, Esq
Glen Carron, Ross-shire
Lent by William Thompson
The Field of Bannockburn, from the Gillie's Hill
Ravenscraig Castle
Lent by Thomas Welsh, Esq, Ericstane

1872 London, from Shooters Hill
Lent by Alexander Mitchell Innes, Esq, Ayton
The River Thames at Henley
Thirlemere, Westmorland
Wetheral Wood
The Avon, near Bristol
The Woods in Autumn
Lent by James Falshaw, Esq, Edinburgh
Buchan Ness
Lent by James Falshaw, Esq

1873 The Quhair and the Tweed at Inverleithen
Lent by John Clapperton, Esq, Master of the Merchant Company
Sweetheart Abbey
Lent by William Forrest, Esq, Edinburgh
Borrowdale
Lent by Alex Young, Esq, Portobello
The Western Shore of Iona – here St Columba landed
AD 565
Barnton Park
Lent by Robert Clark, Esq, Edinburgh
Lanercost Abbey, Cumberland
Lent by Dr Robertson
A Derelict Ship
Lent by William Nelson, Esq, Hope Park
Canty Bay
Lent by Dr Robertson

1874 Crossthwaite Bridge, Cumberland
On the Thames: Thunderstorm clearing off
Lent by, Thomas Chapman, Jun, Esq, Edinburgh
St Andrews
Lent by William Paterson, Esq
Glen Shin, Ross-shire
A Wet Village
Styehead Pass, Cumberland
Lent by J Julius Weinberg, Esq, Dundee
Tiney
Lent by Mrs Wallace, Murray Villa, Grange

239

Skye
Lent by Mrs Bough, Jordan Bank, Morningside
Braid

1875
Peel Castle, Isle of Man
Peel Harbour, Isle of Man
Eagle Crag, Borrowdale
Roger – A Dog's Head
Lent by George Thompson, Esq, Edinburgh
Ash trees – study
Crummock Water, Cumberland
Braid, looking West
Scene from The Bride of Lammermoor
*Lent by the Association for the Promotion of the Fine Arts of
Scotland*
Graves of Forgotten Kings: Iona
Lent by Alexander Younger

1876
Edinburgh, from Bonnington
Lent by the RSA
The Rocket Cart
Lent by Alex Young, Esq, Portobello
The Tweed and Teviot: Windstorm
Lent by John Clapperton, Esq
Edinburgh, from Inchkeith
Naworth Castle, Cumberland
Lent by Capt Lodder RN
The Crieff Hills
Lent by Alex Young, Esq, Portobello
Troup Head

1877
West Wemyss harbour
Lent by Thomas G Taylor, Esq
The March of the Avenging Army ... crossing the Solway
into England
During a Thunderstorm at Sunset
Lent by John Grieve, Esq, London & Edinburgh
Distant View of Carlisle
Cadzow Forest
Lent by A White, Esq
The Thames at Greenwich: sun breaking through the Mist
Lent by Dr Dewar
Pentcaitland Church
Mary McGee
Lent by Mrs Bough

1878
Ullswater, from Pooley Bridge

Lent by R Clark, Esq
Bylaff Glen, Isle of Man
Tam o'Shanter
Lent by William Paterson, Esq
On the Avon, near Bristol
Eiderlin, Argyllshire
The Billowness, Fife
 'A blast o' Januar wind
 Blew hansel in on Robin'
Lent by W Paterson, Esq

Dundee **1877**	**Albert Institute** Harbour Scene A Showery Day in Highlands A Rainy Day
Glasgow **1849**	**West of Scotland Academy** The Baggage Carts – Carlisle in the Distance *Lent by H L Anderson, Esq, Renfield Street* Olivia's Garden – Shakespeare's Twelfth Night Lorton Mill, Cumberland Gilnockie Tower, River Esk Maryport Harbour Edinburgh from St Leonard's
1850	Barges on the River Irwell, Lancashire Institute of the Fine Arts, proposed to be erected in George's Square, from design by J. T. Lochhead, Esq, Architect Broughty Castle, near Dundee
1851	Glade in the Forest, Cadzow Glen Messan Kirkcudbright Castle Bothwell Castle Canal Scene, Cheshire The Fisherman's Return – Sunrise The Fisherman's Departure – Sunset
1852	On the Irwell, Lancashire The Old Forest – Sunset Bothwell Castle, near Uddingston Off St Andrews
1853	Wishaw Banks A Woody Lane; Tinkers Encamped A Ford on the Clyde, above Lanark Dysart on the Coast of Fife

Calais Harbour (figures by L. Tessen)
On the Irwell: Sunrise
Barnclutha
Beech Trees: Autumn
Bothwell Castle
Lent by A G Macdonald, Esq
Govan
Lent by A G Macdonald, Esq
Cadzow Forest Oaks

Glasgow Institute of the Fine Arts

1861–62 Dunkirque from the Lower Harbour
Near Cambuslang
Lent by A G Macdonald, Esq, Glasgow
Glasgow Bridge
Lent by A G Macdonald, Esq, Glasgow
Victoria Bridge
Lent by A G Macdonald, Esq, Glasgow

1862–63 Dysart Tower
Edinburgh Castle from the Canal – Sunrise in Vapour
Ankarstrom, on the Zuider Zee
London from Greenwich Park
On the Marrbank – Sunrise
Aberdour from the Pier Head
The Way to the Forest
Lent by William Lawne, Esq
Tobermory
Duart Castle, Mull
Broadford, Skye
Trongate of Glasgow
The Quirang, Skye
Glasgow from Garngad Hill
Oban
Ben Nevis
Fingal's Cave, Staffa
Loch Alsh
Castle Urqhuart
River Ness
The Cuchullin Mountains, from the Sound of Sleat

1863–64 The Upper Pool of the Thames – Sun rising through Vapour
Lent by John Pender, Esq, Manchester
Edinburgh from Calton Hill

1865 Barncluith

The Plains of Flanders
Haugh-head, near Hamilton
A Breezy Day on the Coast
Loch Achray
Lent by Thomas Bouch, Esq
Ullswater
Mount Blanc, Switzerland
Cora Linn, Lanarkshire
Falls of Stone-Byres, on the Clyde

1866 In the Trossachs
Lent by John Moffet, Esq
The Broomielaw from the Bridge – 'Let Glasgow Flourish'
The Drove at Sunrise – Hoar Frost; 'The rigid hoar frost melts before his beam'

1867 Off Tantallon Castle – Morning after a Storm
The Vale of the Teith from Lanrick
In Glenlyon – Spring-Time

1868 St Monance – Fishing Boats going to Sea
Skelmorlie – Storm
Ben Ledi, looking into the Pass of Leny
Stennis, Orkney
Duchel Moor
Kelly Woods
Dumbarton Castle, from Langbank

1869 Lock Achray
The Great Oaks, Cadzow Forest
Canty Bay
The Gipsies' Haunt

1870 On the Way to the Forest
Craignethan Castle
The Thames at Chiswick – Moonlight
Ben Ledi, from Callander
Oak Trees, Cadzow Forest

1871 The Junction of the Rivers Eamont and Lowther
London from Hungerford
Lent by D S Cargill, Esq
Brougham Castle, Westmorland
Highead Castle, Cumberland

1872 Port-na-Coriah, Iona
Here St Columba landed, A.D. 650
Then their way they wended

243

To the pure and pebbly bay,
And the holy cross uplifted.
Then did saintly Colom say;
'In the sand we now will bury
This trim craft that brought us here,
Lest we think of Oats of Derry,
And the land we hold so dear.'
Then they dug a trench and sunk it
In the sand to seal their vow
With keel upward, as who travels
To the sand may see it now.
Professor Blackie

Dhuheartach Rock
Lying 15½ miles south-west from the island of Iona,
showing the Lighthouse Works now in progress
Lent by Daniel Stevenson, Esq
Carlisle Castle
Ullswater – a Rain Storm

1873	The Clyde from Bishopton
	Stye Head pass, Borrowdale, Cumberland
1874	St Monance – Day after Storm
	Cadzow Forest – Spring Time
1875	Crosthwaite Bridge, near Keswick
	Borrowdale
	Eagles' Crag, Borrowdale
	Caldbeck, Cumberland
	Windsor Forest
1876	McLean's Cross, Iona
	The Birthright of the Gael

Scottish Society of Water Colour Painters

1878	Dobbs' Linn, near Moffat
	Cellardyke
	Pittenweem
	Carting Seaweed – Fife
	Bending a Net, Pittenweem
	St Monance

Leeds	*Leeds National Exhibition*
1868	Huntsmen and Hounds coming Home – Frosty Night approaching

Liverpool	**Liverpool Academy**
1855	Leith Roads, looking towards Edinburgh – Wind and Tide
	Dysart, Coast of Fife
	Port Glasgow, Evening
1856	Cattle crossing the Echaeg, Ayrshire
1857	Verdurer and Fallow Deer – Hoar Frost
	'When the hoar frost was chill
	On moorland and hill,
	And was freezing the forest bough'
	Edinburgh, from Bonnington
	Pitch Place, Near Guildford
	Holme Wood Common
1858	Oak Trees breaking into Leaf, Cadzow Forest
	St Andrews
	Cadzow Forest
	Lane at Barncluith
1859	The Hayfield
1860	The Dreadnought
	Cadzow Forest – Sunset
	On the Beach at Portobello
	Liverpool Society of the Fine Arts
1861	Dumbarton Castle on the River Clyde
	Dutch Trawlers beating to Windward
	Liverpool Autumn Exhibition
1876	A Rocket Cart
London	**The Royal Academy**
1856	Tarbet Harbour, Loch Fyne – Sunset
1857	Goalen Castle, Sound of Mull
	Holmwood and Common, Surrey
1862	Dutch Brig drifting from her Anchor
1865	The Vale of the Teith
1868	Cader Idris
1871	Sunrise on the Coast: North Berwick
1872	Winton House, East Lothian, a Frosty Morning
	A Sunny Day in Iona
1873	Iona looking North in the Sound of Mull
	Edinburgh from Dalmeny

1874	London from Shooters Hill
1875	Canty Bay Yanwath Hall, Westmorland
1876	Kirkwall Harbour, Orkney

Manchester *Royal Manchester Institution*
1847

Scene on the Ashton Canal
Return from Hunting – Evening
Airey Force, Gowbarrow Park, Westmorland
Stye Head, Cumberland
Askham Mill, on the River Lowther, Westmorland

1848 Olivia's Garden. Scene from the Twelfth Night

1851 Gilnockie Tower, on the River Esk – Sunset

1854 Sweetheart Abbey
Entrance to Cadzow Forest
Beech Trees, on the Avon, Lanarkshire

1855 Edinburgh from St. Anthony's Chapel, Arthur's Seat
Lent by Messrs D Bolongaro & Son

1856 Stoke Lane, Guildford
Newhaven Harbour, during the Herring Fishery
A prize picture of the Edinburgh Art Union, 1856
Lent by William Muir, Esq

1857 An English Village – Winter

1858 Dutch Herring Buss running out of Port – Stiff Breeze
Craig Nethan Castle
The Way to the Forest
The Sands at Whitchurch – Morning
View of Edinburgh, from Bonnington

1859 Fishing Smack and Lugger on the Beach at Portobello
A Hay Field, Haugh Head
Springtime: The Old Forest
Private property
Tarbet Harbour, Loch Fyne – Sunset
Lent by John Knowles, Esq
A Cold Windy Day on the Scotch Coast
Private property
Early Morning on the Coast. Fishing Boats Unloading

1860 Holmwood Common
Sun breaking through the Mist

Hay Field
Newhaven Harbour
Oaks – Cadzow Forest
Lent by C H Mitchell, Esq

1861 Dunkirque, looking into the Upper Harbour

1862 Dunkirque Harbour – Rain, Clouds and Wind
Hay Field, looking north
Worsley Hall: Seat of Right Hon The Earl of Ellesmere
Contributed by Mr J C Grundy
Dysart on the Fife Coast
Heywood Gold Medal
Scene in Naworth Park
Contributed by Mr Hadfield
Looking from Flanders into France: Dunkirque in the
Distance: Storm clearing off
Glasgow: Looking South

1863 The Pier Head at Aberdeen
Lindisfarne, Holy Island – Misty Sunrise
Tantallon Castle – Rainstorm clearing off
On the River Clyde
Stonebyers, on the Clyde
Ullswater, from Barton Fell

1866 Dunkirk Harbour

1868 Don Quixote

1869 Newhaven
Norham Fair

1870 The Junction of the Rivers Eamont and Lowther
Brougham Castle
Cellar Dyke
Lent by Samuel Barlow, Esq
Lindisfarne
Lent by Samuel Barlow, Esq

1872 The North-West Lighthouse, Shetland Islands, the most
Northerly Point of Great Britain
Contributed by George Falkner, Esq

1874 Rabbit Shooting
Dunkerque Sands
Contributed by J J Leech, Esq
On the River Avon, near Bristol
Hanham Ferry, near Bristol

1875	Yanwath Hall, and the River Eamont
	The Fens, Lincolnshire
	Lent by William Orr, Esq
	Coastguards using Rocket Apparatus
	Lent by William Orr, Esq

| 1876 | Aberdour Harbour |
| | Old Mill, Ambleside |

1877	On the Avon, near Bristol
	West Wemyss Harbour – Sunrise (1854)
	Lindisfarne
	Holy Island

1879	'When the hoar frost was chill
	On the moorland and hill,
	And fringing the forest bough'
	Lent by T Aitken, Esq

Major Loan Exhibitions held after Bough's Death

1880	*Glasgow Institute of the Fine Arts Loan Exhibition*
	On the East Coast
	Lent by Alexander Rose, Esq, Glasgow
	Bass Rock
	Lent by Dr Douglas Reid, Helensburgh
	Hayfield
	Lent by A Macdonald, Esq, Aberdeen
	Road Scene
	Lent by J Cochrane, Esq, Glasgow
	Billingsgate
	Lent by James F Low, Esq, Monefieth
	Keynsham Lock, near Bristol
	Lent by R W Rankine, Esq, Edinburgh
	Old Mill
	Lent by Robert Ramsey, Esq, Glasgow
	Yanwath Hall
	Lent by Robert Ramsey, Esq, Glasgow
	On the Coast of Morven
	Lent by James Donald, Esq, Glasglow
	Loch Ard
	Lent by Col Alex Wilson, Bannockburn
	Holy Island
	Lent by Capt Lodder, Edinburgh
	Calais Old Pier
	Lent by Joseph Henderson, Esq, Glasgow

Sunset
Lent by Provost Wilson, Govan
Edinburgh Castle from the Canal
Lent by Mrs J H Young, Glasgow
Newton, near Carlisle
Lent by John McGavin, Esq, Glasgow
Maclean's Cross, Iona
Lent by J G Orchar, Esq, Glasgow
On the Shore at Arrochar
Private Property
Canty Bay
Lent by J Leadbetter, Esq, Broughty Ferry
Sunrise on the Marr Bank
Lent by Douglas Murray, Esq, Longyester
Chorlton Hall
Lent by James Donald, Esq, Glasgow
Hay-Making Scene
Lent by A R Henderson, Esq, Glasgow
Tarbet, Loch Fyne
Lent by T Donald, Esq, Glasgow
Starley Burn, Coast of Fife
Lent by John Blair, Esq, Edinburgh
Tail of the Bank
Lent by J W Young, Esq, Edinburgh
Hanham Ferry, near Bristol
Lent by Andrew H Mclean, Esq, Glasgow
Peel Castle
Lent by A Gilchrist, Esq, Glasgow
St Andrews
Lent by A J Kirkpatrick, Esq, Glasgow
Portrait
Lent by Dr Douglas Reid, Helensburgh
Brecon Hill Tower, Kirklinton, Cumberland (painted at the age of 16)
Lent by J Fisher, Esq, Carlisle
Herring Boats Going to Sea
Lent by Mrs Horn, Edinburgh
In the Trossachs
Lent by Mrs Menzies, Edinburgh
Sunset
Lent by Kenneth Thomson, Esq, Crosshill
Bothwell Castle
Private Property
The Quirang, Skye
Lent by T Chapman, Esq, Edinburgh

The Rocket Cart
Lent by J Anderson, Jun, Esq, Glasgow
Stirling Castle from the Borestone
Lent by Lieut Colonel Alex Wilson, Bannockburn House
On the French Coast
Lent by James F Low, Esq, Monefieth
Edinburgh from Bonnington
Lent by James Gardiner, Esq, Edinburgh
A Rainy Day, Crawford Moor
Lent by J W Lamb, Esq, Dundee
Sunset on the East Coast
Lent by R J Bennet, Esq, Glasgow
In the Highlands
Lent by William McCall, Esq, Glasgow
Kilmalcolm Hill
Lent by James Hay, Esq, Edinburgh
Crossing the Moor
Lent by J Anderson, Jun, Esq, Glasgow
Crossing the Moor
Lent by J Anderson, Jun, Esq, Glasgow
Kirkwall from the Holm Road
Lent by J W Young, Esq, Edinburgh
Bass Rock in a Storm
Lent by Douglas Murray, Esq, Longyester
Hoyhead
Lent by J J Weinberg, Esq, Dundee
Bowness
Lent by James Carnegie, Esq, Edinburgh
The Port of London
Lent by J T Whitelaw, Esq, Glasgow
Newark Castle
Lent by Capt Lodder, Edinburgh
Entry to Ruthven Garden, Hamilton
Lent by George Black, Esq, Glasgow
Callernish
Lent by R J Bennet, Esq, Glasgow
Marine View
Lent by Miss McKerracher, Glasgow
Smugglers Attacked and Alarmed
Lent by J T Whitelaw, Esq, Glasgow
Rain clearing off Ben Wyvis
Lent by Thomas McDougall, Esq, Eskvale
London from Greenwich Park
Lent by Thomas Wiseman, Esq, Glasgow

Aberdour Harbour
Lent by Edward Martin, Esq, Glasgow
Cadzow
Lent by Andrew Maxwell, Esq, Glasgow
St. Anthony's Chapel – Moonlight
Lent by James Richardson, Esq, Glasgow
Loack Roag
Lent by Provost Wilson, Govan
Woodcutting in Cadzow Forest
Lent by J T Whitelaw, Esq, Glasgow
Dysart Harbour
Lent by Mrs Horn, Edinburgh
Cadzow
Lent by A Brown, Esq, Glasgow
Road Scene
Lent by J Cochrane, Esq, Glasgow
Dysart
Lent by J Cochrane, Esq, Glasgow
A Fishing Village
Lent by Mrs J H Young, Glasgow
Edge of the Pool
Lent by Miss McKerracher, Glasgow
Largs Bay
Lent by Leonard Gow, Esq, Kirkintilloch
Great Arenhine, Lewis
Lent by James Donald, Esq, Glasgow
Anstruther
Lent by R W Rankine, Esq, Edinburgh
Hayfield
Lent by George H Wallace, Esq, Bellahouston
Peel Harbour, Isle of Man
Lent by Leonard Gow, Esq, Kirkintilloch
Modena during the Austro–Hungarian Campaign
Lent by J Cochrane, Esq, Glasgow
Lock in North Wales
Lent by Joseph Henderson, Esq, Glasgow
Burns' Cottage
Lent by Henry Gourlay, Esq, Dundee
Harvest Scene, Ross of Mull
Lent by William Johnston, Esq, Glasgow
Canty Bay
Lent by James T Hay, Esq, Edinburgh
Druidical Stones, Lewis
Lent by P Mackindoe, Esq, Glasgow

St Andrews
Lent by Alex Rosen, Esq, Glasgow
Kirkwall
Lent by Robert Mudie, Esq, Broughty Ferry
Edinburgh Castle – Arrival of the Troops
Lent by A Sanderson, Esq, Edinburgh
Cadzow Forest
Lent by Mrs Horn, Edinburgh
The Baggage Waggons
Lent by H L Anderson, Esq, Glasgow
Sunset
Lent by D Macdonald, Esq, Greenock
Thunderstorm
Lent by Robert Ramsey, Esq, Crosshill
St Monance
Lent by Leonard Gow, Esq, Glasgow
Glen Sannox
Lent by Miss McKerracher, Glasgow
Crossing the Bridge
Lent by J Anderson, Jun, Esq, Glasgow
Lancaster Sands
Lent by John McGavin, Esq, Glasgow
Loch Leven
Lent by Mrs A Muirhead, Edinburgh
A Storm at Keynsham Lock
Lent by Dr George R Mather, Glasgow
Kirkwall Fair – A Rainy Day
Lent by W McTaggart, Esq, RSA, Edinburgh
Bothwell Castle
Lent by J Irvine Smith, Esq, Glasgow
A Cheshire Canal
Lent by Dr A Blair Spence, Dundee
Entrance to Cadzow Forest
Lent by J E Poynter, Esq, Glasgow
Yanwath Hall
Lent by Henry Gourlay, Esq, Dundee
Distant View of Windsor Castle, 1878
Lent by T Chapman, Esq, Edinburgh
Glasgow Bridge
Lent by A G Macdonald, Esq, Glasgow
St Andrews
Lent by J R Findlay, Esq, Edinburgh
Dumbarton Castle
Lent by Hugh Pollock, Esq, Glasgow

Off East Wemyss
Lent by T Chapman, Esq, Edinburgh
Styehead Pass
Lent by J J Weinberg, Esq, Dundee
Bass Rock – Pleasure Party Landing, 1860
Lent by T Chapman, Esq, Edinburgh
Braid Hills
Lent by James F Low, Esq, Monefieth
Bass Rock, North View of the Prisons
Lent by T Chapman, Esq, Edinburgh
Borrowdale
Lent by J Cochrane, Esq, Glasgow
Old Mill and Castle
Lent by Robert Ramsey, Esq, Crosshill
Red Lion Inn at Knowsley – Coach Coming In
Lent by John M Keiller, Esq, Dundee
Near Aberdour
Lent by R W Allan, Esq, Glasgow
Marine View
Lent by Dr Douglas Reid, Helensburgh
The Weald of Kent
Lent by Percy Westmacott, Esq, Newcastle-on-Tyne
St Monance – Day after the Storm
Property of the Institute
Blowing Fresh
Lent by Dr A Blair Spence, Dundee
Goalen Castle, Kerrara
Lent by A C Lamb, Esq, Dundee
Holy Island Sands
Lent by Thomas McDougall, Esq, Eskvale
Cadzow Castle
Private property
Brougham Castle – Evening Effect
Lent by William Johnston, Esq, Glasgow
Pier by Moonlight
Lent by Robert Hamley, Esq, Crosshill
Cadzow Forest
Lent by James Jamieson, Esq, Kirkcaldy
Ben Ledi
Lent by P Macindoe, Esq, Glasgow
The Clyde from Broomielaw Bridge
Lent by Thomas Henderson, Esq, Glasgow
Kilmorach Mill
Lent by J Cochrane, Esq, Glasgow

Peel Castle
Lent by Mrs A Muirhead, Edinburgh
Queen Mary's Well, Barncluith
Lent by Dr George R Mather, Glasgow
Edinburgh Illuminated on the occasion of the Prince of Wales
 Marriage
Lent by Edward Martin, Esq, Glasgow
Left by the Tide
Lent by Kenneth Thornton, Esq, Crosshill
Inchcolm
Lent by W D McKay, Esq, ARSA, Edinburgh
Distant View of Carlisle – the last work of the Artist
Lent by Mrs Bough
St Monance - Moonlight
Lent by Thomas Pearson, Esq, Glasgow
Balmoral
Lent by John M Keiller, Esq, Dundee
Corby Castle
Lent by James F Low, Esq, Monefieth
Inchmahome, Lake of Monteith
Lent by James Faed, Esq, Edinburgh
Dunstanbro' Castle – Storm
Lent by James F Low, Esq, Monefieth
Harvest Field
Lent by Henry Gourlay, Esq, Dundee
An Old Pet
Lent by J E Poynter, Esq, Glasgow
Head of Loch Fyne
Lent by G B Simpson, Esq, Broughty Ferry
Naworth Castle
Lent by J J Weinberg, Esq, Dundee
Deer on Mountain Top
Lent by W Forrest, Esq, Edinburgh
A Quadrangle of the old College, High Street
Lent by Dr George W Mather, Glasgow
On the Thames
Lent by R J Bennet, Esq, Glasgow
Fingals Cave
Lent by A G Macdonald, Esq, Glasgow
Stockwell Bridge
Lent by A G Macdonald, Esq, Glasgow
Illustration – "The Deformed Transformed"
Lent by James Jamieson, Esq, Kirkcaldy
Cadzow
Lent by Henry Gourlay, Esq, Dundee

St Monance – A Summery Day
Lent by John Aitken, Esq, Glasgow
A Hay Field
Private Property
At Arbroath
Lent by George B Simpson, Esq, Broughty Ferry
Rainy Day
Lent by A C Lamb, Esq, Dundee
Old Aberdour Harbour
Lent by Thomas Chapman, Esq, Edinburgh
On the Irwell, Manchester
Private Property
Braid Hills – Looking West
Lent by D Macdonald, Esq, Greenock
Beauly Abbey
Lent by Robert Ramsey, Esq, Crosshill
Royal Review Edinburgh 1860
Lent by R Bryson, Esq, Edinburgh
Cove, Cockburnspath
Lent by Thomas Chapman, Esq, Edinburgh
Lock Scene
Lent by A R Henderson, Esq, Glasgow
St Monance
Lent by A C Lamb, Esq, Dundee
Hayfield – Gale
Lent by James Mudie, Esq, Broughty Ferry
Caldbeck Church
Lent by A C Lamb, Esq, Dundee
Illustration – "The Deformed Transformed"
Lent by James Jamieson, Esq, Kirkcaldy
Cathedral, Iona
Lent by James G Orchar, Esq, Broughty Ferry
Woody Lane
Lent by Robert Ramsey, Esq, Crosshill
Caldbeck Church
Lent by James F Low, Esq, Monefieth
Canal Scene
Lent by James Carnegie, Esq, Edinburgh
Sweetheart Abbey, Dumfriesshire
Lent by W Forrest, Esq, Edinburgh
Stirling Castle
Lent by A C Lamb, Esq, Dundee
Dysart – Low Water
Lent by Capt Lodder, Edinburgh

Gamekeeper going his Rounds
Lent by Lieut Colonel Alex Wilson, Bannockburn
View in the Lake District, Cumberland (1842)
Lent by J Fisher, Esq, Carlisle
Trongate
Lent by A G Macdonald Esq, Glasgow
A Storm
Lent by James Jamieson, Esq, Kirkcaldy
Gowbarrow Park – Twilight
Lent by James Jamieson, Esq, Kirkcaldy
Illustration – "The Deformed Transformed"
Lent by James Jamieson, Esq, Kirkcaldy
Pittenweem
Lent by John Henderson, Esq, Partick
Felling Timber – Cadzow Forest
Lent by Thomas Chapman, Esq, Edinburgh
Ben Ledi, from Pass of Leny
Lent by James G Orchar, Esq, Broughty Ferry
Illustration – "The Deformed Transformed"
Lent by James Jamieson, Esq, Kirkcaldy
In Cadzow Forest
Lent by James Faed, Esq, Edinburgh
Roadside Farm at Braid, near Edinburgh
Lent by James Faed, Esq, Edinburgh
Old Clydeneuk, on the River Clyde
Lent by J E Poynter, Esq, Glasgow
Bannockburn, from the Gillies Hill
Lent by Lt Colonel Alex Wilson, Bannockburn
On the River Avon
Lent by Leonard Gow, Esq, Glasgow
On the Clyde
Lent by William Gillespie, Esq, Glasgow
Windy Day
Lent by Andrew Maxwell, Esq, Glasgow
Dunblane Cathedral
Lent by W Stevenson, Esq, Cumbernauld
Clyde, from Dalnottar Hill
Lent by A G Macdonald, Esq, Glasgow
In Cadzow Forest – Evening
Lent by William Gillespie, Esq, Glasgow
Dumbarton and its Ship-Yards
Lent by Baillie Paul, Greenock
Stockwell Bridge
Lent by A G Macdonald, Esq, Glasgow

Portrait of Mrs Bough
Lent by Mrs Bough, Edinburgh
Barncluith
Lent by A G Macdonald, Esq, Glasgow
A Rainy Day
Lent by A G Howat, Esq, Glasgow
Sunset
Lent by Leonard Gow, Esq, Glasgow
A River Scene, Cumberland
Lent by James Donald, Esq, Glasgow
West Wemyss
Lent by J G Orchar, Esq, Broughty Ferry
Sketch in Cheshire
Lent by John Carrick, Esq, Glasgow
Passing Shower
Lent by Leonard Gow, Esq, Glasgow
Illustration – "The Deformed Transformed"
Lent by James Jamieson, Esq, Kirkcaldy
Ullswater, from Pooley Bridge
Lent by Thomas Chapman, Esq, Edinburgh
Anstruther
Lent by J Blair, Esq, Edinburgh
On the Clyde
Lent by Thomas Chapman, Esq, Edinburgh
Peel Castle and Harbour, Isle of Man
Lent by Thomas Chapman, Esq, Edinburgh
Edinburgh Castle – Troops Arriving
Lent by Dr George R Mather, Glasgow
Holy Island Castle
Lent by D Macbeth, Esq, Edinburgh
Cadzow Forest
Lent by A M Bayne, Esq, Glasgow
Borrowdale
Lent by D Macdonald, Esq, Greenock
Glasgow Cathedral
Lent by A G Macdonald, Esq, Glasgow
On the Thames
Lent by Thomas Pearson, Esq, Glasgow
Kellie Castle, Fife
Lent by James Faed, Esq, Edinburgh
Loch Achray
Lent by Thomas Chapman, Esq, Edinburgh
Borrowdale
Lent by William Johnston, Esq, Glasgow

Tarbert, Loch Fyne
Lent by William Johnston, Esq, Glasgow
Sands, Holy Island
Lent by Andrew Maxwell, Esq, Glasgow
Borrowdale
Lent by W Stevenson, Esq, Cumbernauld
Staff
Lent by A G Macdonald, Esq, Glasgow
The West Coast of Mull – The Sun Sinking into a Fog Bank
Lent by R Kidston, Esq, Edinburgh
St Monance, Coast of Fife
Lent by James Faed, Esq, Edinburgh
Canal Scene, Bruges – Moonlight
Lent by R Kidston, Esq, Edinburgh
Rob Roy crossing the Ford, black and white
Lent by R J Bennet, Esq, Glasgow
'Under the Hawthorns' done on a blotting pad
Lent by J M Gow, Esq
Drawing done with Candle Snuff
Lent by A C Lamb, Esq, Dundee

1896 **Loan Exhibition of Oil Paintings and Watercolour Drawings by Sam Bough RSA opened July, 1896, Corporation Art Gallery, Carlisle**
Peter's Crooks, on the Liddel
Lent by Mrs W B Nanson, Carlisle
Wetheral
Lent by Robert Hill, Esq, Carlisle
On the Avon, near Bristol
Lent by A D Grimond, Esq, Dundee
Distant View of Carlisle (unfinished)
Lent by R Vary Campbell, Esq, Sheriff of Dumfries & Galloway
View of Carlisle from the North East (1843)
Lent by Mrs Sewell, Carlisle
Brough Marsh (1872)
Lent by S Boustead, Esq, Harraby
Ullswater (1843)
Lent by Miles MacInnes, Esq, Carlisle
Rosehill (1844)
Lent by William Sewell, Esq, London
The Junction of the Quair with the Tweed (1875)
Lent by Mrs Mary Clapperton, Edinburgh
Seascape (1865)
Lent by Thomas Swan, Esq, Edinburgh

In Naworth Woods
Lent by Thomas Nanson, Esq, Carlisle
View on the Lyne (1843)
Lent by Mrs Sewell, Carlisle
'Within a Mile of Edinburgh' (1860)
Lent by John Paton, Esq, Stirling
Peel Castle, Isle of Man (1874)
Lent by Mrs Muirhead, Edinburgh
March of the Avenging Army – Crossing the Solway (1877)
Lent by John Grieve, Esq, Hawthornden, Midlothian
Ullswater
Lent by Miles MacInnes, Esq, Carlisle
Sunset, East Coast – Musselburgh Harbour (1862)
Lent by James T Tullis, Esq, Rutherglen
Broomielaw, Glasgow
Lent by Robert Croall, Esq, Midlothian
Holy Island – Sunset
Lent by Alex Fraser, Esq, Dundee
Portrait of the Owner (1861)
Lent by Dr Douglas Reid, Helensburgh
Cricket Match (Newcastle v Carlisle) at Carlisle
Lent by C J Howe, Esq, Putney SW
Inchcolm (1857)
Lent by William D McKay, Esq, Edinburgh
View in Furness
Lent by Mrs W B Nanson, Carlisle
The Rocket Cart – Isle of Wight (1876)
Lent by James Lindsay, Esq, Edinburgh
Dysart Harbour at Low Water – Gale Blowing (1860)
Lent by David Tullis, Esq, Edinburgh
Coast of Fife – Moonlight
Lent by Messrs Wallis and Son, London
Edinburgh, from the Canal (1864/5)
Lent by Robert H Brechin, Esq, Glasgow
Lanrick, from the Gardens
Lent by Sir Robert Jardine, Bart, Castlemilk
Vale of Avon, from Haughhead (1859)
Lent by John Ramsay, Esq, Tayport
Loch Ard (1875)
Lent by Alexander Wilson, Esq, Bannockburn
Cramond, Firth of Forth (1862)
Lent by Mrs John B Atkinson, Southport
Crossing Solway Sands (1877)
Lent by John Ramsay, Esq, Tayport

Otter Hunt
Lent by John Fleming, Esq, Stanwix
Barges on the River Irwell (1850)
Lent by A C Lamb, Esq, Dundee
Cadzow Forest (1856)
Lent by E W Langlands, Esq, Glasgow
Port of London (1858)
Lent by David S Cargill, Esq, Glasgow
Kirkstall Abbey (1857)
Lent by Sir W Arrol MP, Ayr
Workington Bridge (1842)
Lent by John Nelson, Esq, York
Dumbarton Rock, from Bishopton (1861)
Lent by Dr Hamilton Wylie, Edinburgh
Cottages at Dalston
Lent by Thomas Anson, Esq, Carlisle
The Mail Coach (1855)
Lent by Leonard Gow, Esq, Glasgow
Edinburgh, from St Anthony's Chapel (1854)
Lent by W K Mackay, Esq, Edinburgh
Seascape – Unloading
Lent by J Hume, Esq, Glasgow
Kirkwall Harbour (1872)
Lent by A M Ogston, Esq, Aberdeen
Edinburgh, from the Canal (1862)
Lent by J Hume, Esq, Glasgow
London from Shooters Hill (1872)
Lent by J T Smith Esq, Edinburgh
Oban Bay (1855)
Lent by J Hume, Esq, Glasgow
View on the Clyde at Hamilton (1864)
Lent by Sir Robert Jardine, Bart, Castlemilk
Cattle Crossing the Solway (1869)
Lent by J M Crabbie, Esq, Dumfries
The Baggage Waggons approaching Carlisle (1849)
Lent by the Trustees of the Late Hugh Locke Anderson, Esq, Helensburgh
The Pool of London (1865)
Lent by W McEwan, Esq, MP, London
St Andrews Bay – Sunrise
Lent by Dr Douglas Reid, Helensburgh
Stratford on Avon (1855)
Lent by Joseph Taylor, Esq, Langholm
Edinburgh, from Bonnington (1856)
Lent by John Robertson, Esq, Dundee

Seascape – Sunset (1860)
Lent by John Jordan, Esq, Leith
Path through the Wood (1864)
Lent by Sir John Watson, Bart, Hamilton
West Wemyss Harbour – Sunrise (1854)
Lent by W McEwan, Esq, MP, London
Seascape
Lent by Mr Councillor Tweedy, Wetheral
A Rustic Bridge
Lent by John Fleming, Esq, Stanwix
Windermere (1857)
Lent by Richard Sewell, Esq, Carlisle
Scene in Norway (1857)
Lent by Thomas Swan, Esq, Edinburgh
Peeling Oak Bark, Cadzow Forest
Lent by Mrs Stead, Carlisle
Ferry on the Eden
Lent by Messrs Wallis and Son, London
Herring Fishing Boats returning at Sunrise to Leith Roads (1871)
Lent by W A Arrol, Esq, Glasgow
Saved (1858)
Lent by Messrs Wallis and Son, London
The Brook
Lent by C J Howe, Esq, Putney SW
Dunkirk (1850)
Lent by William Beattie, Esq, Glasgow
Grange in Borrowdale (1846)
Lent by Robert Barton, Esq, Carlisle
'Ceaseless misery, endless woe,
Has brought the old place to what you see.
Oh! beware of a suit in Chancery.' (1853)
Lent by Messrs Wallis and Son, London
Dysart (1863)
Lent by G M Low, Esq, Edinburgh
Edinburgh from Bonnington (1875)
RSA Diploma Picture
Lent by the President and the Council of the Royal Scottish Academy
Sunset – Morecambe Bay (1856)
Lent by James Brechin, Esq, Edinburgh
Cadzow Forest – Drying Clothes (1855)
Lent by Richard Sewell, Esq, Carlisle
Devol Glen, Port Glasgow (1854)
Lent by Dr Douglas Reid, Helensburgh

Gylen Castle, Kerrera Island – Sunset (1878)
Lent by A C Lamb, Esq, Dundee
Winter Scene (1865)
Lent by Henry Gourlay, Esq, Basingstoke
Inchmahome, Lake of Menteith (1877)
Lent by James Faed, Esq, Edinburgh
Landscape with Figures
Lent by Alex S Stevenson, Esq, Weybridge
A Scene at Canty Bay
Lent by James Pringle, Esq, Edinburgh
Canty Bay
Lent by John Leadbetter, Esq, Broughty Ferry
Forest Confessional – Cadzow Forest (1851)
Lent by Mrs Sewell, Carlisle
Burns' Cottage and Alloway Kirk (1869)
Lent by Thomas Swan, Esq, Edinburgh
Hoy Head, Orkneys (1864)
Lent by J J Weinberg, Esq, Dundee
A Highland Stream (1870)
Lent by Colin McCuaig, Esq, Edinburgh
Dunstanboro' Castle (1869)
Lent by James F Low, Esq, Monefieth
Stonehenge
Lent by William Wright, Esq, Carlisle
Cellardyke Harbour (1856)
Lent by P S Brown, Esq, Broughty Ferry
View in Cumberland (1847)
Lent by Charles Moody, Esq, Glasgow
Lanercost Priory (1870)
Lent by Miss Robertson, Edinburgh
Long Walk, Windsor (1872)
Lent by Arthur Sanderson, Esq, Edinburgh
Brougham Castle, Penrith (1848)
Lent by Mrs Sewell, Carlisle
St Andrews
Lent by P S Brown, Esq, Broughty Ferry
Yanwath Hall (1876)
Lent by Robert Ramsey, Esq, Glasgow
St Andrews – Morning after a Storm (1852)
Lent by John Jordan, Esq, Leith
Naworth Cstle (1873)
Lent by J J Weinberg, Esq, Dundee
On the Thames – Thunderstorm clearing off (1873)
Lent by the Executors of the Late George Coward, Esq, Carlisle

Holyrood Garden, sepia drawing
Lent by C J Howe, Esq, Putney, SW
The Weald of Kent (1875)
Lent by P G B Westmacott, Esq, Newcastle on Tyne
Burns' Cottage, Ayr
 'Twas then a blast o' Januar win'
 Blew hansel in on Robin'
Lent by Henry Gourlay, Esq, Basingstoke
View near Knutsford (1855)
Lent by James Pringle, Esq, Edinburgh
MacLean's Cross, Iona (1870)
Lent by James G Orchar, Esq, Broughty Ferry
A Gale on the East Coast – Sea Running (1869)
Lent by James Lindsay, Esq, Edinburgh
Lane Scene in Autumn (1855)
Lent by John Jordan, Esq, Leith
Glen Messan (1849)
Lent by R Vary Campbell, Esq, Sheriff of Dumfries & Galloway
Field of Bannockburn and Carse of Stirling, from Gillies' Hill
(1870)
Lent by Alexander Wilson, Esq, Bannockburn
Caldbeck Church (1874)
Lent by James F Low, Esq, Monefieth
Glasgow from Garngad Hill (1852)
Lent by Sir W Arrol, MP, Ayr
Solway Sands (1875)
Lent by Mrs Mather, Glasgow
Kirkwall Fair – A Rainy Day (1865)
Lent by W McTaggart, RSA, Edinburgh
Brougham Castle, Penrith (1848)
Lent by Mrs Sewell, Carlisle
Eamont Bridge, Penrith (1870)
Lent by C J Ferguson, Esq, Carlisle
The End of the Day (1856)
Lent by Messrs Wallis and Son, London
Sty Head Pass (1873)
Lent by J J Weinberg, Esq, Dundee
St Monance Harbour – Moonlight (1878)
Lent by Robert Ramsey, Esq, Glasgow
St Monance (1866)
Lent by John Robertson, Esq, Dundee
Edinburgh Castle – Time Gun going off
Lent by Arthur Sanderson, Esq, Edinburgh
A Mill on the River Lowther, Westmorland (1856)
Lent by A C Lamb, Esq, Dundee

Old Billingsgate (1864)
Lent by James F Low, Esq, Monefieth
Loch Leven (1868)
Lent by R Roy Paterson, Esq, Edinburgh
West Coast of Mull (1876)
Lent by R Kidstone, Esq, Edinburgh
Old Machars, Aberdeen
Lent by Thomas Swan, Esq, Edinburgh
Carlisle Castle Gate (1869)
Lent by Mrs Sewell, Carlisle
Niddrie Castle, Edinburgh
Lent by Mrs Bough, Carlisle
Lochearnhead
Lent by W H Blackstock, Esq, Glasgow
Dumbarton Castle (1869)
Lent by Hugh Pollock, Esq, Glasgow
Loch Katrine
Lent by James P Gibson, Esq, Edinburgh
Tourists at Iona (1870)
Lent by A S Stevenson, Esq, Weybridge
In Norway
Lent by Thomas Swan, Esq, Edinburgh
The Thames above Richmond (1854)
Lent by R Kidstone, Esq, Edinburgh
Naworth Castle – Wind and Rain
Lent by John Jordan, Esq, Leigh
Newark Castle (1854)
Lent by R Kidstone, Esq, Edinburgh
St Monance, Coast of Fife (1876)
Lent by James Faed, Esq, Edinburgh
In Cadzow Forest (1852)
Lent by R Vary Campbell, Esq, Sheriff of Dumfries & Galloway
Glen Carron (1869)
Lent by Messrs Wallis and Son, London
St Andrews (1971)
Lent by J R Findlay, Esq, Edinburgh
Battle of Bothwell Bridge (1865)
Lent by James T Tullis, Esq, Rutherglen
Appleby Church – 'Each in his narrow cell for ever laid' (August 1878)
Lent by Mrs Sewell, Carlisle
A Street Scene in Norway (1862) – pencil sketch
Lent by James M Gow, Esq, Edinburgh
Druids' Circle, Keswick (1875)
Lent by Mrs Sewell, Carlisle

Anstruther (1858)
Lent by R Kidstone, Esq, Edinburgh
Peel Castle, Morecambe Bay – Morning (1855)
Lent by Mrs Sewell, Carlisle
Kirkwall Harbour (1866)
Lent by James G Orchar, Esq, Broughty Ferry
Bungaree (1872)
Lent by Mrs Sam Bough, Edinburgh
On the Canal, Manchester
Lent by Mrs Bough, Carlisle
Scotch Terrier (1860)
Lent by William McCall, Esq, Glasgow
Peel Castle, Morecambe Bay – Afternoon (1855)
Lent by Mrs Sewell, Carlisle
The Horse Fair (1875)
Lent by the Executors of the Late George Coward, Esq, Carlisle
Carlisle Town Hall – Moonlight (1878)
Lent by Colin McCuaig, Esq, Edinburgh
Bass Rock, from Canty Bay (1870)
Lent by Miss Robertson, Edinburgh
Stirling Castle, Wallace Monument in the Distance (1876)
Lent by A C Lamb, Esq, Dundee
Stirling Castle from the Borestone (1870)
Lent by Alexander Wilson, Esq, Bannockburn
Guildford, Surrey (1865)
Lent by A S Stevenson, Esq, Weybridge
Alnick Castle
Lent by T B Bell, Esq, Carlisle
Haymaking
Lent by A R Henderson, Esq, Glasgow
Seascape – Sunset
Lent by Robert Ramsey, Esq, Glasgow
White Kirk Sands (1857)
Lent by James G Orchar, Esq, Broughty Ferry
Sunset – The Upper Valley of the Clyde
Lent by Dr Argyll Robertson, Edinburgh
A Country Road – Wind and Rain
Lent by James W Lamb, Esq, Dundee
Sunset – Ross of Mull
Lent by Mrs Gibson, Wetheral
Holme Wood Common
Lent by A S Stevenson, Esq, Weybridge
Iona (1871)
Lent by A S Stevenson, Esq, Weybridge

On the River Beauly (1873)
Lent by James T Tullis, Esq, Rutherglen
Sportsmen Returning
Lent by James P Gibson, Esq, Edinburgh
At Aberdour (1856)
Lent by A R Henderson, Esq, Glasgow
Cornfield (1869)
Lent by Henry Gourlay, Esq, Basingstoke
View on the Avon (1862)
Lent by Alexander Wilson, Esq, Bannockburn
Dwar Valley – Sunshine and Rain (1876)
Lent by A C Lamb, Esq, Dundee
Dunfermline
Lent by the Executors of the Late George Coward, Esq, Carlistle
Eel Traps, Dumfriesshire
Lent by R M Hill, Esq, Carlisle
The Western Islands, Ben More and the Ross of Mull (1870)
Lent by James T Tullis, Esq, Rutherglen
Caldbeck Church (1874)
Lent by W McCall, Esq, Glasgow
Cottages in the Carse of Gowrie (1869)
Lent by A S Stevenson, Esq, Weybridge
Rob Roy crossing the Ford at Aberfoyle, sepia drawing
Lent by Robert I Bennet, Esq, Ayr
Under the spreading Hawthorn, blotting paper
Lent by James M Gow, Esq, Edinburgh
Review in the Queen's Park, Edinburgh, July 1868, sepia
drawing
Lent by Mrs Sewell, Carlisle
Old Oaks, Cadzow Forest (1853)
Lent by A Mallock Bayne, Esq, Glasgow
Langdale Pikes (1854)
Lent by Mrs Sewell, Carlisle
On the West Coast (1858)
Lent by Robert Brechin, Esq, Glasgow
Kelly Castle, Fifeshire
Lent by James Faed, Esq, Edinburgh

SELECT BIBLIOGRAPHY

Art

Hilary Beck, *Victorian Engravings*, London, 1973.

Mungo Campbell, *The Line of Tradition: Watercolours, Drawings & Prints by Scottish Artists 1700–1990*, Edinburgh, 1993.

James L. Caw, *Scottish Painting 1620–1908*, Bath, 1975.

P. Darcy, *The Encouragement of the Fine Arts in Lancashire 1760–1860*, Manchester, 1976.

Trevor Fawcett, *The Rise of English Provincial Art: Artists, Patrons and Institutions outside London 1800–1830*, London, 1974.

R. H. Fuchs, *Dutch Painting*, London, 1978.

Paula Gillett, *The Victorian Painter's World*, Gloucester, 1990.

Paul Goldman, *Victorian Illustrated Books 1850–1870: the Heyday of Wood-engraving*, London, 1994.

Esme Gordon, *The Royal Scottish Academy of Painting, Sculpture and Architecture, 1826–1976*, Edinburgh, 1976.

Julian Halsby, *Scottish Watercolours 1740–1940*, London, 1986.

William Hardie, *Scottish Painting: 1837 to the Present*, London, 1990.

James Holloway & Linsday Errington, *The Discovery of Scotland*, Edinburgh, 1978.

John House, *Landscapes of France: Impressionism and its rivals*, London, 1995.

W. D. Mackay, *The Scottish School of Painting*, London, 1906.

Christopher Newall, *Victorian Watercolours*, London, 1987.

Kenneth Smith, *Early Prints of the Lake District*, Nelson, 1973.

William Vaughan, *German Romantic Painting*, New Haven, 1994.

Christopher Wood, *Victorian Panorama: Paintings of Victorian Life*, London, 1976.

Artists

Julius Bryant, *Turner: Painting the Nation*, London, 1996.

Trenchard Cox, *David Cox*, London, 1947.

Lindsay Errington, *Robert Herdman 1829–1888*, Edinburgh, 1988.

Lindsay Errington, *William McTaggart 1835–1910*, Edinburgh, 1989.

Andrew Greg, *John Wilson Carmichael 1799–1868*, Tyne & Wear, 1982.

Helen Guiterman & Briony Llewellyn, *David Roberts*, London, 1986.

267

Marshall Hall, *The Artists of Cumbria*, Newcastle upon Tyne, **1979.**

Marshall Hall, *The Artists of Northumbria*, Newcastle upon Tyne, 1982.

Martin Hardie, *John Pettie*, London, 1908.

Paul Harris & Julian Halsby, *The Dictionary of Scottish Painters 1600–1960*, Edinburgh, 1990.

David Hill, *Turner in the North*, New Haven, 1996.

James Moore 1819–1883, Belfast, 1973.

Stephen Wildman, Richard Lockett & John Murdoch, *David Cox 1783–1859*, Birmingham, 1983.

Katherine Michaelson, *David Octavius Hill (1802–1870) and Robert Adamson (1821–1848)*, Edinburgh, 1970.

Pieter van der Merwe, *Clarkson Stanfield 1793–1867*, Tyne & Wear County Council Museums, 1979.

People

Bryan Bevan, *Robert Louis Stevenson: Poet and Teller of Tales*, London, 1993.

Jenni Calder, *RLS: a Life Story*, London, 1980.

Ruth D'Arcy Thompson, *The Remarkable Gamgees: A Story of Achievement*, Edinburgh, 1974.

Ruth D'Arcy Thompson, *D'Arcy Wentworth Thompson, The Scholar Naturalist 1860–1948*, London, 1958.

Hunter Davies, *The Teller of Tales: in Search of Robert Louis Stevenson*, London, 1994.

William Farish, *The Autobiography of William Farish: the Struggles of a Handloom Weaver*, London, 1996.

Cargill Gilston Knott, *Life and Scientific Works of Peter Guthrie Tait*, Cambridge, 1911.

Julie Lawson, *William Donaldson Clark 1816–1873*, Edinburgh.

Craig Mair, *A Star for Seamen: the Stevenson Family of Engineers*, London, 1978.

James Pope-Hennessy, *Robert Louis Stevenson*, London, 1974.

Louis Stott, *Robert Louis Stevenson and the Highlands and Islands of Scotland*, Stirling, 1992.

R. C. Terry (ed.), *Robert Louis Stevenson: Interviews and Recollections*, London, 1996.

Places

Peter F. Anson, *Fishing Boats and Fisher Folk on the East Coast of Scotland*, London, 1971.

Peter Bicknell & Robert Woof, *The Discovery of the Lake District 1750–1810*, Grasmere, 1982.

Van Akin Burd & James S. Dearden, *A Tour of the Lakes in Cumberland: John Ruskin's Diary for 1830*, Aldershot, 1990.

Charles J. Smith, *Historic South Edinburgh*, Edinburgh, 1979.

Sydney Towill, *Georgian and Victorian Carlisle: Life, Society and Industry*, Preston, 1996.

T. W. Carrick, *The History of Wigton*, Carlisle, 1992.

David Daiches, *Glasgow*, London, 1977.

Alan Hamilton, *Essential Edinburgh*, London, 1978.

Stuart D. Ludlum, *Exploring the Lake District 100 Years Ago*, London, 1985.

Tom McGowran, *Newhaven-on-Forth: Port of Grace*, Edinburgh, 1994.

F. Marian McNeill, *Iona: a History of the Island*, London, 1973.

Allan Massie, *Edinburgh*, London, 1994.

Gary S. Messinger, *Manchester in the Victorian Age: the Half-known City*, Manchester, 1986.

D. R. Perriam, *Carlisle: an Illustrated History*, Carlisle, 1992.

Alexander Smith, *A Summer in Skye*, Edinburgh.

INDEX

271

McLean, Andrew, 106
McLellan, Archibald, 77
McMillan, James, 16–18, 30–31, 168
McTaggart, William, 92, 105, 108–
 109, 112–113, 161, 170–171,
 175, 179, 193, 195, 202, 214–
 215, 217, 222–224, 231
Millais, John Everett, 80–81, 104, 176
Miller, William, 125
Mitchell, Charles, 54, 165
Moffat, John, 136
Monet, Claude, 170
Monks of St Giles, 137
Monro, Sheriff, 153
Montgomery, Very Rev. Dean, 193
Monticelli, Adolphe, 231
Moore, Dr James, 182–183
Morgan, Billy, 9
Morgan, Rev. Morgan, 3
Morris, Mrs, 50
Moss, Rachel, 207
Mossman, John, 64
Mounsey, Major George Stevenson,
 7
Muir, Ian, 52
Muller, William James, 99, 221, 231
Murison, Dr, 41
Murray, David, 193, 222
Murray, Lord, 103
Murray, Richard, 21
Murray, W. H., 68, 76, 78
Musgrave, Sir George, 21, 33
Mutrie, Misses, 59

Nanson, William, 23–24
Napier, Robert, 77
Nasmyth, Alexander, 62
Nelson, James, 183
Nelson, Thomas, 33, 35, 183
Nesbit, Mrs, 122, 124
Nesbit, Thomas, the elder, 111, 118–
 119, 121
Nesbit, Thomas, the younger, 119
Nesbitt, John, 127, 164, 175
New Theatre Royal, Edinburgh, 124

Newcombe, Frederick Clive, 6
Nicol, Erskine, 108, 114, 121, 197
Nimmo, William, 147
Nixson, Paul, 12–14
Noble, Robert, 175
Nollekins, Joseph, 21
Nutter, Matthew Ellis, 9, 13–15, 19–
 21, 38, 221
Nutter, William Henry, 26, 162

Old Society of Watercolour Painters,
 150
Olympic Theatre, Edinburgh, 98
Orchar, James Guthrie, 76, 171
Orchardson, William Quiller, 109,
 119
Ormerod, George W., 56

Page, Dr, 34
Paterson, William, 147, 178–180, 183
Paton, Joseph Noel, 64, 104, 121, 197
Paton, Waller Hugh, 104
Payne, W. A., 63
Peddie, James Dick, 160–161, 172,
 193
Peel, John, 224
Percy, William, 53–55, 164–165, 200
Pettie, John, 109, 112–113, 119–120,
 173, 200
Phillip, John, 94–96, 146, 197, 200
Pinnington, Edward, 17, 27, 39, 72,
 75, 202–207, 212, 215, 222–223
Pissarro, Camille, 170
Playfair, William Henry, 89
Poussin, Nicolas, 25, 221
Pratchitt Brothers, 163
Pre-Raphaelite Brotherhood, 81,
 104–105
Prince's Opera House and Theatre
 Royal, Glasgow, 60, 62, 64, 67–
 68, 70–73, 75
Prout, Samuel, 47, 198

Queen's Theatre, Edinburgh, 114,
 128, 133

Queen's Theatre, Manchester, 56, 58

Raines, Dr, 101
Rayson, John, 38
Reid, Alexander, 123
Reid, Douglas, Dr, 115, 193
Reid, James, 64
Rembrandt, Harmensz van Rijn, 155
Richardson, Thomas Miles, Junior, 46
Richardson, Thomas Miles, Senior, 19, 21, 28, 30, 69, 221
Richardson, William, 163
Richmond, Canon, 200
Richon, Victor, 159
Roberts, David, 47, 105, 221
Robertson, Mrs, 166
Robinson, Mr, 168
Rodgers, James, 81
Romanes, Mrs, 159
Ronaldson, John, 155
Ross, Robert, 55
Rossetti, Dante Gabriel, 164
Rothwell, Selim, 60–61, 165
Routledge, Margaret, 24
Roy, John, 27
Royal Academy (RA), 59, 78, 94, 119, 131, 137, 148, 163–164, 171, 173, 221
Royal Association for the Promotion of the Fine Arts in Scotland (RAPFAS), 103, 107, 111, 124, 126, 168, 198
Royal Institution for the Encouragement of the Fine Arts in Scotland, 89
Royal Manchester Institution, 56, 60, 77, 85, 90, 96, 99, 105, 108, 112, 115, 117, 120, 124, 137, 150, 171, 173, 179
Royal Scottish Academy (RSA), 39, 68, 72, 75, 80–81, 83, 86, 89, 92, 97, 99, 102, 104–105, 107–108, 110, 114, 116, 120–121, 124–125, 128–130, 132, 134–136,

143–153, 155, 159–164, 166, 169, 171–173, 176–177, 179, 181, 194, 203, 204
Rubens, Peter Paul, 25, 221
Ruisdael, Jacob van, 82, 155, 221
Ruskin, John, 59, 81, 103
Russell, Sandy, 177
Ruthven, Lady Mary, 132–133, 164

Saber, Mr, 175
Sala, George Augustus, 52
Scott, Sir Walter, 11, 20, 27, 29, 35, 143, 168, 198
Scott, Thomas, 176
Scottish Society of Painters in Watercolours, 181, 194
Seneca, 213, 224
Sewell, Jane (née Wright), 8–9, 33, 39, 45, 161, 203
Sewell, John, 203, 206
Sewell, Margaret, 186, 202–205
Sewell, Richard, 203, 205
Sewell, Thomas, 33, 39, 45, 49, 53, 57, 77, 85, 91, 99, 113, 115, 146, 161, 164, 166, 168, 184, 193, 203
Sheffield, George, 14–15, 18–19, 25, 38, 221
Sheffield, John, 49
Sheffield, Mary, 25
Sheffield, Thomas, 7, 25, 46
Sherwen, Mrs Caroline, 184, 187
Shields, Henry, 101
Simpson, Georgina, 162
Sloan, Mr, 56, 58
Smellie, Mr, 206
Smiles, Samuel, 9
Smirke, Robert, 2, 25
Smith, Isabella, 11
Smith, John 'Warwick', 2
Society for the Encouragement of the Fine Arts in the North of England, Carlisle, 5, 13
Socrates, 213, 224
Sowerby, Richard, 163
Spedding, Mr, 41